Photography and the Art of Chance

Photography

and the

Art of Chance

ROBIN KELSEY

THE BELKNAP PRESS OF HARVARD UNIVERSITY PRESS

Cambridge, Massachusetts, and London, England

2015

First printing

Library of Congress Cataloging-in-Publication Data

Kelsey, Robin, 1961–

 Photography and the art of chance / Robin Kelsey.

 pages cm

 Includes bibliographical references and index.

 ISBN 978-0-674-74400-4 (alk. paper)

 1. Photography, Artistic—Philosophy. 2. Chance in art. I. Title.

 TR642.K445 2015

 770—dc23

 2014040717

For Cynthia Cone

Contents

Introduction *1*

1 William Henry Fox Talbot and His Picture Machine *12*

2 Defining Art against the Mechanical, c. 1860 *40*

3 Julia Margaret Cameron Transfigures the Glitch *66*

4 The Fog of Beauty, c. 1890 *102*

5 Alfred Stieglitz Moves with the City *149*

6 Stalking Chance and Making News, c. 1930 *180*

7 Frederick Sommer Decomposes Our Nature *214*

8 Pressing Photography into a Modernist Mold, c. 1970 *249*

9 John Baldessari Plays the Fool *284*

Conclusion *311*

Notes *325*

Acknowledgments *385*

Index *389*

Photography and the Art of Chance

Introduction

Can photographs be art? Institutionally, the answer is obviously yes. Our art museums and galleries abound in photography, and our scholarly journals lavish photographs with attention once reserved for work in other media. Although many contemporary artists mix photography with other technical methods, our institutions do not require this. The broad affirmation that photographs can be art, which comes after more than a century of disagreement and doubt, fulfills an old dream of uniting creativity and industry, art and automatism, soul and machine. For those of us who find the best of photography compelling and full of insight, this recognition is a welcome historical development.

The situation, however, is not as rosy and simple as all that. It's not as though the art world assimilated photography solely on the basis of disinterested inquiry and careful argument. There were many incentives at work, including the lure of a profitable new market and the desire for more accessible museums. Institutional gatekeepers often suppressed, dismissed, or answered only vaguely the many questions raised about how well photography satisfies our demands on art. As a result, some of us who hold the aesthetic potentials of photography in high regard nonetheless have deep misgivings about the terms of its assimilation. Although some troubling aspects of these terms have received significant attention in recent years, one issue remains neglected: chance.

Photography is prone to chance. Every taker of snapshots knows that. The first look at a hastily taken picture is an act of discovery. In this one, an expression is exuberant or a gesture is winning; in that one, a mouth is

agape or a hand blocks a face. Once in a blue moon, a rank amateur produces an exquisite picture. Trained photographers may be better at anticipating when and how such a picture might be made, but even they take scores of shots for every one worth posting or publishing. For amateur and professional alike, the successful picture can be an uneasy source of pride. Pressing the button fosters a sense of having produced the picture, but how far does that responsibility extend? Has the person who has accidentally taken a superb photograph made a work of art? The conspicuous role of chance in photography sets it apart from arts such as painting or literature. Whereas in a traditionally deliberate art form, such as the novel, chance comes across as something contrived, in photography it comes across as something encountered. What does it mean that photography so often entails a process of haphazard making and careful sorting?

These are questions that the art world has tended to muffle or ignore. Chance, one might say, lacks a constituency. Generally speaking, it valorizes neither the photograph nor the photographer. Most photographers, collectors, and curators would prefer to suggest that a picture speaks for itself and therefore the circumstances of its production are immaterial, or to presume that pictorial success reflects a mastery of the medium. But the notion of pictures speaking for themselves is problematic if not paradoxical, and inference of mastery from any particular photograph, due to the role of chance in the medium, is unwarranted.[1] Photographs, to be meaningful, must be products of history, and that history is haunted by chance.

In the twentieth century, the assurance that what may seem like luck is actually a matter of skill and effort became a shibboleth of photography books and exhibition catalogues. A passage from *Photography and the Art of Seeing*, published in 1935, offers a typical account: "Nor must we overlook that the operator's success largely depends upon his taking his shot at the moment when the interest of the scene culminates. This is not a matter of lucky chance, but of artistic skill which is the outcome of synthetic effort. The most convincing proof of the foregoing assertion is to be found in certain remarkable photographs."[2] Such blanket assurances that mastery can be read directly from the exceptional photograph without regard to its history have underwritten the art photograph both as museum object and as commodity.

Art authorities have often dismissed chance as an issue only troubling the ignorant. Consider this passage from an article in the *Yale University*

Introduction

Art Gallery Bulletin discussing a recently acquired series of photographs by Robert Adams, a selection of which had been published as a book:

> For non-photographers, the ratio of negatives to pictures-in-books that Robert Adams produced on this project most likely seems large: over 5,000 pictures made and, of those, fewer than one hundred selected for initial publication. Unsurprisingly, these figures are, for photographers, less an issue than an irrelevant distraction: Garry Winogrand, on being asked in public forum just how many pictures he had to take to make a good one, replied irritably, "Art isn't judged in terms of industrial efficiency," a remark that should suffice as the last word on the subject.[3]

Why the last word? Winogrand's response offers tart rhetoric but little substance. The supposedly naive question he received is actually of the utmost relevance. It is precisely the "industrial" quality of photography that allows photographers to take so many pictures for each one selected for display. Even the "non-photographers" denigrated in the passage know this, because they are in fact photographers. The issue is not efficiency but instead how meaning is produced in a medium prone to chance.

Rather than impatiently dismiss the problem of chance in photography, some of the medium's greatest practitioners have explored it with dogged brilliance. This book is devoted to the work of a handful. It interprets their photographs and texts in light of the entangled histories of photography, art, and chance to discover whatever insights this work may proffer. It does so from a conviction that these photographs and texts constitute a vital legacy for our times and remain promisingly open to the future. Underlying the effort is a belief that through the study of art we can know ourselves and our world more intimately and ardently, an engagement our humanity requires.

The book's argument is narrow in some respects and broad in others. It links a series of practitioners who worked in England or America: William Henry Fox Talbot (1800–1877), Julia Margaret Cameron (1815–1879), Alfred Stieglitz (1864–1946), Frederick Sommer (1905–1999), and John Baldessari (1931–). Readers familiar with the histories of photography and art may recognize these names as canonical, and in several respects that status is precisely the point. These practitioners enjoyed the privilege of working canonically—that is, of contending deeply and critically not only

with prevailing circumstances but also with a constellation of vigorous thinkers and practitioners coming before and alongside them. Canons suffer the subjugations and exclusions pervading society at large, and the generally pale and almost wholly male membership of this series of practitioners is cause for lament about the past and for impatience with the present. But the call-and-response structure that canonical work builds through the generations is the baby in the proverbial bathwater, worthy of preservation even as we seek to discard the prejudices that have constrained canon formation to date. Canons are saturated with power, but with critical vigilance they can serve to divulge and resist it. They can show the reliance of cultural achievement on participation, dialogue, emulation, encouragement, and rivalry. Canons are conversations around which a culture can define itself, and without them collective aspiration and social value threaten to dissipate into the blunt and banal exchanges of commerce.

The span from Talbot to Baldessari encompasses almost the entire era of analog photography. Apart from a brief discussion of our digital moment in the conclusion, this book is about the photography of plates, films, emulsions, and shutters. It is about the investment that modernity made in the industrial magic of photochemistry and the black boxes of cameras, and how this investment changed the production and consumption of images. It is about the verve and ingenuity with which certain practitioners sought to make art from the action of light. But this history is not a paean to a lost age. It is an account of struggles with contradictions that still rend and baffle our society. The implications of these struggles remain immense, and artists of our own day are finding effective means to address them. In support of present and future efforts to find such means, those of us who personally experienced the onset of the digital era may bear a special responsibility to relate the issues and insights of the analog past.

There is one claim, it should be clear from the outset, that this book does not make. That claim is that art is the essence or sole fulfillment of photography. With respect to social value, photography as a means of knitting people together in rewarding associations, or of alerting them to atrocity, or of enabling them to convey the significance of their existence, or of amplifying their visual experience to encompass new scales or temporalities, takes no backseat to photography as art. The book claims only that the testing ground we call art, to the extent that it entails a commitment to critical reflection on means and ends, can foster awareness of how photography carries out its many functions, and how it might do better. Built into

the argument is the belief that photography as art has been inextricably bound to its other operations.[4]

The basic elements of this book's story—photography, art, and chance—have all changed markedly over the years. Dovetailed with the chapters on the work of the featured practitioners are chapters that trace these changes from one generation to the next. The book thus alternates between a tight focus on an individual practice and a broader optic taking in the historical circumstances that this practice engaged. Even the broad chapters, however, tend to concentrate on particular texts or pictures to bring out the vivid dispositions of each historical moment. This structure affirms the value of close reading and looking in the search for historical meaning.

Some readers may be surprised at the notion that chance has a history. Chance may seem always mere chance, the imp that escapes all systems. A roll of the dice in 1840 may seem the same as one in 1930. This impression is crucial to the argument, but equally important is the recognition that the significance of chance has changed throughout the modern period.[5] For many Victorians, chance was a spectral agent in Darwinian evolution that imperiled traditional accounts of creation. For some Cold War analysts, it was an instrumental input into simulations of international strife. Across the generations, chance has been encountered or enlisted in new forms.

The concept of chance is difficult to grasp even in principle. Consider this 1962 effort at defining the closely related term *random* by the physicist and information theorist Donald MacKay: "Having made this division [between randomness in events and randomness in states] we must further distinguish between (a) the notion of *well-shuffledness* or impartiality of distribution; (b) the notion of *irrelevance* or absence of correlation; (c) the notion of *'I don't care'*; and (d) the notion of *chaos*."[6] Rather than approach chance through such a taxonomic framework, this book will wade through a fertile muck of kindred notions. Various strains of chance, randomness, luck, and accident will come into play, including all the strains MacKay mentions, but they will take impure forms. History is messier than philosophy, and these various strains of chance and its cognates have mingled incessantly in molding attitudes toward the world and toward art.

Although chance changes over the years and from one situation to the next, it has possessed enough continuity to give this story shape. It has remained a mostly negative concept. As an agent, it has lacked purpose or obligation. Whether associated with the gambling den, the Darwinian

mutation, or the decay of radioactivity, chance has been about spontaneity and surprise, about the event that seems to come from nowhere to interrupt an existing order or give rise to a new one. It sets a limit to any scheme, plan, or account. This is still the way of chance today. When all other explanations are exhausted or abandoned, chance is what remains.

How we view chance depends on the agent we imagine it to supplant or delimit. When we imagine that agent to be God, chance becomes a feature of secular cosmology. In a world saturated with intention, there is no room for it; divine will or design pervades matter and events down to the last particular. To attribute something to chance is to forfeit faith in an omnipotent and omnipresent creator. Chance is therefore associated with doubt, and with doubt about divine providence in particular.

It may seem odd to suggest that a book about photography is about doubting God, but in some sense this is true. Photography and chance are bonded by an indifference associated with the Enlightenment and its skepticism regarding theological explanation. Photography records whatever is before the camera, giving the stray and trivial the same treatment as the main and essential, as if everything were equivalent. Chance is the same. A die may come up showing any number of pips from one to six, and the odds of each are equal. Such radical indifference is associated with the withdrawal of God and the advent of a disinterested cosmos in which the place of humanity is random and unprivileged. In the modern mix of order and disorder, we are a sum of chemical and biological accidents. From the work of Galileo and Charles Darwin to contemporary astrophysics, scientific inquiry has discovered evidence of cosmic indifference and undercut the notion of a universe intended by God for humanity.[7]

Photography and secular thought have thus been bound by the ways in which they circumscribe causation. In early modern Europe, chance impinged on the explanatory sufficiency of providence. It served to cover the gap between human knowledge of causes and the operation of divine laws that were presumed, albeit with a weakening faith, to govern even incidental phenomena. As the tracking of statistical regularity gained respect as a means of acquiring knowledge in its own right, chance began to inhere in the world. It thus marked a limit on what appeals to providence or natural law could explain. Secular thought removed the hand of God from ordinary events, while photography removed the hand of the artist from pictorial marking. Whether investigating phenomena or making pictures, moderns turned to mechanical causes and aggregate results. Marked by

indifference and prone to chance, photography was thus a pictorial medium tailored to the secular drift of the modern era.

If this claim seems a stretch, consider that photography arrived roughly alongside the notion of geologic time. The publication of Charles Lyell's *Principles of Geology* in three volumes between 1830 and 1833 did much to supplant the biblical account of creation with a story of geologic gradualism. A few years later, in early 1839, experimenters in France and England announced the invention of photography. The coincidence is striking: while scientific minds were boggling at the notion that the earth had shaped itself without design through the incremental action of earthly forces, there arrived a technology heralded as enabling "all nature" to "paint herself" through the incremental action of light.[8] The threatened displacement of the artist as a maker of pictures came alongside the threatened displacement of God as a maker of the world, and a crisis of meaning accompanied both. What did a picture mean—or a world mean, for that matter—if it just took form of its own accord?

Or consider that photography appeared soon after Robert Brown in 1827 observed pollen grains under a microscope jiggling randomly, a phenomenon now known as Brownian motion. Brownian motion was more in keeping with pagan accounts of matter than with the biblical story of creation. In the first century B.C.E., Lucretius had noted the random dancing of dust particles in beams of sunlight and inferred that such spontaneously moving atoms must make up the universe. For Victorians in the early decades of the nineteenth century, the behavior of tiny particles of matter—whether pollen grains, shoreline sand, or droplets of light-sensitive silver—was a source of unsettling fascination. Closely observed, these particles behaved in autonomous and unplanned ways. From pictures to hillsides, forms that had seemed intrinsically a matter of design were revealed to be the cumulative effect of autonomous and haphazard activity.

The modern notion that the world is composed of marvelous aggregations of autonomous particulars, of course, abides by the form of the market. Adam Smith's invisible hand has long been the preeminent sign for the power of capitalism to make a prosperous order from atoms of self-interested action.[9] According to Smith, although each man with capital may pursue his own wealth, security, and ease, the effect at times will be an allocation that inadvertently advances the welfare of society at large. In *The Wealth of Nations*, published in 1776, he cited circumstances under which the investor is "led by an invisible hand to promote an end which was no part of

his intention."[10] Smith's receptivity to the notion that selfish individual acts could tend toward social betterment was informed by his faith in a benevolent deity, but in the late eighteenth and early nineteenth centuries such faith grew scarce. The invisible hand increasingly seemed a careless mechanism, distributing aggregates ungoverned by providence. In this respect as well, the withdrawal of the hand in photography and the resulting openness of pictures to chance was in keeping with modern times.

In the absence of God, the need to contend with chance became a secular binding agent. Pollen grains were innocuous enough, but some operations of chance put life and prosperity in jeopardy. As an indiscriminate source of suffering, chance was a power against which all people in principle could rally. The rise of the modern welfare state was, among other things, a hard-won recognition that the harshest consequences of chance justified public insurance against risk. If sufferers did not endure the hard lessons of divine judgment, but instead the arbitrariness of an indifferent universe, then they had a strong claim on the individual conscience and the public purse. The negative cast of chance made it universal, enabling the state regulating its effects to bind citizens otherwise splintered by differences of affiliation or identity.[11] As an egalitarian principle of the modern period, chance played a key role in establishing progressive social programs and philosophies. The political philosopher John Rawls suggested that the social contract should be negotiated from behind a "veil of ignorance" concerning the participant's social position because chance, not God, will make the allotment.[12] By the same token, a society given over to chance could ostensibly make opportunities for good luck available to all. Whereas state lotteries offered a miniscule shot at instant wealth, photography promised the ordinary person a significant share in the prizes of pictorial fortune.

Along with insurance and state lotteries, art was a way of contending with secular uncertainty. In search of new meaning, modern society placed much hope in the integrative powers of human creativity, exalting art as an antidote for faltering belief. But this collective effort to compensate humanity for God's withdrawal was hampered by paradox. The rise of secularism added to the burden of art but weakened its authority, which for centuries had been modeled on divine creativity. The analogy between artist and God had particularly obsessed the masters of the Florentine Renaissance, against whom so many later artists were judged.[13] How could an artist exercise godlike powers when God himself had been routed by doubt?

With respect to this conundrum, photography appeared as both destroyer and redeemer. On the one hand, it threatened to extend the callous logic of aggregation into the last bastion of meaningful social expression. On the other hand, it bore the potential to wring from that logic some compensatory enlightenment and aesthetic value. Guided by the right intelligence, some enthusiasts believed, the mechanical ways of photography could reveal, address, or momentarily overcome the mechanical ways of the world. The chapters that follow consider ingenious efforts to deliver on this homeopathic promise. What Terry Eagleton said of his recent book—that it "is less about God than about the crisis occasioned by his apparent disappearance"—could be said about this one as well.[14] Although the entwinement of photography and theological doubt grows less salient in the later chapters, it remains a burden with which the featured practitioners implicitly grapple. In one way or another, all five ask chance for a measure of redemption.

Our view of chance changes considerably if we imagine it to supplant or delimit the agency of a human entity rather than that of God. In the secular context, chance becomes a limit on responsibility. Attributing an event to chance puts it beyond the reach of blame or credit. The exculpatory side of chance is crucial to modern legal regimes. *It was an accident.* Such words have been used to deny responsibility at every level of society, from individuals seeking to swindle insurance companies to corporations shielding themselves from liability for flawed products. If religion has been an opiate of the masses, then chance has been an alibi of the powerful. Time and again, efforts to ensure occupational or consumer safety have had to reframe the accidental as the inevitable. For photography as art, credit rather than blame has been the tricky issue. Chance has threatened to fill the disconcerting gap in the medium between intention and result.

The five practitioners featured in this book all faced a different struggle for credit and looked for redemption in a different form. In the mid-nineteenth century, Talbot, one of the inventors of photography, endeavored to defend the value of pictures made by his indifferent and capricious process. This defense required him to address key aesthetic and theological problems of his time. Could a picture that simply recorded things as they were constitute a work of art? Could a stray detail bear signs of the world's intelligibility? Such questions had been troubling important Victorian thinkers before photography arrived, and the new technology only complicated the search for answers.

As Victorians of Talbot's generation drove God away from terrestrial affairs, they also began mastering chance. They did so through statistically driven management and mechanized means of production. While insurance companies converted risk and uncertainty into predictable returns, factories used machines to minimize accidental variation. Uniformity was a watchword of the modern economy, which aimed to produce precise and interchangeable parts and commodities. Because many Victorians feared a loss of humanity in this pursuit of exact equivalence, accident and error took on connotations of human vitality and uniqueness. Chapter 3 describes how Cameron exploited such concerns to find aspiration in photographic happenstance.

The next two chapters concern vapor. Since the days of Lucretius, the play of moisture and other particulate matter in the atmosphere has been a vital locus for chance. By the early nineteenth century, clouds, mists, and fogs had become crucial to the Romantics as a means of countering what many regarded as the desiccated rationality of the Enlightenment. Such obscurant vapors offered spirited natural forms to revive or compensate for a curtailed faith in divine immanence. Vaporous atmospheres could also be visual archives of historical change. The great painter J. M. W. Turner, for example, depicted smoke and steam as well as natural vapors to contend atmospherically with the unsettling effects of modernization. Within decades, photographers were looking to vapor as a means of transmuting the world into a visual poetry that their apparatus could transcribe. Chapter 5 considers the winter that Stieglitz, wielding a new handheld camera amid the turbulent atmospheres and restless streets of New York City, courted chance and mobility to represent modern life.

Living without ritual certainties has inspired modern efforts to find solace or liberation in the everyday. By the middle decades of the twentieth century, certain photographers were celebrated as seers who could perceive and distill moments of transcendence in the spontaneous action or stray remnants of ordinary life. The horrors of two world wars fueled a desperation to experience pockets of redemption, while also subjecting to immense pressure the mythic capacity of the seer to find and deliver them. Belief in ties binding chance to the unconscious and to the primitive informed the search for photographic epiphanies, the results of which filled the pages of illustrated magazines. Not everyone, however, thought the celebrated purveyors of quotidian insight were hitting the mark. Chapter 7 addresses the wartime photography of Frederick Sommer, who spurned the exaltation of spon-

taneous elegance and instead explored the bracing estrangement of material indifference.

The final two chapters concern the decades following the Second World War, when the institutions of the art world began to assimilate photography. As this process gathered momentum, curators and critics strove to determine how best to define photography as a modernist medium. Because of it fluid and ubiquitous presence in society at large, photography seemed to stand as much for the impossibility of keeping media distinct as for the possibility of being a new one. Museums responded to the challenge of making photography into an autonomous art by constricting acknowledgment of the complex, varied, and troublesome conditions of its actual production. Meanwhile, certain social critics had begun to analyze the functions of photography with unprecedented rigor. As museum practice fell behind the best thinking on photography, artists found an opportunity to unsettle the art world and upend or renew the terms of American modernism. Chapter 9 describes how one such artist, John Baldessari, used randomized simulation to model the workings of chance in photography and thereby address the new interdependence of photography and art. The book concludes with a brief consideration of photography and chance in the digital era.

If the argument succeeds in its aims, the reader will have a new regard for the struggle to make photography into art. In the process, she or he may also have a better understanding of modernity and the challenge it has posed to those seeking to maintain a cultural practice of bringing complex yet intelligible forms into the world. If it helps those who are currently engaged in making photographic art, so much the better. Although this book celebrates instances of extraordinary achievement, the history it relates is one that threatens the viability of art as a public occasion for meaning. For the conversation this book describes to be carried forward, new means of restoring that viability through a collective commitment to the social function of art will need to be found.

This book is about photography, but it is also about the search for meaning in the modern world. For those who find the random indifference of that world bewildering and tough to bear, the pictures motivating this book can be a source of understanding, encouragement, and honest relief. The history that follows explains and affirms that possibility.

1

William Henry Fox Talbot
and His Picture Machine

Photography emerged in France and England in the 1830s in the midst of a profound shift in the perception and meaning of chance. At the beginning of the century, belief in determinism reigned. The elegant conceptual power of Newtonian mechanics was still the polestar of the scientific community, which by consensus imagined the universe as knit together by calculable cause-and-effect relations, bodies and forces operating on one another with clockwork precision. Any apparent play of chance was assumed to be an effect of an incomplete understanding of causes and natural laws. Chance, in other words, was but a provisional name for causal relations not yet properly grasped. In 1814, the great mathematician Pierre-Simon Laplace endorsed a determinism characteristic of his time: "Given for one instant an intelligence which could comprehend all the forces by which nature is animated and the respective situation of the beings who compose it—an intelligence sufficiently vast to submit these data to analysis—it would embrace in the same formula the movements of the greatest bodies of the universe and those of the lightest atom; for it, nothing would be uncertain and the future, as the past, would be present to its eyes."[1] For Laplace and many others, chance was a placeholder for unknown causal operations in a universe ruled entirely by formulaic laws. Until the missing knowledge was acquired, chance would span the gap between divine omniscience and human understanding.[2] As Laplace said of the seemingly random changes in weather: "The curve described by a simple molecule of air or vapor is regulated in a manner just as certain as the planetary orbits; the only difference between them is that which comes from our ignorance."[3]

The Newtonian turn in scientific understanding in Europe was entangled with unsettling shifts in the experience and understanding of God. For scientifically minded individuals such as Laplace, the notion of an utterly comprehensible clocklike universe, where past and future could be revealed as fully determined by inexorable mechanics, posed an exhilarating challenge for human intelligence. But this determinism troubled others. Positing a universe wholly governed by mechanistic laws seemed to push the hand of God back to the moment of creation, making him thereafter irrelevant to its affairs. Disputes arose regarding the existence and nature of miracles, which could be viewed either as heartening moments of divine intervention or as unsettling disruptions of a lawful system. Reconciling Newtonian mechanics and free will became a pressing problem. What sense could one make of free will in a universe that unfolded in a determined sequence of cause and effect? The retreat of God from the course of everyday events and the emergence of seemingly universal laws threatened to make the world a disenchanted place, wholly lacking in freedom or spontaneity.

By the end of the nineteenth century, the determinist consensus had frayed. No longer did scientific thinkers so confidently presume a strictly mechanical operation of natural laws behind the activity of every mote or molecule. Led by James Clerk Maxwell's stochastic (that is, chance-based) model for the movement of gas particles and Darwin's understanding of the role of random variation in biological evolution, science curbed its Newtonian determinism to accommodate probability. In the words of philosopher of science Ian Hacking, "a space was cleared for chance."[4] By 1892, the logician and scientist Charles Sanders Peirce could boldly assert that the theory of universal necessity lacked a persuasive foundation.[5] He attributed the specification of the world "altogether to chance . . . in the form of spontaneity which is to some degree regular."[6] In the span of several decades, chance had gone from being a placeholder for absent knowledge to—in the philosophy of Peirce, at least—a prime agent in the generation of the world's particulars.[7]

This epistemological shift arrived alongside broad changes in the social meaning of chance. Long associated with games of dice or cards, chance in the nineteenth century began to infiltrate other realms of social activity. State compilers of social statistics, analysts of financial markets, and even theorists of evolution grappled with new roles for probabilistic distributions. The widening scope of chance gave rise to anxieties about how it might

compromise traditional moral orders. Many expressed fear that society had become too prone to irrationality and caprice. The booms and busts of the modern financial market seemed maddeningly random. At the same time, chance enabled experts in statistics, including the actuaries of a burgeoning insurance industry, to exercise greater administrative control over society. Following the pioneering work of Jakob Bernoulli (1655–1705) and Thomas Bayes (1702–1761), these experts could calculate degrees of uncertainty for inferences based on sampling. Such calculation had powerful applications in various fields, including medical research, where it yielded better ways to assess the comparative efficacy of treatments. But even this "taming of chance," to use Hacking's phrase, did not quell anxieties about the modern erosion of moral authority and epistemological certainty. Despite proving its power as a means of enhancing prediction and assessment, chance remained distressingly at odds with faith in a divine will undergirding moral judgments and earthly events. The secure foundation of morality lay open to question. At Trinity College in 1833, theologian Thomas Birks delivered an oration in which he mocked the "idolaters of science," who "dream that wisdom itself may in time be reduced to a formula, and virtue to a refined and subtle problem of chance."[8]

In the midst of this turn toward chance, an automatic way of making pictures arrived. In January 1839, François Arago, director of the Paris Observatory, proclaimed that his acquaintance Louis-Jacques-Mandé Daguerre, working from results he had produced in collaboration with Joseph-Nicéphore Niépce, had discovered a way to produce pictures through the action of light. Later that month, William Henry Fox Talbot of England announced that he too had invented such a process.[9] Both processes employed a camera obscura, a box or chamber with a tiny hole through which light casts an inverted image of what is outside. Such devices had become widely used in the seventeenth and eighteenth centuries, often as an aid to artists, who could trace the projected image by hand. Daguerre and Talbot both discovered that a surface treated with silver iodide inserted into a camera obscura could record the projected image automatically. Chemical treatment of the surface after removal made it no longer reactive to light. The two processes differed significantly, however: Daguerre's process, which he called the daguerreotype, produced a unique and highly detailed image on a polished metal plate, whereas Talbot's process, which he eventually termed the calotype, produced a fuzzier but readily replicated image on paper. Although the images produced by both processes were, like mirror

images, laterally reversed, the images Talbot produced also rendered light areas dark, and dark areas light. Exploiting the translucence of paper, he was able to re-reverse the "negative" image in both respects by putting another sensitized piece of paper underneath the paper bearing the image and exposing the latter to light. This process, which yielded a "positive" image, could be repeated to make multiple copies.[10]

Chance reportedly played roles in the invention of both processes. Daguerre is said to have discovered the capacity of mercury vapor to develop a latent photographic image when he unwittingly left an exposed plate near a mercury spill.[11] Talbot stumbled on common table salt as a fixer (an agent that would render the image nonreactive to additional light) when he noticed discrepancies at the edges of his unevenly coated photographic papers.[12] He also realized the possibility of developing a latent image when an underexposed piece of sensitized paper was "accidentally exposed" to more daylight outside of the camera.[13] But Talbot also experienced the downside of chance. Upon hearing of Daguerre's process, he publicly admitted that he could not "help thinking that a very singular chance (or mischance) has happened to myself, viz. that after having devoted much labour and attention to the perfecting of this invention, and having now brought it, as I think, to a point in which it deserves the notice of the scientific world,—that exactly at the moment when I was engaged in drawing up an account of it, to be presented to the Royal Society, the same invention should be announced in France."[14] After so many welcome accidents, Talbot encountered rum luck.

While Daguerre and Talbot independently tinkered, serendipity was in the air. Horace Walpole coined the term *serendipity* in a letter first published in 1833, the same year that the idea of photography reportedly occurred to Talbot on the shores of Lake Como.[15] In the letter, Walpole defines the term as "accidental sagacity" and explains its origins in this way: "I once read a silly fairy tale, called the Three Princes of Serendip: as their highnesses travelled, they were always making discoveries, by accidents and sagacity, of things which they were not in quest of: for instance, one of them discovered that a mule blind of the right eye had traveled the same road lately, because the grass was eaten only on the left side, where it was worse than on the right."[16] Walpole fashioned the term *serendipity* to refer to such a conjunction of intellectual acuity and happenstance, when powers of observation and reasoning are brought to bear on an accidental encounter. Although the term's common usage now as a synonym for good fortune

has blunted this original meaning, in Talbot's day the notion of apprehending the import of the unexpected was fundamental to the scientific and industrial revolutions under way. In 1828, Friedrich Wohler accidentally synthesized an organic compound, urea, from inorganic starting materials, thus undermining the vital force theory of organic chemistry. In 1833, the American frontier physician William Beaumont encountered by chance a patient with a permanent gastric fistula left from a gunshot wound and used him to conduct experiments and observations that radically changed the theory of digestive physiology. In 1839, the year that photography was introduced to the world, Charles Goodyear, having encountered a rubber compound accidentally left on a stove, patented vulcanization.[17]

Such stories of accident in scientific progress left Victorians uneasy. Victorian culture extolled the moral link between effort and reward, and great men of science were held up as exemplars of foresight, logical thinking, and hard work. Defenders of this moral order downplayed the significance of accident in stories of discovery or invention. In *History of the Inductive Sciences,* published in 1837, William Whewell argued, "In all cases of supposed accidental discoveries in science, it will be found that it was exactly the possession of [a distinct and well pondered] idea which made the accident possible."[18] Whewell later compared the role of accident in scientific discovery to the spark that discharges a gun that is already pointed and loaded.[19] There is "little propriety," he claimed, "in speaking of such an accident as the cause why the bullet hits the mark."[20] In their journals and correspondence, men of science occasionally felt the need to distinguish their discoveries from the serendipitous. Talbot's brilliant friend Sir John Herschel wrote discreetly but excitedly to Talbot about a new photographic paper he had produced, insisting: "I will only say further of it that it is no *chance* discovery. I found it where I looked for it, and where I know I shall find something better worth looking for."[21] Herschel's contorted last clause wrestles with the troublesome role of chance in scientific investigation. The syntax—he will "find something better worth looking for"—reverses the ordinary sequence of looking and finding, tacitly acknowledging that the scientist often finds something worth seeking but not in fact sought. The virtues of serendipity, as Herschel knew, were always haunted by the amorality of blind luck.

Talbot, in his first public paper on photography, took a middle course. He described his invention, and the inductive scientific method he believed

it to confirm, as a mix of serendipity and experimental diligence: "This remarkable phenomenon [of photography], of whatever value it may turn out in its application to the arts, will at least be accepted as new proof of the value of the inductive methods of modern science, which by noticing the occurrence of unusual circumstances (which accident perhaps first manifests itself in some small degree), and by following them up with experiments, and varying the conditions of these until the true law of nature which they express is apprehended, conducts us at length to consequences altogether unexpected, remote from usual experience, and contrary to almost universal belief."[22] In this description, Talbot both acknowledges and downplays the role of accident in scientific discovery. Accident "perhaps" plays some part in the observation of unusual circumstances, but from this germinal event the inductive method generates a systematic testing of variables and causal possibilities. When Talbot wrote his paper, this modern procedure was bringing about radical shifts in human understanding that severed belief from ordinary experience and inherited assumptions, anchoring it instead in empiricism.

As a product of a new "engineering culture" in England that sought material improvements across every area of human desire, photography was both wondrous and unsettling.[23] It was hailed as an instance of natural magic that an inquisitive and restless society had chanced upon, a marvelous surprise in a series of marvelous surprises. But unease lurked beneath the wonder. The arrival of photography called into question the entire cultural order of pictures, from high art to illustration, finished painting to rough sketch. It upset a precarious social apparatus that determined pictorial value. Although this upheaval has been described many times, these descriptions have neglected one of the most disruptive features of photography: its openness to chance.

Talbot knew from the start that chance was a problem. His concern surfaces in a book he wrote to describe and promote his invention, *The Pencil of Nature*, illustrated with salt-paper prints and published in installments between 1844 and 1846.[24] A remarkably prescient defense of photography, *The Pencil of Nature* anticipates a wide range of uses for the medium, including photocopying, courtroom exhibits, and botanical illustrations. For some uses, the radical indifference of the process seemed a boon. But for others, it was a problem. This was especially true when it came to Talbot's aspirations to see photography become a new art. To overcome this problem, he enlisted chance.

This enlistment responded to the implications of substituting an automatic chemical process for a traditional kind of labor. In *The Pencil of Nature*, Talbot recalls that his desire to invent photography emerged from his frustrated attempts to draw landscapes while vacationing in Italy, and his desire to render unnecessary the painstaking and skilled effort of the artist's hand.[25] He refers to photography as "a royal road to Drawing" and asserts that it "dispenses with all that trouble" that traditional drawing and its mastery required. The proof that photography had displaced the old labor of depiction was that it made the intricate picture and the simple picture equally easy to produce. As Talbot remarks, "It is so natural to associate the idea of *labour* with great complexity and elaborate detail of execution, that one is more struck at seeing the thousand florets of an Agrostis depicted with all its capillary branchlets . . . than one is by the picture of the large and simple leaf of an oak or a chestnut. But in truth the difficulty is in both cases the same."[26] Astonishingly, photography had made the depiction of an elaborately ornamented façade as quick and easy as that of a single brick. Invented in the wake of other efficient contraptions, including the lawn mower (1830), the sewing machine (1830), the reaper (1831), the revolver (1836), and the telegraph (1837), photography was yet another ingenious labor-saving device.[27]

Such ingenious devices were morally complex, and the tale recounted in Genesis was partly to blame.[28] Because the Bible links the need to work to the eating of the forbidden fruit ("Cursed is the ground for your sake / In toil you shall eat of it / All the days of your life"), industrial machines bore the promise of restoring the conditions of Eden. Photography, as a seemingly miraculous device that grew out of landscape aesthetics on both sides of the Channel, was particularly bound to the garden and thus to the prospect of such a return. But it was equally cogent to regard modern machines as proud attempts to rival God and to disobey his word. Work was a prescribed means by which humanity might atone for original sin. If one accepted the Fall as inherent in the earthly condition, then work was an integral part of a sacred covenant.

Subtracting labor was particularly problematic in the making of pictures. The skilled effort of the artist, by virtue of the judgment that guided it, had long been understood to give pictures much of their value. A work of art or scientific illustration required discrimination, synthesis, and the application of expertise. A nineteenth-century writer summed up the painterly achievement of Raphael in these words: "Not that genius alone, or labor

alone, would have made him the prince of painters, but labor united by genius; labor lifted up and inspired by genius, and genius controlled and made practical by labor."[29] Art was an amalgam of applied skill and inspired imagination. Even the illustration of the naturalist required a synthesis of craft and expert reasoning.[30] So the question was: even if photography could produce a picture by means of the action of light, could that picture be worthy of art or science if its particulars were not fashioned by a skilled hand guided by proper judgment? Talbot crafted an affirmative answer by appealing to serendipity.

In *The Pencil of Nature*, the issue of labor and value comes to a head in a discussion of the seventh photograph in the book, *The Open Door* (Figure 1.1). In that discussion, Talbot betrays his pride in contributing to what he hopes will be "a new art" of photography. But his claim that photography had vanquished pictorial labor renders unclear the effort or expertise in which he takes pride. Talbot negotiates this conundrum by arguing that the crucial aesthetic act is one of recognizing accidental encounters with the picturesque: "A painter's eye will often be arrested where ordinary people see nothing remarkable. A casual gleam of sunshine, or a shadow thrown across his path, a time-withered oak, or a moss-covered stone may awaken a strain of thoughts and feelings, and picturesque imaginings."[31] Talbot proposes that art is a matter of the eye. He implies that sensitivity to the chance encounter binds the eye of the photographer to that of the painter. Both photographer and painter rely on a capacity to detect the potential of accident to stir the imagination or soul. Under this scheme, the true creative act in the pictorial arts is the arresting of the eye, the momentary cropping of a portion of a chanced-upon visual field. Talbot embraces the notion of the pictorial composition as a found object, whose aesthetic potential only the sensitive eye can discern.[32]

The contrast between Talbot's handling of the issue of chance in his accounts of his invention of photography, on the one hand, and in his discussion of the production of a picturesque photograph, on the other, is revealing. In the invention narratives, chance delivers curious results that spark an arduous process of scientific inquiry and technological improvement. Stumbling on the capacity of table salt to arrest the light sensitivity of his photographic papers is merely a catalyst to diligent experimentation and intelligent tinkering. But in the production of a picturesque photograph, stumbling across a broom in a doorway and apprehending the aesthetic potential of the scene supplants rather than inspires labor. By suppressing

Figure 1.1 William Henry Fox Talbot, *The Open Door,* 1844, salt print from a calotype negative. Schaaf 2772; Private collection, Courtesy of Hans P. Kraus Jr., New York

the considerable difficulty of the calotype process, Talbot suggests that once a serendipitous discovery occurs, only the brief use of a camera, some paper, and some chemicals is required. As an invention, photography emerges from great foresight and labor; as a modern commodity, its satisfactory use ostensibly requires only a little practice and, if aesthetically pleasing results are desired, an educated eye and a bit of luck. Talbot thus understood and exploited the inconsistency between espoused morality and the emergent consumer economy. His accounts associate photography as a product with a modern mode of opportunism that existed uneasily alongside Victorian moral affirmations of the bond between effort and achievement.

Talbot could have done otherwise. He could instead have emphasized the hard work that making aesthetically pleasing photographs required. Even without acknowledging the true difficulty of his photographic process, he could have posited a kinship between photographer and painter by stressing the aesthetic preparation that can inform the work of both. After all, there are good reasons to believe that he had not actually encountered the broom in the doorway by accident. Unattended rakes, brooms, and wheelbarrows were stock picturesque motifs of Dutch painting and English art manuals. For Talbot, the motif of the abandoned broom had special resonance, because it resembled the brush or pencil that the artist would no longer need and thus was a conspicuously apt symbol for the labor-saving capacities of his invention. The discovery that Talbot made various photographs of brooms in doorways during the 1840s only heightens suspicion that *The Open Door* was more a product of scene construction than of chance.[33] Why, then, did Talbot not suggest that photography and painting were akin by virtue of the common practice of basing pictures on careful arrangements of figures and things?

The answer lies, I think, in Talbot's investment in transferring the locus of creativity wholly to the eye. Such a transfer was necessary to reconcile his claim that photography was a labor-saving device with his claim that it was a medium of aesthetic value. For both claims to be sound, pictorial beauty could not be a function of work. If arranging brooms in doorways was the stuff of art, then presumably arranging paint on canvas would be as well, and issues of skill and manual facility would still loom large. If, however, the crux of artistic production was purely a matter of seeing, then photography could render manual skill unnecessary without forfeiting aesthetic potential. Talbot construes the real artistry of all pictorial art as an opportunism of sight. In his scheme, discovering a picturesque subject requires aesthetic sensibility and inspiration; transposing it to a surface, whether canvas or photographic paper, is merely a matter of mechanical industry. Talbot demotes the application of paint to canvas, or graphite to paper, to the status of ordinary labor, as if it were merely the burdensome execution of a creative perception. He makes the artist akin to the new executive, whose privileged role is to envision what labor and machine will produce.[34] This strain of thinking became central to many later defenses of photography as a medium of art. For example, in 1865, the photographer and painter John Moran wrote: "But it is the power of seeing and deciding what shall be done, on which

will depend the value and importance of any work, whether canvas or negative."[35]

Although simply worded, Talbot's argument was radical. The practice of amateur drawing in early Victorian England was something done at leisure, often on holiday, for purposes of self-cultivation and amusement. It was not regarded as a form of drudgery. Indeed, the training of the hand and the training of the eye were understood to be intertwined. In Jane Austen's novel *Northanger Abbey* (1803), the provincial Catherine Morland, while on a country walk with her wealthy friends, the Tilneys, laments her ignorance of drawing: "[The Tilneys] were viewing the country with the eyes of persons accustomed to drawing, and decided on its capability of being formed into pictures with all the eagerness of real taste. Here Catherine was quite lost. She knew nothing of drawing—nothing of taste. . . . She confessed and lamented her want of knowledge; declared that she would give anything in the world to be able to draw."[36] For Catherine Morland and other Victorians, drawing and taste, the felicitous hand and the aesthetic eye, were deeply entwined. Talbot pried them apart to exalt the power of photography as a labor-saving device. He not only invented a mechanism for making pictures automatically but also invented a notion that drawing, which had been a form of self-improvement and a sign of social standing, was independent of aesthetic looking and a task best left to machines.

In Talbot's scheme, taking advantage of chance often requires a timely click as well as a sensitive crop. All of the cases he cites of stumbled-upon arrangements explicitly link the picturesque to time. The time-withered oak and the moss-covered stone indicate effects of long duration, but the casual gleam of sunshine and the shadow thrown across a path are fleeting effects, for which a quick use of the apparatus could prove essential. Indeed, the broom in his famous photograph operates like the gnomon of a sundial, marking the time of the exposure as a passing moment. Once the photographic apparatus was set up and the lens cap removed, time did the work of making the image, and more or less became its subject. Photography embedded a moment of illumination on the reactive surface of the photographic plate.

Talbot's defense of the aesthetic potential of photography ran counter to academic tradition. Aesthetic discourse in England generally defined high art against the momentary, the indiscriminate, the mechanical, the particular, and the accidental—all qualities associated with photography. The ideas of the painter Sir Joshua Reynolds were a touchstone in this respect.

His *Discourses on Art,* which he delivered as lectures in the late eighteenth century, remained a cornerstone of English aesthetics through most of the nineteenth. In them, he argues that art is fundamentally selective and synthetic. The right impression of the true artist, he says, is the result of the accumulated experience of a whole life, a "mass of collective observation."[37] This accumulated experience enables the artist to synthesize a higher type from encounters with individual cases. The true student of painting, he claims, must "overlook the accidental discriminations of nature."[38] He "will permit the lower painter, like the florist or collector of shells, to exhibit the minute discriminations, which distinguish one object of the same species from another; while he, like the philosopher, will consider nature in the abstract, and represent in every one of his figures the character of the species."[39] According to Reynolds, for artistic representation to be significant, the artist must draw upon his experience to compose particulars that speak through form to higher typological truths instead of mere accident. Indeed, in his view, providing accidental detail is "worse than useless," because it "dissipates the attention."[40]

In making his argument, Reynolds uses the camera obscura as a foil for the achievements of the exceptional painter. "If we suppose a view of nature represented with all the truth of the camera obscura," he writes, "and the same scene represented by a great Artist, how little and mean will the one appear in comparison of the other, where no superiority is supposed from the choice of the subject. The scene shall be the same, the difference only will be in the manner in which it is presented to the eye. With what additional superiority then will the same Artist appear when he as the power of selecting his materials, as well as elevating his style?"[41] According to Reynolds, a great artist, even if restricted to a scene that appears in a camera obscura, will nonetheless draw on his experience to render the elements of the scene in their general significance, while the camera will attend exclusively to the arbitrary particulars before it. Setting the artist free to compose a scene from his imagination and synthesize his many observations of nature would only increase the superiority of his picture. The artist can also elevate his style through the use of historical, biblical, or mythological allusions, which can enrich pictorial meaning in ways that the camera obscura cannot. Reynolds thus defines art in a way hostile to the aesthetic claims that photographers would later make.

Countering Reynolds, Talbot in *The Pencil of Nature* tries to shoehorn photography into art by appealing to the aesthetic potential of accident.

He proposes that the photographer with an artistic eye trained by study and experience will be able to recognize when the particulars of a scene momentarily coincide with a picturesque ideal. Such a photographer will see the artistic possibilities of a broom propped in a doorway and lit by the sun just so. Talbot's formula makes the exercise of artistic judgment a matter of taking a composition from the world rather than using a pencil to make one on paper. Selection and rejection of nature must therefore traffic in whole scenes rather than parts. The artist using photography has to rely on the good fortune of encountering coherent picturesque arrangements for the camera to frame and record. As the Victorian photographer Henry Peach Robinson later put it, "[Nature] knows nothing of composition, or light and shade. . . . [I]t should be the photographer's business to secure Nature's flukes."[42] Only by finding these flukes can the photographer avoid having the indiscriminateness of photography yield the extraneous details that Reynolds criticizes as dissipating the attention. In this way, Talbot in *The Pencil of Nature* seeks to reconcile artistic value and the freedom from onerous effort that photography promised.

Although Talbot contradicted central strains of academic aesthetics, his appeal to the felicitous order of accidental formations was not without precedent. Leonardo da Vinci recommended that artists look at the accidental patterns in marble for chance resemblances, and Piero di Cosimo, according to Vasari, took delight in imagining that he saw "equestrian combats," "fantastic cities," and the "grandest landscapes" in clouds or other random shapes. To these Renaissance artists, fostering a habit of finding resemblances in accidental shapes (in scientific terms, indulging in pareidolia) was a way to obtain inspiration for new designs. Leonardo deemed the habit "very useful in stimulating the mind" and fostering inventiveness.[43]

As the picturesque emerged in the eighteenth century, the habit of finding order in accident was renewed and elevated. English devotees of gardens and landscape began to seek the impression of design in the accidental and the impression of the accidental in the designed. No longer was perceiving order in chance formations merely an amusing way to stimulate the inventive faculty; it was also an exercise of sensibility valued in its own right. Joseph Addison wrote in 1712: "Hence it is that we take Delight in a Prospect which is well laid out, and diversified with Fields and Meadows, Woods and Rivers; in those accidental Landskips of Trees, Clouds and Cities, that are sometimes found in the Veins of Marble; in the curious Fret-work of Rocks and Grottos; and, in a Word, in any thing that hath

such a Variety or Regularity as may seem the Effect of Design, in which we call the Works of Chance." Addison weaves together in this passage the diverting variety of "well laid out" grounds, a product of aesthetic composition, and the delightful resemblances to landscape that appear by chance in the veins of marble. In a marvelous bit of circularity, he argues that the designed garden ought to appear as a work of accident, to echo the effect of the accidental landscape in marble that seemed the work of design. He elsewhere recommended that English gardeners follow what he took to be the Chinese practice of designing grounds replete with such delightful "accidents" and thereby "conceal the Art" behind their work. Addison thus wove the illusion of design in happenstance and the illusion of happenstance in design into a dialectical circuit of picturesque delight.[44]

The emergence of the picturesque shifted aesthetics toward sensibility, supervision, and points of view. The double movement between design and accident arrived as the English countryside was undergoing economic rationalization. Rural lands were being surveyed and enclosed to enforce property rights and boost agricultural efficiency. The scholar Ann Bermingham has put the dialectical relationship succinctly: "As the real landscape began to look increasingly artificial, like a garden, the garden began to look increasingly natural, like a preenclosed landscape."[45] The result, she says, is that "nature was the sign of property and property the sign of nature."[46] For this reason, cultivating the appearance of wild nature to luxuriously supplement a rationalized agricultural regime became a source of genteel pride. As Addison wrote: "Nothing can be more delightful than to entertain ourselves with Prospects of our own making and to walk under those Shades which our own Industry has raised."[47] By "our own industry," Addison largely meant the industry the gentry could afford to employ. In the middle of the eighteenth century, a typical English landscape garden might cover thirty or forty acres, thus requiring a substantial team of workers to fashion or maintain it. Addison's pride was rooted in aesthetic vision and managerial capacity, not manual facility mixed with genius.

Talbot exploited the turn to the picturesque and the historical entwinement of landscape and photography to affirm that his invention abided by the same principles. For the gentleman overseeing his garden or the user of photography, pleasure derived from a mix of tasteful vantage and supervised execution. With photography, once the man of proper sensibility found a pleasing prospect, he had only to direct his clever apparatus to make a negative. Afterward, he could either make prints himself or delegate the

Figure 1.2 William Henry Fox Talbot, *Loch Katrine,* 1844, salt print from a calotype negative. Schaaf 2788; Hans P. Kraus Jr., New York

task to others, as Talbot did when he established his photographic production facility at Reading. The picturesque transformation of the English countryside was ensuring an abundant supply of agreeable views, and the man of means could always travel to find more elsewhere in Britain (Figure 1.2).[48] The landed gentry could thus tastefully confirm its good taste, discovering delightful accidents of nature that had been preserved or imitated under its supervision. These conditions allowed the painter John Constable to aver in 1836: "Selection and combination are learned from nature herself, who constantly presents us with compositions of her own, far more beautiful than the happiest arranged by human skill."[49] Constable praises nature for its compositions. To be sure, he believed in the mediating powers of

the artist. He elsewhere disparaged "mere copies of the productions of Nature, which can never be more than servile imitations."[50] Nonetheless, his exaltation of the beautiful compositions found in nature ran counter to academic prescription. Talbot, in arguing that photographers could happen upon compositions worthy of art, followed a precedent that Constable and other Romantics had set. But he did so as a supervisor, not as a traditional artist. For him, photography and the picturesque were deeply embedded in an ideology favoring managerial vision over more bodily ways of molding forms, such as pruning or painting.

In *The Pencil of Nature,* Talbot struggles against tradition but also harnesses one of its central arguments. Painters, in their effort to distance their art from the denigrated category of the mechanical, had long insisted that the art of painting lay principally in the mind, not in the hand. Reynolds opens his seventh discourse with such an insistence:

> It has been my uniform endeavor, since I first addressed you from this place, to impress you strongly with one ruling idea. I wished you to be persuaded, that success in your art depends almost entirely on your own industry; but the industry which I principally recommended, is not the industry of the *hands,* but of the *mind.* As our art is not a divine gift, so neither is it a mechanical trade. Its foundations are laid in solid science; and practice, though essential to perfection, can never attain that to which it aims, unless it works under the direction of principle.[51]

European painters and sculptors had long strove to elevate their work above the mechanical labor of artisans.[52] To secure a lofty social standing, they had insisted that the value of their work stemmed primarily from mental industry and brilliance, not from manual skill. Talbot, rather than remain satisfied with the subordination of the mechanical, seeks to remove it from art altogether. He purports to free aesthetic principle from any reliance on the mundane specifics of bodily industry.

In this regard, his insistence on relocating the artistic faculty in the eye was a brilliant move. To defend painting as a liberal art and not mere mechanical work, academic doctrine emphasized the synthetic capacities of the mind, which were nourished by instruction, experience, and practice. The hand was trained and disciplined so that it could deliver an aesthetic idea as paint on canvas. Thus art was a product of a coordinated agency

between mind and body.[53] Talbot, having developed a process that withdrew the skilled hand and restricted the imagination to scenes in the world, displaced the traditional sites of agency and substituted the eye. The eye would no longer be a passive receptor, an imagined target for the finished work, but a decisive agent in pictorial production. It was where the mind could register and sift the sensuous particulars of the world. What had been a matter of thinking and handling would now be a matter of seeing. This model for photography as art would gather steam well into the twentieth century.

Talbot's reconciliation of art and automatism, however, had several shortcomings. One was the improbability of encountering a scene that offered a satisfactory configuration of forms and lacked extraneous details. Talbot had evidently arranged his broom carefully for a reason. What was the likelihood of finding an ideal arrangement in the world? Of finding an individual case coinciding with a desirable type? Many thought the odds were slim. The Victorian economist and logician William Stanley Jevons was skeptical that higher laws would ever put themselves on display in an arbitrary swath of facts: "The probability is infinitely small that a collection of complicated facts will fall into an arrangement capable of exhibiting directly the laws obeyed by them."[54] Was such an encounter in the arts also highly improbable, tantamount to a miracle? And even if an operator was lucky enough to have such an encounter, what were the odds that he or she would expose the plate at the ideal moment? The hope for photography as art rested on such new questions, and some writers coming after Talbot offered doubtful answers. Decades after *The Pencil of Nature* was published, the American critic William J. Stillman acknowledged that "nature occasionally produces, by accident, arrangements of her material, so harmonious and happy, that we consider them unusually fit subjects for the painter." But, he continues, "nature never yet arranged a subject so that in some of the minute details, at least, it shall not be discordant, and demand of art some modification to make its harmonies perfect." Completing the blow to photography, he adds that the necessary modification is "beyond the power of the camera"[55] Later still, in 1926, the aesthetician Roger Fry saw long odds of encountering satisfactory pictorial conditions:

We here touch on one of the most definite limitations of photography used as an art. The chances are too much against success where a complex of many volumes is involved. The co-ordination necessary to

aesthetic unity is, of course, only an accident in nature, and while that accident may occur in a single volume such as a human head, which has its own internal principle of harmony, the chances are immensely against such co-ordination holding for any considerable sequence of volumes, and although the control of the artist may extend to certain things such as the disposition of draperies, he is bound on the whole to depend on the fortunate accidents of the natural kaleidoscope.[56]

History showed that Talbot had embarked on a steep climb. The Reynold-sian critique that photography failed as art because it lacked expert and crit-ical modification of encountered nature proved to be enduring. The alter-native to relying on the chance encounter, of course, was to arrange things before the lens. But if obtaining an ideal composition required adjustments to encountered scenes—manually moving brooms about or altering the lighting (tactics that Talbot in his writing strenuously suppressed)—then the art of photography would become more or less an unskilled form of scenography. The *hands* of the photographer would require defending, an outcome Talbot wished to avoid.

A second problem for Talbot's scheme was the weak link between the picturesque photograph and the sensibility of the camera operator. It was one thing for a photograph to faithfully record a picturesque scene, and quite another for it to record the operator's *recognition* of that picturesque-ness. The eradication of a certain kind of pictorial labor called the nature of photographic authorship into question. Robinson was finessing this point when he said, "It should be the photographer's business to secure Nature's flukes."[57] If nature could have its flukes, then surely photographers could have theirs as well. In other words, if the rare practitioner of taste could make beautiful photographs through a cultivated discernment, what would prevent a legion of uncultured operators from occasionally doing so by sheer accident? What would differentiate a photograph that spoke to the aesthetic refinement of the operator from one that attested merely to the quirks of dumb luck? The traditional arts had never posed this problem to a significant degree. A painter might have a lucky day, when conditions endowed the paints on his or her palette with the perfect viscosity, but there was no such thing in painting as a lucky masterpiece. The bond be-tween aesthetic sensibility and pictorial output was presumed to be firm. The automatism of photography, whereby the action of light over a brief interval of time generated the image, destroyed this traditional lamination

of intention and result. In the 1840s, when photography required cumbersome equipment and slow processes, the configuration of things before the lens doubtless seemed deliberately chosen. But as subsequent innovations simplified and accelerated photography, chance further dissolved the bond between the image and its maker.

Talbot in *The Pencil of Nature* identifies a second operation of chance in photography. In his discussion of a photograph of Queen's College, Oxford, he acknowledges that after a propitious scene has been photographed, the image may show things that the operator of the camera had failed to notice (Plate 1a). He writes:

> In examining photographic pictures of a certain degree of perfection, the use of a large lens is recommended, such as elderly persons frequently employ in reading. This magnifies the objects . . . and often discloses a multitude of minute details, which were previously unobserved and unsuspected. It frequently happens . . . —and this is one of the charms of photography—that the operator himself discovers upon examination, perhaps long afterwards, that he has depicted many things he had no notion of at the time. Sometimes inscriptions and dates are found upon the buildings, or printed placards most irrelevant, are discovered upon their walls: sometimes a distant dial-plate is seen, and upon it—unconsciously recorded—the hour of the day at which the view was taken.[58]

In this passage, Talbot implies that he was unaware of the clock face on the tower in the background when he exposed the plate, that the dial was, in his words, "unconsciously recorded." At the time, several decades before Freud, *unconsciously* could either mean "without conscious intention" or "without being aware of what one is doing."[59] Talbot implies that while taking the photograph of Queen's College he did not register the inclusion of the clock dial in the background and discovered it only later (Plate 1b).

This passage constitutes an admission that the eye of the operator, no matter how sensitive to the picturesque accidents of the world, lacks the capacity to take full credit for the plenitude of the photograph. To be sure, something analogous could happen in painting. W. B. Yeats recalls his father, a painter, saying, "I must paint what I see in front of me. Of course I shall really paint something different because my nature will come in unconsciously."[60] But when J. B. Yeats paints otherwise than he consciously

intended, it is *his* nature, via his hand, that receives the credit. In the photograph by Talbot, the nature in front of the lens delivers the hands of the clock via the invisible hand of photochemistry. A multitude of causes could explain why the clock tower is where it is, but from the point of view of the operator, the clock face is accidental. Chance has filled the gap between the incomplete attention of the photographer and the indiscriminate receptivity of his or her apparatus.[61]

If *The Open Door* represents the chance encounter with a propitious configuration of forms in the world, *Queen's College, Oxford* represents the chance encounter with an unforeseen detail in a photograph. The first encounter concerns the unpredictability of the picturesque, occurs before production, and belongs, one might say, to the photographer. The second encounter concerns the possibility that a photograph might exceed the intentions that informed its production. Although Talbot describes this encounter as belonging to the photographer ("the operator himself discovers upon examination"), it belongs properly to any viewer. The first encounter motivates the photograph; the second interrupts the general intention that informed its making.[62]

Although the term *chance* may describe both the happenstance of encountering a picturesque broom in a doorway and that of unexpectedly spotting a clock face in a photograph, for Victorians the two instances differed. The photographer roaming with his camera was presumably looking for lucky encounters with the picturesque. Like a gambler rolling dice, he had a desired outcome in mind, and his relationship to it lay between actively trying and passively hoping.[63] The unexpected detail in a photograph was quite different. It could be an unexpected source of either fascination or distress. It largely operated outside the codes governing photographic aesthetics and was more like an accidental interruption than a lucky dice roll.

In *The Pencil of Nature*, Talbot's discussion of the role of the photographic detail, albeit deft, betrays anxiety. Haunting it is the possibility that the stray particulars of the photograph might speak gibberish, obscure the intended message, or otherwise constitute the sort of pointless pictorial matter that Reynolds denigrated for dissipating the attention.[64] Talbot celebrated the photographic tendency to record detail as a wonder, but he also understood its possible shortcomings when it came to aesthetic value. In his discussion of the photograph of Queen's College, he concedes that some bits of writing caught by the camera may be "most irrelevant." One

of Talbot's principal challenges in defending photography was to salvage its significance from the noise of the arbitrary.

Talbot's rationalization of the unexpected detail in photography consists of two moves. The first is to associate it with the wondrousness of photography writ large. The chemical emergence of the photographic image possessed a quality of magic, and Talbot claimed that the cropping up of unsuspected details in the finished photograph constitutes "one of the *charms of photography*."[65] The implication is that the surprise appearance of the stray photographic detail is not an unwelcome distraction from the intended composition but rather a pleasant cause for astonishment.

Talbot's second and subtler move is to suggest that the surprising inclusions of photography tend to signify. When Talbot recommends that viewers of photographs use a "large lens . . . such as elderly persons frequently employ in reading," he associates photographic details with linguistic signs.[66] Moreover, all of the "unobserved and unsuspected" details that he mentions are notations or measurements, whether alphabetical (inscriptions and placards), numerical (dates), or analogical (clock dials). The details that an operator of a camera could neglect to notice when making a photograph were, of course, far more various: for example, a vase in a window might escape attention, or a bird perched on a gutter. By mentioning only details that are decipherable sets of marks, Talbot subtly insists that the inadvertent detail of consequence bears a symbolic value. If the serendipitous encounter allows an operator to express his or her taste and sensitivity in a photograph, the unexpected detail allows a photograph to talk back.

But what, according to Talbot, does a photograph talk back about? The accidental details that he discusses are, for the most part, not any old notations and measurements, but notations and measurements that mark time and place. Dates or inscriptions on buildings and momentary configurations of clock hands precisely memorialize moments and sites. The clock face interests Talbot especially because it can record the time of the picture's making. The stray detail thus confirms and augments for him the evidentiary promise of the photograph, its marvelous delivery of a certain there and then. In both *The Open Door* and the picture of Queen's College, Oxford, the camera's crop bears with it a sign of its click.[67] In *The Open Door*, the sign takes the form of a picturesque allusion to the sundial; in *Queen's College, Oxford*, it takes the more modern form of the clock.

In Talbot's day, the legibility and import of small details in the world were pressing matters. As modern society drifted toward epistemological

doubt and empiricism, theologians strove anxiously to reconcile material minutiae with the notion that God's plan informed all of creation. The accidental detail thus became a religious concern. Talbot's use of the clock face as an exemplar of the overlooked detail harnessed a familiar discourse in this respect. Decades earlier, William Paley had begun his famous defense of deism by contrasting the experience of stubbing one's foot against a rock to that of coming across a watch.[68] The latter object, he claimed, announces its purposeful design in the clever intricacy of its construction, much as the human eye announces the divine intelligence of the natural order. Paley wrote: "What does chance ever do for us? In the human body, for instance, chance, i.e., the operation of causes without design, may produce a wen, a wart, a mole, a pimple, but never an eye. Amongst inanimate substances, a clod, a pebble, a liquid drip, might be; but never was a watch, a telescope, an organized body of any kind, answering a valuable purpose by a complicated mechanism, the effect of chance. In no assignable instance hath such a thing existed without intention somewhere."[69] With his reference to "causes without design," Paley grudgingly acknowledges chance as an agent in the constitution of the world, opening a crack in determinism that would widen as the century progressed. For him, the analogy between God and a watchmaker was a way to protect deism from the encroachment of chance. Responsive to such struggles, Talbot takes pains in his discussion of *Queen's College, Oxford* to suggest that the accidental detail in photography is more like a watch than a wart.[70] Just when the photographic camera has underscored the shortcomings of the divinely engineered eye, the face of a clock—a sign of inspired intelligence in its own right—reassuringly crops up in the blind spot. The attention of the operator may have faltered, but photography, immune to the uneven registrations of human perception, still finds intelligent order in the world.

Talbot's camera recorded the clock face because the photographic plate was indifferent to all that lay before the lens. To those steeped in a tradition of manual pictorial marking, this indifference was astonishing. Talbot observed that the photographic "instrument chronicles whatever it sees, and certainly would delineate a chimney-pot or a chimney-sweeper with the same impartiality as it would the Apollo of Belvedere."[71] Talbot was once again putting the best possible spin on his invention. Impartiality was a gentlemanly virtue and a necessity of civil procedure. But the radical indifference of the camera went beyond impartiality. Aside from its set parameters, photography internalized no judgment at all.

In the middle of the nineteenth century, indifference and chance were inextricably linked. In *A Treatise of Human Nature*, David Hume writes that "chance is nothing real in itself" and is "merely the negation of a cause." As a wholly negative concept, chance offers no basis for differentiation, and thus can only "leave the mind in its native situation of indifference." In this formulation, chance is a prior condition, a void before causes, a state of radical sameness. Hume elaborates:

> Since therefore indifference is essential to chance, no one chance can possibly be superior to another, otherwise than as it is compos'd of a superior number of equal chances. For if we affirm that one chance can, after any other manner, be superior to another, we must at the same time affirm, that there is something, which gives it the superiority, and determines the event rather to that side than the other: That is, in other words, we must allow of a cause, and destroy the supposition of chance; which we had before establish'd. A perfect and total indifference is essential to chance, and one total indifference can never in itself be either superior or inferior to another. The truth is not peculiar to my system, but is acknowledg'd by everyone, that forms calculations concerning chances.[72]

Hume illustrates this concept with a discussion of the roll of a die with one marking on four sides and another on the two remaining sides. The belief that the probability is higher that the marking on four sides will turn up than the marking on two, he asserts, stems from the understanding, first, that certain causes will result in the die landing with *some* side up, and, second, that "there is nothing to fix the particular side, but that this is determin'd entirely by chance."[73] "The chances present all these sides as equal," he adds, "and make us consider every one of them, one after another, as alike probable and possible."[74] According to Hume, an understanding of causes justifies the expectation that the die will end with one side facing up, but which of the six that side will be remains a matter of indifference and thus equivalence. Hence the odds of the one mark is 2/3 (4/6), while the other is but 1/3 (2/6).

For Hume and other probabilistic thinkers of his day, chance entailed indifference, which entailed equivalence. The paradigmatic instance of chance was the roll of a die, whereby all faces have an equal probability of ending up on top. In photography, which also combined physical causes

with probabilistic outcomes, the indifference of the apparatus established equivalence across both time and space. For photography, any instant was like every other, and the same held true for any position within the visual field. The photographer could have intentions with regard to both the moment of exposing the plate and the arrangement of things before the camera, but the apparatus itself was indifferent. For this reason, chance always had its say.

This susceptibility to chance troubled the early inventors and users of photography. In 1853, Herschel wrote a letter discussing the usefulness of photography for astronomical observation in which he notes the distressing likelihood that atmospheric disturbances would produce a distorted image at any given moment. "The probability is extreme," he comments, "that the operator would seize *the wrong instant.*"[75] Photography had broken the flow of time into a series of equivalent instants, subjecting it to the arbitrary play of probability. For Herschel, the photographic camera, by seizing on a single instant in a world subject to the subtle play of atmospheric forces and other unpredictable phenomena, had made the production of an image like the throw of a die.

When Talbot wrote *The Pencil of Nature,* time in Victorian society was becoming uniform and ever more divisible. Although the clock was a medieval microcosm derived from the natural diagrams of the sundial and the divine order of celestial orbits, for Victorians it was rapidly becoming a sign of modernization. It was taking on connotations of the timetable and labor hour, of the gridded regularity of the train schedule, of the artifice and indifference of an abstractly measured life. Although clocks had always divided time into an isometric diagram, only now was time becoming a regular series of empty slots that could be filled with anything or assigned an arbitrary value. Different instances of a given time increment were becoming equivalent, and workers were to be paid an hourly wage. Time would no longer be tied loosely to the local drift of sunrise and sunset but instead uniformly calculated from the standard of mean Greenwich time.[76] As a visual repository of a moment, the photograph became caught up in this turn toward uniformity and equivalence. Talbot, by featuring the clock face as an example of an unexpected detail, associated photography with both solar wonder and modern time.

This mix of temporal enchantment and mechanical rationality gives *The Pencil of Nature* much of its productive ambiguity. In many ways, Talbot's brilliant meditations on photography are meditations on the elusive

nature of photographic time. Drawing on Romanticism, Talbot implicitly likens the formation of the image on the photographic plate to growth or decay, as if the photograph were a plant or a ruin, and marks time in *The Open Door* as a wistful and shadowy passing.[77] But the very discourse of labor efficiency that he uses to extol his invention betrays a recognition that such romantic conceptions were empowered by their opposition to the temporal order of industry. Introduced just two years after the standard of Greenwich mean time, photography was a modern means of calibrating and organizing time. Photographs were equivalent to one another, not because they looked the same but because they had an equal purchase on the past.

When Herschel suggests in his 1853 letter that photography is subject to chance, his point is that the camera lacks the capacity to judge between moments. He contrasts photography with human vision in this way: "The eye receives *all* [instants] and the judgment throws aside all but the distincter impressions."[78] According to him, our judgment arrives at an accurate image by sifting through the accidental variations in individual impressions on the retina. Like Reynolds, Herschel affirms that human judgment is necessary to filter out accidental variations that threaten to obscure underlying truths. This filtering process is a quasi-statistical pursuit of a mean or middle quantity. Reynolds, as Robert Wark has noted, was "more empirical" than many of his predecessors and relied more "on direct observation and a sort of averaging process."[79] Herschel, who worked more strictly in a scientific mode, relied on the method of least squares to correct for statistical anomalies. The filtering processes of both thinkers, however, were only *quasi*-statistical. For them both, discernment required judgment and not simply calculation. Herschel disliked and distrusted extensive calculation and reserved room for expert judgment in the interpretation of data. He preferred graphs drawn with a free and graceful hand to mechanically plotted points.[80] The photographic camera, by evacuating a certain opportunity for the exercise of discrimination and synthetic judgment, brought out the arbitrariness of the instant and subjected the making of pictures to the play of probability.

In photography, as in dice and cards, chance sidles up to cheating. Just as *The Open Door* seems on reflection to be a dubious case of lucky encounter, so the photograph of Queen's College, under scrutiny, seems an unlikely instance of accidental inclusion. What elicits suspicion almost immediately is the photograph's ungainly composition. Other available views would

have been more in keeping with the aesthetics of the day. Indeed, the best reason to take the particular view Talbot did was to capture, at the center of the image, the clock tower peeking out from behind the cupola containing the statue of Queen Caroline. This suggests that Talbot not only included the clock tower deliberately but also valued the pictorial doubling of the one tower by the other. This doubling puts into dialogue an indexical diagram and a classical likeness, an authority of time and a temporal authority, a mechanical timepiece and an array of solar shadows cast by the columns at the center of the image. It thus invokes the intersection of natural and cultural registers in which Talbot sought to establish his new art. The high probability that Talbot staged his ostensibly chance encounters with both broom and clock puts *The Pencil of Nature* at the start of a long historical interplay in photography between chance and imposture.

While Talbot's new invention was changing the relationship between chance and picture making, the modern science of probability and statistics was changing the relationship between chance and knowledge. The classical model of probability, established in the seventeenth and eighteenth centuries, took probability to be a measure of uncertainty. Supposing that what seemed to be chance was the hidden working of causes inadequately understood, adherents to the classical model took probability to be a model of sound judgment, one measured against the good sense of the reasonable man. According to the classical model, if the results of probabilistic calculation did not square with the intuitions of reasonable men concerning the lawful order of the world, then the calculations were lacking.[81]

What Hacking has called the "avalanche of printed numbers," an explosive increase in the publication and study of social statistics in the 1820s and 1830s, particularly in France, discomfited the classical model.[82] The discovery that statistical regularities could be discerned in seemingly irrational social data, from the number of dead letters accumulating in the Paris postal system to rates of suicide, raised doubts about the adequacy of probability as an approximation of intuition.[83] No reasonable man could foresee that he would observe "year after year, within one or two units, the same number of suicides by drowning, by hanging, by firearms, by asphyxiation, by sharp instruments, by falling and poisoning."[84] A new generation of statistically minded thinkers no longer regarded probability as merely the measure of uncertainty when the laws of cause and effect were obscure; instead, they found the meaning of probability in the rough

regularity of social data itself. In 1844, the same year the first installment of *The Pencil of Nature* was published, the statistician Adolphe Quetelet's monograph introducing the notion of the bell curve appeared and, in the words of Hacking, "transformed the mean into a real quantity."[85] In work by Quetelet and certain of his peers, it was the order within the data that mattered, not the ascertainment of deterministic laws governing the emergence of this or that datum.

The critic Siegfried Kracauer, among others, has noted that the emergence of photography "coincided with the spread of positivism."[86] But this link must be treated with care. Although nothing is more positivistic, in the sense that we tend now to understand the term, than modern statistics, the thinker most closely associated with positivism, Auguste Comte, rejected probabilistic thinking because it was too detached from specific knowledge of the workings of natural laws.[87] As Comte wrote a few years after the publication of *The Pencil of Nature:* "The irrational approval given to the so-called Calculus of Chances is enough to convince all men of sense how injurious to science has been this absence of control. Strange indeed would be the degeneration if the science of Calculation, the field in which the fundamental dogma of the invariability of Law first took its rise, were to end its long course of progress in speculations that involve the hypotheses of the entire absence of Law."[88] Comte feared that the new emphasis on the regularities of social data would open epistemology to the indeterminism he detested.[89] So-called statistical laws, which took probabilistic distributions as lawful in themselves, were to Comte no laws at all.

Talbot's photographs of brooms in doorways and buildings at Oxford were akin to the probabilistic aggregates Comte disparaged.[90] One could not control the photographic process entirely, but one could nonetheless appreciate the order that spontaneously emerged. In his landmark book, Quetelet writes that people unfamiliar with modern statistics are always astonished that "errors and inaccuracies are committed with the same regularity as a series of events whose order is calculated in advance."[91] Talbot likewise is charmed that the regular form of a clock dial could appear in a photograph by sheer accident. By likening the unexpected clock dial to the magical delivery of the photograph itself, Talbot encouraged viewers to bracket any concern for the exact causes of the image before them. They could take the photograph as it is—such is its charm—and discover order in it that the camera operator never intended. Similarly, Talbot's peers who were pioneering modern statistics bracketed concern for the certainties of

causal sequences and took their statistical data as they were, discovering order that reasonable men could not have foreseen. Order simply came to the surface, unexpected and after the fact. The black box of the camera had a counterpart in the black box of the new statistical society.

In the years after *The Pencil of Nature* was published, photography quickly established itself as a particularly disruptive taming of chance. Elsewhere this taming was yielding great returns. By jettisoning determinism, statisticians were discovering an immense supply of useful information. They were learning that governing and manipulating the world did not require the imputation of intentionality or design behind phenomena, and their godless order was ushering in new powers for the modern state. No matter how many learned men at podiums bemoaned the loss of certainty, modern bureaucrats reveled in their new forms of statistical control. But many Victorians fancied art as something more than an instrument of social regulation—indeed, many imagined it an antidote to the bureaucratization of power. Under these circumstances, photography was a troublesome development. An automatic process sandwiched between the chance encounter and the accidental inclusion, photography combined immense depictive capacity with weak intentionality. It dispensed with the godlike designing powers of the artist in favor of aesthetic sensibility, serendipity, and the play of chance. Like the new social statistics, photography tended to shift the production of meaning away from design and toward analysis after the fact. Like a statistical table, the photograph contained an order that was stumbled across, discovered in the blind spot of ordinary perception. While Talbot suggested that the accidental stuff of photography could reveal instants of familiar beauty or orderly intelligence, photographers coming later, pressed by other doubts, would seek other wonders.

2

Defining Art against the Mechanical, c. 1860

In *The Pencil of Nature,* Talbot expresses the hope that he is contributing to the creation of a new art. He proffers *The Open Door* as an example of the picturesque beauty that his photographic process, buoyed by serendipity, can deliver. The stakes for him as an inventor were personal, but Victorian society soon had a broad investment in the aesthetic potential of photography. Modern commerce was spawning cheap products and crass appeals, while academic art seemed to be losing touch with actual experience. Many Victorians worried about a widespread loss of cultural integrity or depth. Making an art of photography offered the possibility of welding traditional value to modern means, of reconciling aesthetic aspiration and commercial enterprise. Because photography's indifference and automatism made it seem like the modern world, its capacity to produce art was a tacit measure of that world's cultural viability.

By the 1850s, most Victorian pundits were dubious about this capacity. Many felt that an embrace in photography of cheap processes and mass quantities had made the medium industrial. Prominent Victorians fretted chronically about their new mechanized economy and its destabilization of social and economic relations, and photography and its mechanical ways often seemed complicit in the dehumanization of everyday life. Some photographers of artistic ambition responded by inventing novel gambits to bring the medium into compliance with the academic codes of aesthetics, and chance played a key role in this effort.

In seeking to align photography with art, these practitioners faced a moving target. The social and economic turmoil of the era was throwing

the definitive qualities of art into question, and the word *art* was ambiguous to begin with. When it appears in the context of Victorian writing on photography, *art* may refer to a skilled trade or a fine art, and the distinction between the two is often unclear.[1] The onset of industrialization was upsetting the categories of human artifacts, and the category of the commodity threatened to overwhelm all others. When Prince Albert and Henry Cole convened the Great Exhibition in London of 1851 to improve the design and manufacture of commodities, they excluded painting because it was not produced by mechanical means or subject to technological improvement.[2] The exposition's Fine Arts Court displayed, among other things, sculpture (admitted because mechanization was changing its production methods), wax flowers, carved eggshells, and lithographs.[3] At the Paris exposition of 1878, the French contribution to the fine arts galleries included oils, watercolors, sculptures and medals, architectural designs, engravings, and lithographs.[4] The inclusion of lithography, a print medium invented at the very end of the eighteenth century, in both exhibits indicated the fluidity of the category "fine arts." This fluidity should not be exaggerated; lithography in the nineteenth century never completely surmounted its connotations of popularity and cheapness, and its status as a fine art remained open to question. Nonetheless, the example of lithography proved that a nontraditional medium could be squeezed into the designation of fine art if it yielded pictures of recognizable aesthetic merit through a process of design and skillful execution. This possibility doubtless gave hope to those wishing to make an art of photography.[5]

From the moment the invention of photography was announced, authorities in the arts struggled to define its cultural status and to forecast its effects. Early commentary often compared photographs to the preparatory studies of painters. In his 1839 report explaining the virtues of the daguerreotype to the French government, François Arago quoted a letter in which the painter Paul Delaroche praised the "correctness of lines," "free and energetic modeling," and "overall richness of tone and effect" of the "drawings obtained by this means."[6] Some of the essential qualities of Daguerre's process, Delaroche wrote, "are so perfected that it will become an object of reflection and study for even the most skillful painters."[7] In England, Talbot defended his invention as "photogenic drawing," and the prints from his calotype process, with their soft tones delivered to a paper positive through a paper negative, seemed drawinglike to many. Other writers compared photographs to mezzotints, engravings, or lithographs.

As these comparisons suggest, early writers addressing the relationship between photography and art proceeded by analogy. What was the photograph like? Every new technology is momentarily disorienting and must be assimilated through comparison to older ones—hence the abundance of anachronisms in our own time, such as the term *horsepower* and the file folder icons on our computer screens. Finding apt analogies for photography was a tall order because of the difficulty of putting agent, process, and product into a cogent scheme. While the product—a realistic, perspectival, monochrome picture—was more or less familiar, the process behind it was not. Before photography, every picture that offered a compelling resemblance could be traced back to the deliberate workings of a skilled human hand. An unsigned painting or engraving found in an attic was still a painting or engraving, and one more or less knew what that meant. Writers struggling to bridge the rift between process and product in photography resorted to such notions as the sun as draftsman or things drawing themselves. Such monstrous metaphors for photographic agency did nothing to mitigate the radical uncertainty into which photography had thrown the question of art. Was art to be found in the product? In the process? Was the status of the agent crucial? Could a tree make its own portrait? Could the sun make a work of art?

In England, the naturalism so vital to Talbot played important roles in answering such questions. Writers embracing it tended to spurn the synthetic ideals of Reynolds and instead advocate depicting things as presented in nature. The issue was less rejecting tradition than reinterpreting it. While Talbot was tinkering with his photogenic drawing process, the critic and essayist William Hazlitt was provoking the academy by arguing that the most celebrated art of the past abided by naturalist principles and not the ideals that academicians had supposed. In an article on the fine arts published posthumously in 1838 in the *Encyclopaedia Britannica*, Hazlitt attributes the greatness of canonical works of art to their representation of "the verity and unaffected dignity of nature." The aesthetic qualities so admired in Greek sculpture, he argues, were not "a voluntary fiction of the brain of the artist, but existed substantially in the forms from which they were copied."[8] In his discussion of Raphael, Hazlitt expressly acknowledges the antagonism between his position and the idealism of Reynolds:

Sir Joshua Reynolds constantly refers to Raffaelle as the highest example in modern times (at least with one exception) of the grand and

ideal style; and yet he makes the essence of that style to consist in the embodying of an abstract or general idea, formed in the mind of the artist by rejecting the peculiarities of individuals, and retaining only what is common to the species. Nothing can be more inconsistent than the style of Raffaele with this definition. In his Cartoons, and in his groups in the Vatican, there is hardly a face or figure which is anything more than fine individual nature finely disposed and copied.[9]

Only a year before the introduction of photography, a leading pundit wholeheartedly endorsed the notion that nature is aesthetically sufficient in its own right and needs only to be deftly copied to make art.

The onset of aesthetic naturalism put to question not merely the synthetic judgment required of the artist but also the hierarchy required of the picture. Constable's pictures and words are instructive in this respect. His remark about learning selection and combination "from nature herself" foreshadowed Hazlitt's repeated use of the term *copied* in describing the production of the highest art of the past.[10] Constable understood that taking compositions from nature meant leveling significance and attention throughout the work of art in violation of the academic requirement of subordinating certain portions of the picture to concentrate attention on its principal subjects. A critic in 1825 complained of Constable's painting, "Plants, foliages, sky, timber, stone, every thing, are all contesting for individual notice, all curled and insipid, and powdered with white, as if he had employed a dredging box in dusting a bed of cabbages or carrots. . . . [T]his is a hand that cannot mend: there is no mind to guide it."[11] Constable refused to subordinate those things that convention deemed incidental, and as a result, stray bits of nature vied for attention as if they were equal players in the pictorial drama. In the middle of the nineteenth century, a new egalitarian naturalism of the copy had arisen to challenge the discourses of Reynolds and their emphasis on ideal synthesis and the pecking order of pictorial attention.[12]

For Hazlitt to say that the highest form of art was essentially copying was provocative, but his assertion came at a time when copying expertly still required astonishing skill. During the Italian Renaissance, the engraver Marcantonio Raimondi had become famous for his copies of paintings by Raphael, and even in Hazlitt's day accomplished copyists were held in high regard. But one year after Hazlitt's essay appeared, photography was introduced, and suddenly there was a way to copy well that required no

traditional skill at all. In retrospect, the historical confluence of naturalism in aesthetics and the advent of photography seems no accident; one can readily understand why a society that embraced the one would desire the other. Victorian aesthetes, however, experienced this confluence as a shock. Just when leading writers on aesthetics were equating artistic achievement with the capacity to copy things with scrupulous fidelity, a machine was introduced that could do just that. Having essentially validated photography as an art medium prior to its arrival, the art establishment scrambled to maintain its cultural authority afterward.

This recoil took more than two decades to play itself out. Within the art world, the initial reception of photography was ambivalent. Delaroche equated photographs with preparatory studies, giving them artistic standing while protecting from rivalry the finished work of art. This "handmaiden of art" line of thinking became commonplace in photography's first decade, with many writers arguing—often unconvincingly—that the new technology would improve painting by giving painters accurate and readily prepared studies. But during the 1850s leading writers on the arts shifted course, insisting that photography had gravitated toward mindless industry and that art needed to be insulated from its ill effects. As photographers pushed their technology toward sharper prints, shorter exposure times, and more efficient production methods, doubts intensified about whether photography had any positive aesthetic role to play at all.

The advent of two new photographic technologies figured prominently in this deepening doubt. The collodion wet-plate negative and the albumen print, both introduced in the early 1850s, responded to specific shortcomings in the photographic processes of Daguerre and Talbot. The daguerreotype was a marvel, but the process produced only a single image. Talbot's process allowed for replication, but the resulting images had a smudgy and fibrous look due to the reliance on paper for both negative and positive. Some aesthetes appreciated the visual softness of the calotype process, but the burgeoning photographic industry deemed it contrary to popular taste, which preferred clarity and exactitude. Practitioners tinkered with unequal success to overcome the limitations of the two processes. While the daguerreotype proved highly resistant to mechanical replication, experimenters had more success overcoming the fibrous indistinctness of Talbot's process. In 1851, an English artist by the name of Archer announced that he had succeeded in using a glass plate instead of a piece of paper for the negative. Around the same time, a French merchant and photographic experimenter

named Louis Désiré Blanquart-Evrard surmounted the fibrousness of the positive by coating the paper prior to exposure with an albumen (egg white) mixture. Experimenters had worked with albumen prints since 1839, but not until Blanquart-Evrard added chlorides to the albumen did the process work well. The combination of the wet-plate collodion negative and the albumen positive allowed the efficient negative-positive process to yield clear images with great detail. Although the resolution did not match that of the daguerreotype, the prints could be stunningly sharp to the unaided eye, and reams of copies could be made from a single negative. These technological innovations facilitated the emergence of a photographic industry that trafficked in mass quantities. The art establishment reacted to these developments with hostility, often by characterizing the historical agency of photography as antithetical to art.

Among the lofty members of the English art establishment, no writer articulated the growing doubts about the aesthetic standing of photography more intelligently than Lady Elizabeth Eastlake. In an important review of 1857, Eastlake uses the word *machine* nine times and *machinery* twice to describe photography. Asserting that photography was machinelike or mechanical was becoming the most common objection to the possibility of photography as art.[13] As the *Photographic News* observed in 1866, "It has become customary amongst many artists to decry photography as a soulless, mechanical method of delineation, and its results as vulgar and despicable."[14] Prior to industrialization, the term *mechanical* referred to both machines and manual work.[15] Automata were mechanical, but so was artisan labor. Indeed, the association with labor was probably stronger.[16] *Mechanical* was set in opposition to *liberal* (as in "mechanical arts" versus "liberal arts") to distinguish activities that were not worthy of a free man from those that were. The mechanical was thus associated with the servile and the unthinking. A character in a sixteenth-century play by John Lyly asserts, "There is no reasoning with these mechanical doltes, whose wits are in their hands, not in their heads."[17] Painters and sculptors sought to avoid the label *mechanical* by insisting that their art lay more in their heads than in their hands.

In Victorian art discourse, *mechanical* was a tricky term. It was not confined to the slavish adherence of the untalented artist to the academic rules of correct drawing or the form of a model. On the contrary, it could describe any manual work lacking inspiration or intelligence, regardless of whether it strictly obeyed rules or forms. Indeed, some practitioners feared

that abandonment of academic discipline and embrace of flourish would lead to "mechanical" handling. Reynolds complains that students enthralled with lively handling of chalk or pencil make "the mechanical felicity, the chief excellence of their art, which is only an ornament."[18] The issue of mechanical handling surfaced in 1877, when the artist James McNeill Whistler sued the celebrated critic John Ruskin for libel. Ruskin had written of a painting by Whistler marked by rapid brushwork and vague representation: "I have seen, and heard, much of Cockney impudence before now; but never expected to hear a coxcomb ask two hundred guineas for flinging a pot of paint in the public's face."[19] At the trial, the Pre-Raphaelite painter Edward Burne-Jones said of Whistler's loose execution: "The danger to art of the plaintiff's want of finish is that men who come afterward will perform mere mechanical work, without the excellencies of color and unrivaled power of representing atmosphere which are displayed by the plaintiff, and so the art of the country will sink down to mere mechanical whitewashing."[20] Splashy handling unguided by proper judgment could be just as mechanical as thoughtless adherence to academic correctness or to the model. Thus the notion of the mechanical had a complex relationship to copying. According to Reynolds, the work of the student who failed to copy exactly was prone to becoming purely mechanical, as was the work of the master who never advanced beyond copying. To make the term more confusing, an artist of modern bent might embrace the term *mechanical* in rebellion against trite sentiment. Constable, for example, once insisted that "in such an age as this, painting should be *understood,* not looked on with blind wonder, nor considered only as a poetic aspiration, but as a pursuit, *legitimate, scientific,* and *mechanical.*"[21] As a derogation of photography, therefore, *mechanical* bore an array of conflicting associations, yet the principal meaning concerned a lack of aesthetic judgment in execution.

In her review, Eastlake argues that photography's suppression of aesthetic judgment disqualifies it as art. She defines art against mechanization by emphasizing the importance of selection and rejection guided by aesthetic intelligence, a formula straight from Reynolds. Art, according to the *Discourses,* requires discrimination, discretion, and synthesis, qualities that Eastlake puts beyond the reach of photography and its "obedience to the machine."

By repeatedly referring to photography as a machine, Eastlake did her best to clarify an ambiguity. The photographic camera smacked of modernity and automatism, but it was a box filled with light, not creaking gears

or churning pistons. It teetered between natural marvel and industrial mechanism. The comforting notion of photography as fairy magic helped to sustain the Victorian hope that modernity would offer subtle compensations for its disenchanting materialism. Although traces of this notion linger in her essay, Eastlake clearly tilts the equation toward an understanding of photography as industry. She writes that technical improvements in photography had made light "portray" with such "celerity" that "collodion has to be weakened in order to clog its wheels."[22] According to this imagery, photography makes light into a machine, and an excessively rapid one at that.

Victorians struggled to locate art in a mechanized future. Because art relied on personal talent and skill, it was routinely set against the dehumanizing aspects of industry and aligned with the traditional values of a patrician class and its supporters, including many who owed their wealth to industry.[23] For those defending these values, the rise of industrialization was often deemed a threat to human creativity. Sir Francis Palgrave warned that the triumphant results of machinery might result in "the paralysis of the imaginative faculties of the human mind."[24] Ruskin offered a similarly grim forecast to his readers: "Day after day your souls will become more mechanical, more servile."[25] By vesting symbolic value in the connectedness of hand and mind, art came to stand for a vanishing economy of apprenticeship, social and material intimacy, and undivided labor. By the same token, art as manual work was haunted by possibilities of obsolescence and inferiority. Prince Albert called the division of labor "the moving power of civilization," and the machine was heralded in one industry after the next as more productive, obedient, and exacting than the hand.[26] The exclusion of painting from the Great Exhibition of 1851 thus spoke ambiguously about its status. On the one hand, it conveyed that the "timeless" art of painting stood above the instrumental advance of mechanical work. On the other hand, it implied that painting did not belong to the future. In her review, Eastlake intimates that photography had traded fairy magic for mechanization and no longer occupied, for better or worse, the same limbo as art.

When Eastlake strives to circumscribe the exalted realm of art, her prose betrays the anguishing difficulty of the task. In a clumsy passage, she writes: "The power of selection and rejection, the living application of that language which lies dead in [the artist's] paint-box, the marriage of his own mind with the object before him, and the offspring, half stamped with his

own features, half with those of Nature, which is born of the union—whatever appertains to the free-will of the intelligent being, as opposed to the obedience of the machine,—this, and much more than this, constitutes that mystery called Art, in the elucidation of which photography can give valuable help, simply by showing what it is not."[27] Her metaphoric talk of reviving the dead of the artist's paint box to produce an offspring "half stamped with [the artist's] features, half with those of Nature" makes art—rather than photography—seem an exercise in Frankensteinian monstrosity.[28] Moreover, even as she ostensibly celebrates the free will of the artist by setting it against an obedience to the machine, her reference to features "half stamped" imagines art as mechanical reproduction. Despite Eastlake's determination to uphold the traditional value of art, the very language she uses to describe creativity has evidently succumbed to the Victorian investment in the machine.

When Eastlake wrote, the meaning and standing of certain skills guided by human judgment had reached a moment of crisis. The new technologies of the industrial age, including photography, were marvelous, transformative, bewildering, and—it is too infrequently noted—humiliating. In his 1852 meditation on the Great Exhibition, the German polymath Gottfried Semper writes: "The most difficult and laborious tasks are now playfully accomplished with means borrowed from science. . . . The machine sews, knits, embroiders, carves, paints, and, reaching deep into the area of human art, puts to shame every human skill."[29] Eastlake similarly notes that photography's "business is to give evidence of facts, as minutely and as impartially as, to our shame, only an unreasoning machine can give."[30] Recent writing on deskilling in the nineteenth century has emphasized that mechanization created a demand for new skills even as it eradicated the need for old ones. Only skilled individuals could make, operate, and maintain machines. But the *amount* of skill required by the modern economy was in some respects beside the point. Mechanization had changed the meaning of skill. It now defined its domain negatively against that of the machine. Skill was what the economy required of a body when no machine had yet been devised to do better. Pride in bodily skill gave way to shame. Work worthy of pride was socially concentrated in the ingenuity and oversight provided by a managerial class, ranging from the floor supervisor to the financier, that oversaw an increasingly automated world. A supporting ideology glorified the mental work of planning and supervising production and denigrated the routine execution of physical tasks as me-

nial labor, shameful work, best left whenever possible to machines. Thus the humiliation of humanity in the face of mechanization was imposed on the working class. Photography, Eastlake writes, "is a better machine than the man who is nothing but a machine."[31] Talbot embraced this ideology to argue that the modern device of photography, by obviating the need for the manual skill of drawing, vested art properly in the mind and eye rather than in the hand.

Once again, Eastlake's precise language is revealing. In a florid passage, she describes the photographic agency of the sun in terms of manual and managerial labor: "Under the magician who first attempted to enlist the powers of light in his service, the sun seems at best to have been but a sluggard; under the sorcery of Niépce he became a drudge in a twelve-hours' factory. On the prepared plate of Daguerre and on the sensitive paper of Fox Talbot the great luminary concentrates his gaze for a few earnest minutes . . . but at the delicate film of collodion—which hangs before him finer than any fairy's robe, and potent only with invisible spells—he literally does no more than wink his eye."[32] According to this capsule history of early photography, the sun transforms from a dull and listless laborer to a pure optical power. By this abrupt shift in metaphor, Eastlake conspicuously omits imagery of the skilled worker or craftsman. Her rhetoric splits the history of photography between the industrial poles of factory drone and pure supervision, between the unthinking hand and the disembodied eye. Thus, even when Eastlake invokes the notion of photography as natural magic, she insists that the sun abide by the new divisions of industrial labor.

Eastlake argues not only that photography is mechanical but also that its mechanics are inherently flawed. In particular, she criticizes distortions stemming from the uneven speed with which the photographic surface reacts to light across the color spectrum and from differently textured surfaces. She also disparages photography for its exaggeration of highlights and shadows. According to her, even if the world were to consist of only two colors, black and white, and all gradations in between, "photography could still not copy them correctly." Although tinkering with photography had produced improvements of many kinds, she deemed these "defects and irregularities of photography" to be "as inherent in the laws of Nature as its existence."[33]

According to Eastlake, these defects and irregularities undermined photography's potential as art. Proper chiaroscuro might be irrelevant in scientific illustration, but it was essential for aesthetic pictures. Although early

photographic processes had rendered broad masses of light and shade in a manner that she found appealing, more advanced processes had forfeited this initial promise. As photography became perfected, its inherent imperfections had revealed themselves, and nature had—in Eastlake's deliciously oxymoronic phrase—"been but more accurately falsified."

A curious tension exists between Eastlake's argument that photography is disqualified as art because it is too mechanical and her argument that it is disqualified as art because of its mechanical flaws. If photography's mechanical nature disqualifies it as art, then why is the perfection or imperfection of its mechanisms even relevant to the discussion?

One way to understand this confusion is to say that Eastlake muddles the issue of whether the aesthetic potential of photography is a question of process or one of product. Because of this muddling, she disparages photography with criticisms on both fronts, and neglects to acknowledge the inconsistency between them. She claims simultaneously that photography entails a *process* of mindless copying and that it yields a *product* that is not copy enough. In *The Pencil of Nature,* Talbot confuses this issue in his own way. On the one hand, he seems to assume that aesthetic value lies in the product, so that the kind or amount of labor that goes into the process is immaterial. On the other hand, he wants the pleasing qualities of the photograph to demonstrate the fine judgment of the aesthetic eye that guided the process. The habitual muddling of the issue of whether the status of photography as art lay in the process or in the product is a symptom of a crisis that photography had brought by delaminating the two.

A more sympathetic way to understand Eastlake's apparent inconsistency is to say that she demanded of any naturalism in art a certain *kind* of copying. In criticizing photography, she writes: "Far from holding up the mirror to nature, which is an assertion usually as triumphant as it is erroneous, it holds up that which, however beautiful, ingenious, and valuable in powers of reflections, is yet subject to certain distortions and deficiencies for which there is no remedy."[34] Today, "holding up a mirror to nature" suggests a looking-glass replication of perceptual experience, but in 1857 the phrase would have invoked the popular use of the Claude glass, a tinted convex mirror that muted colors, softened contours, and unified the space of any landscape view reflected in it. Victorian travelers would hold a Claude glass opposite pleasant views to produce a reflection reminiscent of the landscapes of Claude Lorrain.[35] Holding a mirror up to nature thus meant producing

an image that converted a view into something resembling a work of art. One could therefore do much to reconcile Eastlake's criticisms by positing that copying was fine, and that mechanical distortions were fine, but that photography had the wrong distortions and was thus copying in the wrong way.

All this, of course, is to take Eastlake at her word. But it is hard not to suspect that for her and many of her peers, photography's sheer popularity and profusion did as much to disqualify it as art as the variable speed with which silver emulsions reacted to light across the color spectrum. At the beginning of her essay, Eastlake recalls that when photographs first appeared, "we examined them with the keenest admiration, and felt that the spirit of Rembrandt van Rijn had revived."[36] Since then, she notes, photography had "become a household word and a household want; is used alike by art and science, by love, business, and justice; is found in the most sumptuous saloon and in the dingiest attic—in the solitude of the Highland cottage, and in the glare of the London gin-palace—in the pocket of the detective, in the cell of the convict, in the folio of the painter and the architect, among the papers and patterns of the millowner and manufacturer, and on the cold brave breast on the battle field."[37] With these remarks, she established the high stakes and long odds of photography cohering as a social form. Her language conjures up a utopian vision of finding the spirit of Rembrandt suffusing social spaces of every rank: the painter's folio, the saloon, the gin palace, the convict's cell. This was the highest promise of photography—a harmonious synthesis of democracy and art. But even as her words invoke this possibility, they sag beneath the weight of its internal contradictions.

What was at issue for Eastlake was perhaps less the pictorial capacity of photography than the social incapacity of art. The name *Rembrandt* was, after all, not only a sign of chiaroscuro, subtle suggestion, and breadth of effect, but also a sign of taste and distinction. The earliest photographs bore a whiff of the Dutch master in part because they were rare and unexpected gifts from the social elite to itself. Their aura could hardly survive the emergence of what Eastlake calls "the legion of petty dabblers, who display their trays of specimens along every great thoroughfare in London."[38] The chemistry of class, not silver, may best explain why Eastlake failed to find the spirit of Rembrandt in the gin palace. Photography, Eastlake writes, "is made for the present age, in which the desire for art resides in a small minority, but the craving, or rather necessity for cheap, prompt, and correct

facts [resides] in the public at large."[39] Photography's soaring popularity in the 1850s—its industrial madness—helped to ensure its subordination as mechanical.

In a neglected passage of her review, Eastlake emphasizes the role of luck in determining the social form of photography. The flip side of photography's failure to rise to the level of art was its radically democratic status, which Eastlake attributed to the social indifference and instinctual thrill of chance:

> It is one of the pleasant characteristics of this pursuit [of photography] that it united men of the most diverse lives, habits, and stations, so that whoever enters its ranks finds himself in a kind of republic, where it needs apparently but to be a photographer to be a brother. The world was believed to have grown sober and matter-of-fact, but the light of photography has revealed an unsuspected source of enthusiasm. An instinct of our nature, scarcely so worthily employed before, seems to have been kindled, which finds something of the gambler's excitement in the frequent disappointments and possible prizes of the photographer's luck. When before did any motive short of the stimulus of chance or the greed of gain unite in one uncertain and laborious quest the nobleman, the tradesman, the prince of blood royal, the innkeeper, the artist, the manservant, the general officer, the private soldier, the hard-working member of every learned profession, the gentleman of leisure, the Cambridge wrangler, the man who bears some of the weightiest responsibilities of this country on his shoulder, and, though last, not least, the fair woman whom nothing but her own choice obliges to be more than the fine lady? . . . They seek each other's sympathy, and they resent each other's interference, with an ardour of expression at variance with all the sobrieties of business, and the habits of reserve; and old-fashioned English *mauvaise honte* is extinguished in the excitement, not so much of a new occupation as of a new state.[40]

The photographer's luck: an excitement spreading across classes and genders, mixing their members, extinguishing English bashfulness and reserve, and heralding a new republic. To put such social transformation on the shoulders of photography would be remarkable in itself; but to put it on the photographer's *luck?*

Eastlake's hyperbole derives in part from the Victorian obsession with gambling, the popularity of which was becoming a definitive moral concern. Gambling was a heterotopic economy, where the rich could become poor, the poor could become rich, and chance substituted for labor. It was where the Victorian virtues of hard work, careful planning, and thrift could count for nothing. As Roger Caillois later put it, chance "grants the lucky player infinitely more than he could procure by a lifetime of labor, discipline, and fatigue. It seems an insolent and sovereign insult to merit."[41] At racetracks and gambling dens, chance exercised its social indifference, and men and women of disparate classes, drawn by the seemingly innate love of wagering, mixed in ways that moral authorities regularly denounced. The extreme swings in fortune that gambling fostered troubled many Victorians. One wrote in *Fraser's Magazine*:

> The wretched men who follow this play [of the dice game of hazard] are partial to it, because it gives a chance, from a run of good luck, to become speedily possessed of all the money on the table: no man who plays hazard ever despairs of making his fortune. . . . Such is the nature of this destructive game, that I can now point out several men, whom you see daily, who were in rags and wretchedness on Monday, and, before the termination of the week, they ride in a newly-purchased Stanhope of their own, having several thousand pounds in their possession.[42]

Gambling thus played havoc with the social hierarchy, prompting legislative restrictions on its indulgence.[43]

The deepest fear was that gambling was not actually the inverse of the everyday economic order but rather its unmasked reality or historical destination. A principal source of this concern was the modern financial market, which many deemed but a large and officially sanctioned gambling den.[44] As Sir Ernest Cassel supposedly said to Edward VII: "When I was young, people called me a gambler. As the scale of my operations increased I became known as a speculator. Now I am called a banker. But I have been doing the same thing all the time."[45] Even while Talbot was establishing the notion of the artistic eye as a kind of executive gaze that remained distant from the mechanical labor it directed, corporate oversight was mingling with financial speculation. One historian has called the surge in railroad investment schemes that began in 1845 the "most wonderful era of

gambling in modern times," and the year that Eastlake's essay appeared, 1857, brought a financial panic widely blamed on speculation.[46] When John Ashton wrote his popular history of gambling in England at the end of the century, he included chapters on horse racing, betting houses, the lottery, the stock exchange, railway mania, and life insurance.[47]

In the midst of moral anxiety about chance and markets, Eastlake construes photography as gambling of a more benign sort, one that unites members of different classes by appealing to their wagering instinct while avoiding the moral depravity and unsettling swings in fortune that made gambling a vice. She uses the language of democracy and revolution to describe the social effects of photographic enthusiasm. Operators are united, as if in a new republic, by their common pursuit of pictorial production, because that production fosters the excitement of luck.

But when the ranks of Eastlake's "legion of petty dabblers" swelled into a full-blown industry, the relationship between photography and gambling become more problematic. The year her essay appeared, the carte de visite, a new form of photography featuring a small studio portrait mounted on cardboard, arrived in England from France (Figure 2.1). The market for these easily exchanged and collected pocket-size portraits quickly boomed.[48] The number of photographic firms operating in London more than quadrupled between 1855 and 1864.[49] By one estimate, about 300 or 400 million cartes de visite were sold in Britain between 1861 and 1867.[50] With great sums of money at stake, the notion of the lucky strike in photography no longer seemed merely a metaphor for pictorial success. The moral qualms about social anarchy and depravity associated with gambling would be directed at photography as well.

Like the gambling den, photography tended to flatten or confuse social distinctions.[51] The camera's indifference was partly responsible. As Talbot observed, his apparatus "would delineate a chimney-pot or a chimney-sweeper with the same impartiality as it would the Apollo of Belvedere."[52] Photography, in violation of ancient conventions, gave everything equal treatment. This equivalence nullified old ways of reaffirming social hierarchy in representation, including the translation of hierarchy into physiognomy. Painters routinely reserved the look of nobility for the upper classes. The indifference of photography to social standing unsettled expectations. As one writer noted in 1864, "Brown and Jones [as sitters] make as good or better photographs than men of the stamp of Newton or Napoleon."[53] Impressive countenances did not belong exclusively to the high and mighty,

Figure 2.1 Daniel Jones, *George Henderson Whitehead,* 1860s, albumen print on card. Courtesy of Special Collections, Fine Arts Library, Harvard University

and not all of the high and mighty possessed impressive countenances. In its indifference, photography conveyed as much. For this reason, early photography and physiognomy were not so mutually reinforcing as some have argued.[54]

Over time, standardization of photographic formats contributed to the social flattening of the medium. Displays of cartes de visite mixed the lofty, the criminal, and the borderline obscene, and presented them all on the same small cards. A writer in the *Daily Telegraph* complained: "In almost every shop window devoted to the sale of photographic prints there are exhibited, side by side with the portraits of bishops, barristers, duchesses, Ritualistic clergymen, forgers, favourite comedians, and the personages in the Tichbourne drama, a swarm of cartes-de-visite of tenth-rate actresses and fifth-rate ballet girls in an extreme state of *deshabille*."[55] In the carte de visite display of the professional studio, the distance between the grand salon portrait of the royal sitter and the small, cheap pornographic print had collapsed. Neither the camera nor the standard photographic format distinguished subjects in the manner that art traditionally required.

As the popularity of the carte de visite increased, the ranks of professional photographers developed an uneven reputation, tainting the medium all the more. The photographer Stephen Thompson, writing in 1862, denounced his fellow practitioners of low moral standing, characterizing them as "the Pariahs of the profession, who prey on garbage, and infest the less reputable quarters of the metropolis and great provincial cities in daily increasing numbers—coarse, vulgar rogues who 'hold out' in filthy dens."[56] The soaring demand for the carte de visite offered an alluring prospect of quick profits. Whereas Eastlake had imagined photography as wagering cleansed of its iniquity, Thompson associated the worst of photography with the turpitude of the gambler's den. In these several ways, Victorians hewing to traditional values regarded photography as an agent of social and moral confusion.

Writers in the photography press routinely denounced the burgeoning market for cheap portraits and affirmed their respect for traditional aesthetic precepts. As art historian Steve Edwards notes, "Scarcely an issue of *The Photographic News* appeared during the 1860s that did not, in some way or another, invoke the sign of Reynolds."[57] Working under this sign, practitioners of artistic ambition sought ways to nullify the role of accident and stress the experience, skill, and judgment that an aesthetic photographic

practice could demand. To devise such a strategy, they understandably looked to the painting of their day.

But here they ran into trouble, because painterly signs of labor, skill, and chance were in flux. Even as the English photographic press endlessly cited Reynolds, leading painters, collectors, and critics were rebelling against his principles.[58] A key source of conflict was the issue of finish. Tradition demanded of any serious painting a proper finish, the final working of the surface that completed the work of art. The finish tended to be a paradoxical achievement, a painstaking expenditure of labor to suppress the signs of labor and make the surface transparent. It sealed the pictorial fiction off from the world with a finality that served as a supreme sign of skill.[59] It ensured that every painterly mark was subsumed into the illusion of the tableau. The picture could retain signs of the artist's touch—Rembrandt's work exemplified that allowance—but these signs had to bolster and enliven the fiction, even as they gave the picture a personal style. In the decades preceding photography, a few Romantic English painters, including Constable and Turner, rebelled against the demands of finish, defiantly granting their daubs or smears of paint greater autonomy. This rebellion led Lord Francis Egerton to complain in 1838 of a widespread "struggle for effect and the scorn of labour and finish."[60] The rebellion against finish threatened to destroy the paradoxical formula and make skill truly invisible. Critics struggled to distinguish the free handling of the master, which could emerge only after long study and devoted practice, from the haphazard paint application of the careless upstart. A London critic wrote in 1830: " 'Freedom of handling' does not mean looseness of touch and negligence—it is a perfection which can only be obtained by labour skillfully directed. The 'slapdash' style is a mark of anything but genius, which is painstaking, resolute, unconquerable—suggesting nothing, slighting nothing; but winning its way through difficulties which disgust and scare the impatient, the weak, and the vacillating."[61] For those sticking to tradition, subduing the play of paint was a moral duty.

Constable and Turner drew specific censure for the autonomy of their marks. Critics accused Constable's early works of hasty handling and insufficient delineation, while his late works drew complaint for the scumbling left in the finish.[62] Either way, his naturalism went hand in hand with a new willingness to let paint register as such. As one reviewer put it, "It is evident that Mr. Constable's lan[d]scapes are *like* nature; it is still more

evident that they *are* paint."[63] Wrestling with this new formula, commentators compared the flecks of white distributed across his late canvases to splashes of whitewash or plaster, snow, or chopped hay.[64] The free handling in Turner's work was equally unsettling. In 1837, a critic wrote of a Turner painting, "White brimstone and stone blue are daubed about in dreadful and dreamy disorder."[65] Inspired by English Romanticism, the Barbizon painters of France used lively impasto in their landscapes, and in the 1850s Gustave Courbet was still baffling and infuriating many critics with his ignoble subjects and incautious brushwork. From these and other precedents, the notion of the artist as "a bohemian who demands a lot of money for a few slapdash brushstrokes" achieved wide currency, especially in France.[66] To counter this notion, academic painters stressed the *fini,* the polished or licked surface. As Charles Rosen and Henri Zerner have argued, the *fini* was "associated with the qualities of probity, assiduity, professional conscience—and also discretion."[67] Whereas more daring forms of virtuosity were difficult to appreciate, the skill required to produce the *fini* was unmistakable even to those who knew little about art. For this reason, it became a key quality of the "grandes machines" of the French salons and "the guarantee for the bourgeois, and especially for the great bourgeois known as the state, against being swindled."[68]

But the *fini* could signify mechanical industry as well as traditional propriety. In his review of the Salon of 1845, Charles Baudelaire defended the modern facture of Jean-Baptiste-Camille Corot by noting, "The public's eye has become so accustomed to these shiny, clean, and industriously polished pieces that [Corot] is always reproached with not knowing how to paint."[69] Baudelaire here identified the contradiction at the heart of the *fini* as a sign. Although the *fini* served to signify traditional labor and skill, its uniformity, seamlessness, and dematerializing effect conformed to the aims of industrial commerce. Indeed, the "grande machine," by combining uniform surface, immediate legibility, and simple moral structure, embraced a commercial mode of representation even as it appealed to nostalgia through hackneyed narratives, stale pieties, and grand gestures toward artistic worth. As Baudelaire perceived and lamented, the art world rose to the defense of tradition by pitting against photography and modern commerce an academic style of painting that had in fact capitulated to their terms. In contrast, rebellious painters such as Courbet, by seeking to give facture a specific intelligibility in pictures of ambiguous narrative and moral structure, worked against the grain of modernization, even while

depicting modern life. The midcentury modernists, in other words, were conservative in their desire to keep artistic touch difficult, but radical in their insistence that the appropriate subject of this difficulty was modernity.

Baudelaire was in the minority. The art world mostly clung to the academic requirement of finish as a reliable index of value. The artist was obligated not only to exercise skill but also to make that exercise visible by otherwise erasing traces of labor. At the Whistler/Ruskin trial, Burne-Jones complained of Whistler: "There is often not so much appearance of labor in one of his pictures as there is in a rough sketch by another artist, and yet he asks and gets as much for one of these as most artists do for pictures skillfully and conscientiously finished."[70] Burne-Jones acknowledges in this passage that the issue is the *appearance* of skilled and conscientious labor. Whistler had upset a regulatory principle by asking high prices for pictures that offered no reliable signs of a corresponding labor value. To function properly, the art market required that such a value be made visible.

Photography played an odd role in this wrangling over finish. On the one hand, it could boast the ultimate finish, the smoothest and most optically precise representational surface. In 1867, the writer Alfred H. Wall claimed that the "great and distinguishing superiority of photographs over all other works of art is in the exquisite refinement, delicacy, and truthful perfection of their finish."[71] On the other hand, photography's finish was more a sign of industrial automatism than of hard-won artistry. Near the end of the century, the photographer Henry Peach Robinson admitted that "the surprise and wonder of the 'finish' of a photograph vanished many years ago."[72] The smooth surface and precisely rendered detail in a photograph had no particular intention behind it and seemed the automatic result of a mechanical process. To distinguish the finish that tradition required from the automatic finish of photography, writers insisted on the role of aesthetic judgment in the former. "Art cares not for the right finish," Eastlake writes, "unless it be in the right place."[73]

To overcome mechanical finish, and to fulfill the academic requirement of selection and rejection from nature, some photographers of artistic ambition combined multiple photographs into a single picture. For example, in 1857, at the Art Treasures Exhibition in Manchester, an event designed to educate popular taste, the photographer Oscar G. Rejlander exhibited a moralistic allegory featuring a large group of figures, entitled *Two Ways of Life,* which he claimed to have made by combining thirty negatives into a

Figure 2.2 Oscar G. Rejlander, *Two Ways of Life,* 1857, albumen print. Royal Photographic Society; National Media Museum, Science & Society Picture Library

single print (Figure 2.2). By means of this process, Rejlander purported to practice the selection and synthesis that academic doctrine demanded of art, and to produce "a most perfect sketch" for artists to use.[74] Soon after the exhibition, he wrote: "The conception of a picture, the composition thereof, with the various expressions and postures of the figures, the arrangement of draperies and costume, the distribution of light and shade, and the preserving it in one subordinate whole . . . require the same operations of mind, the same artistic treatment and careful manipulation, whether it be executed in crayon, grey-in-grey, paint of any description, or by photographic agency."[75] Whereas Talbot had chosen to emphasize the opportunistic eye of the photographer in search of the picturesque, Rejlander instead stressed the arduous building up of a picture from theatrically composed elements. To those who thought combination printing was "unphotographic," Rejlander responded: "Why should I be blamed for not letting all appear that might happen to be depicted on the plate, when either I do not want it, or when it might be hurtful to the general effect?"[76] No stray clock for him. By weeding out what diverged from his artistic intent and combining the rest into a harmonious whole, Rejlander conspicuously abided by academic doctrine. He strove to produce a thoroughly

composed picture without any interruptive detail, an illusionistic surface entirely suffused with his intentions. Viewers understood the picture as an effort, in the words of one, to "rescue photography from the reproach that it was merely a mechanical art."[77]

Combination printing was a way to drain chance from photography. The photographer did not have to encounter a picturesque composition fortuitously and expose the film at precisely the right angle and time. He did not need a miraculous conjunction of events. In 1870, one critic made precisely this point. In a discussion of the collaborative combination printing of Henry Peach Robinson and Nelson King Cherrill, he wrote: "Messrs. Robinson and Cherrill's instantaneous effects, principally seascapes, are doubtless the finest things of their kind and size yet produced. Of course, it need not be supposed they are from single negatives. Wild seabirds are not usually obliging enough to place themselves in front of just the particular part of [the] subject required at the very moment when the camera is there waiting to take them. The highest praise is due to the conception and the carrying out of these pictures without the necessity of a miracle being worked to make them."[78] Combination printing was a way of circumventing the improbability of encountering optimal arrangements in the world.[79]

In *Two Ways of Life*, Rejlander used combination printing to claim a measure of the traditional value of finish by making the seamlessness with which he combined images from different negatives signify his darkroom skill. The continuity of the picture surface, ordinarily presumed in photography to be an automatic outcome, became in combination printing a marker of respectability and value. Whereas the perfect finish of the ordinary photograph spoke only to industrial magic, the immaculate surface of Rejlander's picture signified his care and expertise. This no doubt contributed to his success in selling the exhibited copy of *Two Ways of Life* to the queen.[80] The official appreciation of *fini* as a sign of probity in painting had, thanks to his composite technique, attached itself to photography.[81]

Rejlander was smart to make the theatricality of his scene explicit by putting his figures on a stage. If the principal objection to photography as art was that its mechanical reliance on reality disallowed artistry, then invoking the theater was a clever means of defense. The stage, after all, was a place where real bodies were transformed into art. If the photographic apparatus could not work on real bodies in the manner that aesthetic doctrine required, then why not artistically reconfigure them in front of the camera? Why not record an instance of theater? Rejlander describes *Two*

Ways of Life in this way: "The world is aptly described by the immortal bard as 'a stage, and all the men and women merely players.' It is upon this stage that I have lifted the *curtain* to introduce to you the *dramatis personae*."[82] Determined to overcome the mechanical in photography, Rejlander introduced artistic discretion into his technical process through combination printing in the darkroom and dramatic artistry before the lens.[83]

Rejlander's restoration of finish as a mark of skill in photography and his invocation of theater were ingenious moves, but he was playing a hopeless endgame. Even the most seamless combination printing could not suppress all of the inconsistencies of lighting and space differentiating the photographs combined into the final work. Chance in photography was not so easy to eradicate as all that. Moreover, Rejlander was striving to align photography with a tradition that was rapidly succumbing to modern pressures, including those exerted by photography. His fastidiously arranged draperies, classical poses, and licked surface imitated a conservative and increasingly disparaged style of academic painting. To make matters worse, by seeking to achieve utterly predictable academic effects, he was willy-nilly aligning his practice with run-of-the-mill studio portraiture. Commercial portrait photographers almost invariably used props, accessories, and backgrounds that consistently and more or less crudely invoked the academic tradition (Figure 2.1). Although these photographers generally made their prints from a single negative, the studio was itself a composite of discrete academic elements, such as draperies, columns, and background scenery. Both Rejlander and the commercial portraitists left themselves open to the charge of producing monstrosities—pictures patched together from disparate pieces—that imitated academic norms left behind by modernist artists such as Constable and Turner.

An even more popular strategy for countering the mechanical character of photography involved the use of soft focus. Both scientific and commercial photography were associated with crystalline clarity, with a fine finish that many critics believed came at the expense of artistic effect. In an essay published in 1860, the watercolorist and photographer William Lake Price claims that among landscape photographers the "parrot cry of 'sharp, sharp'" fosters an inclination toward "painfully elaborated details, instead of broad effects of light glancing through the landscape."[84] In this criticism, Price shifts the basis of mechanical thoughtlessness from photographic process to photographic practice, comparing the uniform preference for sharp focus

Calotype. *Burnham Beeches.* *Sir Wᵐ Newton.*

Figure 2.3 William J. Newton, *Burnham Beeches,* c. 1855, salt print from calotype negative. National Media Museum, Science & Society Picture Library

in landscape to the mindless repetitions of a parrot. By vesting the mechanical in practical habits rather than in chemical reactions, Price introduces the possibility that it can be overcome, that proper use of soft focus can free photography from its thoughtless ways. Several years earlier, Sir William J. Newton, a miniature painter who exhibited regularly at the Royal Academy, emphasized that photographers aspiring to produce "artistic" studies should resist the clamor for maximum clarity (Figure 2.3). To secure a general effect, he wrote, "I do not consider it necessary that the whole of the subject should be what is called *in focus;* on the contrary, I have found in many instances that the object is better obtained by the whole subject being a little *out of focus,* thereby giving a greater breadth of effect, and

consequently more *suggestive* of the true character of nature."[85] Newton thus followed the precepts of Reynolds, who exalted the general idea and warned, "The usual and most dangerous error is on the side of minuteness."[86]

Unlike Newton, Eastlake in her essay makes no effort to guide contemporary practice. To be sure, she expressly sympathizes with him, noting that "mere broad light and shade, with the correctness of general forms and the absence of all convention, which are the beautiful conditions of photography, will, when nothing further is attempted, give artistic pleasure of a very high kind."[87] But whereas Newton sought to guide photographic practice toward art, Eastlake puts the artistic pleasure of photography in the past. She does not call for photographers of artistic ambition to return to the calotype or the daguerreotype, nor does she consider ways that photographers using the collodion process might approximate the effects of earlier photography through adjustments in focus or choice of printing paper. In other words, although she raises technical objections to photography, her argument renders a historical judgment on broader grounds. The issue for her is not simply that many photographs do not seem like traditional pictures, but rather that the formidable historical force of photography writ large seems antagonistic to art.

Nonetheless, Eastlake contributed vitally to photographic practice by offering, in dribs and drabs, a modern aesthetic. This aesthetic centered on the poignant respite from mechanization that certain forms of reproductive imperfection could afford. In her essay, she draws a distinction between, on the one hand, a popular preference for maximum clarity, neatness of appearance, and uniform finish and, on the other, a higher taste for indistinctness, irregularity, and surface accident. She writes of recent landscape photography: "Here the success with which all accidental blurs and blotches have been overcome, and the sharp perfection of the object which stands out against the irreproachably speckless sky, is exactly as detrimental to art as it is complimentary to science."[88]

Eastlake construes this aesthetic of accident as a thing of the past but unwittingly invites its return. This invitation stems from her argument's incoherence. While she argues that the perfections of photography run counter to art because art as a process is not mechanical, she also argues that the imperfections of photography run counter to art because they render photographs untrue to nature. By trying to have it both ways, Eastlake inadvertently offered photographers the possibility of playing one paradigm and objection against the other. What would happen, in other words,

if a practitioner used the inherent faults of a photographic process with aesthetic discretion? What if he or she used mechanical distortions with judgment to improve nature in the manner that Reynolds required? And what if a practitioner did these things while cultivating the accidental indistinctness that Eastlake associated with photography's lost artistic promise? These are questions that Julia Margaret Cameron's photography would raise.[89]

3

Julia Margaret Cameron
Transfigures the Glitch

At some point in the early days of photography, John Herschel sent "specimens of Talbotype" to his friend Julia Margaret Cameron, a colonial woman of aristocratic descent living in Calcutta.[1] Cameron later moved to England, where in the 1860s and 1870s she made her own photographs, now celebrated as art (Figure 3.1). But even critics and historians who have lauded her aesthetic achievement have puzzled over the role of haphazardness in her work. Cameron invited, preserved, and defended signs of sloppiness and chance in her photography when other serious practitioners were seeking to eliminate them. Whereas Talbot emphasized the accidental encounter, Cameron highlighted the play of chance in the optical, chemical, and material processes of photography. In doing so, she brilliantly negotiated a host of contradictory Victorian commitments.

The puzzle of Cameron's haphazard ways is not new. Writers in her day routinely remarked on the blemishes she abided. Although Cameron used up-to-date processes to make wet-plate collodion glass negatives and albumen prints, she showed scant concern for the forms of technical mastery that almost all professional photographers deemed essential to their craft. In 1865, one reviewer wrote:

> It would have been well had the fair artist paid some attention to the mechanical portion of our art-science. A piece of the collodion torn off the shoulders of *Agnes* (who otherwise, by the way, is hard and patchy); a broad fringe of *stain* three inches in length over the arm of

Figure 3.1 Julia Margaret Cameron, *Lovlor Kuhn the Sisters,* 1864, albumen print from glass negative. Courtesy of George Eastman House, International Museum of Photography and Film

James Spedding; brilliant comets flashing across *Alfred Tennyson;* [and] tears chasing each other not only down the cheeks, but the brows, the arms, the noses, and the backgrounds of many of her best-arranged subjects;—these, and many other defects of a similar nature, compel us to say that it is a subject for regret that this lady does not secure the services of an efficient operator to enable her productions to be given to the public in a more presentable form.[2]

In making albums for friends, Cameron would print from cracked nega-
tives and trim prints haphazardly. Fascination with her tolerance of tech-
nical defectiveness has persisted through the years. Photography curator
Julian Cox recently inventoried the flaws of the only surviving large plate
negative by Cameron, a portrait of the banker George Warde Norman. He
found a spot on the glass that the sticky collodion mixture failed to reach;
pinholes around the sitter's face, suggesting a depleted silver nitrate bath;
areas missed when Cameron developed the plate; a comet on the sitter's
topcoat left by dust or dirt during development; and areas missed when
the plate was varnished.[3]

Historians have struggled to understand not only Cameron's darkroom
technique and album-making methods but also her camerawork.[4] Whereas
most portrait photographers of her day used ample overhead lighting to
produce a sharp image, Cameron preferred the chiaroscuro created by
angled and restricted sources of light. Often working in a relatively dim
space, she opened up her camera's aperture to let in more light, but this
severely limited her depth of field. From what we know of her equipment,
aperture settings, and typical indoor conditions, one scholar has approxi-
mated her depth of field at between 1 ¾ and 2 ¼ inches.[5] That is, her
process limited crisp focus to a vertical slab of space about two inches
thick. Even in her portrait photography, this narrow depth of field routinely
softened much of the image. Cameron also refused to employ headrests or
other devices to help sitters remain still during her exposures, which despite
her wide aperture remained long due to the restricted lighting. This almost
guaranteed that involuntary movements would produce blurs.[6] As a result
of these technical conditions, many Cameron photographs offer few if any
areas of sharp focus. More curious yet, sharp focus is often reserved for areas
that pictorial convention would have deemed of secondary importance. For
example, in a photograph entitled *A Dantesque Vision,* the face of the model
(Lady Elcho) is luminescent and indistinct, while the bark of the tree against
which she leans is rendered in exact detail (Figure 3.2).[7] In numerous por-
traits, whether made indoors or outdoors, the area of clearest focus repre-
sents clothing or vegetation rather than the subject's face. Although a
preference for soft focus was not uncommon among Victorian photogra-
phers of artistic pretension, this arbitrary allocation of focus was bizarre.

Whereas writers on Cameron's work once tended to chastise her for poor
technique, they now often assign her glitches a positive value.[8] Cox, for

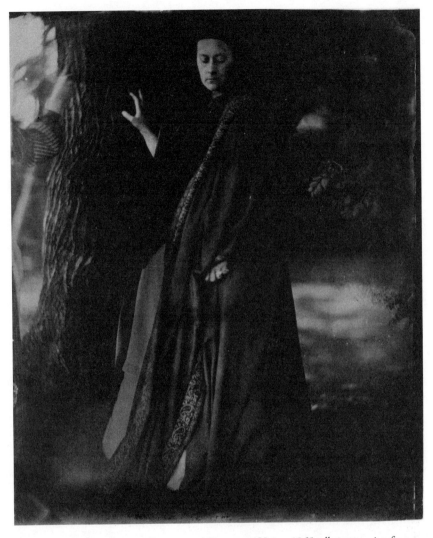

Figure 3.2 Julia Margaret Cameron, *A Dantesque Vision*, 1865, albumen print from glass negative. © Victoria and Albert Museum, London

example, has argued that Cameron "was not afraid to reveal the exigencies of her own labor, as though leaving traces of her hand convincingly demonstrated that her work was made very consciously and by an artist rather than a machine."[9] This gloss touches on vital paradoxes at work in Cameron's practice, whereby accidents come to signify ambition and

defects to signify distinction. By bringing forth these paradoxes, her photography took on a wayward originality.

At first blush, the popular appeal of chance as described by Eastlake would seem anathema to Cameron, who is known for her portraits of great intellectuals, literary scenes of knights and maidens, and high-flown remarks about the eternal verities of art. But Cameron's circumstances made her relationship with photographic gambles complex. While she practiced photography, her patrician family was experiencing an economic free fall. Her French maternal grandfather had been a page to Marie Antoinette and a member of Louis XVI's Garde du Corps, her father and paternal grandfather had been officers of the British East India Company, and Cameron herself, although born and married in Calcutta, had been educated in Versailles under her grandmother's care. This background lent her a sense of innate nobility and social entitlement she never shed. Her fortunes, however, turned in the 1860s, when the coffee plantations in Ceylon owned by her husband, Charles Hay Cameron, faltered, and the family sank ever deeper into debt. The Camerons borrowed thousands of pounds from close friends and relatives, and their lenders at times expressed impatience with the family's inability to square its finances.[10] The descent was precipitous. Their annual income over the years fell from £10,000 (during prosperous days in Calcutta) to a mere £800.[11] In September 1866, Charles Norman, their son-in-law, described Charles Hay as "utterly penniless."[12]

These conditions put the familiar status of Cameron as an "amateur" in a different light.[13] With her husband suffering chronic health problems, she managed the household budgets and was keenly aware of the family financial strain, even as she persisted in habits of expenditure and generosity more befitting her comfortable past than her precarious present. When Norman, one of the family creditors, gave Cameron her first camera, she—and perhaps he—saw it as a means to improve her finances.[14] Cameron wrote to Herschel: "When I started photography I hoped it might help me in the education of one of my Boys."[15] Impressed by the great sums that her neighbor Alfred Tennyson had garnered from his poetry, she admitted to seeking "fortune as well as fame" with her photography.[16] Unwilling to submit to the dirty business of ordinary commercial work, the nearly bankrupt Cameron gambled with photography as art. Split between her aristocratic moorings and her everyday financial worries, she fashioned a divided practice. Her themes and references were literary and lofty, but her truck with amateur theatricality and celebrity culture was more or less

vulgar. The tension between her elitism and her mercantile aspirations surfaces in her correspondence. In a letter to her friend Henry Taylor, she wrote: "I hold the Public to be 'swine,'" but elsewhere she confessed to Herschel: "It is of extreme importance to me to sustain the sympathy & high opinion of the public."[17] She aggressively pursued famous sitters and with equal fervor sought signatures for her photographs to increase their value. To Herschel she wrote: "The photograph of you is to my idea doubled in value by *your* genuine autograph. I have marked the place with pencil for your dear name."[18] Cameron also implored her literary friends to praise her work in the press. When she had finished production of photographic illustrations for two gift books in 1875, she pleaded to Sir Edward Ryan: "A notice in the *Times* for Xmas would sell all my books."[19] Cameron made a habit of giving albums of her photographs to friends well positioned to loan her family money or to extol her work in the press.[20] She gave a splendid album to Lord Overstone, who over the years loaned her family more than £6,000.[21] Acknowledging her assiduous pursuit of famous or charismatic sitters, she once described herself as "a hardened beggar."[22] By choosing models for her heroic figures from the lower classes as well as the upper (she found her King Arthur in a porter from a local pier), Cameron abetted the dicey circulation of status and identity that marked both modernity generally and her own life in particular. Although she achieved some renown, one of her contemporaries wrote of her practice, "I fear it is not a successful speculation."[23]

The deep fissure between Cameron's privileged past and her commercial ambitions enabled her to address fundamental contradictions in Victorian culture. Artists and writers of her day struggled with the demand to transcend commerce even as they were ever more subject to its whims and effects. As the scholar Mary Poovey has said of Victorian writers, "On the one hand, they were called prophets; on the other, they felt they had 'no rank or position at all.' On the one hand, they were touted as superior to the 'commercial ideas' that threatened a cultural 'decline'; on the other, they felt themselves hostage to the rise and fall of taste and the good will (or business sense) of publishers, advertisers, and booksellers."[24] For Cameron, photography became a means by which to negotiate not only the financial descent of her family but also the chasms that modern commerce had driven between aesthetic expectations and market reality.[25]

This negotiation required restoring the aesthetic promise of photography. By the 1860s, Eastlake was far from alone in believing that photography

had squandered that promise. As one writer observed, "The remark has often been made that the earliest essays in photography occasionally rendered broad and beautiful effects of light and shade, and conveyed suggestions of life and motion, which have gradually disappeared as the optical and chemical means and appliances of the photographer have been perfected."[26] As technical advances and professional practices had made photography precise and predictable, shrinking the role of chance, the aesthetic potential of the medium had receded. The midcentury portrait studio was engineered to subdue all forms of accident: head clamps and supporting stands limited unwanted bodily movement, and mirrors concentrated lighting to minimize obscuring shadows and permit sharp focus. Props and backdrops served to ensure that the final picture signified academic taste and respectability. Studio professionals fretted obsessively about accidents and blemishes, and countless articles in professional journals advised practitioners on how to eliminate them. For Cameron, the glitch was a way to spurn this moment of commercialization and connect her practice back to the origins of photography.

The recuperative side of Cameron's practice comes through in her letters and unfinished autobiographical essay, "Annals of My Glass House."[27] In these writings, she relates a history of self-teaching that recalls the early investigations of photography in makeshift laboratories by English gentlemen such as Talbot and Herschel. She describes converting her "coalhouse" into a darkroom and her "glazed fowl house" into a glass studio. She claims to have spoiled her first photograph "by rubbing [her] hand over the filmy side of the glass," and having another ruined by the sitter's "splutter of laughter."[28] Over the years, her letters to Herschel continually emphasize her independence. In one she writes, "I do all alone without *any* assistance & *print* also entirely by myself."[29]

This history of photographic self-teaching through trial and error disclaims any account of professional apprenticeship or by-the-manual training and follows instead the model of the gentleman amateur, puttering with chemicals at home in a spirit of open inquiry. Even though Cameron began working long after a photographic establishment had arisen, used the latest technology, and evidently learned directly from Rejlander, her writings imagine an independent origin for her practice.[30] She does not pretend to have invented new processes; rather, her story of tinkering legitimates an independence of approach and aim. "I first started a branch of the art hitherto untried," she writes.[31] Personally linked to photography's origins

through her friendship with Herschel, Cameron imagines a lineage that leapfrogs photography's professionalization and aesthetic decline. In another letter to Herschel she asks: "What is focus—and who has a right to say what focus is the legitimate focus?"[32] Cameron audaciously presumes to establish photography and its standards anew.[33]

Serendipity has a central place in accounts of Cameron's work. Her contemporary Coventry Patmore, a poet and critic, wrote: "The beautiful has hitherto been often the accident of the inexperienced photographer. . . . An amateur photographer, Mrs. Cameron, was the first person who had the wit to see that her mistakes were her successes, and henceforward to make her portraits systematically out of focus."[34] Patmore, like other supporters, understood Cameron to have discovered in her accidents a new aesthetic. In "Annals," Cameron takes up this notion herself: "I believe that what my youngest boy, Henry Herschel . . . told me is quite true—that my first successes in my out-of-focus pictures were a fluke. That is to say, that when focusing and coming to something which, to my eye, was very beautiful, I stopped there instead of screwing on the lens to the more definite focus which all other photographers insist upon."[35]

The precise language of Cameron's recollection suggests that the role of luck in her progress was a sensitive matter. When she writes that her son characterized her first successes in out-of-focus pictures as a "fluke," her diction betrays moral ambivalence. The use of *fluke* to mean an unpredictable success dates to Cameron's lifetime and emerged in billiards to describe a lucky shot. Cameron had cause to dislike this association. In her letters, she repeatedly complains about the idleness of her two youngest sons, Charles Hay and Henry Herschel, who whiled away their hours playing billiards.[36] She writes to her eldest son, Hardinge: "Charlie Hay . . . never opens a book, never does any copying work or any work of any kind—strolls away to Billiards after his mid-day breakfast or hires a trap & drives . . . and always he and Henry spend the whole evg. at the Billiard table!"[37] Under these circumstances, the word *fluke* spoke not only of chance but also of waste and indolence, connotations that grate against the hopeful notion of serendipitous discovery. Cameron tempers these unwelcome aspects of the word by clarifying ("that is to say") that her use of focus was a deliberate embrace of an unexpected satisfaction.

In this delicate way, Cameron negotiated competing accounts of chance in the production of photographs. In the serendipity account, a picture manifests the intention to put accident to a specific use that attests to the

maker's sensitivity and supple-mindedness.[38] In the gambling account, a picture is but a lucky strike, an outcome leaving a gap between the aim of producing photographic art and the selection of particular works to exemplify that aim. While Cameron proffered a tale of serendipity, her critics often proposed the less unflattering alternative. "Some of Mrs. Cameron's productions are undoubtedly beautiful," wrote the cantankerous pundit Alfred H. Wall in 1865, "but if these were not obtained by chance, but by design, why are they not more common?"[39] The question is barbed but the underlying logic astute. Wall recognizes that the role of chance in photography may require the judge of photographic achievement to employ a probabilistic calculus. Expertise, he suggests, separates itself from luck in the practitioner's rate of success, a formula that would trouble photography for generations to come. Although Wall failed to recognize that Cameron was cultivating accident to refashion the criteria for pictorial success, he shrewdly understood the basic predicament that she and other ambitious photographers faced.

Cameron responded to that predicament by demoting skill and valorizing chance. Many writers on Cameron's photography have misunderstood these modernist moves and ignored her account of her practice. They have emphasized her technical progress as a photographer over time, even though she tended to disregard or dismiss it. For example, Herschel wrote to Cameron in 1866: "You have by your own marvelous industry, & perseverance conquered those difficulties of manipulation which so cruelly marred your most promising earlier attempts so that you have now to look forward to a brilliant & triumphant career of success which will set you above criticism."[40] Such accounts have run directly against Cameron's habit of proclaiming the excellence of some of her earliest and least technically accomplished photographs. There is a print of *La Madonna Aspettante* in an album at UCLA, about which Cameron writes: "The first month of my Photography!! and never surpassed."[41] Over the years, Cameron remained consistent in this high appraisal of her early and technically messy work. In "Annals" she writes: "I exhibited as early as May '65. I sent some photographs to Scotland—a head of Henry Taylor, with the light illuminating the countenance in a way that cannot be described; a Raphaelesque Madonna, called 'La Madonna Aspettante.' These photographs still exist, and I think they cannot be surpassed."[42] Cameron's insistence that she made unsurpassed pictures in the first month of her photography forcefully rejected the link between photographic excellence and technical skill.

Like Patmore, she understood the mindless pursuit of exactitude to run counter to aesthetic possibility. Success for her depended principally on communicating a worthy idea, which for the unskilled photographer was perforce a function of noble intention and good luck.[43] For all her interest in Raphael and the Elgin Marbles, Cameron embraced a modern notion of art. Years before Whistler explained in court that the greatness of a painting lay in conveying an idea and could not be judged by the labor of its execution, Cameron was implicitly making such radical claims on behalf of her photography.[44]

Near the end of "Annals," Cameron follows Eastlake by characterizing the glitch as a mark of lofty sensibility. To do so, she introduces a foil, a prospective sitter who has written her a letter: "Miss Lydia Louisa Summerhouse Donkins informs Mrs. Cameron that she wishes to sit for her for her photograph. Miss Lydia Louisa Summerhouse Donkins is a carriage person, and therefore, could assure Mrs. Cameron that she would arrive with her dress uncrumpled. Should Miss Lydia Louisa Summerhouse Donkins be satisfied with her picture, Miss Lydia Louisa Summerhouse Donkins has a friend *also* a Carriage person who would *also* wish to have her likeness taken." After quoting this letter, Cameron recounts her response: "I answered Miss Lydia Louisa Summerhouse Donkins that Mrs. Cameron, not being a professional photographer, regretted she was not able to 'take her likeness' but that had Mrs. Cameron been able to do so she would have very much preferred having her dress crumpled." Having finished this account, she adds, "A little art teaching seemed a kindness." By relating this anecdote, Cameron establishes her class distance from the commercial portrait photographer, a defensive move that her compromised financial situation made necessary. Unlike the commercial portraitist, Cameron chose her sitters and did not need to suffer the stuffy presumptions of Miss Lydia Louisa Summerhouse Donkins. But Cameron associates this difference with an aesthetic preference: Cameron, unlike Donkins and the professional photographer that Donkins imagines, would prefer the young lady's dress crumpled.[45]

Cameron thus uses the glitch as a sign of the noncommercial nature of her enterprise. The low aesthetic of the popular, embraced by a legion of portrait photographers, was all neatness and propriety. It was about pressed suits, fresh flowers, clear focus, and unblemished prints. It was about middlebrow aspirations and the desire for respectability. It was about clear and complete articulations—and punctilious reproductions—mocked

by Cameron in her rhythmic refrain of "Miss Lydia Louisa Summerhouse Donkins." The high aesthetic embraced by Cameron cultivated an untidiness of both personal and photographic appearance, including the messiness of stained linens, disheveled hair, fingerprints, and arbitrarily uneven focus. It deemed the pursuit of mere respectability a lowly affair. Lady Troubridge recalled that when she sat for a picture, "Aunt Julia, with ungentle hand, touzled our hair to get rid of its prim nursery look."[46] The determined lack of fastidiousness tacitly affirmed the concentration of noble minds on higher things and associated those higher things with a divine but unruly enlivenment.[47] In one letter, Cameron explicitly defends the blemishes on her prints. "As to spots they must I think remain," she writes. "I could have them touched out but I am *the only* photographer who always issues untouched Photographs and artists for this reason amongst others value my photographs. So Mr. Watts and Mr. Rossetti and Mr. du Maurier write me above all others."[48] There was a difference between touch, in the form of a fingerprint or other blemish, and *touched up*. Cameron's photographs were *untouched* because she let imperfect touches remain. Doing so was a way of declaring that one aimed beyond the petty contingencies of modern routine and beyond the meticulousness that served as an alibi for a failed imagination. "A little art teaching seemed a kindness"—Cameron characterizes her rebuff to Miss Donkins as a lesson in distinguishing neatness and propriety from art.

Caught between constricting circumstances and an innate sense of nobility, Cameron made the gap between flawed materiality and romantic ideals the burden of her art. Her photographs are stubbornly contingent objects that gesture toward a better form. Their signs of material shortcoming range from irregularities of surface and focus to the haphazard manner in which she often trimmed her prints for albums. In a letter to Herschel accompanying an album, she wrote: "I had a great desire to squeeze all my best photographs into y. Book. I am afraid some will miss the margin but you won't care so long as your eye meets the picture I have been endeavoring to give."[49] Driven by a desire that exceeded the material limits under which she worked, Cameron crammed her photographs into the album, trimming individual pictures too little or too much but retaining the hope that his eye would meet the mental image of her aim. The gap between her ideal album for Herschel and the album she actually gave him runs parallel to the gap between the ideal pictures she imagined and the actual photographs she produced. Overcoming the mechanical nature of

photography required a photograph to gesture beyond itself, so that the viewer saw inwardly toward a more perfect impression. For her, the traces of material contingency in her photographs, which technically minded writers have perceived as flaws, were so many indications of imaginative reach.[50]

The ideal pictures at which Cameron aimed were perhaps less important than the aiming itself. As one writer noted at the time, her "out of focus" photographs "give the hope that something higher than mechanical success is attainable by the camera."[51] Her photographs were arguably all about giving viewers that hope. Despite the antimodern air of her sad madonnas, her response to the predicament of photography was more prescient and agile than Rejlander's. Instead of restoring the stature of the finish and laying claim to a stale academic legitimacy through composite printing, Cameron embraced imperfection as a newly vigorous sign of historical plight and human yearning. Peter Henry Emerson contrasted the two practitioners with characteristic bluntness: "Rejlander is a mere mechanic when compared to her."[52] Cameron may have thought the same. She once had Rejlander pose for a photograph as a hurdy-gurdy man, a crank-turning operator of a disreputable musical instrument.[53] In the glitch, she found a way to rescue her photography from the cranking out of pictures.

Cameron's decision to work with the new wet-plate process contributed to the complex modernism of her practice. If, as Eastlake had suggested, the early salt-paper prints of Talbot and his followers had set the bar for photographic aesthetics, then why not take up the older technology, as some others had done? Why work with the collodion and albumen processes that Eastlake and others associated with photography's aesthetic decline?[54] Cameron eschewed the nostalgia of the salt print to subject processes associated with industrial perfection to the enlivening accidents of her labor. The viscous liquidity of wet plates and albumen prints gave her glitches a gendered meaning. The drips, streaks, and blotches participated in what Carol Armstrong has termed Cameron's "hystericization of the photograph."[55] Using technical processes associated with clear opticality, Cameron produced pictures redolent of an emotive, overly liquid, out-of-control vision. The words of the critic quoted above—"tears chasing each other not only down the cheeks, but the brows, the arms, the noses, and the backgrounds of many of her best-arranged subjects"—speak to this mingling of glitch and feminine excess. Cameron's long exposure times often caused her sitters' eyes to well, and their glistening orbs gave her photographs a liquid

Figure 3.3 Julia Margaret Cameron, *Sir John Herschel,* 1867, albumen print from glass negative. © The Metropolitan Museum of Art; Image Source: Art Resource, NY

reflexivity (Figure 3.3). Like Alice swimming through a pool of her own tears, Cameron resourcefully negotiated the signs of overpowering feminine sentiment that she produced.[56]

Feminine fluidity, of course, comes in forms less acceptable to Victorian acknowledgment than tears, and Cameron's failure to control the sticky wetness of her collodion process eroticizes and maternalizes her photography. The body of the "fair artist" seems to have spilled over into the

dry optics of the medium, blurring its clarities and spotting its immaculate surfaces.[57] The domestic authority of the Victorian woman stemmed from her ability to regulate her desire and thus restrain the tendency in the modern era for wants to run rampant. It was through her that the domestic sphere was to tame the instinctual drives and rapacious inclinations of market life.[58] Cameron, however, strewed her domestic space with signs of her irrepressible passion. In "Annals," she recalls retaining the "habit of running into the dining room with my wet pictures," which "stained such an immense quantity of table linen with nitrate of silver, indelible stains, that I should have been banished from any less indulgent household." She left excessive traces of her sticky desires throughout the domestic sphere of her house and studio, as well as in the passionate spaces of her photographs.

Part of the genius of Cameron's photography was the way she combined this feminine messiness, which materially flouted the demand for regulated sexuality and household order, with a theatrical practice centered on virtue and self-restraint. She disciplined her servants and relatives in a high Victorian manner by insisting that they perform exacting and virtuous forms of selfhood before her camera, while her own material processes overflowed their bounds. Discipline was a matter of theater; excess, a fact of creative life. By associating feminine materiality with aesthetic ambition, she provoked many male critics to regulate her practice by harping on its lack of neatness.

For Cameron the glitch was a way to outwit patriarchy. In the Victorian art world, as Ann Bermingham has observed, "the professional artist expressed his individual genius and imagination," while "the lady amateur practiced art for amusement and to display her taste and skill, to strengthen the domestic bonds of love and duty, to serve the community, and to improve her taste and that of the nation."[59] The lowly standing of photography as an aesthetic form largely relegated professional photographers to the feminine side of this equation. They were expected to display sensibility and skill, to serve the community, and to elevate taste. Cameron took advantage of this discrepancy between art and photography to play each off the other to circumvent obstacles that confronted her as a woman. By using the glitch as a sign of superior discrimination, she indicted the stifling criteria of the male-dominated professional photography establishment and suggested that a woman's amateur efforts might have a stronger claim to art. She also skirted this establishment by befriending and

exchanging pictures with painters such as George Frederick Watts, a practice that brought photographic amateurism alongside painterly professionalism. At the same time, by representing her photography as more akin to the innovative tinkering of a gentleman amateur scientist than the edifying amusement of a lady amateur artist, she evaded the gendered constraints that Watt's art world enforced.

Playing photography and fine art off each other left Cameron vulnerable to the charge that her photographs merely mimicked art of other media. In particular, by positioning her photographs as lively and unfinished gestures toward an inspired idea, Cameron implicitly likened them to sketches. But was the imperfect finish of her photographs really akin to the imperfect finish left by hurried brush or crayon? In 1866, one writer thought the implied analogy misleading:

> We have frequently expressed our conviction that, in many respects, the labours of this lady were in the wrong direction; that the production of a rough, hasty, suggestive sketch, with details imperfectly made out, was at times admissible and admirable in painting, because it embodied a fine thought which might have been lost in more coldly laboured and more highly finished work; but that, as in photography less time or effort was required for producing the most marvelous details than for their studious omission in the picture, the reasons which justify the painter's rough sketch have no bearing on the productions of the camera.[60]

According to this writer, who had the perspicacity to see that Cameron's use of focus was purposeful, the relationship of sketchiness to labor in photography inverted the relationship in painting. Whereas in painting sketchiness stemmed from a meaningful and necessary spontaneity, in photography it stemmed from an artificial and superfluous care.

For Cameron, however, this inversion made complete sense. Whereas modern painting needed to escape the deadening labor of the academic salon entry, photography had to overcome the automatic clarity of the studio portrait. Sketchiness was the meeting ground between them, a place where painting could be quickened and photography slowed, and by either route a modern form of artistic labor could find its value. Sketchiness invited accident into the process of marking to betray welcome signs of human vitality and striving. As the critic Ernest Chesneau said in the 1880s: "Any

object which has passed from first to last through only one pair of hands, is far more beautiful than machine-wrought products of the same class, notwithstanding minor imperfections of the hand-work; nay, these very imperfections contribute to give it individuality—as it were, a soul. The product of the machine is lifeless and cold; the work of man is living, like man himself."[61] By crafting a practice accommodating various glitches, including the surface blemish of glass negative or paper positive, the haphazard allocation of focus, and the irregular cutting of the print, Cameron brought the vitality of the sketch to photography.

Perhaps more broadly than any other practitioner, Cameron took advantage of the complex operations of chance in photography. In photographs, accidents appear in two related but divergent forms: the glitch and the inadvertently recorded detail. Cameron in her practice embraced both. She not only resisted an endless stream of suggestions to touch up her photographs to improve their technical standing but also prized certain of their unforeseen details. Jutting out from the margin of a portrait she made of the writer William Michael Rossetti is the partial form of a hand holding an umbrella over the subject. The intruding digits beg to be masked out, but as Cameron explained in a letter to Rossetti: "I never print out the hand holding the umbrella because I always remember proudly it is [the poet Robert] Browning's hand!!"[62] Cameron deems this incidental trace of the great poet's presence too precious to excise, even though it interferes with the arrangement of the portrait.

From Talbot and his clock dial onward, the role of the accidental detail in photographic experience has drawn the attention of great writers. They have noted memorably how such arbitrary details seem to address us directly, reaching out from the past to remind us of time's irreversible passage. Writing in 1859, Oliver Wendell Holmes recalls spotting a gravestone inscription included willy-nilly in a view of Alloway Kirk, an experience leading him to muse about "these incidental glimpses of life and death running away with us from the main object the picture was meant to delineate."[63] Decades later, Walter Benjamin, after discussing an old photograph bearing the gaze of a sitter who, he believes, would soon afterward commit suicide, writes of "the tiny spark of accident" that, "all the artistic preparations of the photographer and all the design in the positioning of his model to the contrary," the viewer "feels an irresistible compulsion to seek."[64] Decades later still, Roland Barthes, in his ruminations on the death of his mother, discusses "the *punctum*," a photographic detail that "lashes" the

ostensible import or *"studium"* of the picture and "attracts or distresses me."[65] According to these writers, the inadvertently included detail disrupts the composure of the photograph to remind us death. Talbot's clock, we might say, ticks for any mortal who descries it.

As her discussion of Browning's hand would suggest, Cameron understood the accidental detail differently, more as a sign of life than of death. The two go hand in hand, of course, but her emphasis decidedly sets her apart from this illustrious chorus. She frequently wrote "From the Life" or "From Life" on prints and albums, highlighting the existential relation that obtains between camera and subject. In her practice, she was more concerned with countering the deadliness of photographic process than contemplating the irretrievable past. For her, the image of Browning's hand marks less his absence in the act of viewing the photograph than his presence—shared with her own—in the act of making it.

By welcoming both the inadvertent detail and the glitch into her photographs, Cameron made them complex registers of chance. The unintended transmissions of both kinds niggle and perturb us, drawing attention from the principal subject of the photograph. Yet the two differ in important ways. Unlike the accidental detail, the glitch is external to the scene represented. It is not received by the viewer as though directly from the world depicted. Indeed, the glitch tends to dispel the magical realism of photography that the accidental detail fosters. It reminds us that photography is not an automatic record or perfect analogue, but rather a contingent chemical process beset by stray materiality and human error. By embracing both forms of accident, Cameron enabled her photographs to signify both the intimate materiality of her process and the living presence of her subjects. Her marred photographs complicate the medium's indifferent delivery of the past, making them subtle spaces of contact between people and times. Many of her subjects seem to look out at us through the materiality of their own reproduction (Figure 3.1).

Cameron's dual emphasis on the living presence of her subject and the material process of her photography signified an exchange of performances. Her sitters and theatrical casts performed for her, and she performed for them. They left traces of their living presence before the lens on the light-sensitive surface of the plate, and she left traces of her living presence behind the camera in the fingerprints, streaks, discolored patches, and other blemishes of her prints. This mingling of signs of performative exchange is one of the most striking qualities of her photography. Her letter to Ros-

setti, who had sat for her several months earlier, offers a revealing glimpse into the importance of reciprocity in her practice:

> I have never heard *from* you & only once *of* you since the afternoon when you very devotedly did your best *for* me & I in my turn did my best with you. For I verily believe I have never had more remarkable success with any Photograph but I should like to know if you yourself are of this opinion. For I have never heard even whether you approve of the picture!
>
> I have printed two special copies for you & addressed them Care of Colnaghi [Cameron's London dealer] & they *now await your claiming them*. Do so soon I pray & tell me what you think of all my late Photography. Your careful criticism was never brought to light—but now if you would in any current Paper notice that my Photographs are all for sale at Colnaghi's you would I think help me on.
>
> I am under a promise to stop Photography till I have recovered my outlay[;] that is to say to take no new Pictures & limit myself to printing from the old & depend upon their sale—but this is duty—& my delight therefore can only be in the past till a lucrative present sets me afloat again. Have you no means of introducing any friendly Paragraphs into any Paper that has *good* circulation.
>
> . . .
>
> Your Brother went to my gallery & his enthusiasm as reported to me was one of my great rewards.
>
> I was going to write and ask him to tell *me* in direct person what I was told he said of the photography but thought the writing to me would bore him. I believe you are not bored & I feel I have a little more claim upon you from the ties of old & I hope enduring friendships with kind remembrances from my husband.
>
> Yrs always truly, Julia Margaret Cameron
>
> As you did not go to the gallery, I urge you to see at Colnaghi's my late large picture. Mr. Wynfield too never went! & that surprised me. My Book there held the one great fact that to my feeling about his beautiful Photography I owed *all*. My attempts & indeed consequently all my success.[66]

The letter tracks a dense network of reciprocity. Cameron describes the production of the photographic portrait as an exchange between herself

83

and her sitter: "you did your best for me, and I in turn did my best with you." She offers her opinion of the result and asks for his. Two copies of the photograph are his for the taking at her dealer's—Colnaghi's—but would he please note in the press that her photographs are for sale there and perhaps write something complimentary about them. She expresses surprise that Wynfield failed to come to her show because (how else are we to interpret the juxtaposition of sentences?) her book at the show gave his work credit for inspiring her. Line after line, Cameron pushes all of her desires and concerns through a matrix of give and take, and the core of this matrix is the exchange of performances that constitutes her photography.

Like so much of Cameron's practice, this emphasis on social reciprocity bore an ambivalent relationship to modernity. On the one hand, it resisted the many signs, articulated bitterly by her acquaintance Thomas Carlyle, that "Cash Payment" had "become the sole nexus" of social relations.[67] On the other hand, it effectively monetized those relations by subsuming them within her photographic speculation. For Cameron, reciprocity was a class-appropriate mode of exchange, but her unexpected financial restraints pressured her to direct that exchange toward the bottom line.

Cameron's photography was highly unusual in foregrounding the performative exchange behind the image. All portrait photography, as Peggy Phelan has noted, "is fundamentally performative."[68] But the dialogue of performances that produces the typical portrait photograph has regularly been suppressed. Throughout the analog era, writers on photography often decried the artificiality of the photographic subject who preens, beams, or emotes for the mechanical eye, and many photographers sought ways around such self-conscious display (famously, Stieglitz photographed a trolley worker from behind, Paul Strand a blind woman, and Walker Evans subway riders unawares).[69] Writers on portrait photography have routinely avoided the subject's performance as well, attributing the look of the sitter to his or her inherent qualities or to the photographer's artistic sensibility and aims. But as Steve Edwards has observed, the bourgeois photographic portrait was a joint production, with both the photographer and the sitter acting as co-authors.[70] Working together, they crafted a fantasy of identity for the sitter that also reflected the taste and technical capacity of the photographer. It is crucial to note, however, that the photograph in general circulation tended to suppress this dialogic process. In other words, photographer and sitter worked together to generate a picture that seemed a natural expression of the sitter's selfhood, as if image and person were one and the

84

same. Cameron, to the contrary, left conspicuous evidence in her pictures of her role in the exchange that had made them.

For Cameron, the exchange of performances that went into the making of a photograph was part of a larger fabric of social bonds. Over the decade or so that she practiced, she showed no interest in producing photographs without a human figure—she made no landscapes, no still lifes, and no architectural views. Not only did she insist on photographing people, but her relationships with them exceeded those established in most commercial portraiture. Cameron's subjects were mainly members of her household, her friends, or members of her friends' families. Even when she drew into her practice people randomly encountered near her home, she enveloped them in acts of lending and giving. She promised her sitters a form of immortality and asked for indulgence in return. Her subjects sat or performed not so much for her camera as for her.

These photographic exchanges were "live" performances, and Cameron demanded that her photographs show as much. She treated life as a stubborn force and insisted that photography fail to quell it. In doing so, she worked both with and against the association of photography with death. In a much cited passage from his book *Camera Lucida,* Barthes writes:

> We know the original relation of the theater and the cult of the Dead: the first actors separated themselves from the community by playing the role of the Dead: to make oneself up was to designate oneself as a body simultaneously living and dead: the whitened bust of the totemic theater, the man with the painted face in the Chinese theater, the rice-paste makeup of the Indian Katha-Kali, the Japanese No mask . . . Now it is this same relation which I find in the Photograph; however "lifelike" we strive to make it (and this frenzy to be lifelike can only be our mythic denial of an apprehension of death), Photography is a kind of primitive theater, a kind of Tableau Vivant, a figuration of the motionless and made-up face beneath which we see the dead.[71]

Although Barthes is unquestionably right about the way death lies behind the photograph, Cameron's practice complicates the equation. As many writers have noted, much of her work recalls the tableau vivant (living picture) or the pose plastique (living sculpture), Victorian parlor pastimes in which one or more people would pose as figures from a work of art. For

this reason, one might expect that the analogy Barthes draws would be particularly apt in her case. But reading the passage from Barthes in light of her photography exposes the limits of his metaphors. Much of the amusement of the tableau vivant lay precisely in the incapacity of the living body to remain motionless. The flaring nostrils, the blinking eyes, the trembling hands, and the unsteady legs: these are but a few of the subtle signs of life that the tableau vivant failed to eradicate. For Victorians, the detection of these signs could lead to laughter and pleasurable release at witnessing the refusal of life to be stilled. In this sense, the instantaneous photograph, contra Barthes, is crucially *unlike* the tableau vivant. The absolute stifling of motion in much photography, its "deathlike sharpness," in the words of one critic, was precisely what Cameron resisted.[72] By using long exposure times, Cameron ensured that her subjects, like the participants in a tableau vivant, would be unable to subdue all of their bodily vitality, and the slight blurring of their faces or hands in her pictures attests to their living presence while the plate was exposed.[73] As Roger Fry has said of her photographs, "The slight movements of the sitter gave a certain breadth and envelopment to the form and prevented those too instantaneous expressions which in modern photography so often have an air of caricature."[74] While Cameron's portraits may indeed remind us of death, it would be obtuse not to recognize how much they traffic, as did the tableau vivant, in the irrepressibility of life.

For Cameron, the exchange of lively energies in her studio overcame the deadly mechanical process that photography could otherwise be. By insisting on long exposure times and refusing studio contrivances that helped sitters hold still, she invited signs of bodily life, including trembling hands and welling eyes, to infiltrate her apparatus. In her photographs, these signs mingle with traces of her own untamable bodily energy, which she never allowed conventional expectations of technique and scruple to suppress. In this way, she answered Eastlake, who had set painting's "living application of that language which lies dead in [the artist's] paint-box" against photography's "obedience of the machine." Cameron was explicit about her ambition to invest her photography with passion. "From the first moment," she writes, "I handled my lens with a tender ardour, and it has become to me as a living thing, with voice and memory and creative vigour."[75] She brought out the minor imperfections of her apparatus to affirm her own restless vitality. The spontaneity of liquid messiness served as an antidote to the numbing descent of photography and modern life into mechanical

precision. Whereas the often blurred traces of her sitters attested to their performances for Cameron, the photographic surface, often blemished by Cameron's irrepressible desires, attested to her performance for them.

Through her glitches, Cameron negotiated what we might call the Medusa-Pygmalion conundrum of early photographic portraiture. According to the usual practice, sitters were held in place before the camera's gaze as if turned to stone, but the ambitious operator sought a way to bring them to life again in the image. Cameron used constricted, oblique sources of light and dark cloths to represent her subjects in a sculpting chiaroscuro.[76] This necessitated long exposure times, which allowed the inherent bodily vigor of her sitters to enliven their plastic forms in the photograph. This Medusa-Pygmalion process had its greatest success in Cameron's life-size portraits, in which the sculptural form of the subject's head shares the dimensions of its living model (Figure 3.3). She wrote that these life-size portraits, which she began producing in 1866 after obtaining a new and larger camera, are "not only *from* the life but *to* the life and startle the eye with wonder & delight."[77] Several of Cameron's sitters remarked on her ability to animate the photographic portrait. Herschel, who was ordinarily reserved in his praise, said an allegorical portrait of one of Milton's nymphs was "really a most astonishing piece of high relief—She is absolutely alive and thrusting out her head from the paper into the air. This is your own special style."[78] Carlyle said of his portrait: "It is as if suddenly the picture began to speak."[79] Ever treading the boundary between high art and crass commerce, Cameron pursued a traditional goal of mimesis, while also capitalizing on a popular fascination with simulacra. Her life-size heads combine the lofty tenor of Watt's portrait paintings with the eerie appeal of Madame Tussaud's wax figures in London.[80]

Cameron thus dabbled in the uncanny. Freud, writing decades after she had died, but drawing on literature from earlier in the nineteenth century, associated the uncanny with moments when "the lifeless bears an excessive likeness to the living."[81] Of particular importance to Freud was the 1816 story by E. T. A. Hoffman entitled "The Sandman." In it, a character named Olympia is revealed to her consorts to be a lifeless doll. In describing the effects of this revelation, Hoffman emphasizes the importance of error or irregularity as a sign of human life. He writes: "[After] the story of the automaton had sunk deeply into their souls . . . an absurd mistrust of human figures began to prevail. Several lovers, in order to be fully convinced that they were not paying court to a wooden puppet required that their mistress

should sing and dance a little out of time."[82] The emergence of automata and machines had given rise to anxieties about the distinctiveness of human nature, making the unpredictable flaw a reassuring sign of humanity. Cameron introduced this formula to photography. Even as she brought dead photographic matter to the verge of life, she insisted that those living in the mechanical age avoid the semblance of death. The glitches of her photography signified that she and her sitters remained passionate and imperfect mortals. As one critic wrote of her work, "That Mrs. Cameron's processes are mechanical no one of course would attempt to deny; but her mechanism is very different from the copy-work of which we are speaking. It gives results that are at once beautiful and uncertain, and which appeal to the imagination, for they are alive with a natural spirit of life and chance and grace and power."[83] By vesting her photographs with "a natural spirit of life and chance," Cameron ensured that the performances on both sides of the camera distinguished themselves from the mechanical movements of automata and thus the deadening productions of an industrial age.

The performances exchanged in Cameron's photography, however, were not symmetrical. Signs of this asymmetry appear in the letter to Rossetti, which opens with a cascading prepositional riff: "I have never heard *from* you & only once *of* you since the afternoon when you very devotedly did your best *for* me & I in my turn did my best with you." Cameron sets out the relevant history in a battery of dyadic relations. She underscores the *from*, the *of*, and the *for* to amplify her rhythmic insistence and to emphasize the discrepancy between her prior intimacy with Rossetti and the silence she now suffers. Then comes *with*, left without underscore and subtly signifying the asymmetry in the performative exchange. Rossetti did his best *for* Cameron, and she did her best *with* him. His performance is of the theatrical kind: like a figure in a tableau vivant, he took his assigned position and tried to keep still, offering himself up to the lens. Her performance entailed fashioning an image from what he offered her. The glitches on her photographs remind us that she was making something of her subject, that she performed the transformative act of making a performance into a picture.

With respect to her famous sitters, the exchange of performances was predicated on an exchange of power. Cameron was notoriously willing to compromise decorum in her efforts to convince prominent men to sit for her. As one witness later recalled, the Italian general Giuseppe Garibaldi "thought she was a beggar when she kneeled before him, her stained hands

upraised, begging to be allowed to take his picture."[84] But once a famous sitter was before her camera, Cameron had her way with him. Tennyson reputedly said to Henry Wadsworth Longfellow, as he left the American poet to sit for his portrait, "You will have to do whatever she tells you. I will come back soon and see whatever is left of you."[85] This reversal lay at the heart of her practice. She claimed in "Annals" that a photograph by her of a great man was "almost the embodiment of a prayer," yet it was she who demanded patience that bordered on devotion. One of her sitters claimed that "the torture of standing for nearly ten minutes without a headrest was something indescribable."[86] For Cameron, such torture was an apt price for the immortality she could bestow. In his diary, William Allingham quotes her as complaining, "Carlyle refuses to give me a sitting, he says it's a kind of *Inferno*! The *greatest* men of the age . . . Sir John Herschel, Henry Taylor, Watts, say I have *immortalised* them—and these other men object!! What is one to do—Hm?"[87] In the end, however, the relationship between Cameron and her sitters was reciprocal. Cameron understood that the immortality she granted her famous sitters was simultaneously granted to her. In a letter to Sir Edward Ryan, she recounted her response to Tennyson's request that she illustrate his poetic retelling of the Arthurian legends, *Idylls of the King*: "Now *you* know, Alfred, that *I* know that it is immortality to me to be bound up with you; that altho' I bully you I have a corner of worship for you in my heart."[88]

The coercion of her less exalted subjects came without worship. One child sitter later recalled being "perfectly helpless" in Cameron's "clutches," and the judicious biographer Victoria Olsen has described Cameron as a "romantic authoritarian" and her sittings with social inferiors as "performances of domination and submission."[89] Cameron filled her tableaux with household staff and reportedly lurked outside her house hoping to catch unwary picturesque children to dress up and pose. One such child later referred to Cameron as "a kind, exacting, though benevolent, tyrant" and to her sitters as "victims."[90] The scholar Jeannene Przyblyski, noting the parallel between Queen Victoria and Cameron, suggests that Cameron adopted the role of "Queen-as-mother," who "enforces compliance, imposing the rule of duty over pleasure."[91]

This domineering relationship raises the possibility that the act of enlivening a human image might smother the subject from which it was taken. The figure that comes to life through the Medusa-Pygmalion process might not be the same as the one that was turned to stone. The critic Sarah Boxer

notes that some of Cameron's sitters "seem to have been psychically snuffed out by their roles."[92] The possibility that art "snuffs out" the vitality of its subjects, even as it gives them aesthetic life, was a central concern of Victorian artists and intellectuals. In the monologue "Porphyria's Lover," first published in 1836, Robert Browning—he of the hand holding the umbrella—weighed the costs of life-giving creativity.[93] When the muse-like Porphyria, who has "glided" into the poet's cottage on a stormy night to kneel and make "the cheerless grate / Blaze up," addresses the poet, he makes no reply. But then

> She put my arm about her waist,
> And made her smooth white shoulder bare,
> And all her yellow hair displaced,
> And, stooping, made my cheek lie there,
> And spread, o'er all, her yellow hair
> . . .
> Be sure I looked up at her eyes
> Happy and proud; at last I knew
> Porphyria worshipped me; surprise
> Made my heart swell, and still it grew
> While I debated what to do.
> That moment she was mine, mine, fair,
> Perfectly pure and good: I found
> A thing to do, and all her hair
> In one long yellow string I wound
> Three times her little throat around
> And strangled her. No pain felt she;
> I am quite sure she felt no pain.
> As a shut bud that holds a bee,
> I warily oped her lids: again
> Laughed the blue eyes without a stain.
> And I untightened next the tress
> About her neck; her cheek once more
> Blushed bright beneath my burning kiss:
> I propped her head up as before,
> Only, this time my shoulder bore
> Her head, which droops upon it still:
> The smiling rosy little head,

So glad it has its utmost will,
That all it scorned at once is fled.
And I, its love, am gained instead!

The exchange of life force from the muse to the poet, which takes us from her stooping to support his cheek on her shoulder to his shoulder bearing her drooping head, addresses the limits of narcissistic love and romantic ideals. The object of such a love must be extinguished, so that the ideal image may be propped up and given but a mere token of life from the artist (the cheek that blushes beneath his kiss).[94] In the last lines of the poem, Browning associates this troubling romantic circuit with a remoteness from God:

And thus we sit together now,
And all night long we have not stirred,
And yet God has not said a word!

Like the dead Porphyria and her blushing cheek, many of Cameron's sitters, particularly the women and children, bear immediately recognizable signs of life—the watery eye, the blur—but a greater vitality seems extinguished or withheld. Cameron's bestowal of immortality to herself and her sitters leave traces of its price. In the midst of lush fabrics, hair, feathers, and other more pliant materiality, weary faces are set, as though the material trappings burden the sitters with their code of the beautiful. Hair in particular offers itself up for our delight regardless of the sitter's mood or will, even when it grants its bearers no visible pleasure. Like that of Porphyria, the lifelessness of many of Cameron's sitters seems directly related to their lush tresses, linking them to other Victorian victims of the asphyxiating perils of desire. In 1870, Dante Gabriel Rossetti, in a poem about the deadly allure of Lilith, remarks of her victim: "his straight neck bent / And round his heart one strangling golden hair."[95]

Trapped in difficult circumstances, Cameron depicted sitters trapped in their own. Even as her photographs adorn sitters with signs of life, those signs betray the oppressive inequality of the exchange her photography required.[96] "No wonder," reflects a child sitter years later, "those old photographs of us, leaning over imaginary ramparts of heaven, look anxious and wistful. This is how we felt, for we never knew what Aunt Julia was going to do next."[97] Recent critics have persuasively observed that Cameron's

sitters exhibit signs of boredom or recalcitrance, and Boxer has noted that this resistance appears "modern."[98] The restless antagonism of subject and material circumstance, and the burden of the subject to live up to ideals imposed from without, are central elements of Cameron's work.

The importance of performative exchange for Cameron finds corroboration in negative evidence of two kinds. The first is an instance of rejected advice. In 1866, Cameron wrote Herschel a long letter in which she asked for his guidance regarding her photography, asserting, "I look to your tellings as teachings only second to inspirations[. T]o me they would have far more value than any thing that could originate in myself."[99] In response, Herschel suggested that Cameron make photographs that represented her sitters as though they were sculpture: "Have you ever tried the effect of draping all the figures of a group in pure white—whitening their *faces* & *hands* & *hair* and then photographing your group as a sculpture—the background also and all of the appendages being white or grey."[100] Here was Barthes's theater, the players all in deathly white. Cameron's reply characteristically mixed flattery with nerve: "No praise that I have had for my Photography has been so precious to me or so dear as your praise. It fed all my ambition! & seemed to nourish the very core of my heart. More than this it had stimulated to new efforts & I have been just engaged in doing that which Mr. Watts has always been urging me to do. A series of Life sised heads."[101] Having emphasized her reverence for Herschel's opinions, she responds to his only suggestion by ignoring it and instead reporting that she is following Watts's advice. This interpersonal strategy is interesting, but the difference between the advice taken and the advice ignored is the real point: Cameron had little interest in rendering her subjects as sculpture, because sculpture is lifeless.[102] Medusa had to give way to Pygmalion.

More subtle evidence dates to 1872, when Cameron made four photographs of the deceased body of Adeline Grace Clogstoun, her grandniece and adopted daughter, who died at age ten when she broke her back roughhousing with relatives (Figure 3.4). The pictures of Clogstoun may be the only photographs by Cameron that do not include a living subject.[103] In making them, Cameron could not elicit a performance by her sitter, and her response to this constraint is telling. In the background of one photograph is an open window, in another a framed picture, in a third a camera. Having no living subject before the lens, Cameron constructed an array of self-referential circuits, whereby the camera was addressed by itself, or its product, or its light. The ostensible subject of her "living" lens, the recip-

Figure 3.4 Julia Margaret Cameron, *Deathbed Study of Adeline Grace Clogstoun,* 1872, albumen print from glass negative. Image courtesy of the National Gallery of Art, Washington

rocal agent of her photographic exchange, had been rendered inert. As a result, the camera looked past the dead body to a sign of its own vital functions. Before the lifeless, her photography could only perform for itself.[104]

By insisting on an exchange of performances in which life figures as an unruly force, Cameron made success from failure. By defining her art as a reach toward the ungraspable, she made imperfection a sign of achievement, and chance a sign of ambition. These paradoxes are at work throughout her photography, but they particularly redeem her literary tableaux, which have often been criticized for their stilted theatricality (Figure 3.5). To mark each photograph as an exchange of performances, Cameron had to ensure that her scenes betrayed their fictiveness. Figures fully absorbed into their roles would suggest an alternate world rather than a performance aiming toward an unattainable ideal. She needed the illusion to fall short. Her clumsy props, vulgar costumes, wooden solemnity, and other signs of

amateur theatricality suffuse her work with the felt insufficiency and aspiration of her time. They enable her tableaux to retain the suggestiveness and romantic value of the sketch. In her literary or allegorical scenes, the human subject is never itself and never its role, but always caught between them.[105] As Janet Malcolm has said of Cameron's work, "We are always aware of the photograph's doubleness—of each figure's imaginary *and* real persona."[106] Only by registering the subject's incomplete transition from actor to role does the photograph signify the transformative impulse Cameron prized. The glitch is a sign of both the resistant materiality of existence and the yearning to overcome it. By exploiting this semiotic doubleness, Cameron made herself into the greatest Victorian photographer. She understood more keenly than any other that to represent Victorian culture was not to represent its people or its ideals but rather the insurmountable and generative gap between them.[107]

Much of the power of Cameron's formula was lost on a generation of scholars steeped in modernism. They tended to laud her portraits but denigrate her theatrical tableaux as farce. Photography historian Helmut Gernsheim declared that her theatrical pictures were "unintentionally comic."[108] But the flaws that bothered Gernsheim and others have a value to which postmodernism is sensitive. When Cameron's figures look sad, as they often do, they look sad as performers as much as they look sad as the characters from literature or myth that she has asked them to play. Although their performative failure may reflect a resistance to Cameron and her coercive casting, it suggests pictorially—and paradoxically—that much of their melancholy is about the incapacity to be properly melancholic, that much of their wistfulness is about lost possibilities of actually being what is to be performed. In all likelihood, this is why Cameron showed no indication that these signs of resistance displeased her. The imperfections of her photography, whether originating in theatrical shortfall or photographic quirk, characterize the gap between ambition and result as inherent in her historical condition. The signs of performative failure in her photography no more upend its sadness than the puns in a tragedy by Shakespeare dispel its pathos (and Cameron doubtless would have liked the comparison).

In the gap between the performances before her camera and the ideals toward which they ostensibly aimed, Cameron inscribed signs of her labor. This is most conspicuous where she manually marked a picture. A scratched halo in *Madonna and Two Children*, a scratched moon in *"So like a shatter'd Column lay the King,"* and prose scrawled onto a letter in a photograph of

May Prinsep are examples of such pictorial addenda (Plate 2). Although many writers have discussed these marks in terms of tactility and touch, their ungainliness is critical to their function. Through these scratches and scrawls, Cameron announces herself as an amateur, asserts that the illusion is always already defeated, and marks that defeat with her laboring hand. To ignore the absurdity of these marks is to miss the point, but to dismiss the pictures for this absurdity is equally daft. The marks signify both the incapacity of the photograph to deliver the ideal on its own and the impossibility of any adequate supplementation. They imagine a truth beyond representation that consigns even the most inspired efforts to the status of crude gestures.

By defeating the very illusions she otherwise proffers so earnestly, Cameron negotiated the dilemma of belief in the Victorian era. Not to believe in the transcendent was for many intolerable, but any claim to believe smacked of delusion or dishonesty. During Cameron's early years of photography, this dilemma came to a head in controversies attending John Henry Newman's conversion to Catholicism and his leadership of the Oxford Movement. Chastising a Protestant "population that only half believes," Newman had vigorously defended belief against doctrinal laxity and secular drift.[109] In 1864, the novelist Charles Kingsley attacked Newman in the press, accusing him of condoning deceit. Kingsley claimed to have forecast that Newman would "end in one or other of two misfortunes. He would either destroy his own sense of honesty—i.e., conscious truthfulness—and become a dishonest person; or he would destroy his common sense—i.e., unconscious truthfulness, and become the slave and puppet seemingly of his own logic, really of his own fancy, ready to believe anything, however preposterous, into which he could, for the moment, argue himself."[110] Kingsley's accusation, however rash, ably articulated the predicament of religious belief in the Victorian era. At best, belief balanced on a knife's edge between deceit and delusion. It remained essential but had become insupportable.

With respect to Victorian debates about belief, Cameron's glitches operate as sacred wounds. In an effort to show Protestants the power of belief, Newman in a published lecture asks his reader to imagine an encounter with a woman who believes she has received the stigmata. In his account, the "mind of a weak sister" has led her through "the very keenness of her faith and wild desire" to "fancy or to feign" that she has suffered Christ's injuries. She "points to God's wounds, as imprinted on her hands, and feet,

and side, though she herself has been instrumental in their formation."[111] In this way, Newman accommodates skepticism about miraculous claims while affirming the passionate strength of conviction. To succumb to delusion or dishonesty, to "fancy or to feign," was the cruel cost of faith. With modern skepticism having routed God, the Victorian subject had to be self-reliant. The "weak sister" had inflicted her own wounds, which she was either pretending or imagining had come from the divine. As a photographer pursuing subjects redolent of traditional ideals, Cameron used a toleration of accident to contend with skepticism and split the difference between deceit and delusion. The ambiguity of her glitches—were they perverse marking or material spontaneity?—left critics struggling to ascertain whether Cameron knew better or was simply incompetent. Her picture's conspicuous flaws punctured photographic illusion and marked her ideals as beyond reach, while ostensibly leaving the earnestness of the effort intact. Cameron left herself open to charges of inadequate skill, but such was the price of avoiding the taint of deceit.[112] Navigating a judgmental patriarchy and an era of unwelcome disillusionment, Cameron made her glitches signs of the material limits that nail all transcendental efforts to the world.

Cameron's emphasis on performative exchange and her accommodation of the glitch shared much of its logic with her colonial past. Before she arrived on the Isle of Wight, she had served as the unofficial hostess of the English colonial government in India. When the wife of the governor-general of India, Lord Hardinge (the namesake of Cameron's fourth child), was abroad, Cameron often organized social functions in her stead. She thus became accustomed to performing Englishness at a great distance from England and to producing a domestic space that was a model for national and imperial ideals. Such colonial performance of imperial culture inevitably produced an imperfect copy of an absent model. Indeed, we can understand her exaltation of the amateur and marred performance, the imperfect copy, as a defense of the colonial culture in which she spent most of her life. The performance of Englishness was ostensibly about continuity and tradition, but the articulation and mobilization of that continuity was always flawed. Even as tradition was reproduced, it had to be strategically adapted to changing colonial circumstances. As the postcolonial theorist Homi Bhabha has argued, the enunciation of cultural difference "is the problem of how, in signifying the present, something comes to be repeated, relocated and translated in the name of tradition, in the guise of a pastness

that is not necessarily a faithful sign of historical memory but a strategy of representing authority in terms of the artifice of the archaic."[113] For Cameron, who came from a colonial family and spent precious little time in England during the early decades of her life, Englishness was primarily summoned from a geographic remove. It was thus doubly a fiction—an improvised derivative of an imagined tradition that had to be performed in India to differentiate and distinguish it from the local culture. After her move to England, Cameron sought to depict the nobility of Englishness in her photography. But the deep structure of differentiation in which she, as a colonial subject, had long performed a copy of culture, to replicate it abroad, continued to infuse her work. In her photographs, especially her illustrations for Tennyson's version of the Arthurian legends, clumsy props and stray glitches declare the artifice of the archaic as such, as though the process of colonization, the cobbling together of an imperfect copy of an imagined tradition from the motley resources at hand, was the face of culture itself.

Although the reflexivity of Cameron's photography—its meditation on what photography is—has often been interpreted in a modernist vein, it also has a colonialist cast.[114] The modernist interpretation has often featured her picture of Vivien and Merlin and its implicit staging of the photographic act. Made to illustrate *Idylls of the King,* the photograph depicts Vivien directing the enchanted magician, as though commanding him to be still, replicating the authoritative relation of Cameron to her sitters (Figure 3.5). Yet writers highlighting this *mise en abyme* generally neglect to note that Cameron offered an explicitly colonialist version six years before, in a photograph known as *Spear or Spare* (Figure 3.6). At the end of the Abyssinian War (1867–1868), Queen Victoria brought to the Isle of Wight the orphaned Prince Alamayou, accompanied by an attendant, and Captain Tristram Speedy, an English adventurer who had gained fame for his role in the conflict. The English press lavished Alamayou and Speedy with sentimental attention, and Cameron, seeking to capitalize on their fame and proximity, secured permission to photograph them in portraits and dramatic tableaux.[115] The tableaux occupy an odd place in her photographic production by virtue of their mixing of contemporary events and theatrical fiction. In *Spear or Spare,* Speedy points a spear at the attendant, holding him in place. In this version of the *mise en abyme,* the command to remain still is more overtly violent than in the photograph of Vivien and Merlin. Cameron promised that if her sitters cooperated, she would

Figure 3.5 Julia Margaret Cameron, *Vivien and Merlin* (from *Idylls of the King*), 1874, albumen print from glass negative. Courtesy of Houghton Library, Harvard University

immortalize them, so for them, as for the figure played by the attendant, the alternative to staying still was a kind of death. *Spear or Spare* imagines stillness as a virtuous quelling of colonial disobedience. Like Vivien, Cameron was a woman, but like Captain Speedy, she was a colonial agent. *Spear or Spare* construes the photographic act, in its pointed demand for stillness, as reproductive of imperial discipline.

Figure 3.6　Julia Margaret Cameron, *Spear or Spare,* 1868, albumen print from glass negative. © Victoria and Albert Museum, London, Gift of Miss Perrin, 1939

The submerged colonial structure of Cameron's practice crops up in her letters. To Herschel she writes: "All these difficulties I have still to master & the Cyanide of Potassium is the most nervous part of the whole process to me. Is it such a deadly poison? Need I be so very much afraid of the Cyanide in case of a scratch on my hand? And when my hands are as black as

an Ethiopean Queen can I find no other means of recovery & restoring them but this dangerous Cyanide of Potassium?"[116] Ethiopia was the modern name for Abyssinia, and so Cameron's black hands belonged to the same imaginary as Captain Speedy. The blackness of Cameron's hands was the messy chemical by-product of her production of Englishness. Behind the camera, hovering above the photographic papers in the darkroom—that is to say, on the other side of the scene of English culture—she took on a sign of that otherness, and required a potentially deadly poison to return her skin to its previous hue. Once again, her position as a colonial subject was triangulated between the Englishness of England and the otherness it made of India. Her friend Henry Taylor remarked that she kept "showering upon us her 'barbaric pearls and gold.' "[117] Cameron and her sisters' "dark complexions and flashing eyes" were, according to one writer, "inherited from their mother's Indian great-grandmother."[118] In Cameron's day, there was gossip that her maiden surname—Pattle—was an anglicized version of Patel.[119] A hybrid subject, Cameron structured her photography in the contradictory terms of colonial fantasy.

Cameron's glitches suspend her photographs in the gaps of culture. These gaps—between the original and the copies that produce it, the signal and the receipt that made it such, and the image and the materiality it can never shed—leaves traces in her pictures. Her photographs are mash-ups of different moments and semiotic categories. Collodion glitches stem from the moment the plate was prepared, the blur of the figure from the moment of exposure, and other defects from the moment the photograph was printed. Some glitches in the final print are surface blemishes, while others are reproduced images of flaws on the negative. Some derive from the performance of the sitter, while others derive from that of the operator. This is not to say that the photograph becomes a final space where all splits are sutured and all traces unite. On the contrary, Cameron's photographs are self-contesting registries in which glitches, chemical and optical, manual and mechanical, continually reproduce the divisions constituting the circuit of meaning production in Victorian culture generally and photography specifically. In the gap between the intimate sociality of her productions and the cultural archetypes they invoke, there is an ambiguous violence to her tender touch. She may have positioned herself as a mother Venus to the Eros of her photography, but she more consistently positioned herself as a mother Victoria to the reproduction of what she imagined as her culture.[120] The spear becomes the finger, the finger becomes

the spear. In the end, what is perhaps most remarkable about Cameron's photography is not its conflicting maternalisms but rather its acknowledgment of, even desire for, signs of their failure. In reaching for a photographic art, Cameron ensured that the social gaps subtending the photographic circuit, and the aesthetic gaps between aspiration and material restraint, would deposit themselves as accidents on photographic paper.

4

The Fog of Beauty, c. 1890

In photography, as in many emergent technological fields, radical uncertainty and experimentation gave way within a generation or so to institutional governance, practical norms, and more or less settled criteria. By the 1880s and 1890s, young aesthetically minded practitioners in England and America had come to regard Rejlander and Cameron as scattershot experimentalists of an earlier era. To counter the mechanical aspects of the medium, this new generation developed a code of tactics that historians today call pictorialism. Many of the photographers who fashioned or sustained this code took pains to distinguish the rare photograph that qualified as a *picture*—and the word was often italicized—from the common photograph that did not. The bugbear of these practitioners was thoughtless precision and finish. A *picture* required a romantic incompleteness that gestured with discrimination toward ineffable truths. Against the popular taste for stark exactitude, swelling numbers of artistically aspiring photographers used mists, focal blur, and surface manipulations to veil contours, soften atmospheres, and otherwise temper visibility. They often opted for the soft matte tones of platinum prints over the harder gloss of albumen. The capacity to appreciate the suggestiveness of such tactics became a mark of aesthetic refinement.

The hostility of pictorialists to the norms of industry and mass commerce extended to their choice of subjects. Quaint landscapes and scenes of rustic life became their stock-in-trade. The *picture* was ostensibly a defense against the ruthless encroachment of crass new markets on visual experience. It was a sanctuary of refinement, bounded by a frame that purported to keep

alienation and poor taste at bay. Scenes of mending, harvesting, washing, and other traditional rural activities, along with dewy landscapes and misty riverbanks, were subjects for *pictures* because they represented the sentimental vestiges of a disappearing past. The soft platinum print stood opposed to the precise studio portrait, while the purported purity of river maidens countered the alleged licentiousness of urban women. An amalgam of misty atmosphere and rustic serenity became a nostalgic bulwark against the social and cultural turbulence of an industrial era.

This rustic turn was by no means limited to photography. As the historian Martin Wiener has written, in the late Victorian era, "The countryside of the mind was everything industrial society was not—ancient, slow-moving, stable, cozy, and 'spiritual.' The English genius, it declared, was (despite appearances) not economic or technical, but social and spiritual; it did not lie in inventing, producing, or selling, but in preserving, harmonizing, and moralizing."[1] The pictorialists, by dint of using a modern invention to idealize a bucolic past, exemplified the contradictory desires of the era.

From the vantage of the present, the doom of this rustic retrenchment is obvious. The code of poetic vagueness that the clubby practitioners of pictorialism developed became every bit as predictable and stale as the popular taste they opposed. The parrot cry of "sharp, sharp" among the multitude was answered by a parrot cry of "soft, soft" among a self-styled elite. The insistent use of softness to idealize a rural past made pictorialism part of a broader nostalgia industry that was part and parcel of modernity. The politics of this industry and its fantasies of refusal were largely conservative. In the name of resisting crassness and inauthenticity, the purveyors of pictorialism invented and idealized a disappearing past that opposed not only certain forms of commerce but also substantive modern freedoms, particularly for women.

But to dismiss pictorialism as nothing but reactionary or complicit nonsense would be a mistake. The movement generated reams of tiresome tenderness but also moments of illuminating struggle and progressive commitment. To say that retreat into misty sentiment was futile is not to say that industry and commerce did not have their horrors, or that pictorialism and its antimodern sentiments had nothing worthwhile to say about them. The new concept of the *picture* was a means of shoehorning photography into the spaces of traditional media such as painting and engraving, and this effort raised important issues concerning the representation of modern

life and the social function of art. Efforts by pictorialists to position their photography against the evils of industrialization and alongside the imagined harmonies of traditional rural life were, on their face, absurd. In its optics and chemistry, photography was a thoroughly modern technology. But the strained ambition of pictorialism nonetheless yielded work of captivating insight into the muddled contradictions of modernity.

Vapor was crucial to the pictorialist cause. It eased the hard contours and sharp details associated with industrial reproduction and opened photography to an unpredictable array of atmospheric effects. Mist and fog were heralded as nature's way of making the world poetic, of transmuting a mundane setting into something ineffable and refined. They were also vital metaphors in the darkroom for the softening effects of platinum papers and other technical means of producing indistinctness. As the nineteenth century came to an end, the aesthetic play of chance in pictorialism routinely involved vapor as either meteorology or metaphor.

In putting their hopes in vapor, the pictorialists linked their efforts to a long history. Ever since antiquity, the aesthetic possibilities and difficulties of vapor had figured prominently in the Western tradition. For leading pictorialists, such as Peter Henry Emerson (1856–1936), exploring these possibilities and difficulties through photography was a way to graft the new medium onto the history of art. To understand this grafting, our story momentarily turns from photography to discuss this broader history of vapor in pictures.

The role of chance in the making of art has a charming mythology. Pliny the Elder (23–79 c.e.), in his account of the origins of painting, tells a story about a picture by Protogenes:

The dog in this picture is the outcome as it were of miracle, since chance, and not art alone, went to the painting of it. The artist felt that he had not perfectly rendered the foam of the panting animal, although he had satisfied himself—a difficult task—in the rest of the painting. It was the very skill which displeased him and which could not be concealed, but obtruded itself too much, thus making the effect unnatural; it was foam painted with the brush, not frothing from the mouth. Chafing with anxiety, for he aimed at absolute truth in his painting and not at a makeshift, he had wiped it out again and again, and changed his brush without finding any satisfaction. At last, enraged with the art which was too evident, he threw his sponge at

the hateful spot, and the sponge left on the picture the colours it had wiped off, giving the exact effect he had intended, and chance thus became the mirror of nature. Nealkes likewise once succeeded in rendering the foam of a horse in the same way, by throwing his sponge at the picture he was painting of a groom coaxing a race-horse. Thus Protogenes even taught the uses of fortune.[2]

Pliny's amusing anecdote is dense with meaning. The formless foam at the dog's mouth thwarts Protogenes because its appearance is not dictated by purpose or design. As the dog's saliva turns to foamy bubbles, its contours and modulations multiply randomly. Like the wart that falls outside William Paley's divine determinism, the froth at the dog's mouth is a stray accident, a useless extrusion, for which the order of nature cannot account. As a result, the painter's purposeful skill in crafting his illusion is too conspicuous; it mimes no structure in the foam itself. Only by throwing his sponge in anger does Protogenes succeed in representing the spontaneous canine froth. Chance here is a supplement or alternative to skilled labor. It completes what skill cannot. Pliny finishes the passage by noting that this happy use of chance could be cultivated deliberately, thus bringing chance into the repertoire of art instruction.

Protogenes needed to find a technique—a specific combination of mental state, materials, and action—that matched his curious subject matter. His usual approach of deliberation and careful brushwork was entirely at odds with the foam he needed to represent. Only by succumbing to his own animal fury, his own boiling over, could he adequately produce a convincing mimesis. He did so by tossing a sponge, an amorphous lump of stuff plucked from the sea and riddled randomly with pores and channels—that is, a displaced, aerated, and shapeless thing, much like the foam he sought to represent. By throwing the sponge, Protogenes kept his distance from the picture. The sponge flew through the air to leave its mark, maintaining an atmospheric gap through which chance could enter and play its part.

The issues raised by Pliny returned in new ways during the Renaissance, when the structure of linear perspective promised to bring everything visible into the strict and lucid geometry of the grid. Ever cognizant of the heavens, Renaissance artists had to contend with the challenge of representing the cloudy sky, which, being immeasurable, polymorphous, and placeless, was intrinsically hostile to their new geometric approach. The viability of perspective as a paradigm for representation had to be established

in opposition to the disintegration and formlessness associated with transcendental experience. Perspective allowed painters to bring the world under control, but drawing the sacred into their art would always require testing the structural boundaries of the grid against the incomprehensibility of clouds. Clouds and perspective in Western painting thus have an interlocking history. The perspectival grid could neither contain clouds nor preclude them, making them a crucial and vexed limit of representation. They marked the passage from earthly to heavenly, from knowable to unknowable, from geometric clarity to unfathomable turbulence. They famously defeated efforts to represent them, but also enticed painters with a promise of pure potentiality and divine metamorphosis.[3]

Italian Renaissance artists occasionally brought the dialectic between vaporous freedom and earthly embodiment explicitly into paint. A favorite subject in this regard was Jupiter, the greatest of the gods, who used his polymorphism to pursue his erotic infidelities. Titian's *Danae* and Correggio's *Jupiter and Io,* for example, represent Jupiter as a vapor harboring a latent corporeal form that copulates with a mortal woman (Figure 4.1). In such pictures, the cloud appears as the formless source of form, a seminal coalescence and dispersion that figures itself as a necessary precondition of creative embodiment. In the *Danae,* the iconic potential of the cloud is literally cashed out in a moment of alchemical bliss.

But what was good for the gods was often maddening for mortals, in whom the polymorphism of clouds, according to Renaissance writers, could foster mental sickness and excessive fancy. Vasari was not altogether sanguine about Piero di Cosimo's tendency to see animals, plants, or other subjects in random visual stuff. He writes that Piero found "a pleasure or satisfaction" from this habit "that drove him quite out of his mind with delight." He then elaborates: "[Piero] would sometimes stop to gaze at a wall against which sick people had been for a long time discharging their spittle, and from this he would picture to himself battles of horsemen, and the most fantastic cities and wildest landscapes that were ever seen; and he did the same with the clouds in the sky."[4] For Vasari, fascination with the projective capacities of human fancy is a mental disorder, contracted in this passage as if by contagion from the spittle of the ill. As in the story of Protogenes, the boundary of order and disorder is associated with salivary expulsions. In passing from inside the body to outside, saliva succumbs to a random dispersal, the contemplation of which can foster a mad desire.

Figure 4.1 Titian, *Danae,* c. 1560, oil on canvas. Kunsthistorisches Museum
Vienna

Craving to see things in the sky was hazardous because not every like-
ness in a cloud was a god in hiding. Vapor could be nothing more than an
empty sign, an accidental enticement to the imagination. The search for
chance resemblances to stimulate creativity was a practice Leonardo en-
dorsed, but with evident discomfort (he admitted that the practice seems
"almost laughable").[5] When it came to pareidolia, the line between inspi-
ration and madness was dangerously fine.

In Renaissance painting, ordinary clouds bearing recognizable forms thus
have an ambiguous quality. Giotto painted a cloud with a devilish profile
in his frescoes in the Basilica of St. Francis (thirteenth century), and An-
dreas de Mantegna painted one containing the vague image of a horseman
in *Martyrdom of St. Sebastian* (c. 1457) and one bearing a face in *Minerva*

Expelling the Vices from the Garden of Virtue (1502). These pictures may be said to push the observer into pareidolia, into seeing with the madness of Piero. Yet the deliberateness of the resemblance remains obvious to the viewer, betraying the lack of accident. As Richard Wollheim has noted, if Mantegna's intention in *Martyrdom* was to represent a cloud that by chance resembled a horseman, he failed miserably.[6] His cumulus looks instead like a cameo surrounded by bubbles. Protogenes presumably would have understood the painter's predicament. He might have advised Mantegna to put down his brush, throw a paint-soaked sponge, and hope for a felicitous mark.

No Renaissance artist was more sensitive to atmosphere as an optical medium than Leonardo. His famous *sfumato* technique reproduced the effect of seeing through vapor (*sfumato* derives from *sfumare*, meaning "to evaporate" or "to go up in smoke").[7] Softening contours and subtly modulating shades, Leonardo's *sfumato* bestowed a rare enlivenment on his painted subjects. His success in this regard has been traced to his study of atmospheric turbulence and particularly the vagaries of wind.[8] In addition to perfecting the *sfumato*, Leonardo devised a system of atmospheric perspective. The more air we look through, the more the moisture within it softens contours, diminishes color intensity, and restricts the color spectrum in favor of bluish hues. Leonardo produced the illusion of distance by painting accordingly.

For Leonardo, the softened contours of *sfumato* corresponded not only to airy turbulence but also to an indistinctness inherent in human vision. Rejecting a standard premise of one-point perspective, he argued that the eye received its input across the breadth of the pupil, diffusing the image, so that "the true outlines of opaque bodies are never seen with sharp precision."[9] Leonardo understood that visual softness came from human physiology as well as meteorological effect.

The history of artistic efforts since the Renaissance to represent atmospheric vapor is too long to recount in full, but it is worth picking up the thread in the Enlightenment, when leading artists sought to tame atmosphere in their pictures, or even siphon it out. In the Renaissance, clouds had represented the ineffable realms of faith, and the Enlightenment strove to dispel superstition and bring the world into clarity and rational order. Joseph Wright of Derby's *An Experiment on a Bird in the Air Pump* (1768) and Jacques Louis-David's *Antoine-Laurent Lavoisier and His Wife* (1788) are indicative of this shift (Figure 4.2). Both pictures represent a man of

Figure 4.2 Joseph Wright of Derby, *An Experiment on a Bird in the Air Pump*, 1768, oil on canvas. © National Gallery, London; Art Resource, NY

science with a glass container into which he has distilled an artificial atmosphere (David includes Madame Lavoisier, who translated English documents for her husband and assisted him in his laboratory). These apparatuses and their distilled contents exemplify the neatness and transparency that Enlightenment thinkers valued in the making of knowledge. In *Air Pump*, Wright pushes the unruly clouds outside the scene, framing them in a grid of windowpanes. His picture is redolent of a scientific culture that puts clouds and their wanton eroticism, their maddening formlessness, under the rational scrutiny of empiricism.

The Enlightenment promised a new degree of freedom from the constraints of nature and the caprice of the gods, and neoclassical painting was marked by its airless clarity of line. At the same time, the very cause of the Enlightenment was tied to revolt and social upheaval. Painting of

the era betrays this shift in instability from heavenly metamorphosis to political turmoil. David in particular made a habit of transferring the natural power of atmosphere to signs of social possibility. Whereas he usually represented clouds as flat and static, he invested the social fabric of billowing curtains (*Oath of the Tennis Court*, 1791), flowing capes (*The First Consul Crossed the Alps at the Col du Grand St. Bernard*, 1801), and cascading dresses (*Portrait of Madame Récamier*, 1800) with arresting turbulence.[10] A power that had once belonged to the unmanageable gods and their heavens had become internal to the dynamism of modern social classes and the state.

The Romantics found the Enlightenment too rigid and bloodless in its rationality, and vapor was vital to their rebellion. They brought clouds, mists, and fogs back with a vengeance. The work of the German artist Caspar David Friedrich is exemplary in this respect. Paintings by Friedrich such as *Fog* of 1807 and *Wanderer above a Sea of Fog* of 1818 feature atmospheric obscuration as a central theme, while others, such as *Winter Landscape with Church* of 1811 and *Easter Morning* of 1828, vigorously exploit its evocative power (Figure 4.3). For Friedrich and other Romantics, vapor was a means of defying the Enlightenment and its neoclassical preference for clarity and precision.[11] Friedrich used mists and fog to isolate and set off the particularity of landscape features, bringing them into the same visual economy as the Romantic fragment.[12] More generally, vapor was a way of putting meaning beyond the reach of narrative and proposition, of making it something suggested rather than shown, felt rather than comprehended. Vapor was associated with the obscure, with dreams, mysteries, and altered states of consciousness. In 1809, a neoclassicist critic wrote a biting account of Friedrich's work, disparaging "that mysticism which currently slinks in everywhere and wafts towards us from art as from scholarship, from philosophy as from religion, like a narcotic vapour."[13] A reviewer of the 1820 Dresden Academy exhibition wrote similarly: "Year after year Friedrich stumbles ever deeper into the thick fog of mysticism. Nothing is foggy or weird enough for him, as he ponders and strives to excite the mind."[14]

The English Romantics were also enthralled with vapor. In essays from the late eighteenth century, the aesthete William Gilpin deems atmospheric turbulence and obscurity mainstays of the picturesque. According to Gilpin, the picturesque emerges from recognizing the gap between what is beautiful in nature and what is beautiful in a picture of it. Smooth and regular things are often beautiful in nature, he argues, but unpleasant when depicted, whereas rough and irregular things, often unpleasant in nature, produce

Figure 4.3 Caspar David Friedrich, *Wanderer above a Sea of Fog,* c. 1818, oil on canvas. bpk, Berlin; Art Resource, NY

pictorial delight. Although the picturesque is associated with an aesthetic movement that cabined the reach of reason, its bifurcation of nature and art rationalized the modern inconsistency of systematizing land and labor in the world while celebrating rustic haphazardness in pictures.[15]

For Gilpin, the irregularity of clouds, and their tendency to break sunlight into irregular patches, makes them essential to the picturesque.[16] His

attitude toward earthbound vapors and atmospheric effects is more equivocal. Although clouds in the sky deliver picturesque beauty by adding variety and contrast, when their fleecy whiteness or precipitation saturates a scene, such as in a blizzard, uniformity ensues, and the hierarchy of attention believed to be essential to the work of art is lost.[17] Light mists, on the other hand, receive his approval. He writes: "Do light mists prevail? / A soft grey hue o'erspreads the gen'ral scene, / and makes that scene, like beauty view'd thro' gauze, / more delicately lovely."[18] Although even light mists would seem to contravene his precepts for the picturesque by softening contrasts of lighting and mitigating the roughness of forms, Gilpin approves the balance they effect between irregularity and grace. A light mist can foster ambiguity and accentuate distance, and in these ways add variety to a picture. The great scientist Hermann von Helmholtz would later assert that the painter "prefers an atmosphere which is not quite clear, because slight obscurity makes the distance appear far off."[19] Gilpin may have the same effect in mind when he notes that a light mist may give mountain views "an added dignity."[20]

In the 1820s, Constable made the study of clouds essential to his Romanticism. He sketched them to enhance his ability to represent their irregular forms and the shadows cast by them.[21] Compared to Friedrich, he stayed close to the priorities of scientific observation, and his cloud studies share a kinship with the meteorological work of his contemporary Luke Howard. But Constable also prized clouds for their abstract and varied succession, which made them a natural analogue to music. "It will be difficult to name a class of Landscape," he wrote, "in which the sky is not the *'key note,'* the *standard of 'Scale,'* and the chief *'Organ of Sentiment.'*"[22] The close relationship between atmospheric vapor and music would figure in pictorial aesthetics for many decades to come.

The painter Turner, born the year before Constable, used the atmosphere as an occasion to experiment with loose, indistinct, and evocative ways of constructing space and marking with paint. In pictures such as *Rain, Steam, and Speed: The Great Western Railway* of 1844, vapor became for him a means to trouble traditional bonds between painting and representation (Figure 4.4). In contending with the resulting pictures at a Royal Academy exhibition, a baffled critic wrote:

We are really at a loss how to approach this magician of colouring. Now he is brilliant as a Prospero, anon extravagant as a Katerfelto,

Figure 4.4 J. M. W. Turner, *Rain, Steam, and Speed: The Great Western Railway,* 1844, oil on canvas. © National Gallery, London; Image Resource, NY

and lastly, wild and mad as a Tom o'Bedlam. The *Dogan[a]* and [No.] 73 *Campo Santo,* have a gorgeous *ensemble,* and [are] produced by wonderful art, but they mean nothing. They are produced as if by throwing handfuls of white, and blue, and red, at the canvas, letting what chanced to stick, stick; and then shadowing in some forms to make the appearance of a picture. And yet there is a fine harmony in the highest range of colour to please the sense of vision; we admire, and we lament to see such genius so employed. . . . No. 182 [*Snow Storm— Steam-Boat off a Harbour's Mouth* (1842)] is a Snow-Storm of most unintelligible character—the snow-storm of a confused dream, with a steam-boat "making signals," and (apparently, like the painter who was in it) "going by the head."[23]

For this critic, Turner's protean transformations and his novel application of paint were baffling. The critic's imagery—"throwing handfuls" of paint and "letting what chanced to stick, stick"—recalls the story of Protogenes

and his sponge and suggests a separation between paint and hand that opens the marking to chance. Like Protogenes, Turner abandoned a more deliberate application of paint to find a better correspondence between technique and subject. Whereas Protogenes found in chance a means of representing salivary foam, Turner famously employed loose brushwork to represent the spume of stormy seas and the broiling vapors of turbulent skies.

Working during a period of rapid industrialization, Turner was extraordinarily sensitive to the interplay between natural vapors and the gassy effluence of machines. In *Rain, Steam and Speed,* natural precipitation mixes with industrial smoke and steam to create a moist and radiant dissolution of paint. Through it a locomotive plunges toward us, penetrating the murk of Maidenhead and grinding out a last phallic vector of linear perspective. The power of the painting is precisely in its ambivalence about this modern dissipation of lucid structure, its blurring of the line between exultation and despair.[24] The ideal linearity of the Renaissance has been hardened into a single ruddy bolt, and the rest of the visual field seems to have dissolved as a consequence. In *Snow Storm—Steam-Boat off a Harbour's Mouth,* the vortex of vapor permeating the image seems driven as much by the ship's dark emission as by the cyclone around it. The steamboat, like the locomotive of *Rain, Steam and Speed,* is out of control, its signals lost and blinding, the victim of a mechanical agency with a head full of steam and nothing else. Whereas the shipwreck was traditionally a source of moral instruction about the awesome might of nature and the noble aspirations but limited powers of humanity, Turner's picture, as the critic rightly senses, is more about madness. He attributes this madness to the artist, who allegedly, like the ship, is going down "by the head." But a more sympathetic reading would attribute the madness to his world and interpret the unconventional handling as the outcome of an intelligent effort to develop a technique that could address the mounting frenzy of industrial capitalism. Steam, after all, was hotness and vacuity as well as power. As Carlyle wrote but a few years before Turner exhibited his painting, "Statistics is a science which ought to be honorable . . . but it is not to be carried on by steam, this science, any more than others are; a wise head is requisite for carrying it on."[25]

Among Victorian critics, none was more sensitive to atmosphere and its representation than Turner's great champion, Ruskin. For Ruskin, the ceaselessly generative sky offered a kind of natural art. "There is not a moment

of any day of our lives," he writes, "when nature is not producing scene after scene, picture after picture, glory after glory [in the sky], and working still upon such exquisite and constant principles of the most perfect beauty."[26] To fail to recognize this aerial beauty was, for Ruskin, to remain incomplete in one's humanity. To see the sky as "a succession of meaningless and monotonous accident," he asserts, is to remain bound to our animal sensations, which we share "with the weed and the worm."[27] This defense of aesthetic sensitivity puts the human desire for form on a middle course: to see too much in the sky, as Piero di Cosimo did, is a kind of mental illness, but to see too little, according to Ruskin, is a kind of depravity.

For Ruskin, in other words, a certain degree of pareidolia is required of those who would find beauty and meaning in the world. Clouds may be a fluid medium of nature, but their meaning remains a strictly human one. He writes: "A cloud, looked at as a cloud only, is no more a subject for painting than so much feculence in dirty water. It is merely dirty air, or at best a chemical solution ill made. That it is worthy of being painted at all depends upon its being the means of nourishment and chastisement to me, or the dwelling-place of imaginary gods."[28] According to Ruskin, clouds as mere chemistry are base and unworthy of representation. They must become subjects of human experience and imaginative engagement to have meaning. The critic who argues that Turner's atmospheric paintings "mean nothing" is like the worm who can discern only accident in the transformations of the sky.

Ruskin also deemed the various vapors drifting through the lower atmosphere essential to the art of landscape. In an extraordinary passage, he writes in *Modern Painters:*

> To the region of the rain-cloud belong also all those phenomena of drifted smoke, heat-haze, local mists in the morning or evening, in valleys, or over water, mirage, white steaming vapour rising in evaporation from moist and open surfaces, and everything which visibly affects the condition of the atmosphere without actually assuming the form of cloud. These phenomena are as perpetual in all countries as they are beautiful, and afford by far the most effective and valuable means which the painter possesses, for modification of the forms of fixed objects. The upper clouds are distinct and comparatively opaque, they do not modify, but conceal; but through the rain-cloud, and its accessory phenomena, all that is beautiful may be made manifest, and

all that is hurtful concealed; what is paltry may be made to look vast, and what is ponderous, aërial; mystery may be obtained without obscurity, and decoration without disguise. And accordingly, nature herself uses it constantly, as one of her chief means of most perfect effect; not in one country, nor another, but everywhere—everywhere at least, where there is anything worth calling landscape."[29]

No other passage so eloquently conveys the overriding importance of atmospheric vapors to English landscape in the middle of the nineteenth century. In Ruskin's view, nature uses vapor constantly to transform the appearance of its elements and thus momentarily perfect itself, and the painter should follow suit. According to him, vapor is a crucial means for the painter to control the variables of visibility, emphasis, tenor, and scale. As the mediation by which the world becomes beautiful, vapor, in a sense, *is* landscape painting.

Ruskin believed careful attention to vapors distinguished modern landscape from the work of the Old Masters.[30] In a discussion of Turner's 1832 watercolor *Jumièges* he writes:

> We have on the right of the picture, the steam and the smoke of a passing steamboat. Now steam is nothing but an artificial cloud in the process of dissipation; it is as much a cloud as those of the sky itself, that is, a quantity of moisture rendered visible in the air by imperfect solution. Accordingly, observe how exquisitely irregular and broken are its forms, how sharp and spray-like. . . . Smoke, on the contrary, is an actual substance existing independently in the air, a solid opaque body, subject to no absorption nor dissipation but that of tenuity. Observe its volumes; there is no breaking up or disappearing here; the wind carries its elastic globes before it, but does not dissolve nor break them. Equally convex and void of angles on all sides, they are the exact representatives of the clouds of the old masters, and serve at once to show the ignorance and falsehood of these latter, and the accuracy of study which has guided Turner to the truth.[31]

Ruskin claims that Turner's study of the industrial atmosphere of England led him to discover a more faithful representation of natural vapor and a better use for the rounded opaque masses that the Old Masters had used for clouds. Those masses, according to Ruskin, turned out to be more ap-

propriate for the representation of industrial smoke. In his view, modern landscape as a set of precepts and sensitivities was emerging out of industrialization and its blighting effects.

Ruskin thought the atmosphere of England in his day was disastrous. The distinction he draws between steam and smoke in his discussion of *Jumièges* presages his long engagement with the moral qualities of vapors. Not all smoke was bad: wood smoke had an innocence that the coal-fueled economy had mostly routed. In a discussion of Turner's *Eggleston Abbey*, Ruskin writes: "One cow is white, another white and red, evidently as clean as morning dew can wash their sides. They could not have been so in a country where there was the least coal smoke; so Turner has put a wreath of perfectly white smoke through the trees; and lest that should not be enough to show you they burnt wood, he has made his foreground of a piece of copse just lopped, with the new faggots standing up against it."[32] Coal and wood smoke represented different social and ecological orders. Vapors had become a way of historically marking a landscape, of setting it within or against industrialization. They were a way of giving a landscape a moral air.

For Ruskin, pictures such as *Eggleston Abbey* were a kind of archive, a repository of atmospheres that the industrial age and its belching smokestacks were supplanting. By depicting mountain mists and other salubrious vapors of the preindustrial world, they could indicate to those who lived in a world of "sulphur, soot, and gaslight" what they were missing.[33] Vapors were a way of negotiating the troubled boundary between modernity and what could be imagined as its antithesis. Modernity *tout court* was not available to vision—the capitalist economy was guided, after all, by the invisible hand. But anxieties about modernity could be worked out in the atmosphere, where visibility and invisibility, the present and the past, met and mingled, and the heedlessness of history could momentarily find form.[34]

By the 1870s, the modern roles of vapor in painting had become deeply entwined with questions of artistic labor. From Turner onward, the determination to represent modern atmospheres in paint had gone hand in hand with a loosening of handling and a tendency to collapse or dissipate the structure of illusionistic space. The gassy character of modernity demanded a new application of the brush. For the Parisian painters Édouard Manet, Gustave Caillebotte, and Claude Monet, the billowing emissions and ironwork of train stations and bridges had become crucial elements in the representation of modern life. In pictures such as Manet's *The Railway* of

Figure 4.5 Edouard Manet, *The Railway,* 1873, oil on canvas. Image courtesy of the National Gallery of Art, Washington

1873, Caillebotte's *Le Pont de l'Europe* of 1876, and Monet's *Le Pont de l'Europe* and *La Gare Saint-Lazare* of 1877, iron, smoke, and steam bring out modernity's cold rigidity and weightless freedoms (Figure 4.5). T. J. Clark has written of *The Railway:*

> It does not take much ingenuity to see that steam in the Manet is a metaphor for a general, maybe constitutive, instability—for things in modernity incessantly changing their shape, hurrying forward, dispersing, and growing impalpable. . . .
>
> Steam and appearance, then: that is certainly Manet's ruling trope. But not simply appearance canceling depth, and ruling out inwardness altogether. Manet and modernism never go that far. The governess is reading and dreaming. For a moment she may be all outwardness and facingness, but she still has two fingers keeping her place in her book. Maybe steam could also be a metaphor for the freedom of the imagination. But then we look again at those implacable railings di-

viding and ruling the rectangle, pressing everything up to the picture surface. Surfaces are too easily organized, that is the trouble with modern mobility and anonymity. Always in the new city freedom (evanescence) is the other side of frozenness and constraint.[35]

The girl in Manet's painting faces into the steam as Friedrich's wanderer faced into the mist, but there the kinship ends. He has reached his prospect through his own ambulatory power, whereas she is rooted in place, her legs truncated by the picture's edge. The train's mobility seems to have come at the cost of her own. Whereas a mysterious distance lies open before him, a grille of iron separates her from the billowing steam. The young woman facing us seems equally trapped, caught in the flattening grid of pictorial space. The space of the city, the picture seems to claim, *is* the space of representation. Led by Manet, impressionist painters of the 1870s revived the interplay of grid and vapor that had so beguiled Renaissance artists such as Correggio. But for them vaporous obscurations no longer bore the whiff of heaven. They were mostly emissions generated by the iron monsters of capital, billowing up in the foreground, tied to the gridded structure of the city by bonds of mechanical power, and signifying the quickening disintegration of social spaces into pockets of displacement.

In 1877, the issues of vapor, modernity, and artistic labor came to a head at the Ruskin libel trial. At issue were Ruskin's harsh words about Whistler "flinging a pot of paint in the public's face."[36] The object of Ruskin's ire was an atmospheric painting entitled *Nocturne in Black and Gold* (Figure 4.6). As Ruskin's fervent support of Turner would suggest, the critic was by no means a curmudgeon with respect to the issue of finish. His concern was that Whistler's dabbling in accident and suggestion stemmed mainly from a gratuitous cultivation of affect and not from an intensive study of nature. Nonetheless, many critics in the press took the occasion to write jeremiads against the want of finish in modern painting more generally and the resulting violation of the social contract between artist and beholder. In a *New York Times* review of 1878, a critic complains that the "void and formless chaos" of Whistler's nocturnes burdens the beholder, whose imagination has to "fill up" the picture.[37] This complaint echoed that of the critic of Cameron's work who had written years earlier that her photographs left the beholder "to work out the idea in his own imagination, if he can."[38] An unfinished picture required a kind of pareidolia on

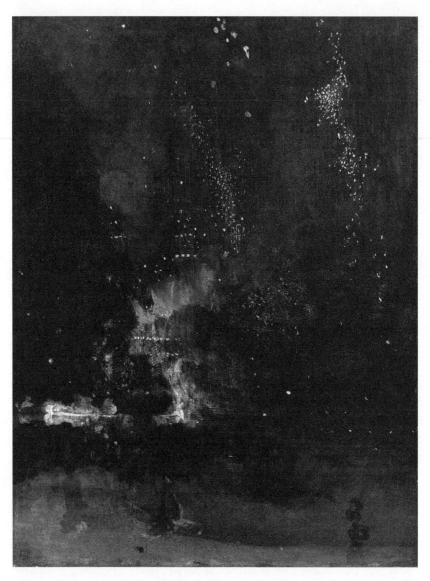

Figure 4.6 James M. Whistler, *Nocturne in Black and Gold: The Falling Rocket,* 1875, oil on panel. Detroit Institute of Arts, USA, Gift of Dexter M. Ferry Jr.; Bridgeman Images

the part of the spectator, an effort to see more representation than the artist had provided. Some critics regarded this demand as a maddening burden.

Clouds and other atmospheric vapors thus tumbled along the boundary of sense and senselessness. In his account of Whistler's art, the *Times* critic writes: "The vivid imagination of the child or the distempered mind of the invalid may trace strange shapes and scenes in the commonplace figures of wall-paper, and see gruesome monsters or forms of fantastic beauty in the pattern of a cambric curtain, but ordinary men and women in a state of health prefer to have their pictures made for them."[39] The critic's references to wallpaper and curtain invoke a domestic and sequestered madness stimulated by decorative pattern and associated with feminized spaces. The imagery sets the bohemianism of artists such as Whistler against masculinity and mental health. The critic's skirting of the obvious example of pareidolia in the context of atmospheric paintings—that is, seeing the shapes of things in clouds—can be understood as a regulatory move, a way of containing and gendering the problem of modernism in painting. But it is also an insistence, shared by Ruskin, that Whistler's approach to painting his nocturnes was not in pursuit of any naturalist truth of atmosphere. For the critic, the nocturnes are mere decoration, products of mental confinement rather than careful observation.

The subject of vapor was bound up with the issue of finish and the proper role of art. The Romantic predilection for mists and fogs had long been a way to resist visual completeness, and now Whistler, according to his critics, was using vapor as an excuse to dash off vague and incomplete pictures. The conservative *Times* critic holds the inherent difficulty of representing vapor accountable:

Ordinary men and women . . . will persist in believing that the true function of art is to reproduce nature with fidelity. . . . If there are vague scenes, like a distant bridge over a dark river on a misty night, that baffle all effort at reproduction, they will readily forego the pleasure of having them on their walls rather than put up with splashes and dashes of black and streaks of yellow, which they must imagine to be the scene that thrills when it is actually looked upon. If an East River ferry-boat in a fog cannot be clearly painted, it can be let alone, and we may not be required to accept in lieu thereof something that looks like a whitewashed wall, with streaks of charcoal suggesting smoke-stacks and fog-whistles, even though it were called a sonata in gray. The public

has had a deal of paint flung recklessly in its face, and it was time somebody protested in the name of cleanliness and propriety.[40]

According to this critic, vapor may lie beyond the powers of painting, and the responsible painter may need to forgo its representation. Attempting to paint things "on a misty night" or "in a fog" cannot justify a loose handling that violates the code of proper finish. In established circles, even at this late moment in the nineteenth century, vapor remained an effective instrument of Romantic rebellion. According to the logic of this review, Protogenes should have given up on the impossible representation of salivary foam and left his sponge where it was.

At the trial, *Nocturne in Black and Gold* was usually characterized either as representing a night atmosphere on the Thames or as having no significant representational content at all. When Ruskin's counsel, Sir John Holker, asked Whistler what the subject of the picture was, he took the first tack: "It is a night piece and represents the fireworks at Cremorne Gardens."[41] Some of Whistler's supporters and detractors who testified were even more insistent on the picture's meteorological content. The painter Albert Joseph Moore, for example, defended the nocturnes by opining, "There is one extraordinary thing about them, and that is that he has painted the air, which very few artists have attempted. I think the sensation of atmosphere in the bridge picture [*Nocturne in Blue and Silver*] very remarkable. As to the picture in black and gold, I think the atmospheric effects are simply marvelous."[42] But at other points in the trial, Whistler took the second tack: "By using the word 'nocturne' I wished to indicate an artistic interest alone, divesting the picture of any outside anecdotal interest which might have been otherwise attached to it. A nocturne is an arrangement of line, form, and color first. The picture is throughout a problem that I attempt to solve. I make use of any means, any incident or object in nature, that will bring about this symmetrical result."[43]

This teetering in the trial between the painting of vaporous atmosphere and the painting of nothing but paint accords with the notion that signs of vapor since the Renaissance have marked the limits of painting as representation. At the trial, vapor signified the ambiguous passage from paint as representation to paint as paint. To attempt to paint certain atmospheres was, in the view of the *Times* critic, to push painting to the point where it could no longer function as a pictorial art and would disintegrate instead into "splashes and dashes." The story of Protogenes was a story of madness

at the limits of art, of an exasperated painter facing the peculiar challenge of representing chaotic froth. It confined madness to an impulsive moment and a small patch in a much larger picture. In the work of Turner, the frenzy of foam, froth, and vapor had spread across the canvas, and in that of Whistler, an irrational fog had enveloped the world. The place of chance and formlessness had lost its classical proportion.

The controversy at the Ruskin libel trial concerning artistic labor centered on the accusation that the painter had "contrived to persuade a number of aesthetic individuals who have more money than brains to pay high prices for a few hours' slapdash work with his brush."[44] But Whistler defended his rapid brushwork on the grounds that his subject required it. Whereas for Protogenes representing the froth at a dog's mouth ultimately required throwing a sponge, for Whistler the elusive idea he sought to represent called for loose handling. "Your manual labor is rapid?" Holker asked during cross-examination. "Certainly," replied Whistler. "The proper execution of the idea depends greatly upon the instantaneous work of my hand."[45]

If Ruskin was incensed, it was doubtless in part because he had defended loose brushwork in analogous terms. Years earlier, he had stood up for those who "express themselves habitually with speed and power, rather than with finish, and give abstracts of truth rather than total truth."[46] He had also suggested more specifically that a quick and sketchy approach was particularly appropriate when representing vaporous atmospheres. Any worthy style, he claimed, was the most direct means the artist could find to depict a subject truthfully, and the traditional materials and discipline of oil painting were ill prepared to represent certain atmospheric conditions. In *Modern Painters,* he asserts that "one accidental dash of the brush with watercolor on a piece of wet or damp paper, will come nearer the truth and transparency of this rain-blue than the labor of a day in oils."[47] According to Ruskin, in painting certain atmospheres, brevity and accident may serve the artist better than patient and deliberate marking.[48]

The issue, then, was whether Whistler had used his rapid brushwork to pursue a truth about atmospheric vapor. For Ruskin, Whistler's aim was detached from any serious mode of naturalistic inquiry, making his way of painting nothing more than a lazy affectation. The severity of Ruskin's contempt confirms that for him the representation of vapor was a moral matter. He considered clean air to be essential to the making of art, and the changing sky to be an index of modern degradation.[49] Vapors in painting were a way of defining and judging history, of making records of the

atmosphere that industrialization was destroying. In this regard, the ostensible subject of *Nocturne in Black and Gold,* a fireworks display, may have figured into his vehemence. In 1871, Ruskin had decried the government's debt financing of nationalist ventures in the following terms: "First, you spend eighty millions of money in fireworks, doing no end of damage in letting them off. Then you borrow money, to pay the firework-maker's bill, from any gain-loving persons who have got it. And then, dressing your bailiff's men in new red coats and cocked hats, you send them drumming and trumpeting into the fields, to take the peasants by the throat, and make them pay the interest on what you have borrowed; and the expense of the cocked hat besides."[50] For Ruskin, every vapor had a moral tale to tell about modernization, and he undoubtedly found Whistler's frilly representation of a fireworks display insensitive to the grim politics at stake. More than mere powder was going up in smoke in this inane celebration of patriotic might. To turn vapor into decoration was to lose sight of its moral content and to wallow instead in empty materiality, to make clouds into "so much feculence in dirty water" and throw paint in the public's face.

For photographers around the turn of the century, Whistler, like Rembrandt, was mentioned frequently in the photographic press as a polestar or kindred spirit. He was a polestar by virtue of his distinctly individuated style and his explicit claim to reach truths beyond ordinary appearances. In this sense, his art was everything most critics claimed photography could never be. At the same time, his poetic treatment of everyday scenes and his effort to disassociate art from traditional signs of artistic labor and skill made him a kindred spirit. His enterprising use of etching and lithography, print media historically subordinate to painting, only enhanced his relevance.

To photographers, Whistler thus offered a route toward legitimacy. They could claim, as did he, to bring vast knowledge and experience to bear on the quick production of a picture, and thus to decouple the picture's value from the quantity of labor expended. They could also implicitly claim, as did he, to use speed and spontaneity as a means to capture the spirit of modern life.

But photographers wishing to exalt Whistler and to exploit his celebrated decoupling of aesthetic value and labor had to contend with his scorn for copying.[51] In his famous "Ten o'Clock" lecture of 1885, Whistler asserted that the great artist "surpasses in perfection . . . what is called Nature."[52] More particularly, he says that such an artist

looks at the flower, not with the enlarging lens, that he may gather facts for the botanist, but with the light of the one who sees in her choice selection of brilliant tones and delicate tints, suggestions of future harmonies. He does not confine himself to purposeless copying, without thought, each blade of grass, as commended by the inconsequent, but, in the long curve of the narrow leaf, corrected by the straight tall stem, he learns how grace is wedded to dignity, how strength enhances sweetness, that elegance shall be the result. . . . In all that is dainty and lovable he finds hints for his own combinations.[53]

Nature is here a repository of visual possibility, a "resource" (to use Whistler's word) that offers hints for the artist's superior compositions.[54] This is the dictum of Reynolds, tailored to a practice based on harmonies of tones and tints. By trotting out the old warhorse of selection and rejection, Whistler, a self-styled modern artist of high ambition, betrays the crisis of art in late nineteenth-century England. Struggling to maintain any claim on the social value of art, he retreats to an aesthetic doctrine that was already a century old.

Even in this retreat, however, the rise of naturalism has left its mark. In his lecture, Whistler occasionally hedges on the superiority of art to nature. Nature is "usually wrong," he writes, and "seldom" succeeds "in producing a picture."[55] Seldom, but not never; when does nature get it right? In a passage articulating an important theory for photographers of the period, Whistler writes:

And when the evening mist clothes the riverside with poetry, as with a veil, and the poor buildings lose themselves in the dim sky, and the tall chimneys become campanili, and the warehouses are palaces in the night, and the whole city hangs in the heavens, and fairyland is before us—then the wayfarer hastens home; the working man and the cultured one, the wise man and the one of pleasure, cease to understand, as they have ceased to see, and Nature, who, for once, has sung in tune, sings her exquisite song to the artist alone.[56]

According to Whistler, in dim lights and obscurant atmospheres, nature undoes its facts, blinds those who are not artists, and "for once" delivers art. This formula offered hope and guidance for pictorialists seeking to counteract the thoughtless automatism associated with photography. By

depicting subjects shrouded in atmospheric indistinctness, they could differentiate their products from mainstream work and claim to transcend the mundane.[57]

As this brief and selective history of vapor in European art would suggest, the handling of atmosphere in late Victorian photography was a crucial matter. For many practitioners, the softening effects of gentle mists and dewy mornings became signs of aesthetic aspiration. Countering a general taste for clarity and exactitude, these signs enabled pictorialists to carve out a compensatory realm of taste in which the finer feelings of both practitioner and patron could be affirmed. Much pictorialism has aged poorly and seems trite today. But the best of it renewed the effort of Turner and Ruskin to contend with the moral complexity of modern atmospheres. Working with steam, smoke, fog, mist, precipitation, and even bodily exhalations, the most ambitious pictorialism sought to make pictures adequate to the weightless possibilities and social metabolism of a turbulent era.

No one worked harder to achieve this goal than Peter Henry Emerson. Between the mid-1880s and the mid-1890s, Emerson produced or coproduced a series of photographic books about the disappearing ways of rural life in the fens of East Anglia, and also wrote an influential treatise on pictorial photography. In his celebrated platinum prints and photogravures, he used steam, smoke, and fog to represent both modernity's gaseous intrusions and the dispersing dreams of a purportedly authentic past. He combined atmospheric vapor and focal blur to slow photography to a dreamlike time of obscurity and accident, seeking to bring poetry to his medium's realism.

In the effort to make photography into art, Emerson understood himself to be, at least in certain respects, the heir to Cameron. Eleven years after she died, he wrote a profile of her ("a labour of love," he said), praising her above all other deceased photographers and asserting that her "pictures alone are worth preserving."[58] Emerson was unusually sensitive to the importance of chance in Cameron's practice and its claims on art. In the midst of his encomium, he asserts that her impulse to produce came "very late in life, and then by chance."[59] Her decision to take up photography was spurred by stray circumstances, making it exemplary of the general truth that the medium used by an artist is "often being determined by chance or some organic idiosyncrasy."[60] By chalking up the choice of medium to mere happenstance, Emerson undercuts the historical privilege of painting over photography. His profile of Cameron also affirms the ac-

cidental origins of her unconventional use of focus. He writes: "Having produced out-of-focus results at first by accident, she was artist enough, and so well advised, that she determined to imitate that effect."[61] For Emerson, being "artist enough" was a matter of discerning the aesthetic value of an accidental result. In this way, he carries forward the scheme of serendipity that Talbot had articulated nearly half a century before.

Like Cameron, Emerson emerged from colonial circumstances to depict idealized scenes of Englishness while also playing the rebellious outsider to the photographic establishment. Born in Cuba (then a colony of Spain) to an English mother and American father who owned a sugar plantation worked by slaves, he came to England when he was around thirteen years old and spent the rest of his life there.[62] In 1881, at age twenty-five, he received an ample inheritance that funded his pursuit of photography. Whereas Cameron favored allegories and literary subjects, Emerson preferred scenes of landscape and rural life in East Anglia, a coastal area of England favored by tourists. Over the course of a decade, he produced or coproduced several photographic books depicting the region, including *Life and Landscape on the Norfolk Broads* (1886, with T. F. Goodall as coauthor), *Pictures of East Anglian Life* (1888), *Wild Life on a Tidal Water: The Adventures of a House-boat and Her Crew* (1890), *On English Lagoons: Being an Account of the Voyage of Two Amateur Wherrymen on the Norfolk and Suffolk Rivers and Broads* (1893), and *Marsh Leaves from the Norfolk Broadland* (1895). The first two books are ethnographic in tone, whereas the later books offer more personal chronicles of his visits to the region's reedy waterways. The gap between Emerson's colonial, slave-generated finances and his romanticized vision of the English peasantry exemplifies certain potent ideological contradictions of his class. Like Cameron, he sought to elevate photographic aesthetics by mixing modernity, nostalgia, and a nationalist mythos. Like her, he had a colonial past that facilitated and partly determined his eccentric yet resonant vision of English modernity and its longings.

As a technician, however, Emerson differed markedly from Cameron. Whereas she invited accident, he strove to eliminate the effects of chance. His credo was: "No haphazard work, but complete control, so that we can mould the picture according to our will."[63] He hewed to this credo, fastidiously delivering a stilled depiction of an English countryside, every gesture and pose carefully fitted to his ethnographic scheme. Although he vociferously opposed many forms of image manipulation (because, as he put

it, the "technique of photography is perfect"), he occasionally used combination printing to substitute one sky or background for another.[64] Many of his pictures, constructed from tight controls, studied poses, and meticulous technique, can seem stilted to us now.

To understand why the unpredictable ways of vapor nonetheless became vital to Emerson requires attending to his theoretical grappling with the possibility of photography as art. In his influential book *Naturalistic Photography for Students of the Art* (1889), Emerson fashions guidelines for moving photography beyond the mechanical. He centers his effort on the breadth of the photographer's discretion, including the many choices stemming from the "plasticity" of photographic development. According to him, practitioners had brought photography down to the status of the mechanical by adopting invalid or inflexible procedures. "It never occurs to them that each picture is a problem in itself, and needs different management from beginning to end," he writes.[65]

In his book, Emerson recognizes only two serious objections to photography as an art. The first is that photography "cannot express an intention."[66] The notion that art required expressing an intention was new. In the *Discourses*, Reynolds very rarely refers to an artist expressing himself, and when he does, he treats the idea with concern. When an artist "is once enabled to express himself with some degree of correctness," he writes, "he must still be afraid of trusting his own judgment, and of deviating into any track where he cannot find the footsteps of some former master."[67] As for the word *intention* and its cognates, Reynolds uses them mostly to refer to the designs of God and nature. When he discusses what an artist intended, the notion often bears a negative connotation of waywardness or pride. For example, he offers this critique of a picture by Paolo Veronese: "It was unreasonable to expect what was never intended. His intention was solely to produce an effect of light and Shadow; everything was to be sacrificed to that intent, and the capricious composition of that picture suited very well with the style he professed."[68] In his *Discourses*, Reynolds keeps the emphasis on the traditional standards to which the artist must aspire if he is to achieve greatness. For him, securing effects and successfully representing shared ideals are what elevate a work of art, and these accomplishments can be measured without regard to intention.

The notion that art expresses an intention really only takes hold in England in the late nineteenth century. At the Whistler/Ruskin trial, when William Michael Rossetti is asked why he deems *Nocturne in Black and Gold*

a work of art, he replies: "Because it represents what was intended."[69] This emphasis on subjectivity and intention responded to the rise of mechanical production and the objective powers of commodification and modern thought. Forced to contend with a market flooded with mechanically produced objects and a culture captivated by the economic prowess of the invisible hand, writers on art attached a new aesthetic value to the individuality of the artist. They exalted the studio and the gallery as sanctuaries of integrated labor in a society given over to mass commerce, and treated artists as high priests of personhood.[70] The subjectivity of artists—their tastes, habits, moods, and intentions—became a protected reserve of humanity in an increasingly crass and mechanized world, and the work of art took on value as a trace of that humanity. Intention became an umbilical cord between artist and work to distinguish the latter from machine-made objects, no matter how wondrous. Although some modern artists, particularly in France, resisted the simple oppositions of this paradigm of intention and expression (think of the pointillist Georges Seurat), it took on great authority around the turn of the century.[71]

Emerson answered the objection that photography cannot express an intention by reiterating the precepts of naturalism. He opines that "all the best art has been done direct from nature, and that no 'intention' requires expression." "No artist worthy of the name," he adds, "ever drew a picture evolved from his inner consciousness."[72] Emerson thus counters the emphasis on subjective expression by carrying forward the observational naturalism of Hazlitt and Constable. Working "direct from nature" was a watchword of much nineteenth-century painting, from Constable and the Barbizon school to the Pre-Raphaelites and the impressionists. It promised an immediacy and freshness that could counter the stale pieties of academic art. Although this outward-directed naturalism stands opposed to the glorification of subjective expression, in some respects these modern positions are two sides of the same coin. Both have their roots in the Romantic rebellion against the academy, and both advocate a directness (one looking inward, the other outward) that diminishes the importance of institutional training and guidance. In championing a naturalism *en plein air* as a paradigm superior to that of individual expression, Emerson set one legacy of Romanticism against another.

The second objection to photography as art that Emerson acknowledges is that the camera "must take whatever is before it."[73] Here again the longstanding emphasis of academic theory on selection and rejection

haunts photography and its indiscriminate apparatus. "Art has nothing to do with forms that are found ready-made prior to its activity and independent of it," the aesthete Conrad Fiedler asserts in an 1876 essay.[74] In response to such thinking, Emerson construes the need to make a picture directly from an encounter with the world as a challenge rather than a barrier to creativity. He argues that having to take the visual field as it is "only makes the field to select from more limited, and gives the artist greater credit when he does a good thing."[75] Every artist works from limited possibilities, and the great photograph, according to Emerson, represents a heroic triumph over particularly restrictive conditions.

Emerson follows Talbot in imagining a picture to be drawn from a single visual encounter rather than synthesized selectively from various ones.[76] He writes: "Nature is so full of surprises that, all things considered, she is best painted as she is."[77] This dictum tasks the photographer with seeking out and transposing the finest of nature's accidental arrangements. In nature, according to Emerson, all poetry, pathos, and tragedy reside; it "only wants finding and tearing forth."[78] To transcribe nature perfectly was beyond the reach of any art, but the painter or photographer could nonetheless "tear forth" its poetry by producing a true impression.[79]

Although Emerson embraced naturalism, he also respected the traditional dictum that a work of art must establish a hierarchy of attention. According to this dictum, the main features and figures of the picture are to be the focus of the painter's labor and to attract the beholder's gaze, whereas secondary features and figures are to remain subordinate. Reynolds argues in his *Discourses* that none of the secondary elements of a painting "ought to appear to have taken up any part of the artist's attention. They should be so managed as not even to catch that of the spectator."[80] The indiscriminate apparatus of photography routinely violated this hierarchical principle. No traditional painter would, to return to the words of Talbot, "delineate a chimney-pot or a chimney-sweeper" as he would "the Apollo of Belvedere."[81] Emerson sought a way to counteract this mechanical uniformity of attention and bring a graded structure to the photographic image.

The flux of the historical moment made this a tricky task. Like Rejlander before him, Emerson struggled to bring photography into alignment with the traditional norms of painting at a time when modernist painting, often spurred by photography, was resisting them. During the Victorian era, many who sought to make photography into art pursued an idea of art that was becoming obsolete.

In *Naturalistic Photography,* Emerson responds to this predicament by trying to forge a photographic approach reconciling naturalism and academic principle. His key premise is that the hierarchy of attention required by the Western pictorial tradition has a counterpart in the aesthetic perception of nature. The cultivated individual able to appreciate a modulated attention in art, he posits, will also bring such a modulation to his perceptions of the world. To illustrate this claim, Emerson asks the reader to imagine an encounter in the field, wherein "we row by on the lake, and are struck by the picture" of a beautiful village girl on a landing stage, with a path behind it leading to a cottage backed by poplars. "If we are cool enough to analyze the picture," he continues, "what is it we see directly and sharply? The girl's beautiful head and nothing else." "Thus," he concludes, "it is always in nature, and thus it should be in a picture."[82] The word *picture* shuttles in this passage back and forth from a scene in nature to one in representation, weaving the two together. Whereas the academic requirement for a hierarchy of attention had traditionally been set against the accidental qualities of nature, Emerson suggests that aesthetic perception in nature actually abides by it, because the eye focuses on the main elements of a scene and relegates the secondary elements to a blurred periphery. Current optical science tells us that the area of sharp focus in human vision is indeed extremely limited, far more so than people generally realize.[83] Rather than challenge academic doctrine in favor of the study of nature, as Constable had done, Emerson uses modern optics to reconcile a traditional pictorial principle with aesthetic experience in the world. He goes beyond Talbot's concern with the capacity of the picturesque to arrest the sensitive eye, asking instead what the arrested eye actually sees.[84] His strategy is modern in its scientism and conservative—or perhaps recuperative—in its defense of visual hierarchy.

A second key premise of Emerson's approach is to suggest that differential focus in photography can produce a hierarchy of attention corresponding to that of the aesthetic perception of nature.[85] Painters, of course, had many ways to prioritize the elements of a picture. In his *Discourses,* Reynolds urges them to use color, value, and density of brushwork—in addition to composition—to subordinate secondary elements and bring out the general idea.[86] But these means of prioritizing pictorial elements were not readily available to photographers, hampered as they were by the indiscriminate interest of the camera lens, the monochrome quality of most photographic processes, and the capricious play of natural light. For them,

focus was an especially promising way to organize the beholder's experience. Emerson recommends a differential focus to break the landscape into layered planes. He suggests that photographers keep the principal elements of the picture sharpest and render secondary elements less distinct.

Because most photographers sought uniform sharpness in their pictures, Emerson had first to disabuse his readers of this ideal. In his discussion of the village girl on the landing, he describes how a pervasive sharpness would contravene our experience of beauty in nature:

> Let us, however, still keep to our scene, and imagine now that the whole shifts, as does scenery on a stage; gradually the girl's dress and the bark and leaves of the willow grow sharp, the cottage moves up and is quite sharp, so that the girl's form looks cut out upon it, the poplars in the distance are sharp, and the water closes up and the ripple on its surface and the lilies are all sharp. And where is the picture? Gone! The girl is there, but she is a mere patch in all the sharp detail. Our eyes keep roving from the bark to the willow leaves and on from the cottage thatch to the ripple on the water, *there is no rest,* all the picture has been jammed into one plane, and all the interest equally divided.[87]

According to Emerson, if the layers created through differential focus are collapsed into a single plane of sharpness, the picture no longer functions as such, because the hierarchy of attention is lost. Just as Gilpin warns the artist against the blizzard, because it gives vision "no point to rest on," so Emerson warns the photographer about losing the picture in an indiscriminate flurry of detail.[88] Differential focus corresponds to aesthetic experience and gives the contemplative eye an ordered picture and a site of repose.

Emerson adds the caveat that even the principal subject should not be left in perfectly sharp focus. Echoing Leonardo, he writes: "Nothing in nature has a hard outline." "Experience has shown," he adds, "that it is always necessary to throw the principal object slightly (often only just perceptibly) out of focus, to obtain a natural appearance."[89] His system thus requires that the principal subject be very slightly out of focus and the subsidiary elements in softer focus. But the photographer has to refrain from pushing the softness of focus to the point that it destroys the structure of the subject.[90] Emerson holds up Cameron as a practitioner who understood these principles in portraiture.[91]

In defending his differential system, Emerson disputes the notion embraced by some of his contemporaries that sharp focus throughout the photograph remains faithful to the experience of nature because the eyes move around when taking in a view and the accumulation of instantaneous perceptions informs the overall mental impression.[92] In *Naturalistic Photography,* he counters this notion by arguing that when a scene in the world is viewed aesthetically—that is, as a picture—the eye lingers in a manner that prioritizes elements in the scene:

> It will be said, but in nature the eye wanders up and down the landscape, and so gathers up the impressions, and all the landscape in turn appears sharp. But a picture is not "all the landscape," it should be seen at a certain distance—the focal length of the lens used, as a rule, and the observer, to look at it thoughtfully, *if it be a picture,* will settle on a principal object, and dwell upon it, and when he tires of this, he will want to gather up *suggestions* of the rest of the picture.[93]

In this passage Emerson makes clear that his differential system of focus corresponds to the experience of nature when nature is viewed as a picture. Visual experience, he implies, is diversified and classified by culture. To view nature as a picture is to adopt a certain sensibility or social mode of delectation that organizes one's perception of the world.

Emerson's argument possesses a fascinating circularity. He advocates making photographs true to our impressions of nature, when nature is viewed as a picture. This line of argument diverges from both Gilpin's theory of the picturesque and Talbot's understanding of photography as an aesthetic practice. Whereas Gilpin locates his aesthetics in the gap between what is beautiful in a picture and what is beautiful in nature, Emerson grounds his in a coincidence between the two. He advocates a use of focus that mimes aesthetic perception in nature. Whereas Talbot celebrates the indifference of the camera and emphasizes the picturesque scene as an objective encounter, as something that arrests the "painter's eye," Emerson insists that pictorial photography must counter that indifference so as to represent the restful experience of aesthetic looking.

The aesthetic looking Emerson exalts is a social privilege and form of authority. Emerson identified himself with "an anthropological aristocracy" sanctioned by social Darwinism.[94] The subject he imagines who rows by the lake and is dazzled by the "picture" of the beautiful peasant girl is a

member of an elite class who travels through a community to which he—and the presumption is that the subject is male—is not bound. He travels through the community to distill and define its truth and beauty for himself and others of his class.[95] Social distance becomes an aesthetic distance that enables the world of the rural poor to be viewed pictorially. Indeed, because this world evidently belongs to an earlier time, aesthetic distance, social distance, and historical distance tend to collapse into each other. Pictorial beauty becomes for the man of means a way of experiencing modern alienation, social superiority, and ethnographic pleasure.

Circularity was not the only problem that Emerson's system of differential focus suffered. His peers advocating a more uniformly soft focus—such as could be produced by a pinhole camera, a certain kind of landscape lens, or an ordinary lens if moved in and out during exposure—could be particularly trenchant in their critiques.[96] In an article from 1889, George Davison, the most celebrated English practitioner of pinhole photography, defends overall soft focus in the following way:

> Where do the definition votaries demand the detail? If all over the picture, in distance as well as in near objects, all are brought into one plane, and perspective effect is lost. If only in one portion of the scene, and the rest falling away, they will be at a loss to explain why detail should be more definite or specially sharp in that plane, or rather, in that curved area. No doubt something happy is gained at times by a soft background to give relief and force to a better defined figure or group, which is the one idea of the picture, but in pure landscape the effect of one plane only being sharp, where unimportant objects right across the picture in that plane are emphasized, is disturbing and unnatural.[97]

In this passage, Davison agrees with Emerson that overall sharp focus destroys pictorial space, but he also discerns a fundamental problem with the system of differential focus. Whereas the painter could select particular objects or features for special attention, the photographer using differential focus must select a plane. Bringing that plane into sharper focus may render the principal objects of the scene crisper, but it will do the same for secondary elements appearing elsewhere in the same plane. Emerson's preference for keeping even the principal objects slightly out of focus raises another problem that other writers have noted. Shifting the focal plane to

throw the principal subject slightly out of focus will often bring lesser parts of the picture into sharper focus, a result that contravenes the hierarchy of attention that Emerson purports to secure.[98] These problems explain why Cameron, who generally shared Emerson's preference for keeping principal subjects slightly out of focus, produced pictures wherein bits of tree bark, beard, or jacket lapel often appear crispest. Because she embraced this accidental quality as a measure of her artistic aspiration and autonomy, this did not worry her. But for Emerson, who sought to give his photography a firm scientific rationale, these mechanical effects of differential focus were troublesome.

Another problem for Emerson concerns atmospheric perspective. In *Naturalistic Photography,* he contends that differential focus not only provides the hierarchy of attention that good pictures require but also reproduces the softening effect of atmospheric turbidity on human vision. He offers a standard account of that effect, noting that the more air one looks through, the more the intervening moisture will soften line and detail. "From this fact alone," he concludes, "objects in different planes are not and should not be represented equally sharp and well-defined."[99] By the same token, Emerson suggests that atmospheric turbidity could remedy the problem of the excessively sharp focal plane. He asserts that photographers can ignore his rule about rendering the principal subject slightly out of focus "when there is much moisture in the air, as on a heavy mist-laden grey day, when we have found that the principal object (out of doors) may be focussed *quite sharply,* and yet appear natural, for the mist scattering the light softens the contours of all objects."[100] In this symmetrical formula, atmospheric moisture and soft focus operate to similar effect. Differentiated focus reproduces the visual consequences of atmospheric turbidity, while atmospheric turbidity assists the photographer in providing the proper mitigation of sharpness.[101]

But this interweaving of focus and moisture suppresses the fact that the softening effects of atmosphere and those of camera optics can be at odds.[102] Atmospheric perspective makes clarity a function of distance, which is why painters could use it to create an illusion of three-dimensional space. According to the formula, the nearer something is imagined to be, the clearer its contours should appear. A photographer, however, can focus a camera on distant things, rendering them sharp and leaving more proximate things blurred. If the most important elements of a scene are in the background, a photographer focusing on the distance will abide by the principle of

perceptual attention but violate the code of atmospheric perspective. To avoid this inconsistency would require focusing exclusively on foreground subjects. But this restriction would be debilitating, and Emerson himself refused to abide by it.

Although in his book Emerson suppresses the conflict between pictorial hierarchy and atmospheric perspective, it surfaces in writing on his work. In a review published in 1890, a critic writes of *The Fringe of the Mere* (Figure 4.7):

> The lilies in the foreground are so indistinct as to look like black patches or dots shooting above the water, while the trees and other objects in the distance are sharp. The lilies are only suggested, says Mr. Emerson. We can see no beauty in them. Nobody would imagine they were lilies any more than lumps of wood floating in the water. We should say it would be improved if the lily section was cut out. In most cases Mr. Emerson advocates having the distance out of focus, which he suggests harmonizes the picture. In the "Fringe of the Mere" he reverses this theory by having the distance sharp and the foreground blurred, and does not give any reason for it. However, it is right that the distance should be distinct, since it is the principal part of the view.[103]

The critic finds himself caught in the gap between atmospheric turbidity and differential attention. At first he finds the soft focus of the foreground absurd, because it makes the lilies as indistinct as lumps of wood, whereas things close at hand—according to atmospheric perspective—are ordinarily sharpest. But then, with awkward abruptness, he asserts that the scene in the distance, because it is the primary element of the picture, is properly more distinct. Although the logic of using differential focus to secure a hierarchy of attention evidently makes sense to this critic, he cannot reconcile himself to the strange softening of foreground contours. When the primary focus of a photograph is outside the foreground, the contradiction between differential focus as a device to secure a hierarchy of attention and differential focus as an analogue to atmospheric perspective rears its ungainly head.

Why did Emerson abide this incoherence in his writing on photography? Why not stick to his perceptual apparatus rationale for differential focus and forgo any truck with atmospheric perspective? The short answer is that

Figure 4.7 P. H. Emerson, *The Fringe of the Mere*, 1888, photogravure, from *Pictures of East Anglian Life*. Courtesy of Houghton Library, Harvard University

the visual effects of vapor were simply too important to ignore. Not only was atmospheric perspective a key principle of the Western pictorial tradition, but vaporous indistinctness had a metaphoric resonance that Emerson needed. He sought to produce photographs "full of sentiment and poetry," and the softening effects of atmospheric vapor were a crucial means of doing so.[104] In response to the acceleration of science and mechanization in the nineteenth century, error and imprecision had taken on a new power to signify human uniqueness. Mists and fog had become predominant Victorian metaphors for the ineffable mediations of human experience and the compensatory balms of sentiment. They signified the filtering effects of emotion, communication, or memory. "Then the lady looked more narrowly at Sir Pellias, and she perceived him as though through a mist of sorrow," Howard Pyle writes in his retelling of the story of King Arthur.[105] Given the metaphoric richness of atmospheric obscurity and the long history of picture makers using atmospheric effects to construct illusionistic space, Emerson needed to extend the analogical reach of focal blur beyond peripheral perception.

Vapor was essential to Emerson's practice as well as to his theory. In the years leading up to the publication of *Naturalistic Photography,* he produced extraordinary platinum prints and photogravures for his books on East Anglia. *The Old Order and the New,* one of forty platinum prints in *Life and Landscape on the Norfolk Broads* (1886), offers a paradigm of sorts for his handling of atmosphere (Figure 4.8). At the picture's center, a wherry containing three men sits midstream, its bow pointing into the distance, where a dilapidated dredging windmill stands next to a steam-powered mill that emits a long trail of vapor from its stack. The dialogue between the vapor trail and the puffy cumulus in the sky give the picture a modern and morally ambiguous structure.

The lyrical breadth of the photograph's title is unusual. Almost all of the other pictures in the book have titles that identify the subject with ethnographic or geographic specificity (for example, *Gathering Water-Lilies, Snipe-Shooting, Poling the Mash Hay, Setting up the Bow Net, Quanting the Gladdon, The Fringe of the Marsh*). Originally, *The Old Order and the New* also had such a title: if Emerson had hewed to the copyright form he submitted for the picture, it would have been called *The Drainage Mills.*[106] But he decided to open up its significance to the broader historical transformation he was depicting. Although the meaning of the photograph has changed over time, this broadening of significance has stuck: museums,

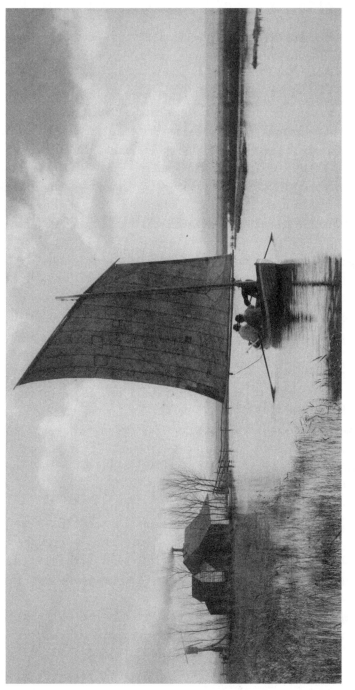

Figure 4.8 P. H. Emerson, *The Old Order and the New*, 1886, platinum print, from *Life and Landscape on the Norfolk Broads*. Courtesy of George Eastman House, International Museum of Photography and Film

authors, and publishers have often used the picture and its revised title to represent Emerson's photography at large.[107]

In Emerson's day, the phrase "the old order and the new" invoked a panoply of bewildering historical changes associated with the rise of capitalism. As Thorstein Veblen wrote at the turn of the century, "The visible difference between the old order and the new is closely dependent on the difference between the purposes that guide the older scheme of economic life and those of the new. Under the old order, industry, and even such trade as there was, was a quest of livelihood; under the new order industry is directed by the quest for profits."[108] With respect to the Norfolk Broads, Emerson decried this historical transformation and the tawdry forms of commerce it generated. Like many members of his class in England, he lamented that the "power of the Machine was invading and blighting the Shire."[109]

In his diatribes against modernization, Emerson often alludes to vapor. In *Pictures of East Anglian Life* (1888), he writes:

The days of this old world life are numbered—soon will . . . the noisy, fussy steam launch send its rippling waves through the dike up to the farmer's front door; soon will the stucco villa, fresh from the jerry-builder's hand, stare at the farmer; soon will he learn such sweet terms as "the Bungalow," "Nelson Villa," "Victoria House," and all the snobbery of philistinism will blare at him from gaudily-painted gates. . . . Will not the modern hotel, with electric bells, elevators, hot-air pipes, dynamo-machine, telephones, ammoniaphones, electric fishing and shooting gear à la Jules Verne, water tricycles, and the devil knows what, spring up? Oh yes! Not long hence before the batterie de diable will be filled with fresh air seekers, not Nature-lovers.[110]

In this passage and elsewhere, Emerson addresses modern upheaval through atmospheric imagery. He begins his jaunty tirade with a steam launch and ends it with fresh air seekers and their ammoniaphones, devices designed to produce artificial Italian air to improve the vocal tone of their users.[111] His words imply that the steam in *The Old Order and the New* is an industrial intrusion, a harbinger of crass effluence to come. The juxtaposition of the windmill and the steam-powered mill make the photograph an archive of historical transformation. The old technology runs on the wind, while

the new burns fuel and emits an artificial cloud. Emerson, like Ruskin, finds in vapors a moral order that judges the present by the standards of the past.

The title bears a curious relationship to the picture. The two mills are routinely—and understandably—interpreted as symbolic representatives of "the old order and the new."[112] In the Victorian era, the historical passage from windmills to steam mills was a ready synecdoche for the economic transformation of modernity. Karl Marx writes in 1847: "The windmill gives you society with the feudal lord; the steam-mill, society with the industrial capitalist."[113] But the composition of Emerson's picture centers not on the mills but on the act of attending to them from the wherry. Its subject is less the transformation of life and landscape on the Norfolk Broads than the witnessing of that transformation.[114] But to what kind of order does this witnessing belong?

Answering this question requires a more patient mulling of the picture. Like the old mill, the wherry takes power directly from the wind. Metaphorically speaking, the winds seem to have shifted, leaving both the old mill and the wherry pictorially inert. The old mill has evidently fallen into quiescence, its static blades contrasting with the turbulent vapor the new mill emits. The wherry, despite its connotations of travel, also seems fixed in place. The picture pins the sail flat, especially at its foot. In an odd coincidence, the line of the sail's foot continues that of the fence rails on the left and leads directly into the thin light border of the marsh on the right. The mast and its reflection form an axis orthogonal to the sail foot, giving the picture a cruciform structure that the gently sloping struts of the oars reinforce. The roughly equal spans above the mast and below the hull tighten the composition further, rendering the wherry as immobile as any sailing boat could be. A transient formal entrapment has overwhelmed the connotations of movement and stitched the sail into the landscape like a patch.

The wherry's occupants have an ambiguous status. Are they locals at work, moving about by traditional means, or are they visitors passing through the landscape, adopting local ways to experience an unfamiliar life? Either way, they unmistakably stand in for the viewer of the photograph. Indeed, the reason the picture is such an apt capsule for Emerson's photography as a whole is that it establishes the analogy so vital to his practice: that between aesthetic perception within the landscape and the naturalistic photograph itself. The scene recalls the critical passage in *Naturalistic*

Photography in which Emerson imagines that "we row by on the lake, and are struck by the picture" of a beautiful girl on a landing stage. Looking at *The Old Order and the New,* we look at a picture as if at a landscape, seeing men in a boat looking at a landscape as if at a picture. This reflexive relation reminds us of our place in the transformative historical shift represented, of our belonging in the act of viewing to the distinctly new order of photography.

We might put the matter another way: although the wherry as a technology may be more like the old mill than the new, the picturesque viewing by the occupants—and its complicity with our viewing of them in the photograph—has a distinctively modern cast. Indeed, no other Victorian photograph so subtly brings to the surface the inherent contradiction between the pictorialist embrace of rusticity and its reliance on modern optics and chemistry. The scene subtly acknowledges that our viewing of the photograph belongs to the age of steam. Both steam mill and photography harness the automaticity of airy pressures to substitute industrial magic for the arduousness of traditional work. In the early years of photography, analogies were commonly drawn between the operation of light in photography and the operation of steam in the production of industrial power. In 1856, for example, the archaeologist and writer Léon de Laborde wrote: "Yesterday, steam, that eloquent expression of modern society, was giving a powerful helping hand to all industrial products imbued with the influence of the arts; today photography, the perfect ideal of mechanical art, is initiating the world to the beauties of divine and human creations."[115] Emerson's photograph recalls this industrial affinity. The men in the boat encounter the old mill and the new; the viewer encounters a photograph representing the picturesque. Both the encounter *within* the photograph and the encounter *with* the photograph participate in a moment of social and technological transformation.

The Old Order and the New invites us to take this analogy further. It invokes not only the transformative modernization of mills but also that of pictures. Although no painting appears in the picture, the center of the composition is dominated by a stretched canvas, a sign for the old order of painting that photography was threatening to render obsolete. The mottled blankness of the sail may subtly suggest the desuetude of canvas as a pictorial support, echoing the obsolescence of the windmill and its orthogonal blades. Or it may simply offer an occasion for Emerson to assert the capacity of photography to take the humble surfaces

of the world as they are, to take canvas as canvas, and to produce an experience of aesthetic delight. In this respect, Emerson makes a stronger claim for the medium than Rejlander did. Whereas Rejlander stitched together negatives to make a painterly picture, Emerson has seized a moment when the accidents of unruly form have done the stitching for him. Harnessing chance, he has made a photographic picture out of the very stuff of painting.

Emerson's brilliant handling of vapor and modernity is evident in another extraordinary and much reproduced picture, the photogravure *A Stiff Pull,* from *Pictures of East Anglian Life* (Plate 3). *A Stiff Pull* depicts two horses drawing a plow up a slope, with a farmer guiding the implement from behind. The composition sets the horses monumentally against the sky, giving them the feel of mythic iconography, as if they were rustic echoes of the horses taking the chariot of Apollo heavenward. Counteracting this empyrean association is the palpably rendered field of dirt. The rural life Emerson depicts, however passionate its aspiration, remains earthbound. The contradiction recalls the picture often attributed to Pieter Bruegel the Elder of Icarus falling into the sea while the oblivious farmer, focused on the task at hand, plows on. But in *A Stiff Pull,* heavenly aspiration and loamy anchorage collapse into the single unit of farmer, plow, and horses. Plowing row after row, turning the soil, lodged in his work, Emerson's farmer is more Sisyphus than Icarus, his horses more godlike than he.

The masterful printing of *A Stiff Pull* has brought out the best of photogravure. The charcoal-like smudging of the clouds, the gleaming hindquarters of the horses, the delicate structure of the harness and plow, the granular palpability of the dirt: Emerson has stressed each disparate element and yet made them cohere. The body of the farmer, blurred by labor, bears within its form the tonal structure of the picture as a whole. His trousers draw darkness up from the soil, while the light striking his shoulders and upper back pull them into the sky. The dark silhouette of his head and hat echoes that of the horses, establishing a sympathetic bond. The sheer materiality of the world seems to deliver all relations and forms. The clouded sky, tactile but vaporous, rises above the scene, its mingled values seemingly definitive of all pictorial possibility.

Although Emerson had devised a powerful combination of theory and practice, he nonetheless recanted the argument of *Naturalistic Photography* soon after the first edition of the book appeared. In a pamphlet he had printed in 1890 entitled *The Death of Naturalistic Photography*, he announces

that he is casting all the teaching and views of *Naturalistic Photography* on "the dust-heap."[116] He offers a succinct rationale for his change of mind:

> To you, then, who seek an explanation for my conduct, Art—as Whistler said—*is not* nature—is not necessarily the reproduction or translation of it—much, so very much, that is good art, some of the very best—is not nature at all, nor even based upon it—*vide* Donatello and Hokusai.
>
> The limitations of photography are so great that, though the results may and sometimes do give a certain aesthetic pleasure, the medium must always rank the lowest of all arts, *lower than* any graphic art, for the individuality of the artist is cramped, in short, it can scarcely show itself. Control of the picture is possible to a *slight* degree, by varied focusing, by varying the exposure (but this is working in the dark), by development, I doubt (I agree with Hurter and Driffield, after three-and-a-half months careful study of the subject), and lastly, by a certain choice in printing methods.
>
> But the all-vital powers of selection and rejection are *fatally* limited, bound in by fixed and narrow barriers. No differential analysis can be made, no subduing of parts, save by dodging—no emphasis— save by dodging, and that is not pure photography, impure photography is merely a confession of limitations. A friend once said to me, "I feel like taking nearly every photograph and analyzing it." Compare a pen and ink drawing by Rico or Vierge, in Pennell's book. I thought once (Hurter and Driffield have taught me differently) that true values could be obtained and that values could be *altered at will* by *development*. They cannot; therefore, to talk of getting the values in any subject whatever as you wish and of getting them true to nature, is to talk nonsense.[117]

In the short span of a year Emerson had drastically lowered his estimation of photography as art. Although he continues to insist that art requires "a differential analysis" and a "subduing of parts," he no longer believes that differential focus and other photographic strategies can supply them. Whereas he had previously asserted that the limited selection powers of the photographer only heightened his or her achievement, he now finds them debilitating. When he writes that "the all-vital powers of selection and re-

jection are fatally limited," he returns, as so many had done before, to the test derived from Reynolds. In an abrupt shift, he posits a deep cleft between nature and art. Although writers on the tract usually emphasize the limits of darkroom manipulation that Hurter and Driffield had discovered, these limits alone cannot account for Emerson's turnabout. Whereas he had previously located poetry in nature, he now finds it in "the individuality of the artist."

A meeting that Emerson had with Whistler in 1890 may have played a key role in his recantation.[118] What we know for certain is that soon after the meeting Emerson abandoned his old position and abruptly embraced views associated with Whistler and the art establishment more generally.[119] Like Cameron and other Victorian photographers of high ambition, Emerson doubtless found himself squeezed between an often intellectually dry or socially uncouth photographic establishment and an engaging and privileged community of painters and other artists, who often disparaged photography's potentials. There are signs that Emerson came to feel very quickly after the first edition of his book appeared that he had become too much like the pontificating photographic amateurs he despised. In his "epitaph" for naturalistic photography, he credited the doctrine with many good acts, including the furtherance of "monochrome photography to the utmost of its limited art boundaries," but also suggested that it "encouraged many amateurs to babble and make the words 'art,' 'truth,' and 'nature,' stink in the nostrils of serious artists."[120] In becoming a booster of naturalistic photography, Emerson had, to his chagrin, abetted the airy pretensions of a swelling class of rule-quoting enthusiasts.

Emerson had good reason to flee a close association with the "babble" of the amateurs. At the time, the trend now known as pictorialism was becoming a monotonous set of conventions, and photography competitions and journals brimmed with photographs of moody landscapes, rustic maidens engaged in simple domestic chores, and wistful scenes of old-world charm. Such picturesque subjects were repeated in prose and practice with stultifying consistency. In 1888, Enoch Root, a Chicago photographer, offered a typical prescriptive list: "Nature abounds in beautiful compositions of some form or another in every locality. An old dilapidated building, with its picturesque surroundings; a group of cattle in a brook; a winding path among overhanging trees; the buttressed ledge of rocks, with sunlit, trailing

vines over dark recesses reflected in some limpid pool; the rock-bound streamlet; the gnarled, fantastic tree trunk—pictures everywhere."[121] Constable's hope that nature would yield up picturesque accidents had become a stock list of artistic subjects, promulgated by photographic journals and memorized by legions of earnest amateurs. Nothing was more predictable than this version of the chance encounter.

The pictorialist adherence to gentle vapors and soft focus was equally strict. In 1892, Edward Wilson, editor of the journal *Photographic Mosaics,* welcomed the abundance of landscapes "with the indefinable outlines and soft atmospheres of Nature." "Here," he continued, "they show us sunlight filtered through a summer's morning mist and haze; there, clouds and wind careening madly over bleak moorlands."[122] Davison's pinhole photographs and other soft-focus work were regularly praised and widely imitated for their atmospheric effects. Emerson by no means bore sole responsibility for initiating or sustaining pictorialism, and his specific tenets and recommendations, as we have seen, could run counter to those of Davison and other soft-focus adherents, but his sense of complicity in the herdlike pursuit of misty sentimentality is understandable.

Curiously enough, Emerson responded in practice to his disillusionment by doubling down on vapor and accident. His final photography books, *On English Lagoons* (1893) and *Marsh Leaves* (1895), are all about the transmuting powers of murk. In *Marsh Leaves,* a slim volume containing sixty-five prose sketches and sixteen photogravures, this thematic emphasis is nearly incessant. We read of "steaming breath," "black, sluggish vapour," "misty moonlight," "ethereal golden vapour," "whitening mists," "wreaths of grey vapour," an atmosphere of "cobweb grey," "gossamer wrapped round the horizon," and a "pale, vapouring grey-blue sky."[123] Emerson associates this atmospheric indistinctness with randomness and error. Locals, quoted in dialect, recount shooting mishaps and capricious anecdotal histories. Time unfolds in *Marsh Leaves,* as Ian Jeffrey has said, "inscrutably, in the fog and among accidents."[124]

In an anecdotal passage in *On English Lagoons,* Emerson associates accident with authenticity and individuality:

> "What's your name?" I asked.
> "Thientific, that's my name sir, though some on 'em call me 'Chizzles,' cause I was prenticed to a carpenter."
> "Who gave you the name, 'Thientific'?"

"Well, sir, I was crowding of coal. I was doing the job, and I crowded out about forty seven ton of coal unloading a wherry, when a man whistles to me *wheit*. I went and shot eleven mallard out of twelve with one shot, and Mr. Jay see the shot and he say, 'That's thientific,' and that name hev stuck to me."[125]

The accidents pile up thickly here: the man spotting the mallards, whistling to our protagonist, who—doubtless due in part to luck—bags eleven of the twelve birds with a single shot; Mr. Jay witnessing the event, misusing the word *scientific,* mispronouncing it due to his lisp, and then the name sticking. A name, the very mark of individuality, is here woven of random turns. Or, put another way, the odd accidents of this social backwater mark individuality as such, a mode of identification diametrically opposed to the utterly predictable labels ("the Bungalow," "Nelson Villa," "Victoria House") that Emerson assures us modernization will bring. Chance here is both the guiding principle of the blundering peasantry and a sign of a personal distinctiveness and authenticity doomed by the monotonous drone of commerce.

In *Marsh Leaves,* Emerson associates the mists with a romantic undoing of regular time. We learn of a raw-boned "Fenman" who disassembles a broken clock and puts the wheels back haphazardly "anywhere he could." Miraculously, the clock's hands move, but "went two hours to one of any other clock."[126] Emerson thus dislodges photography from the regular ticks and tocks of modernity, ripping apart the conjunction between the two that Talbot had fashioned in his photograph of Queen's College. Later in *Marsh Leaves,* Emerson describes a pocket watch: "She want frying. She'd no face on her, and her inside was out of order; she want to have a box o' liver pills."[127] The time of *Marsh Leaves* is sick time, feverish with reverie. Photography as regular mechanism has given way to photography as dream.

One of the many dreamlike photogravures in *Marsh Leaves* is *The Bridge* (Figure 4.9). As is the case with many Emerson pictures, the titular subject is subordinate pictorially to an atmospheric effect. In this case, a stream of vapor emitted by a locomotive slants across the sky above the bridge, curling back at the end, its billowing form reflected in the rippling water below. Anthropomorphic, as if it were a coal-fired genie with turned head and stumpy arms, the vapor inflects the tender pictorialist scene with a haunting agency. Ethereal but menacing, it bridges the two shores more markedly than the spindly trestle supporting the train.

Figure 4.9 P. H. Emerson, *The Bridge,* 1895, photogravure, from *Marsh Leaves.*
Courtesy of George Eastman House, International Museum of Photography and
Film

Or so it does when looked at in many reproductions. In the original book,
the horizontally composed photogravures are positioned so that the top of
the image runs along the binding. The user thus first encounters *The Bridge*
on its side, the plume and its reflection opening upward like a cursive letter
V. The shape is glyphlike, faintly legible, a vaporous crotch. At first encounter
we are disoriented, lost in a fog, seeing things but unable to make sense of
them. Atmospheric vapor has once again taken pictorial legibility to the
brink of dissolution. Looking for a lost world, we stumble upon a modern
picture.

Plate 1a William Henry Fox Talbot,
Queen's College, Oxford, 1843, salt
print from calotype negative
Canadian Centre for Architecture, Montréal

Plate 1b Detail of Talbot, *Queen's
College, Oxford*
Canadian Centre for Architecture, Montréal

Plate 2 Julia Margaret Cameron, *Madonna and Two Children*, 1864, albumen print from glass negative

Courtesy of George Eastman House, International Museum of Photography and Film

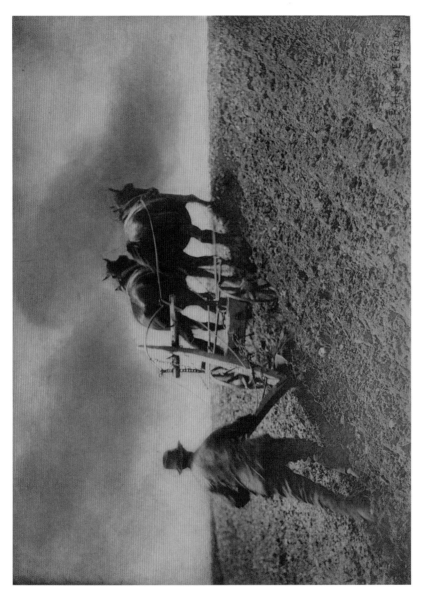

Plate 3 P. H. Emerson, *A Stiff Pull*, 1888, photogravure from *Pictures of East Anglian Life*

Courtesy of Houghton Library, Harvard University

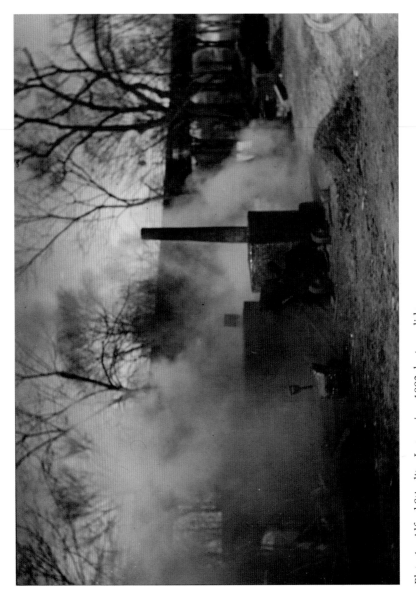

Plate 4 Alfred Stieglitz, *Impression*, 1892, lantern slide
Courtesy of George Eastman House, International Museum of Photography and Film

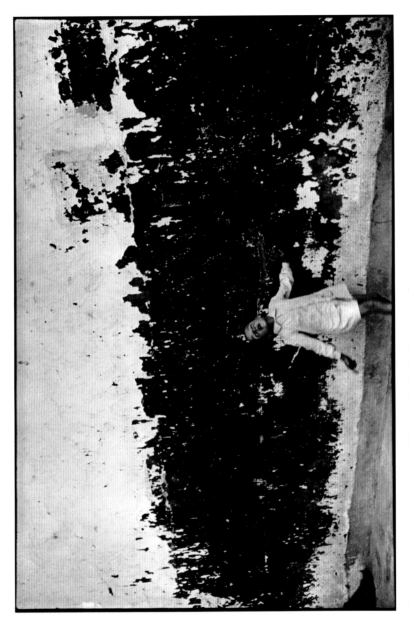

Plate 5 Henri Cartier-Bresson, *Valencia, Spain*, 1933, gelatin silver print © Henri Cartier-Bresson/Magnum Photos

Plate 6 Frederick Sommer, *Jack Rabbit,* 1939, gelatin silver print

Plate 7 John Baldessari, *Floating: Color*
Color Photographs
6 photographs, 14 x 11 inches each
Courtesy of John Baldessari

Plate 8 John Baldessari, *Throwing Three Balls in the Air to Get a Straight Line (Best of Thirty-Six Attempts),* 1973
Artist's Book
9 3/4 x 12 7/8"
(Detail)
Courtesy of John Baldessari

5

Alfred Stieglitz Moves
with the City

From a negative that the American photographer Alfred Stieglitz made in the winter of 1892–1893, he produced a lantern slide entitled *Impression,* now in the collection of the George Eastman House (Plate 4). The slide depicts an asphalt paving operation. The thick pin of a paver's chimney anchors the image, holding together the converging diagonals of an elevated railway and a graded road. Steam and smoke billow around the wheeled apparatus, smudging the surrounding forms and obscuring the spatial recession. A boy, whose form nearly merges with the oven, stoops to feed it with wood fuel transported with the aid of a small handcart. The fuel will keep the asphalt hot and properly viscous for spreading. Behind and to the right, stands a vague vertical form. It could be a man in natty attire, rendered ghostly by having moved during the exposure, or it could be a street light. The ambiguity is unsettling.

The picture mulls over the alchemy of modern life. The bare trees stand like the skeletal remains of an arboreal past, through which capital, with its iron and fire, asphalt and smoke, advances to accelerate people and property. Some trees will be spared to retain pockets of greenery, while others will be cleared to accommodate development. The contrast between the stark and erect smokestack and the obscure, stooping figure suggests the subordination of workers to industrial agency. Modernity appears as a turbulent transformation of matter, sustained by new burdens on human labor. All this transpires in an atmosphere of expenditure. The mists and fogs of the English fens have given way to the workaday vapors of the city street.

In the early 1890s, new photographic technologies were fulfilling an old dream. Daguerre and Talbot had each designed and promoted a process meant to enable any gentleman to make realistic pictures. To keep photography simple, Daguerre had built his camera with a fixed aperture.[1] "Everyone can use the daguerreotype to make views of his chateau or country house," he proclaimed.[2] Talbot had worked hard to streamline his photogenic drawing process, touting it as a means of dispensing with the need to acquire and exercise traditional skill. But despite these efforts and promises, early photographic processes, including those that Cameron and Emerson used, were tricky to master. Cameras and plates were bulky and cumbersome, and achieving much control in the darkroom required study and care. As a result, the production of photographs remained limited to professionals and serious amateurs. The typical user of photographs was strictly a consumer, collecting images through gift or purchase.

But the commercial dream of photography as an effortless way to make pictures lived on, and many tinkerers sought to fulfill it. Emerson's dry plates were easier to work with than Cameron's wet ones, but the dispositive moment arrived in 1888, when George Eastman introduced the first Kodak camera. It housed a roll of flexible celluloid film long enough for one hundred exposures. It had a wide-angle lens and a fixed aperture, enabling the owner to simply point and shoot. Once the limit of exposures was reached, the owner sent the entire camera back to Kodak, where the film was removed, processed, and replaced with a new roll. The owner then received by mail the reloaded camera and prints from the spent film. Although in subsequent years Kodak issued a steady stream of enhancements, including technology enabling the owner to send only the exposed film back to the company, its first camera had established the paradigm. As Eastman's slogan had it, "You press the button—we do the rest." Kodak technology renewed the promise of photography as a picture-making process of magical ease.[3]

The new handheld cameras were fast as well as convenient. In the decade before the first Kodak, Eadweard Muybridge in the United States and Étienne-Jules Marey in France had pioneered the use of speedy mechanical shutters and highly sensitive films to record bodies in motion with a minimum of blur. Whereas Talbot in 1851 had to resort to an electric spark in a darkened room to capture a sharp image of a moving subject (newsprint he had attached to a revolving wheel), photographers of the Kodak era could manage quite well in broad daylight.[4] Pictures circulated of people

midleap, birds midflight, and water midsplash. When the hunting term *snapshot* entered the popular photographic lexicon, it referred not only to the spontaneity with which someone could make a picture but also to the capacity of that picture to stop the world in its tracks.

Today it is difficult to imagine how disorienting so-called instantaneous photography initially was. People had never seen the world—and themselves—in this way before. At first the new images elicited much lurid fascination. In his annual review of 1888, the photographer and journal editor Edward Wilson offers this account of the new high speed technology:

> No sooner would things become real quiet than some bright-surfaced messenger would come and excitedly announce "a balloon caught on the ascent!"—a lightning flash arrested!—a cannon-ball exposed in its murderous career!—a group of racers gathered in two, two and a half, three, five feet from the winning post!—a bicycle wheel with its upper portion revolving more rapidly than the lower felloe!—a star located by its own track! A cyclone taken in the very act of emptying a lake of its water and whirling it up to the clouds!—a "local freight" shown up plunging headlong into the "Western Express!"—a thief caught with his fingers holding the plunder midway between his own and his victim's pocket! A murderer, with hand uplifted, under the electric light, in the act of striking the blow which cost two lives. Each day seems to bring some new "freak" for the museum of photographic possibilities, and the end has not come.[5]

Wilson's use of the word *freak* betrays both the radical novelty of instantaneous photography and the aggression with which pictorialists defended their aesthetic paradigm against it. Pictures of horses galloping, tornadoes whirling, and athletes leaping offered a mesmerizing world of violent and unpredictable motion that seemed to draw photography toward cheap and sensational pleasures and away from any artful pursuit of beauty. In the early years of Kodak, photography societies would occasionally agree to exhibit a photograph of a tennis player in action, but only as an experiment in the pictorial possibilities of high-speed work. To those steeped in nineteenth-century aesthetics, the sort of action photograph that became a staple of *Life* or *Sports Illustrated* in the twentieth century was borderline grotesque.

But the visual instants the new cameras snatched from an impatient world were unmistakably modern. They affirmed the power of chance to inject spontaneity and surprise into a material culture increasingly governed by mechanization. Freed of its tripod-demanding bulk, the camera had unprecedented mobility, and photographers began to roam city streets in search of new subject matter. Their fast-reacting films and quick shutters accommodated the pace of modern life. Taste gradually began to shift from stilted scenes of posed figures, dewy meadows, and desolate medieval piazzas toward dynamic images of urban bustle. The city spaces photographers encountered were changing and accelerating. Electric lamps were replacing gaslights, and electric trams were supplanting horse-drawn cars. Engineers were using steam-powered machines to pave roads with smoother surfaces to facilitate bicycle travel and other popular forms of transport and leisure. As the nineteenth century neared its end, the newly mobile camera met the newly mobile city.

This acceleration of photography and urbanism generated new roles for chance. Swift cameras and films revealed every passing minute to be loaded with fractional seconds of formal possibility. Promising arrangements on the city street came and went in a flash, making watchfulness and quickness essential. Both the chance encounter with a subject worthy of depiction (see Talbot's *The Open Door*) and the chance encounter afterward with an unexpected element in the photograph (see Talbot's *Queen's College, Oxford*) quickened and intensified. The visual field became a space of unconscious apprehension, from which the handheld camera drew fleeting and unforeseen pictures. The speed of the apparatus empowered the wielder of the camera but also challenged his or her control. Whereas the photographer seeking the picturesque encounter in the middle of the nineteenth century combined *trying* and *hoping* in the course of his explorations, the photographer wielding a handheld camera melded the two with a click of a shutter.[6]

The problem of photography as an artful process, which Talbot had so deftly finessed, thus returned with a vengeance. If a person with a Kodak camera could simply point and shoot, often unaware of the exact configuration of any moving forms before the lens, leaving development and printing to an industrial plant, what kind of art could photography be? While Eastman rolled out his remarkable new technology, members of photographic societies were still insisting that experience and skill were crucial

to pictorial success. In 1888, the London photographer Edward Dunmore offered this defense:

> Can any one suppose any accomplished painter made grand pictures as soon as he knew how to manipulate colors? And yet many photographers expect to do so directly [once] they have acquired sufficient skill to make a negative. The idea is absurd. Years of study and practice, and many disappointments, must necessarily be experienced before a clever and finished work can be exhibited for public criticism. Why, then, should the photographer be an exception to the rule, and why should one who has really greater difficulties to contend with imagine he can make a picture (except by accident, which in all probability can never be repeated) than a man who by laborious study has learnt, after many failures, to properly handle brushes and color?[7]

Although Cameron had claimed to make "unsurpassed" photographs in her first month as a practitioner, Dunmore and most other serious Victorian students of photography continued to insist on a firm proportion between laborious study and aesthetic achievement. According to Dunmore, photography was at least as difficult to master as painting, and therefore pictorial success in the one medium was as hard-earned as in the other. He grudgingly concedes in parentheses, however, that a neophyte could accidentally produce a photograph worthy of being called a picture. The possibility of pictorial success coming about by chance irritated Victorian defenders of photographic art like a pebble in a shoe. To fend off this threat of chance, Dunmore resorts to the notion of probability. The lucky novice, he suggests, would likely be unable to produce a second picture of the same quality; skill will show itself over time. His concession that the measure of artistic competence in photography must be probabilistic is more troubling than he acknowledges. It means that a photograph standing alone cannot reliably convey an intention or sensibility. It means that photographic art can happen only in the aggregate.

In the 1890s, photographers of artistic ambition responded to the technological watershed of their day by redoubling their efforts to overcome the mechanical aspects of the medium. The challenge was formidable. Decades of effort had largely failed to elevate photography to the status of a pictorial art, and every innovation making photography easier to practice

left would-be artists a steeper hill to climb.[8] With the introduction of the Kodak process, photography had lost even its lowly standing as a craft. It had become a diversion, like riding a bike. Not only did it require no traditional artistic skills, it seemingly required no skill at all. Desperate to find a way to signify artistic intent in their pictures, many practitioners began to manually work the surface of the photographic negative or positive print. They brushed, scratched, and rubbed surfaces to bring the aesthetically guided hand to bear on the production process. Various substances, most prominently gum arabic, were used to make the surface more amenable to manipulation. Such tactics allowed practitioners to claim that the resulting picture was replete with intention and not reliant on purely mechanical means.

The desire to make photographic labor visible was doubtless amplified by copyright concerns. In 1884, the Supreme Court had handed down a groundbreaking decision in Burrow-Giles Lithographic Company v. Sarony, a case concerning the unauthorized reproduction of a portrait photograph that a photographer named Napoleon Sarony had taken of Oscar Wilde.[9] Burrow-Giles argued that as mere mechanical reproductions photographs are not productions of an author and do not warrant copyright protection. Although the Court explicitly refrained from resolving this issue in general terms, it sided with Sarony on the particulars of the case, determining that he had carried out an "original mental conception" by posing Wilde in front of the camera and "selecting and arranging the costume, draperies, and other various accessories . . . arranging the subject so as to present graceful outlines, arranging and disposing the light and shade, [and] suggesting and evoking the desired expression."[10] By emphasizing selection and arrangement, the Court drew on hoary academic standards for the production of aesthetic value. Whereas Talbot had sought to vest creativity in the eye of the photographer, the Supreme Court insisted on finding it only in tangible signs of handiwork. When pictorialists hewed to stilted scenes with dramatic lighting and artificially posed figures, or experimented in surface marking, they may have been responding in part to legal pressures to demonstrate their authorship.

For aesthetically ambitious photographers, however, the embrace of surface manipulation was a problematic response to difficult times. It deliberately reversed the historical trajectory of photography by rolling back its automatism, pairing pictorialism's nostalgic return to rustic subject matter with a nostalgic return to manual marking. Because the often vague pic-

torial effects of this manual work were associated with fogs and mists, subject matter and process both trafficked in a taste for the vaporous. But this nostalgic appeal left pictorialists vulnerable to the charge that their work imitated other media and had abandoned photography altogether. The return to manual marking retreated from Talbot's radical relocation of creativity to the eye, thus raising problems he had proleptically sought to avoid. If the art in photography consisted of manual work, then why make an art of photography at all?

No one answered the challenges of these new circumstances more brilliantly than Stieglitz. The son of a prosperous American businessman who had emigrated from Germany, he took up photography while studying engineering in Berlin. He quickly adopted the practice of fashioning photographs in imitation of academic paintings and mastered the visual idiom of the picturesque.[11] Wistful scenes of rustic women laundering by the lakeside or resting after collecting brushwood, or of quaint medieval streets in slanting sunlight, became his stock in trade. His debt to Emerson was substantial and acknowledged, and for years he abided by his predecessor's preference for platinum printing and photogravure because these processes could suggest "atmosphere."[12] In 1890 he returned to the United States to live in New York City, where he struggled to practice his pictorialist principles within a New World milieu.

The best of Stieglitz's photography from the 1890s emerged from his doubts about pictorialism in America. In an 1892 essay entitled "A Plea for Art Photography in America," he writes:

> When we go through an exhibition of American photographs, we are struck by the conventionality of the subjects chosen; we see the same types of country roads, of wood interiors, the everlasting waterfall, village scenes; we see the same groups at doorsteps and on piazzas; the same unfortunate attempts at illustrating popular poetry; the same etc., etc., *ad infinitum.*
>
> Such attempts at original composition as we come across are, with some few meritorious exceptions, crude—that is to say, far-fetched and unnatural. In some cases, where the idea is undoubtedly good, the resulting picture shows an entire lack of serious study of the subject, and suffers from want of that artistic sense which loves simplicity and hates all superficial make-up. Simplicity, I might say, is the key to all art—a conviction that anybody who has studied the masters must

arrive at. Originality, hand-in-hand with simplicity, are the first two qualities which we Americans need in order to produce artistic pictures. These qualities can only be attained through cultivation and conscientious study of art in all its forms.

Another quality our photographs are sadly deficient in is the entire lack of *tone.* Those exquisite atmospheric effects which we admire in the English pictures are rarely, if ever, seen in the pictures of an American. This is a very serious deficiency, inasmuch as here is the dividing line between a *photograph* and a *picture.*

Atmosphere is the medium through which we see all things. In order, therefore, to see them in their true value on a photograph, as we do in Nature, atmosphere must be there. Atmosphere softens all lines; it graduates the transition from light to shade; it is essential to the reproduction of the sense of distance. That dimness of outline which is characteristic for distant objects is due to atmosphere. Now, what *atmosphere* is to Nature, *tone* is to a picture.

The sharp outlines which we Americans are so proud of as being proof of great perfection in our art are *untrue* to Nature, and hence an abomination to the artist. It must be borne in mind, however, that *blurred* outline and *tone* are quite different things.[13]

In this passage, Stieglitz affirms key precepts of pictorialism, including the importance of atmosphere and modulated sharpness, but criticizes the American pursuit of them. American pictorialism, he claims, was suffering from a predictability of subject matter, an excess of contrived or overwrought scenes, and a lack of compelling atmospheric effects. His jab at "superficial make-up" targeted excessive surface manipulation. Although he implored his peers to address these problems, Stieglitz was also searching for his own solutions.

In the winter of 1892–1893, Stieglitz decided to take a handheld camera into the streets of New York. He was by no means making a clean break from the rural retreats of pictorialism; in 1894, he would return to Europe to make serene photographs of women harvesting, spinning, and mending in bucolic surroundings. But he was momentarily abandoning the pursuit of those sleepy ideals and taking a fresh tack. Rather than resist the new handheld camera technology, he adopted it with discrimination. At a time when most of his pictorialist peers were concentrating instead on manipulating the surfaces of their large plates, his decision was bold. Although

questions linger about his equipment, he may have roamed the streets with a Tisdell & Whittlesey quarter plate (3¼-by-4¼-inch) detective camera now in the Stieglitz collection of the George Eastman House.[14] He almost certainly worked from dry plates, because his early results with celluloid film displeased him. Whatever his camera, he decided for a season to forgo efforts to find an atmospheric rusticity in America rivaling that of England and to turn instead to the turbulent streets of the city. Among the photographs he made that winter is *Impression.*

Impression has a ruddy tone that conveys a sense of warmth and vulcanism.[15] As the quoted passage from his "plea for art photography" would suggest, Stieglitz took toning very seriously. It was for him a means of providing a softening atmosphere without blur. He used an array of chemical solutions to produce warm (red, brown) and cool (blue, green-blue) tones in many of his slides from the 1890s, a fact obscured by the many reproductions in gray scale. In some cases, he toned the entire picture; in others, a particular subject. In his day the language of darkroom work was overtly atmospheric. A key issue in toning actually occurred during the development of the negative, when the photographer determined the extent of silver deposits on the areas of greatest highlight. Without such deposits, these areas would be clear glass and not take toning. Stieglitz favored depositing silver even in highlights, a development tactic called "fogging" the plate that enabled him to tone the entire image. *Impression,* for example, has no areas of clear glass.[16] Yet Stieglitz warned that the extent of the deposits should not be excessive. "Veil and fog are not synonymous in this case," he wrote. "Fog is always to be avoided in slides."[17] Stieglitz did not want the deposits to block too much of the light projected through the slide; he wanted viewers to experience an atmospheric radiance.

The term "fogging" suggests the extent to which vapor had become part of the structuring nomenclature and metaphors of photography. This integration was perhaps inevitable. Photography runs on light, and natural light is largely a function of the position of the sun and the condition of the atmosphere. When Stieglitz roamed the streets of New York, photographers of any consequence, whether or not they prized depictions of mists, clouds, or fog, had to be expertly sensitive to the effects of atmosphere on the photographic process. As he notes in the passage quoted above, atmosphere is "the medium through which we see all things." Light and atmosphere determined how any given emulsion would react when a plate was exposed. This fundamental relation followed photography

into the darkroom, where the effects of development were likened to those of vapor.

In making *Impression* and other photographs in the winter of 1892–1893, Stieglitz tore vapor from the countryside and put it on the city street. This move refashioned pictorialism radically. To be sure, there was an urban picturesque, with conventions for representing such subjects as the street urchin or the ragpicker, and a few serious photographers, such as Paul Martin in London, were experimenting with the handheld camera as a way to represent them. But what Stieglitz did that winter stands apart. In the early 1890s, the photographs selected for photography exhibitions and journals rarely if ever depicted the mingling vapors of the industrial city. A picture might represent the evening mist on the Thames or a dewy morning in a public park, but such "potted" forms of the picturesque were a far cry from an asphalt paver surrounded by fumes. Indeed, in the early 1890s, there was precious little art in any medium featuring such a subject.[18] The great paintings of rail-yard smoke and steam—including the four already mentioned: Manet's *The Railway,* Caillebotte's *Le Pont de l'Europe,* and Monet's *Le Pont de l'Europe* and *La Gare Saint-Lazare*—are familiar now, but in the early 1890s they remained obscure. Most Americans knew impressionism at best remotely and only for its scenes of gardens and countryside. The noteworthy Monet shows in New York in 1891 and Boston in 1892 stuck to pictures of such subjects, doubtless because they were thought most likely to appeal to American audiences. By 1897, a few photographers had joined Stieglitz in taking up the depiction of industrial vapors (in particular, Frederick Marsh and Godfrey Heisch contributed several pictures each of gasworks and other industrial subjects to the Royal Photographic Society exhibition that year), but the decision in 1892–1893 to use the restless gases of the city street as a subject for pictorial photography moved the medium into a new mode. The smoke and steam of *Impression* were clearly speaking to a turbulent present as well as a misty past. But what were they saying? Set within a modern city hell-bent on developing new fluid efficiencies, what might these vapors mean?

Although Stieglitz featured a turbulent atmosphere in *Impression,* he eschewed the soft or differential focus associated with pictorialism. Notwithstanding the gassy effluents billowing about the paver's oven, the slide is mostly crisp and clear, as were the others Stieglitz made that winter. Whereas Emerson had bound focal blur to atmospheric moisture, Stieglitz was separating them. To soften his atmosphere he instead used tone. His

adherence to a largely clear focus affirmed that the airy vagueness or obscurity in the image belonged to the world and not to a tired affectation. His photographs depicted a vaporous city but conveyed a desire to *see*. In hewing to a clarity of vision, Stieglitz was banking on his capacity to combine a European-educated sensibility with what one defender of photography called the "realism and love for hard, positive facts, so natural to the American temperament."[19]

Stieglitz's rejection of soft focus has often been lauded as a modernist turn toward a more purely photographic aesthetic. In critic Sadakichi Hartmann's famous essay of 1904, "A Plea for Straight Photography," Hartmann reviews an exhibition organized by Stieglitz and fellow photographers Joseph Keiley and Edward Steichen. In the review, Hartmann takes pictorialism to task for its "general tendency towards the mysterious and bizarre" and its inclination "to suppress all outlines and details and lose them in delicate shadows, so that their meaning and intention become hard to discover."[20] He laments the "trickeries" pursued in the effort to make photographs into pictures and wonders whether the resulting work is still photography or "merely an imitation of something else."[21] Why, he asks, "should not a photographic print look like a photographic print?" He advocates a turn toward the "straightforward depiction of the pictorial beauties of life and nature," holding up Stieglitz's *Winter on Fifth Avenue* as an exemplar (Figure 5.1).[22] Although acknowledging that Stieglitz had "eliminated several logs of wood that were lying near the sidewalk," he nonetheless deems the picture properly photographic. He notes that Stieglitz, although a defender of gum bichromate practitioners and their manual manipulations, drew as much pictorial value from the world as possible and kept manipulation to a minimum.

But this standard account of the emergence of "straight" photography presumes too readily that a notion of "the photographic" was self-evident. The question of what belongs intrinsically to photography and what does not is resolutely historical. Stieglitz would not have accommodated an American taste for "hard, positive facts" through sharp focus unless blur had lost some measure of its atmospheric appeal. The historical causes of this loss are surely complex, but changes in the meaning of photographic blur outside pictorialism may have affected Stieglitz and the more perspicacious of his peers.

In this regard, the photographic experiments of Francis Galton in the 1870s may be important. In a series of infamous experiments with

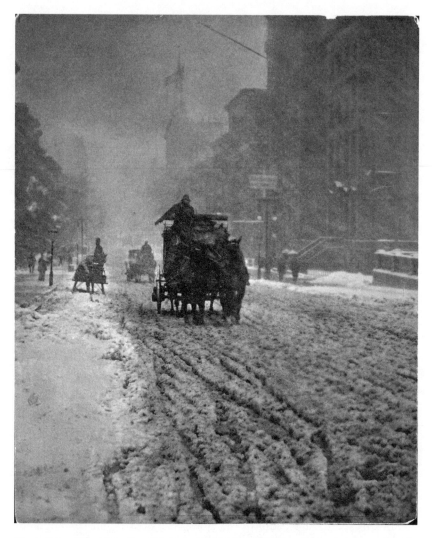

Figure 5.1 Alfred Stieglitz, *Winter on Fifth Avenue*, 1893, carbon print. Courtesy of George Eastman House, International Museum of Photography and Film

composite photography, Galton had given blur a statistical value (Figure 5.2). His aim was to establish a correspondence between personal appearance and a typology of character traits. Belief in physiognomy (the idea that facial features indicate character traits) or phrenology (the idea that head shape does the same) has a history stretching back to ancient times, but some Victorians saw in photography an opportunity to strengthen its sci-

Figure 5.2 Francis Galton, *Comparison of Criminal and Normal Populations.* From Karl Pearson, *The Life, Letters and Labours of Francis Galton,* vol. 2, *Researches of Middle Life* (Cambridge, 1924). Copyright © 2011 Cambridge University Press, reprinted with permission; Image courtesy of The Boston Athenaeum

entific basis. Galton, notoriously interested in regulating human reproduction to produce superior human beings, sought to establish a physiognomic typology grounded in categorical analysis and statistical measurement.[23] By merging portrait images of several individuals of a particular categorical type—for example, arsonists or Jews or Anglo-Saxon engineers—Galton believed he could suppress accidental facial characteristics and distill a type's essential look.

Galton proceeded systematically. If he had ten arsonists, he would expose each face to the photographic plate for one-tenth of the ordinary exposure time, giving his subjects equal weight and keeping all variables of distance, framing, and focus constant. The final image was more than a physiognomic average; it was a statistical distribution in pictorial form.

Where the features of the composite face were clear, the individual instances had held closely to the mean; where they were blurred, the distribution was broader. Like James Clerk Maxwell, Galton had looked into atmospheric diffusion and found probabilistic data. His composites offered bell curves in the form of a portrait.

Widely discussed and reproduced, Galton's composite photography intervened in a contentious and often confused Victorian discourse on the relationship between individuals and types. An old strain of thinking with roots in Plato regarded the essential type as a paragon, an imagined perfect specimen of which encountered instances were but degenerate replicas. A newer approach regarded the essential type as a kind of statistical average, from which individual specimens drifted, variable to variable, in one direction or another. Quetelet's "l'homme moyen" or "average man" was a prominent example. Some radical Victorian thinkers ventured into a full-blown nominalism that made averages mere conveniences. In producing his composite photographs, Galton mixed old and new by seeking a typological essence in the average of individual specimens. He turned the fuzzy photographic contour into a statistical index and defined the type by the distributions that bunched about the mean. The arsonist could be seen in the patches of clarity that these bunched distributions produced.

Galton's practice thus threw a wrench into debates about which was more truthful or natural in photography, sharp or soft focus. Many practitioners of sharp focus claimed that their approach more honestly engaged with things as they are or as we mentally apprehend them, while many pictorialists took the position that a softer focus suppressed accidental details and brought out essential forms. Some writers on photography struck a balance by asserting that sharp focus brought one closer to scientific truth, whereas soft focus brought one closer to artistic truth. Galton approached this conversation tangentially by devising a scheme that made the degree of sharpness a statistical quality, so that both the sharp and soft areas of the image delivered information about the sample and thus allegedly the type. This information distilled the essential from the inessential. Where the composite was relatively sharp, the essential traits of a physiognomic type were allegedly revealed. The more blur, the weaker the correlation.

The Galton example demonstrates that photographic blur in Victorian England had an unstable meaning. Blur could suggest an ineffable registration of timeless truths or mere statistical noise. Pictorialists had no monopoly on its significance. As time went on, the basic act of putting the

world out of focus increasingly seemed a photographic trick unable to support claims to aesthetic superiority. The pursuit of soft focus in the name of pictorialism came to seem as thoughtlessly determined by popular taste as the pursuit of sharp detail by legions of Kodak users.

By using a handheld camera on the streets of New York to depict its vapors clearly, Stieglitz made a new subject of modern atmosphere. His approach implied that the materiality of gases mattered as much as their modulation of visibility. He underscored the point in *Impression* by representing the emission of vapors at their industrial source and associating them with the transformation of the street. Held fast by his apparatus, these vapors do not belong vaguely to nature or even to modernity; they belong to a particular city at a particular time.[24] The larger meanings of his work that winter in New York ripple outward from that insistent specificity.

While pictorialists sought out scenes of rustic tranquility, New York was remaking its infrastructure. This transformation relied heavily on putting matter through its phases. The steam engine, the prime technology of industrialization, generated power by changing a liquid into a gas, and industry multiplied the powers of such material mutation over time. Asphalt had to be heated to over three hundred degrees Fahrenheit and spread while molten. It retained a resilient sponginess after cooling, making it a suitable surface for a more fluid society. Material phase changes were both practical instruments and powerful metaphors for the historical transformations that modernity was effecting.[25] "All that is solid melts into air," as Karl Marx and Friedrich Engels famously put it.[26] In making *Impression,* the scientifically trained Stieglitz used his own alchemical processes to combine the resilience of brick, the molten state of asphalt, and the evanescence of fumes.

Victorians subjected the gaseous state of matter to intensive scrutiny. The behavior of gas particles had baffled investigators until Maxwell, in a manner akin to that of his contemporary Darwin, considered how chance might help explain it. In 1850, soon after a review by Herschel of Quetelet's *Theory of Probabilities* appeared in the *Edinburgh Review,* Maxwell, then a student at Edinburgh University, wrote in a letter to his friend: "They say that Understanding ought to work by the rules of right reason. These rules are, or ought to be, contained in Logic; but the actual science of Logic is conversant at present only with things either certain, impossible, or *entirely* doubtful, none of which (fortunately) we have to reason on. Therefore the true Logic for this world is the Calculus

of Probabilities, which takes account of the magnitude of the probability (which is, or which ought to be in a reasonable man's mind)."[27] According to Maxwell, chance was not merely operative at the margins of a deterministic universe, it was at the heart of any scientific understanding of the world.

Maxwell developed his kinetic theory to contend with the complex mechanics of particle motion in gases. In 1856, August Krönig had proposed treating the behavior of gas particles stochastically to address the otherwise insurmountable challenge of accounting for the paths of each particle through calculation. He wrote in an article that if "the wall facing the gas atoms is regarded as very rough, the path of each molecule must be irregular and its calculation impossible. Yet according to the laws of the theory of probability one is able to assume, in spite of this chaos, complete uniformity."[28] As did several of his leading scientific peers, Krönig turned to the laws of probability to cope with a daunting calculus. Fellow German physicist Rudolf Clausius soon offered a more refined kinetic theory of gases that distinguished atoms from molecules and introduced the notion of the mean free path, which enabled him to tame the chaos of particles with statistical approximations. Maxwell then took the probabilistic modeling of particle behavior to another level of subtlety by moving away from mean values for velocity and toward a distribution curve. In May 1859, he wrote in a letter: "Of course my particles have not all the same velocity, but the velocities are distributed according to the same formula as the errors are distributed in the theory of 'least squares.'"[29]

Maxwell's use of the error distribution curve or normal distribution to account for the behavior of gas particles was a scientific turning point. The curve had arisen from efforts to apprehend the statistical regularity of errors in astronomical measurement. In the seventeenth century, Galileo had first noticed that small errors were more frequent than large ones, and that errors were distributed symmetrically around a particular value, an insight later refined by Laplace and Carl Friedrich Gauss, who demonstrated that these errors followed a bell-shaped curve. In 1846, Quetelet reported that the physical characteristics of human populations (he used the height and chest measurements of soldiers in his famous examples) tended to abide by this same curve. Maxwell, by trenchantly suggesting that the velocities of gas particles adhered to this curve as well, brought the normal distribution to bear on a physical process in a new way. Probability was no longer only a means to account for measurement errors, population characteristics, or regulari-

ties in human activity; it was also a way to understand the fundamental behavior of matter in a gaseous state.

Maxwell's probabilistic approach represented a decisive move away from Newtonian mechanics. In a lecture he delivered at Cambridge in 1871, he said:

> In applying dynamical principles to the motion of immense numbers of atoms, the limitation of our faculties forces us to abandon the attempt to express the exact history of each atom, and to be content with estimating the average condition of a group of atoms large enough to be visible. This method of dealing with groups of atoms, which I may call the statistical method, and which in the present state of our knowledge is the only available method of studying the properties of real bodies, involves an abandonment of strict dynamical principles, and an adoption of the mathematical methods belonging to the theory of probability.[30]

In grappling with the fundamental properties of matter, probability had begun to supplant the mechanistic tracking of individual bodies as the leading method. Whereas Newtonian mechanics had done wonders to account for the grand scheme of celestial motion, Maxwell's kinetic theory served to model the behavior of particulate matter taken in the aggregate, laying the foundation for what would become statistical mechanics.[31]

With Maxwell's theory, the cloud of gas, which many Romantics had taken as exemplary of the ultimate resistance of the world to lawful explanation, had become subject to probabilistic calculation. Billowing smoke and steam, such as that depicted in *Impression*, could no longer be assumed to escape scientific mastery. Indeed, they could be regarded as by-products of a new calculus, which the modern market and state were harnessing for instrumental purposes. While Maxwell was devising his models for statistical mechanics, he was also providing the theoretical basis for industrial devices, such as the governor, which regulated the speed of the steam engine.[32] The industrial science of matter, by accepting the epistemological power of chance, had begun to colonize the cloud.

In the early 1890s, the scientifically informed Stieglitz had multiple reasons to distance vapor from the saccharine mysteries of the countryside and the soft focus of pictorialism.[33] Galton's equation of blur with statistical noise had reinforced doubts about whether soft focus delivered much

beyond meaningless uncertainty or fuzzy logic. Meanwhile, the statistical modeling of gas mechanics by Maxwell and others had extended the reach of science into vapors previously thought to be impervious to its methods. Add to that Stieglitz's own concern that American pictorialism was mired in tired and contrived forms of sentimentality, and his decision to take an invigorating modern approach to the representation of vapors makes considerable sense. Without a doubt, he still wanted the modulating visual effects that vapor provided, but he wanted those effects to signify differently. The smokes and steams of *Impression* speak without wistfulness to the profound material remaking of New York. In them, the play of happenstance seems utterly compatible with modernization and its troubling dissipations.

Stieglitz's tendency to exhibit his winter photographs of New York streets as lantern slides had atmospheric implications of its own.[34] In 1897, several of the street pictures were among the forty-two lantern slides he showed at the annual exhibition of the Royal Photographic Society in London. Stieglitz considered the lantern slide to be an American invention, and his use of it was part of his effort to reinvent American pictorialism. The Society kept to its usual practice by displaying the slides by means of an optical lantern.[35] Optical or magic lanterns were popular devices, and Maxwell himself had experimented with them, inventing a means of using filters to produce a color image.[36] The optical lantern came in many forms, but all cast an image of a slide on a screen by means of a boxed lamp that projected a beam of light through an aperture fitted with lenses. Light passed through the slide to make a spectral projection many times its size.[37] The effect was softening, diffusing, and dramatically illuminating. Even when looking at Stieglitz's lantern slides on a light table today, light permeates and enlivens each small picture, especially any vaporous parts, in ways that printed reproductions cannot convey.

In London, projection of the slides enlivened the atmosphere of the exhibition room. As an optical lantern's light beam crosses a darkened space, it reveals ordinarily invisible dust motes dancing randomly in its path (Figure 5.3). The projection of *Impression* thus illuminated the airy wonder of modernity in both virtual and real space. While the beam of light threw the image of turbulent vapor on a screen, it disclosed particulate turbulence in the room. In 1897, this interface of magical atmospheres would have had a distinctly social cast. The tumbling motes within the beam of light, the mingling gases of the city street depicted in the image, and the

Figure 5.3 Joseph Bradford teaches an architectural history class using the first electric slide projector at Ohio State University, 1895. Photo courtesy of The Ohio State University Archives

buzz of the London streets outside would have converged in the social experience of those present. Whereas a photographic print on an exhibition wall would have concentrated the attention of one or two people at a time, lantern projection drew together a room of viewers. By exploiting the peculiar qualities of projection, Stieglitz made grappling with the modernization of his day a matter of social attention.[38]

Into this space of social concern, the illuminating beam of the projector would have borne religious and scientific associations. The revelation of motes was a Romantic trope for mortal transience, recalling the moment in Genesis in which God breathes life into dust. The optical lantern was a machine of microcosmic creation, bringing an animating light into darkness. As Percy Bysshe Shelley wrote, "When the lamp is shattered / The light in the dust lies dead—/ When the cloud is scattered / The rainbow's glory is shed."[39] When *Impression* was projected in London, the dancing particles in the beam would have mirrored the swelling vapors depicted in the shimmering image, animating the latter through this association. Shelley had bound dust and vapor in his lines, and Ruskin had written: "Aqueous vapor or mist, suspended in the atmosphere becomes visible exactly as dust does

in the air of a room."[40] As puffs of random particles, both dust and vapor were signs recalling Victorian scientific debates about particulate motion and Maxwell's famous theory about the internal dynamics of gases.[41] Via connotations of romantic yearning, scientific inquiry, and industrial magic, the double illumination in the act of projection would have conveyed—in ways that are now difficult to retrace—the social, material, and intellectual turbulence of modernity.

Doubtless aware that exhibiting slides of gritty New York streets as works of art was risky, Stieglitz worked hard to manage their reception. In 1897, the same year he showed *Impression* and other slides at the Royal Photographic Society exhibition, journals published two articles by him defending the aesthetic potential of his experiments. In the article quoted above, he defended the lantern slide, while in the other he defended the hand camera. In the latter, an essay entitled "The Hand Camera—Its Present Importance," Stieglitz takes pains to distinguish his approach from that of the ordinary "button-presser." The difference, he claims, concerns the role of chance. He writes: "The majority of hand camera workers [shoot] off a ton of plates helter-skelter, taking their chances as to the ultimate result. Once in a while these people make a hit, and it is due to this cause that many pictures produced by means of the hand camera have been considered flukes. At the same time it is interesting to note with what regularity certain men seem to be the favorites of chance—so that it would lead us to conclude that, perhaps, chance is not everything, after all."[42] In this passage, Stieglitz acknowledges that the handheld camera would allow the careless snapshooter to make a successful picture through luck. Struggling to secure criteria to distinguish photographic art, he suggests that what separates the great photographer from the everyday "button presser" can be expressed in terms of probability. Whereas the "button presser" will rarely make a lucky shot, Stieglitz will produce fine pictures with some frequency. This probabilistic understanding of artistic excellence, which echoes Dunmore's formula, is a peculiarly modern notion. It makes photography into a statistical distribution that reveals proficiency in the long run.

When using a handheld camera, according to Stieglitz, the key is patience. He explains: "In order to obtain pictures by means of the hand camera it is well to choose your subject, regardless of figures, and carefully study the lines and lighting. After having determined upon these watch the passing figures and await the moment in which everything is in balance; that is, satisfies your eye. This often means hours of patient

waiting." But even patience does not automatically yield success. In describing a particular photograph he took, Stieglitz acknowledges that "the result contained an element of chance, as I might have stood there for hours without succeeding in getting the desired picture." Stieglitz recommends combing the city for a visually promising site, and then waiting patiently there for the good fortune of witnessing a compelling configuration of figures. His approach makes the city into a scattering of more or less accidental outdoor stages, outfitted with propitious lines and lighting. Happenstance then populates these stages with anonymous actors following no script but the responsibilities, habits, or whims of modern life. In the 1850s, Oscar Rejlander had sought to make photography into art by stitching posed scenes into a theatrical whole; forty years later, Stieglitz advocated taking a setting from the street and letting the unpredictable dynamism of city life supply the drama. The players—his "figures"—could be vapors as well as people. In making many of his early pictures on the streets New York, the moment when "everything [was] in balance" was when the unpredictable flow of atmospheric turbulence and human bodies had inadvertently become a picture. One moment before and one moment after, everything would be different. Serendipity came in the click of a shutter.

Asphalt paving may seem like poor dramatic fare, but in the winter of 1892–1893 it was a matter of great interest in New York. Photographs by Stieglitz of asphalt paving, such as *Impression, Asphalt Paver,* and a lantern slide now known as *Asphalt Paving beside Smoking Kettle,* captured a city reinventing its streets (Figure 5.4). The craze spurring the change was the bicycle. In the late 1880s, the development of the pneumatic tire and the chain drive, which obviated the need for a very large front wheel, greatly enhanced the safety and comfort of the bicycle as a form of recreation and means of transport. In the early 1890s, sales of the new "safety bicycles" boomed, and the modern city began to shift its infrastructure, appearance, and rhythms to accommodate the demand. Today, the association of the modern road with the automobile is so strong that we tend to forget that it was the bicycle that first inspired the turn to smooth pavement. The experience of a swift bicycle ride on a flat road was exhilarating. As one contemporary wrote, "Cycling is the perfection of motion, more like what flying must be than anything that has ever been tried."[43] The bicycle afforded its rider a heady independence as well. The new technology had the capacity to foster democratic social change, especially for women.[44] By 1896,

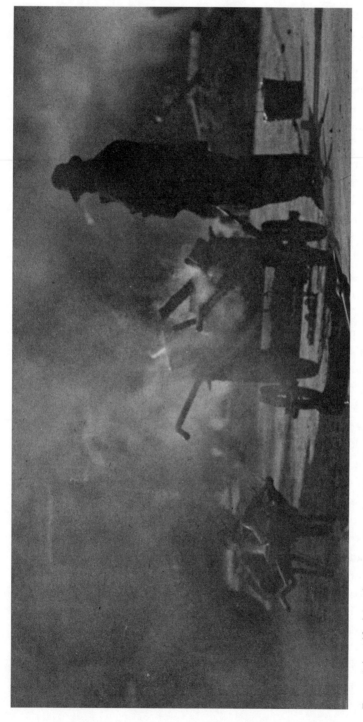

Figure 5.4 Alfred Stieglitz, *Street Paver beside Smoking Kettle*, c. 1893, lantern slide. Courtesy of George Eastman House, International Museum of Photography and Film

the suffragist Susan B. Anthony could aver: "The bicycle has done more for the emancipation of women than anything else in the world."[45]

As modernity entered a phase of unprecedented personal mobility, the near simultaneous emergence of the safety bicycle and the handheld camera around 1890 linked the two technologies in both the industrial economy and the popular imagination.[46] Companies popped up that specialized principally in the manufacture of the two products. Indeed, Folmer and Schwing, a company that produced a handheld camera Stieglitz owned, was a gas light and bicycle manufacturer that initially sold cameras as accessories.[47] The mounting of cameras on bicycles quickly became a fad, and in 1897, George Eastman introduced the "Bicycle Kodak," which was designed for that purpose. The combination of bicycle and camera brought speed, quickness, and spontaneity to the perceptual experience of the city. According to the landscape historian J. B. Jackson, the mobile modern subject experienced a different nature: "An abstract nature, as it were; a nature shorn of its gentler, more human traits, of all memory and sentiment. The new landscape, seen at a rapid, sometimes even terrifying pace, is composed of rushing air, shifting lights, clouds, waves, a constantly moving, changing horizon, a constantly changing surface beneath the ski, the wheel, the rudder, the wing. . . . To the perceptive individual there can only be an almost mystical quality to the experience; his identity seems for the moment to be transmuted."[48] The safety bicycle and the handheld camera were part of an acceleration and fragmentation of human experience. Whereas the bicycle sped up the experience of surroundings, the camera quickened the possibilities to record and represent them. Although it is tempting to say that handheld cameras allowed photographers to record the experience of modern mobility, it is more accurate to say that they produced a new form of that experience. Indeed, the snapshot representing moving bodies in a static momentary pose recorded precisely what the subject flying by on his or her bicycle *could not* see.

In the winter of 1892–1893, due primarily to the bicycle craze, asphalt paving was transforming the city. Twenty years earlier, a Belgian chemist at Columbia University, Edward de Smedt, had developed a new method of paving with asphalt. In 1872, New York City tried out his new mixture on Fifth Avenue and in Battery Park. But these experiments did not immediately yield a surge in street paving. A decade or more later, most American roads, including those in New York City, remained rudimentary, their surfaces either cobblestone in high-traffic areas or simply dirt. In the

DRAWN BY A. CASTAIGNE. ENGRAVED BY H. DAVIDSON.

PARK AVENUE, NEW YORK, WITH ASPHALT PAVEMENT.

Figure 5.5 A. Castaigne, *Park Avenue, New York, with Asphalt Pavement,* 1893, from *The Century Magazine.* Courtesy of Widener Library, Harvard University

early 1890s, Americans enchanted with the safety bicycle launched what came to be known as the "good roads movement," petitioning both federal and local representatives for smoother and more resilient roads on which to ride. In 1892, 3,000 bicycle riders participated in the opening of a paved New Jersey road for bicycles, called the "bicycle railroad," and two years later Brooklyn opened a similar thoroughfare. In October 1893, *The Century Magazine,* a popular American monthly, published an article entitled "Street Paving in America." One of the engraved illustrations in the article depicts a new asphalt pavement on Park Avenue. Roller skaters— participating in another fad—enjoy the wondrous new pavement, while bystanders look on (Figure 5.5). By 1896, New York City had adopted asphalt as its standard paving material.[49]

Stieglitz therefore made his photographs of asphalt paving at a pivotal time, when bicycles, pavement, and photography were bound together. In his essay on the handheld camera, he grudgingly acknowledges the entwinement. The essay begins: "Photography as a fad is well-nigh on its last legs, thanks principally to the bicycle craze. Those seriously interested in its advancement do not look upon this state of affairs as a misfortune, but as a disguised blessing, inasmuch as photography had been classed as a sport by nearly all of those who deserted its ranks and fled to the present idol, the bicycle."[50] In this cantankerous passage, Stieglitz imagines that the camera fad is "on its last legs," because everyone has taken to wheels. He intimates that the fleeting popularity of the camera among the new bicycle enthusiasts had exacerbated the difficulty of establishing photography as an art medium. He seeks to distinguish his use of the handheld camera from the sport of taking snapshots around the city. Mobility must be guided by vision, he suggests, if it is to rise above aimlessness. Even in the midst of his snit, he recognizes the extent to which the modern world was being shaped by leisure and by the accelerations of a consumer-driven culture, an insight with which his photography was reckoning.

In the early years of the twentieth century, the young French photographer Jacques-Henri Lartigue would find a modern subject in the bicycle and its reckless freedoms, but for the elder Stieglitz the new machine held no allure. Unlike the sublime behemoths of train and steamship, the bicycle seemed an unserious affair, a leisure toy suited to the meandering pleasures of women, children, and idle men. This is doubtless why its kinship to the camera had to be quashed. Moreover, the bicycle had a shortcoming more directly related to pictorial photography: it produced no vapor. To find a new picturesque in the city, Stieglitz turned away from the bicycle and focused his attention instead on the structural transformation it was engendering. If the bicycle was too frivolous and formally inert to contribute directly to a new urban pictorialism, he would feature the fume-spewing machinery of the asphalt paver instead.

Taking up the subject of asphalt paving was an ingenious way for Stieglitz to grapple with the possibility of an urban pictorialism. The rustic idylls with which photography exhibitions brimmed often represented farmers and rural laborers working the land. Scenes of harvesting, haying, and plowing were common. By selecting the asphalt paver as a subject, Stieglitz found a way to address the working of the land in an urban context. At the time, of course, New York was a mecca for poor European immigrants,

many from southern or eastern Europe, and many having left rural lands in hopes of a better life. We know nothing of the boy at work in *Impression,* but not so long before the picture was made his parents may well have performed rural labor more in keeping with pictorialism. The paving movement of the 1890s literally resurfaced much of the city, covering old roads with a smoother, more resilient skin. Whereas the rural scenes of pictorialism waxed nostalgically about rootedness and tradition, Stieglitz's urban pictures meditated on mobility and change.

The reflexivity of the paving pictures is remarkable. While the city re-paved itself, Stieglitz engaged in his own alchemical experiments in improving modern surfaces, from carbon and platinum prints to glass slides. In slides such as *Impression* and *Asphalt Paving beside Smoking Kettle,* he brought the alchemies of road making and photography together, drawing on their common use of gaseous pressures and liquid processes to produce transporting pleasures. Road making and photography were linked in other ways as well. As the scholar Helmut Müller-Sievers has recounted, the steam roller and the film spool belonged to a large family of nineteenth-century technologies based upon the rotating cylinder, a distinctively modern kinematic principle not found in nature.[51] The kinship between road and photography extends back to the early photographic experiments of Nicéphore Niépce, who used asphalt (bitumen) as a light-reactive material. Although Stieglitz rejected spool film in favor of plates, his paving pictures, with their wheels and stacks, invoke this interwoven history of technological turns.

The close relationship of surface and gas invoked by Stieglitz's paving pictures has yet broader implications. Photography and roads both yielded modern surfaces that reduced the recalcitrant materiality of the world to a slick platform for vaporous possibility. Surface and gas are basic components of modern life: air pressure and tire, road and exhaust, daguerreotype and mercury vapor, touch screen and cloud computing. In the great flattening of modernity, ghostly emanations hover above our gridded surfaces. There is magic in this relation, but also the specter of substantial loss. In English, the term *gas,* which dates to the seventeenth century and is based on the Greek word for chaos, alternates in meaning between momentary delight (what a gas!) and bloated pretense (what a gasbag!). Stieglitz's title for his slide *Impression* speaks to the mutable evanescence and airy pretension attending the modern flatness of art.

Stieglitz's paving pictures unmistakably address the interdependence of vapor and grid. In a manner reminiscent of Turner's *Rain, Steam, and*

Speed and Manet's *The Railway,* they bind modern freedom and evanescence to hardened material constraint. Although asphalt was a new means of mobility, the pavers are mired in their work. The agonistic bond between cloud and geometry that philosopher Hubert Damisch found in Renaissance art returns in these pictures to question the brutal operations of an industrial order. In *Impression,* steam and smoke interrupt photographic transparency and obliterate much of the perspectival space it was designed to deliver.[52] The billowing clouds of smoke and steam that float above the new asphalt grade break down the order of the grid even as the machines that emit them work to perfect it.

The pictorial relationship between *Impression* and *Rain, Steam, and Speed* is particularly tight. In both images a railway has stiffened space into a linear thrust that transverses a vaporous dissolution. In the Turner painting, the brick bridge emerges from a swirl of rain and steam, hardening as it rushes toward the viewer, whereas in the Stieglitz photograph, the railway disappears at it comes closer, its regular marking of space dissolving into the smoke and steam of the paving apparatus. Stieglitz has also dropped the railroad's iconic smokestack to the ground, embedding it in a transforming urban infrastructure. Whereas *Rain, Steam, and Speed* depicts modernity's shocking onrush, *Impression* considers instead its volcanic alchemy.

Stieglitz's engagement with vapor in his street photographs of 1892–1893 is resolutely historical. Rather than indulge in trite sentiments about vanishing rustic beauty, he brought his camera into the very midst of urbanization. For him, vapor was an opportunity to have a go at chance, to see if he could opportunistically harness its formlessness on behalf of form. He was after an unfamiliar beauty, drawn from the unsettling aggressions and accelerations of modernization. The eroticism of *Impression* speaks to that ambition. Whereas Jupiter wrapped himself around Io in an amorous embrace, the steam and smoke in *Impression* enfold the figures more callously, the seminal ardor of the sky god having been replaced by the hard iron of the smokestack. The generative processes that Stieglitz caught in the act are more Hades than Zeus, the foreground an underworld of instrumental mastery and industrial ambition.

The pictures of paving are disruptive. They dispense with glittering window displays, fashionable strollers, and other stuff of modern urban fantasy. Instead, they offer the industrial underbelly of this dream—a moment of dirty labor, when crushed and molten minerals are poured and shoveled and graded in the midst of choking gas. The paving is a

Figure 5.6 Alfred Stieglitz, *The Terminal,* 1893, lantern slide. Courtesy of George Eastman House, International Museum of Photography and Film

resurfacing. Once it is complete, the history of the road and its remaking will be hidden. The boy bent under the labor of paving will be gone, and strollers, roller skaters, and bicyclists will appear. Stieglitz recorded a moment of transformation, when rock became liquid and liquid became gas. By drawing our attention to the thinning trees, billowing vapors, and stooping boy, he reminds us of the social costs that this transformation bore.

Perhaps the greatest picture that Stieglitz made in the winter of 1892–1893 is *The Terminal* (Figure 5.6). In 1894, he exhibited it as a carbon print at the Royal Photographic Society Exhibition in London, and in 1897, as a lantern slide at the same venue. The picture depicts the old New York City post office, where the Harlem streetcar line had its terminus and the

horse-drawn cars, having arrived from Harlem, turned and headed north. Vapor again plays a vital role. Steam rises from the horses' bodies, and carbon dioxide billows from their nostrils. These vaporous tufts speak to animal vitality, to warm-blooded processes of respiration and metabolism. They float like a connective tissue between the gray stone above and the white or muddied snow below.

In *The Terminal,* Stieglitz daringly asserts that everyday scenes of modernity can supply a monumental significance to rival that of antiquity. He renders the horses and the figure immediately before us as powerful sculptural forms. Above them, the neoclassical façade of the post office speaks to traditional authority, its unadorned entablature providing a classical rubric or measure for the dramatic arrays of human and animal bodies below it. In the ancient world, the pediment and entablature framed the heroic narratives of antiquity; in the modern world, photography frames the fleeting configurations of everyday life. In *The Terminal,* Stieglitz has seemingly dumped the heroic figures from the pediment to the street, to mix myth with the everyday and heroism with anonymity.

The figure tending the horses has his back turned toward us, preserving his modern status as an urban everyman. Facing a veil of equine steam, he invites comparison with figures from nineteenth paintings who look into vapor, such as the protagonist of Friedrich's *Wanderer,* or the young girl in Manet's *The Railway.* Unlike the romantic figure of Friedrich's painting, the man tending the horses in *The Terminal* looks to his labor. Whereas Friedrich's wanderer more or less stands in for the viewer, the man tending horses offers a mode of absorption that the viewer is unlikely to know. The worker tends to the needs of the animals in his care, a practical matter that his own body blocks from our sight. If something invisible is invoked here, it is not the ineffable transcendentalism of the landscape, but rather the untended life and labor of this man. Whereas Manet focused in *The Railway* on the quiet desperation of the dreamy bourgeois subject, Stieglitz found his Gordian knot in the submission of the anonymous worker to the demands of his job. Forgoing the confrontational camera that stages direct encounters with members of the lower classes—think of Jacob Riis (aggressive), of Lewis Hine (compassionate), or of Walker Evans (disinterested), Stieglitz preserves the social inaccessibility of the street laborers he records. Although this difference may have stemmed from social discomfort or fear, it yields something closer to respect. In disclosing the vulnerability

of this labor, pointing the camera at the worker was perhaps intrusion enough.[53]

Stieglitz's reworking of Romanticism brought it to a high pitch of ambivalence. On the one hand, he evidently wanted photography to partake of Charles Baudelaire's redemptive dream of finding accidental beauty on the streets of the modern city. In his famous 1859 essay "The Painter of Modern Life," Baudelaire writes: "For any modernity to be worthy of one day taking its place as 'antiquity,' it is necessary for the mysterious beauty which human life accidentally puts into it to be distilled from it." In *The Terminal,* Stieglitz distills an aesthetic power rivaling that of antiquity from the unpredictable circulation of bodies and vehicles of his city. On the other hand, the picture seems to brood uncertainly about this modernist dream. Enshrouded in vapor, the man and the horses seem vulnerable to dispersion or disappearance. At issue in *The Terminal* is not only the modern transience of the street, that endless kaleidoscopic unfolding of chance encounters, but also the historical transience of the social and material constitution of the street as such. The turbulent vapors of the image, in other words, speak as much to the evanescence of horse transportation, of labor as a kind of humane caretaking, as they do to the unexpected pleasures of the everyday. In 1893, the signs were plentiful that horse-drawn cars would soon give way to more mechanized modes of transport. The elevated railway had been running for years throughout New York City, and the new overhead wire system for electric trolleys that Frank Sprague had invented was being rapidly adopted. In this sense, the resonance with the antique speaks as much to historical vulnerability as to aesthetic wonder.

In the mid-1890s, the class dimensions of Stieglitz's photographs of New York streets would have loomed large as well. Less than a week after he ventured forth with his camera into a February blizzard, the Philadelphia and Reading Railroad went bankrupt, news that would prove a harbinger of economic trouble. After jittery months, the stock market crashed, precipitating a panic of unprecedented proportions, widespread business and bank failures, and soaring unemployment. While Stieglitz was exhibiting his carbon prints and lantern slides of urban laborers, the Panic of 1893 and its aftermath were making the welfare and unrest of the working class pressing issues. The Pullman strike of 1894 shut down much of the rail traffic in the western part of the United States and led to riots and violent suppression. The swings in the capitalist economy—predictable in their

sheer inevitability, but shocking in their timing and severity—underscored the extent to which modernity had been organized around chance. As the Panic had revealed, the economic security of the worker could disperse like a cloud of steam.[54]

During the winter of 1892–1893, Stieglitz brought a long history of vapor and chance in representation to bear on the problem of making modern photographs worthy of the Western pictorial tradition. In the photographs he made, many vital issues from that tradition, including the difficulty of matching artistic technique to a world of material instability, the inherent antagonism of linear perspective and opaque gases, and the role of atmosphere as a moral repository of historical transformation, came into play. Stieglitz understood that making modern photographs in the Kodak era would require an unprecedented acceptance of chance and a willingness to shape the virtues of photographic practice, such as preparation and patience, around its necessity. In the twentieth century, structuralists would sometimes compare art to a game of chess. But in the late nineteenth century, Stieglitz convincingly demonstrated that bringing the depiction of vapor into modern pictorial form would require photography to imagine itself more as street poker.

6

Stalking Chance and
Making News, c. 1930

In Europe and America between the world wars, the relationship of photography to chance changed in response to radically new conditions. The speed, mechanization, and uncertainty of industrial society accelerated during this span at a shocking pace. As John Dewey said in 1925: "Man finds himself living in an aleatory world; his existence involves, to put it baldly, a gamble. The world is a scene of risk."[1] For photographers responding to these conditions, psychoanalysis, primitivism, and the rise of mass media all loomed large. So did modernist art: ambitious photographers adopted and adapted elements of Cubism, Futurism, Constructivism, and Surrealism, altering or abandoning pictorialist principles to embrace an array of approaches more capable of grappling with the flux of modern experience. This complex and tumultuous passage in the history of photography and chance defies easy summary, but crucial to its unfolding were certain methods, assumptions, and aspirations. Together they constituted a broad myth construing the photographer as a roaming visionary or hunter of dreams. Pursued in texts and photographic practices, this myth imagined photography as a way of perceiving and capturing the elusive visual poetry of everyday life. It cast the photographer no longer as a custodian of taste but instead as a modern seer. It imagined the camera to be an intuitively controlled extension of the photographer's body. Whereas Talbot entrusted the aesthetic potential of photography to the "painter's eye," by the 1930s many believed that photography had a vision of its own. Muybridge's high-speed images had revealed a previously unseen reality embedded in motion, and in the 1890s the discovery of X-ray imagining by

Wilhelm Röntgen enabled photography to penetrate the world's opaque layers. In 1931, nearly a century after Talbot had observed how the camera could yield details "unconsciously recorded," Walter Benjamin coined the term "optical unconscious" to describe the power of photography to disclose the unseen.[2] According to this new myth, photography allowed the seer to share revelatory moments with the multitude.

The myth of the photographer as a hunter of dreams was capacious enough to encompass two distinctly different paradigms. One implicitly likened the photographer to a predator, prowling streets and byways in search of formal epiphanies, wielding the camera with honed reflexes to seize accidental configurations in the blink of an eye. Another cast the photographer as a scavenger, picking through banal and discarded things in search of unlikely beauty. Whether conceived as a panther stalking the living or a vulture picking through the dead, the photographer as a hunter of dreams sought art in the unconscious intersection of human intuition, animal instinct, and mechanical capacity. In this chapter, three texts (one from after the Second World War) and a selection of photographs will help us to come to terms with this myth and its historical meaning.

In the late nineteenth century, photography by no means stood alone as a way of contending with chance through patience and decisiveness. It sidled up alongside other pursuits in this regard, including hunting and financial speculation. The notion of the photographer as a hunter long predates the arrival of Kodak. Sir John Herschel first applied the hunting term "snap-shot" to high-speed photography in 1860, and others at the time recognized the structural proximity of the two pursuits.[3] The emergence of the handheld camera only strengthened this affinity. Stieglitz's recommended procedure for practitioners using such a camera in the city included preliminary study of locations to become familiar with their sightlines, and patient waiting to capture the instant when subjects came propitiously into view. This was hunting in a nutshell. Like the street photographer and the hunter, the speculator strove to monitor an unpredictable stream of information, wait patiently for the right moment, and then act decisively when it arrived. Sharing this common structure, photography, hunting, and speculation enabled subjects to perform the quickened opportunism that modernity required.

Darwinism played a key role in this triangulation. Photography and speculation drew legitimacy from their structural kinship to hunting. As technical pursuits shorn of familiar skills and modes of work, photography and

speculation seemed more manly and honorable when linked to the imagined subsistence of ancestors. This was particularly important in the world of finance. Writers romanticized Wall Street as a jungle, and suggested that any capitalist seeking to master it needed wiles and patience to make a timely pounce. At the same time, hunting excursions into the wilderness were touted as a means of purging the stresses of the boardroom or trading floor and restoring both body and spirit. Although hunting required the same virtues of preparation, patience, and decisive action that allegedly frayed the nerves of the capitalist, the exercise of these virtues in the wild was deemed recuperative. Hunting in the wilderness replenished not only the master of finance but also the metaphor that helped to validate his work and wealth.

"His" work and wealth: this economy of metaphor was intensively gendered. The speculator and the hunter were masculinized models of subjectivity, and photography only marginally less so. If Wall Street did not sufficiently confirm masculinity, a speculator could go afield with gun in hand to escape urban life, shed softening habits and frivolous influences, and restore his robust primeval powers. Photography's kinship with hunting also gave it a masculine cast. As a small gunlike instrument, the handheld camera was associated with stealth and aggression.[4] Anxiety about the male "Kodaker" stalking unwilling female subjects to capture their images cropped up repeatedly in the popular press.[5] More generally, writers often represented contestation with chance in any consequential form as a pursuit reserved for men. Some novels from the turn of the century that targeted a largely female readership addressed how the gendered structure of economic life precluded women from exploiting the logic of speculation and left them at the mercy of chance. In Edith Wharton's *The House of Mirth,* Lily Barth's compromised autonomy as a woman leads to her failure as a speculator in the market of romance.[6] The rules of the game are stacked against her, as they were against Cameron, who financially failed to carry out a successful speculation with her photography. In Joseph Conrad's *Chance,* the narrator repeatedly attributes the turns of modern life to happenstance, but the story itself suggests that the female protagonist Flora de Barral faces steep odds in contending with them. Society corrals chance in ways designed to maintain its power relations and ideological commitments.

Around the turn of the century, no one brought speculation, hunting, and photography together more vividly than Anthony Weston Dimock.

"I took my camera shot from a distance of forty feet." So far as known, this is the first photograph ever taken of a live wild elk. Rocky Mountains, Wyoming, Sept. 10, 1887.

Figure 6.1 Anthony Weston Dimock, *"I Took My Camera Shot from a Distance of Forty Feet,"* 1887, from *Wall Street and the Wilds.* Courtesy of Widener Library, Harvard University

Dimock was a Wall Street wunderkind who at age twenty-three made a fortune speculating in gold and by thirty reportedly controlled the Bankers and Merchants Telegraph Company and various steamship lines.[7] He devoted much of his middle age to his hobbies of hunting and photography. In 1915, a small press published his book *Wall Street and the Wilds,* an autobiographical celebration of his exploits in speculation, wilderness adventure, marksmanship, and photography (Figure 6.1).[8] In the opening chapters, Dimock offers an account of his early education in finance and his apprenticeship on Wall Street, interleaved with full-page reproductions of photographs he later took of Seminole Indians and wildlife in the backcountry of Florida. Through this asynchronous dovetailing of images and text, Dimock thematically joins Wall Street to the primeval wilderness as he imagined it.

In his book, Dimock represents himself as a modern man contending with risk and makes no bones about the proximity between speculation and gambling. He asserts that the "calamitous" issuance of greenbacks as

legal tender during the Civil War "changed business into gambling, and made of gambling a business."[9] He describes a gold market "strike" he made that "began with a bet and ended with the luck of a prize in a lottery."[10] His contending with chance extended to his adventures in the wilds. In words that echo Stieglitz's description of street photography, Dimock recounts a bear hunt in which he "gaze[d] steadily for the chance that Fate might grant" him.[11] Financial windfalls, hunting trophies, and captivating photographs were all products of a shrewd and patient accommodation of uncertainty.

Over time, moral considerations led Dimock to prefer the recreational challenge of photography to that of hunting. In 1892, a photography journal published his essay "Camera vs. Rifle," which advocated shooting animals with a camera to make "sport unalloyed with cruelty."[12] In *Wall Street and the Wilds,* he writes:

> I like to forget the brutal bags of game I made in the long ago, but the thought of each camera shot brings pleasure. The life history of birds and animals as pictured by the camera contrast curiously with the game bag product of the fowling piece and the bloody trophies of the rifle. One represents conservation and construction, the other destruction alone. I look upon my own little efforts with the camera as belonging to the twentieth century, and upon those days of slaughter of bird or beast as representing my inheritance from the Cave Dweller.[13]

Evolution may have threatened to reduce humanity to primate status, but in the popular imagination it also carried the hope of species improvement. The substitution of the camera for the gun, which morally reconfigured the tourist rituals of safari and hunt, could be construed as a form of moral progress. The photograph became the bloodless trophy, the humane trace of the fateful encounter, a less violent proof of the pursuer's instincts and skill. Photography enabled the adventurous male to balance the restorative and legitimating exercise of primal vigor with the enlightenment of modern ethics.

Hunting and photography were pleasurable ways to contend with chance in part because, unlike speculation, they systematically hid bad decisions and rotten luck. The gallery or trophy room represented an extreme winnowing of results, leaving on display only the most impressive specimens. No signs of the ungainly photograph or the missed elk were visible. These

spaces restricted history to the statistical outliers, those moments of happy coincidence when the shutter clicked with figures positioned just so, or the hunter stumbled on the prodigious bull elk and aimed the bullet true. But in the financial markets, all bets counted, the losses as well as the gains. Success was measured by a tally of every outcome. Speculation was a cumulative pursuit, like insurance, in which the unpredictability of individual results had to be tamed in the aggregate. Photography and hunting offered the compensatory fantasy of a winners only world.

Because success in speculation required prevailing in the aggregate, Dimock sought a system that would give him a statistical edge and align his fortunes to the law of averages. He respected the "law of chances which, admitting that nothing is more uncertain than the hours of a single life, proves that nothing is more immutable than the average length of life of a million."[14] The astute investor in stocks or gold, like the life insurance man or the scientist grappling with the velocities of gas particles, looked past the caprice of individual cases in hopes of finding regularity in large numbers.[15] Those who thought they could control chance at the level of the individual bet were deluding themselves. Nonetheless, Dimock witnessed a nearly universal need among his fellow speculators to believe in such mastery. In a chapter entitled "Business or Gambling," he asserts: "From Monte Carlo to the police-protected dens in New York; from the Exchanges, big and little, down to the bucket and policy shops, each player of the game has his system. . . . [T]he purpose of each is to convert chance into certainty, and all are alike futile."[16]

According to Dimock, the successful speculator had to acknowledge the intractability of chance and find advantage in the hollow hopes of others. Believing that chance lay beyond the reach of hunches and trends, Dimock used a cold and mechanical system to guide his investment decisions. Indeed, he attributed his success to his stubborn refusal to follow the impulses or intuitions that ruled the actions of the multitude. In his book, he writes: "I had no keen perception of the trend of prices, no intuition of what the next turn was to be. Whatever I did was in the line of mathematics and not of impulse. The work was mechanical, and a machine could have done it better than I. Always I was buying when I felt like selling and selling when every impulse impelled me to buy." Dimock's strategy was precisely to oppose instinct, which governed the herd and never made the market look stronger than when it was about to collapse, and never weaker than when a new bull run loomed. To tame chance in the long haul for

him meant suppressing emotional responses and gut instincts and operating as mechanically as possible. "I made of myself a nerveless machine," Dimock recalls, "and for nearly all the three hundred minutes of each daily session stood beside the curved rail that enclosed the Gold Room pit buying five thousand gold at every eighth decline and selling the same amount at every eighth advance."[17] The burden of this unfeeling approach was, Dimock added, "almost greater than I could bear."[18] Like a poker player who maintains an expressionless attitude while exploiting the incapacity of other players to do the same, the speculator Dimock exercised tremendous self-control over his emotional nature to gain a statistical edge in a betting game prone to chance. Whether Dimock actually possessed any insight into the aggregate behavior of gold prices over time or simply got lucky is open to question, but his belief that the mastery of chance in the long run required respecting its radical independence in the short was distinctively modern.

In the modern era, the machine as a model for human behavior has met with ambivalence. On the one hand, Dimock and many other writers have associated machines with virtues such as tirelessness and self-control. As Peter Galison and Lorraine Daston have argued, many Victorians made the camera a polestar for scientific objectivity because of its immunity to desire, fatigue, or bias. Like the speculator Dimock claims to have been, the new scientific observer in the laboratory or the field sought to operate as mechanically as possible and had to endure the pains of this self-restraint. On the other hand, scores of writers have blamed the exaltation of the machine for smothering human creativity and feeling. In his book *The Revolt against Mechanism,* published in 1934, the popular writer and lecturer L. P. Jacks argues that an enmity "unquestionably exists" between "mechanism and mind."[19] "Our *habits of thought,*" he warns, "have followed the development of machinery by moulding themselves more and more on mechanical models," to the point that creative thought was "not much in evidence."[20]

Managing this ambivalence has entailed many efforts to integrate the best of humanity with the best of machines. Cameron said that her camera had "become to me as a living thing, with voice and memory and creative vigour," and Dimock recalled, "That which bore me up and carried me through was the constant throbbing of the machine I had created."[21] Although modernity required bringing the machine into intimacy with the body, it often promised a reciprocal extension of human vitality to the ma-

chine. The search for a fruitful synthesis between mortal sensibility and mechanical power contributed to the quest to make photographic art.

According to Dimock, the calculating intelligence that enabled him to succeed in speculation operated below the threshold of consciousness. He writes in his book: "We didn't talk in those days of subconscious selves, but I had one that worked overtime for me. As with nods and words I bought and sold, jotting down as many of the transactions as nimble fingers were capable of, and holding the rest in memory, that subconscious imp kept tabs on my trades and had a balance sheet ready for me the instant I asked it." Dimock construes the subconscious as a kind of gremlin accountant providing him with a secret capacity to contend with the bewildering accelerations of the modern world.

As a paradigm for photography, the hunter of dreams drew on the emergence of psychoanalysis and its theories of the unconscious. In the early twentieth century, Darwinism and industrialism combined with Freudianism to mingle ideas about the primeval and the mechanical with new understandings of unconscious drives and pathways. The dark recesses of mental life became a target of investigation and analysis, a placeless site of mechanical operations and compulsive repetitions, immune to reason and compromising the will. Casual users of psychoanalytic thinking, including Dimock, often took a rosier view of the unconscious, regarding it as a repository of uncanny ability. But whereas Dimock imagined the subconscious as a calculating imp that helped him resist instinct and intuition, many others associated the unconscious with precisely these incalculable dimensions of psychic life.

The relationship between psychoanalysis and modernity is complex. Freud's theories, although unquestionably modern, reaffirmed the importance of classical literature in the midst of a boom in popular media. According to Freud, even a modern reader who consumed nothing but the comics and gossip columns had the story of Oedipus at work in his or her psychic depths. Moreover, at a time when chance seemed to be taking hold in the world, Freud's theories called for a return to determinism. The old deistic notion that what seems like accident is actually the result of hidden causes was revived by Freud in his analysis of everyday mistakes.[22] His theory suggested that minor errors *(Fehllestungen),* such as slips of the tongue, are not accidental but rather caused by unconscious wishes erupting into involuntary action. During an era in which chance repeatedly resisted the explanatory power of determinism, psychoanalysis countered with a

reassertion of the scope of mechanical causes and the analytic capacity to trace back to them from effects. Freud proposed new ways of demonstrating that seemingly accidental details abided by hidden laws and familiar narratives that scientific inquiry could reveal. He traced these laws and narratives not to the design or word of a single creator but rather to the drives and dynamic structure of the human psyche and the dramas of human development. Unconscious desire, not the intricate mechanics of a clocklike divine order, now allegedly occupied humanity's blind spot.

Freud's determinism recuperated meaning with a small *m* only. It was the very indifference of the universe, its blank arbitrariness, that explained the selfish drives of the unconscious and the narratives of psychic development. Freudianism enabled an endless interpretation of experience, but that experience was of a world otherwise given over to chance.

Freud's disillusioned account of the selfish and violent drives lurking in the human psyche was perfectly suited to the anxieties of the interwar moment. The irrational horrors of the First World War had dashed much faith in modernization, and many struggled to come to terms with "enlightened" Europe's capricious drift into chaos and slaughter. Freud's grim determinism seemed to account for social trauma as well as individual neuroses.

While Freud gave moderns a way to understand the psyche without God, physicists were giving them a way to understand matter and energy without Newton's lawful order. The emergence of quantum mechanics, which treated tiny bits of matter as probabilistic entities that mixed qualities associated with particles with qualities associated with waves, fascinated and befuddled a curious public. Darwin had conjectured that chance was the best means of understanding genetic mutation, and Maxwell had done the same for the velocities of gas particles. But probability kept finding its way deeper into physical phenomena. Building on the work of Maxwell, Ludwig Boltzmann and Josiah Gibbs developed statistical mechanics, which showed that, in the words of Norbert Wiener, "the statistical approach was valid not merely for systems of enormous complexity, but even for systems as simple as the single particle in a field of force."[23] Subsequently, a new generation of physicists, including Max Planck, Albert Einstein, Werner Heisenberg, Max Born, and Erwin Schrödinger, took chance deeper still. They opened up a strange atomic world in which the elegant mechanics imagined by Newton simply did not operate, and probability—in a new and bizarre form—governed the elementary properties of matter and energy.

To be sure, many subscribed to the notion that the new theories were provisional or incomplete and would be superseded ultimately by as yet undiscovered deterministic laws. Planck regarded his mathematical modeling of the quanta of emitted or absorbed radiation in this fashion, and no less an authority than Einstein insisted that "God doesn't play dice with the world." But modern physics increasingly accepted the notion that chance might be inherent in the minute workings of nature. As Wiener put it, "Chance has been admitted, not merely as a mathematical tool for physics, but as part of its warp and weft."[24] Some followed the philosopher C. S. Peirce in believing that this insight made room for a freedom and spontaneity that determinism had foreclosed. Others saw a world prone to sheer irrationality.

Lay thinkers who enlisted quantum mechanics or psychoanalysis to fashion a modern outlook often ran roughshod over the original theories. Some made a hash of Heisenberg's uncertainty principle, while others invoked Freudian slips and unconscious drives in a manner alien to anything Freud wrote. But for many cultural histories, including this one, popular misapprehension as such is largely beside the point. In the early decades of the twentieth century, quantum mechanics and modern psychology pervaded thinking and belief to great and complex effect, and parallels between the two were often drawn.[25] Although scholars tend to separate Freud and his theories from other strains of modern psychological thinking, lay publics between the wars wandered about in a welter of related ideas and drew upon this notion or that to suit their purposes or predilections. In photography and the visual arts, the emerging notions of an unconscious (individual or collective) or a subconscious (a term Freud rejected) were particularly important. Chance became a window into the mysterious hidden dynamics of psychic life.

The rise of psychoanalytic thinking had profound effects on images as well as chance. According to Freud, every dream was potentially laden with hidden implications, and processes such as condensation or displacement made unearthing them an intricate dialogic process. In the arts, intelligent engagement with images had traditionally demanded sensibility and an appreciation for various forms of beauty, awe, or delight. Freud turned away from the taste for such ineffable pleasures and toward analytic significance. His theory of dreams thus greatly amplified the generative capacity of the individual as a source of meaning. Freud spent more pages interpreting the dreams of anonymous patients than most art critics had ever devoted to a

painting or sculpture. With respect to the generation of meaningful images, the democratic dimension of his paradigm was radical. Many writers have pointed out the threat that photography posed to the visual arts by bringing image production to the untrained and the unskilled. Far less attention has been given to the threat that psychoanalysis posed by attributing *deeply meaningful* image production to everyone under the moon. Few people may be artists, but everyone is a dreamer.

Psychoanalysis shifted the role of professional expertise from generating images to interpreting them. By suggesting that dreams are images worthy of analysis, psychoanalysis deskilled the production of meaningful images. Producing dreams requires no effort. The establishment of psychoanalysis as a professional practice, however, ensured that only a select few were qualified by education and training to interpret them. Images were free, but the production of interpretations could cost you plenty.

Psychoanalysis also wreaked havoc with the exalted Victorian notion of intention. Under the new paradigm that Freud proposed, conscious intentions masked unconscious drives. Dimock may have imagined the hidden psychic agent to be a helpful gremlin, but Freud posited within the unconscious the bestial imp of the id. Overturning Victorian salon chatter about sensibility and refinement, Freud looked to the exalted art of Leonardo and saw castration anxiety. Psychoanalysis essentially wrested intentions away from the social actor and placed them in the hands of the analyst. If the meaning of an image or object issued from hidden psychic mechanisms, then intention was at best a symptom.

Psychoanalysis and photography are closer than most people realize, and their historical interdependence deserves more scholarly attention. To begin with, one could hypothesize that Freud, by arguing that dreams and actions have unintended origins and are best interpreted afterward via expert scrutiny, extended work that photography and Talbot had begun.[26] Talbot recognized that his photograph of Queen's College, Oxford, was an incompletely intended act susceptible to fuller disclosure through analysis after the fact. By loosening the bond between intention and image production, photography and its literature introduced an economy of unconscious imagery decades before Freud. As Marshall McLuhan wrote in 1964, "The age of Jung and Freud is, above all, the age of the photograph, the age of the full gamut of self-critical attitudes."[27] The indiscriminate attentions of the camera extended beyond the limits of conscious recognition and thus familiarized modern thinkers with the concept of latent significance.

Photography estranged human subjects from their own bodies and perceptions and thus prepared the way for psychoanalytic approaches.

While Freud wrote, the emergence of snapshot technology was amplifying the retrospective character of taste and discernment in photography. The use of fast cameras and processes was enabling photographers to work at speeds that made anticipating the final image difficult. A novice using such equipment could accidentally produce a picture with aesthetic merits presumed to require expertise to appreciate. The author of a preface to a catalogue of a major 1892 exhibition of photography laments that "it is possible for a person with an hour's instruction to produce photographs at once possessed of merits and faults each equally beyond his comprehension."[28] Because pictorial merits could be produced accidentally, the real measure of art, this writer implies, is in the capacity to discern them after the fact. Whereas Talbot had suggested in his discussion of *The Open Door* that an operator with a "painter's eye" could produce a beautiful picture, the writer of this 1892 preface suggests that the locus of art had shifted to the assessment of pictures already made. In this new era of photography, the process of selection and rejection from nature that academic doctrine required of art was being supplanted by a process of selecting and rejecting photographs (or, with exposed negatives routinely subjected to cropping and other adjustments, parts of photographs). Photographic art was threatening to become a matter of editorial discrimination, of the retrospective recognition and evaluation of aesthetic qualities in pictures composed in large measure by chance.

In the early decades of the twentieth century, the issue of perceiving significance in accidental images became important in the field of psychology as well. In 1921, Herman Rorschach proposed using inkblots as a means of bringing forth the unconscious psychic contents of the interpreter. His clinical procedure entailed the analyst presenting subjects with a series of cards bearing inkblots and asking them to report what they saw. Since the inkblot as an image was utterly arbitrary, the interpreter became the true source of its significance, and whatever was perceived (for example, "a bat" or "a couple kissing") betrayed aspects of his or her psychology. Chance thus allowed the analyst to isolate unconscious processes that would otherwise be immersed in complexities of intersubjective exchange.[29]

While Rorschach was developing and promoting his theory, an interest in accidental images was also emerging in the arts. In 1920, the surrealist Francis Picabia published in his review *391* an inkblot entitled *The Blessed*

Virgin; in late 1921 or early 1922, the artist Man Ray produced his first Rayograph of scattered and seemingly random objects; and in 1922, Stieglitz made the first of his many cloud photographs. Steeped in an intellectual culture pervaded by psychoanalytic thinking, these artists began producing pictures strewn or blotted with random stuff. In the mere course of three years, Picabia, Rorschach, Man Ray, and Stieglitz all launched inquiries into what modern subjects might see, and reveal of themselves, in dark patches of randomness.

Stieglitz searched the random play of clouds for forms that he could fashion into images corresponding to his subjective states. To put it glibly, he wanted to find his own inkblots. Although related to his early work, his cloud photographs constitute a distinct phase in his practice. They remove vaporous accident from the social and topographic structures of misty landscapes, foggy harbors, city streets, and chugging steamboats and take it skyward. In these pictures, vapor forms an ambiguous space that serves as its own ground. Whereas Man Ray, Picabia, and Rorschach produced images in which quasi-random forms lie strewn within a blank rectangular field, Stieglitz created rectangular fields by cutting out pieces of the sky. As the critic Rosalind Krauss has brilliantly discussed, these pictures seem not only haphazard but also resistant to internal order.[30] A prominent curator of photography has asserted that Stieglitz, in making the *Equivalents*, "intervened against nature."[31]

Stieglitz's cloud pictures are small and ambiguous. In one, a thick dark form snakes vertically, sending off a truncated branch to the left (Figure 6.2). Although the central form initially reads as figure against ground, the viewer soon realizes that it constitutes a void, a negative space defined by the fleecy-edged forms that surround it. From behind a wispy clot, and equidistant from the left and lower edges of the picture, a bright orb peeks. Is it the sun? Is it the moon? We are not sure. The horizon has disappeared and relations of value have become unfamiliar. So many distinctions—light and dark, near and far, day and night, figure and ground—have been forfeited. The interdependence of positive and negative at the heart of film photography seems to have spread to the cosmos. It is as if we have spun around and fallen down, leaving too little blood in the brain. By isolating a portion of the sky and annulling the temporal cues that light might otherwise provide, the photograph refuses the familiar categories of landscape, view, or scene, and brings vapor to the brink of abstraction.

Figure 6.2 Alfred Stieglitz, *Portrait of Georgia, No. 3*, 1923, gelatin silver print. National Gallery of Art, Washington, Alfred Stieglitz Collection, © Georgia O'Keeffe Museum / Artists Rights Society (ARS), New York

Although Stieglitz's cloud photographs are usually referred to as the *Equivalents*, and most have that word in their title, he called this picture *Portrait of Georgia, No. 3*. His turn to clouds emerged from a period of intense photography of Georgia O'Keeffe's body, and his obsession with her spilled over into the series that followed. With *Portrait of Georgia, No. 3*, Stieglitz promises a portrait of O'Keeffe, but on terms that defy the portrait genre. Although tradition rooted portraiture in the notion of a synthetic representation that sums up the essence of the subject, his title informs us that the portrait is the third in a series, and the heart of the picture is empty. Stieglitz thus doubly undermines the synthetic totality that traditional portraiture was expected to deliver.

Stieglitz's romantic gambit to bring vapor to its pictorial apotheosis was a brilliant capstone for his practice, but history was moving elsewhere. Instead of rising heavenward, photography between the two world wars was

finding its principal engine of aesthetic innovation in the earthly concerns of journalism. A series of technological developments had facilitated this development. The first dated to the 1890s, when the bicycle and handheld camera crazes were in full swing. At the time, newspapers were sky-rocketing in popularity, and the shortcomings of wood engraving as a means of illustration—its slowness, its labor-intensiveness, and its lack of immediacy—were weighing the industry down. Inventors sought a means of photomechanically transferring photographic imagery to a printing matrix that could be used alongside type on a rotary press. This led to the development of the halftone process, which used a screen to convert a photograph into a matrix of dots. The dots were variably sized and distributed in a manner that mimicked the continuous range of grays of the photograph from which they were derived. Whereas wood engravings had to be printed separately from type, halftones became a part of a single printing matrix that integrated photographic images and text. This enabled the popular press to be more responsive to the growing demand for eye-catching and quickly digestible news. As the century turned, daily papers featuring photographs, local gossip, and sensational reportage achieved broad readership in American cities, with Joseph Pulitzer's *New York World* and William Randolph Hearst's *New York Journal* leading the way. By the 1920s and 1930s, illustrated magazines featuring photography were burgeoning in Europe and America.

A second key technological development concerns the electrical transmission of photographs. The mass media sought to annihilate time and space in the delivery of news, giving instantaneous communication a global reach. The telegraph had made such transmission of verbal reports a reality, but images were more difficult.[32] Over the years, inventors made various efforts to transmit pictures through electrical signals, and in 1924 the American Telephone & Telegraph Company (AT&T) demonstrated a practicable telephotography machine. By 1935, the Associated Press had launched its wirephoto service, enabling photographs to be almost instantly transmitted to media outlets around the world.[33] A year later, Henry Luce introduced *Life,* which soon became the flagship American illustrated magazine.

A third technological development concerned camera technology. Between the wars, a booming newsstand culture fostered a popular taste for dynamic images of modernity. New cameras, such as the Leica, accelerated the shift. Small, light, and unobtrusive, the Leica used a roll of 35 mm

celluloid film, which had been designed for motion pictures, and a high-quality lens that enabled the user to make fine enlarged prints from the small negatives. By the 1930s, the Leica was standard equipment for many European photojournalists, who lauded its ease and mobility, claiming that the camera became an extension of the body and thus responsive to its reflexes. In the United States, many photojournalists used the Speed Graphic camera, which was slower to operate than the Leica and used larger sheets of film, but was also capable of delivering spectacular images of a dynamic world. With the availability of such cameras, photographs of dancers midleap, of race cars careening, and of gleaming industrial machinery became standard fare in the popular press.

These accelerating technological developments arrived alongside changes in the pictorial language of photography, including a major shift involving visual obscurity or blur. Whereas the pictorialists gave mists and murk connotations of remoteness, longing, and regret, ambitious photographers in the early decades of the twentieth century largely shed these connotations in favor of a crisp modernist aesthetic. Those abiding by this new aesthetic either eschewed blur altogether or gave it connotations of ephemerality, eroticism, or speed. Rather than soft focus or mist, movement of camera or subject was usually the cause of visual imprecision.

The Futurists were among the first to assert that photographic blur in the twentieth century must have a new meaning. Inspired by modern painting, the Italian artist Anton Giulio Bragaglia, along with his brother Arturo, pursued a practice of "photodynamism" that sought to convey the dynamic sensations of bodily movement.[34] The photograph *Typewriter* of 1913, printed on a postcard to ensure its own mobility, shows the typist's hands blurred by motion, as if a "molecular passion"—to use Bragaglia's phrase—were pushing matter beyond the medium's grasp (Figure 6.3).[35] The softness and imprecision of the forms have nothing to do with sentimentality or wistfulness, but instead signify the dynamism of an impetuous reality. The make of the typewriter, *Sun,* appears in bold letters on the side of the machine, offering a pun on the solar workings of photography. While the hands of the typist disappear into a blur of kinetic energy, the hand of the artist disappears into the automatism of light.

The discontinuity in blur's meaning should not be exaggerated. As it was for Cameron and for the pictorialists, blur for the Futurists signified a reach toward truths defying representation. The blur marked photography's boundary, the limit of its capacity to render life visible. Both Cameron and

Figure 6.3 Anton Giulio Bragaglia, *The Typist*, 1911, gelatin silver print. Image Source: Art Resource, NY, © The Metropolitan Museum of Art / Artists Rights Society (ARS), New York / SIAE, Rome

Bragaglia used blur to signify a pushing of that limit and a gesture beyond it, and thus a refusal to settle for the deathly stasis ("the snapshot's bestial error," Bragaglia writes) that satisfied conventional taste.[36] Both practitioners sought a synthetic approach that could fill the image with a living reality rather than an arbitrary instant and thereby make photography into art.

Illustrated magazines and newspapers fostered a popular taste for images of speed and surprise. In the 1920s and early 1930s, André Kertész was one of several practitioners who brilliantly reshaped photography in light of this new demand. Having moved from Budapest to Paris in 1925, Kertész fashioned an aesthetic around locating and recording strange coincidences and enigmatic scenes of urban life. He worked as both predator and scavenger, arresting fleeting action and bringing out the uncanny dimensions of stray things. His photograph *Meudon* of 1928 is exemplary of the former mode (Figure 6.4). It depicts an evocative configuration drawn from the everyday bustle of the city. The steam of the locomotive, which

Figure 6.4 André Kertész, *Meudon*, 1928, gelatin silver print. ©
Estate of André Kertész / Higher Pictures

had filled impressionist canvases and photographs by Stieglitz, appears in
the distance as only one of several icons making up an inscrutable assem-
blage. Such accidental combinations of forms abided by the Surrealist con-
cern for disjunctive modes of representation.[37]

Such accidental assemblages of subjects and forms bore connotations of
unconscious significance. Just as otherwise nonsensical dreams, through
the operations of displacement and condensation, now seemed dense with
latent meaning, so pictures such as *Meudon* appeared to convey puzzling
truths about modern life. Benjamin came at this kinship between photo-
graphic insight and psychoanalytic process with his freighted notion of the
optical unconscious. The notion is somewhat paradoxical because the

unconscious of the individual, as Freud envisioned it, was more or less implicitly predicated on a universe without a psychic structure of its own. But Benjamin's term gets at something vital about photography between the wars. Through its accelerations, photography *did* seem to be revealing something about reality. The notion of the optical unconscious provocatively suggests that photographs are what the world dreams while humans are more or less awake.

Another extraordinary early practitioner in this photojournalistic mode was Martin Munkácsi. A Hungarian photographer, Munkácsi in 1930 was working on assignment in Liberia for the *Berliner Illustrirte Zeitung* when he made his famous photograph of three boys running into Lake Tanganyika (Figure 6.5). The picture's combination of youthful exuberance, material spontaneity, technological speed, and global reach makes it emblematic of an emerging magazine culture and its photographic style. Reminiscent of Protogenes's lucky throw of a sponge, light splattered itself on Munkácsi's film in a perfect image of frothy dispersal. Although the German magazine decided not to print the picture, it was featured in a photography annual and often reproduced afterward. Was it art? The style itself seemed to answer: who cares? By 1930, the modern world had become too impatient for the kind of gallery prattle that Victorians would have brought to bear on the question. It was a marvelous photograph, depicting dynamic bodies that run and leap into the spray as though quickened by the freedoms of modernity. It had a lot more verve than the stilted pictures of "the little shepherdess" that passed as aesthetic ambition in photography of the late Victorian era. If it sold magazines, so much the better.

Or so the enthusiasts of the time felt. In an economically troubled, war-shadowed, media-infatuated Europe, publishers cast commercial froth as a photographic lightness of being. They celebrated pictures such as Munkácsi's as flashes of insight that embraced rather than shunned the transient contingencies of snapshot practice. To detractors, such as the Weimar critic Siegfried Kracauer, this new paradigm was one of obfuscation and false promises. By lifting the lithe forms of his African subjects out from their colonial matrix of cultural and economic struggle and placing them within a commercial discourse of exotic license and spontaneous pleasure, Munkácsi and his industry cloaked a grim social reality in the guise of uplifting revelation. The aesthetics of spontaneous pleasure promulgated by the new magazine culture had by no means emerged spontaneously. Because magazines were themselves marketed as momentary gratifications, to be grabbed

Figure 6.5 Martin Munkácsi, *Liberia,* c. 1930, gelatin silver print. © Martin Munkacsi Courtesy Howard Greenberg Gallery, New York

from the rack and swiftly read, the spontaneous dispersion and joyful in-stantaneity that filled their pages was an economic interest. Generating fantasies of the innocent primitive constituted an industry, and one that needed raw materials from abroad. This use of photography put an old op-eration into a new form.

Encountering Munkácsi's photograph from Lake Tanganyika allegedly inspired Henri Cartier-Bresson to take up photography. While training as a painter in Paris, Cartier-Bresson took a keen interest in the Surrealist André Breton's notions of spontaneity, intuition, revolt, and "objective chance," the coincidence or accident that seems to take the form of a signal or to make a repressed desire manifest.[38] In keeping with the modernist habit of seeking stimulation from preindustrial societies, Cartier-Bresson in 1930 traveled to the Ivory Coast, where he contracted a serious illness. During convalescence he happened upon Munkácsi's photograph, and soon afterward obtained a Leica camera and began taking photographs on the streets of Europe.

While traveling in Valencia, Spain, Cartier-Bresson photographed another youthful body in a state of ecstatic mobility (Plate 5). Although his picture of a boy running along a wall has surreal content, it partakes of a journalistic visual idiom and has the crisp immediacy of a report. Wear has erased the wall's paint along a broad and irregular strip, forming a dark cloudlike form surrounded by white. Through this abstracted space runs the boy, head thrown back as if in blind ecstasy, left hand reaching out in tactile communion with the wall, right hand, blurred by velocity, pointing down into the void below. Although the boy was evidently awaiting the return of a ball thrown in the air, the picture escapes that simple narrative.[39] The moment seems an everyday epiphany, as if the photographer has snatched a blind pocket of deliverance from modernity's turbulent flow.

Although one can trace this mythology of the everyday back to Stieglitz and his lantern slides from the streets of New York, Cartier-Bresson's photograph bears signs of historical change. In particular, vapor is no longer essential to the equation. Cartier-Bresson was not allergic to its attractions (his famous photograph of the man leaping behind the Gare Saint-Lazare would not be the same without the moody haze in the background), but clouds and atmosphere rarely govern visibility in his photographs. Rough-edged chance appears instead in broken plaster, torn clothing, or the worn patch on the wall along which the boy runs. Whereas the vaporous cloud was a spontaneous phenomenon, the worn patch represents an accumulation of everyday *social* activity, of the restless movement of people in the modern world. As did Munkácsi, Cartier-Bresson gave spontaneity over to the social body, a transfer that echoed that of Jacques-Louis David in an earlier moment of revolutionary aspiration.

But the structure of Cartier-Bresson's approach nonetheless remained true to Stieglitz. Consider this description by the photography curator and historian Clément Chéroux of Cartier-Bresson's working methods:

> First of all, the photographer looks for a background that seems to him to have an interesting form. Sometimes it is a wall running parallel to the foreground of the image, or a space proportional to the graphic lines already supplied. Then he waits for one or more living, moving creatures—children, a man, a dog—to take their place within this constellation of forms, in what he calls a simultaneous coalition. Thus one element of the picture's geometry is premeditated, while the other—in fact, the more important element—comes about by sheer chance.[40]

Although Cartier-Bresson looked for different action and preferred more geometrically distilled backgrounds than Stieglitz did, his procedure took the same basic form.[41] This commonality may help explain why Cartier-Bresson once asserted that "the thirties were still the nineteenth century."[42]

Although the American reception of Cartier-Bresson has mainly celebrated him as a quick-reflexed hunter of fleeting beauty, his actual practice was more complex. In the early 1930s, he also played the scavenger, making photographs of discarded animal remains, laundry out to dry, and poor people sleeping in the street. These inert subjects contained moments of uncanny animism and biting commentary. He also had no compunctions about arranging a scene in what the critic A. D. Coleman has termed a "directorial mode."[43] Having received his artistic training in the company of Surrealists and having practiced collage, Cartier-Bresson understood that the uncanny could be made as well as found. In one of his most celebrated pictures, he asked a companion to pose next to shelves containing jumbled shoes.[44]

Nonetheless, over time Cartier-Bresson embraced his reputation for having mastered the spontaneous instant and thereby became the most influential spokesperson for the photographer as a hunter of dreams.[45] In *The Decisive Moment*, a book about the practice of photography that he wrote after the Second World War, he seeks to reconcile the speed of modernity with the rich intentionality that traditional art required. The photographer, he writes, "composes a picture in very nearly the same amount of time it takes to click the shutter, at the speed of a reflex action."[46] In

response to the feverish pace of modernity, the photographer's mental faculties, he suggests, have accelerated to make perception and judgment instantaneous. He summarizes: "To take photographs means to recognize—simultaneously and within a fraction of a second—both the fact itself and the rigorous organization of visually perceived forms that give it meaning."[47]

Cartier-Bresson thus puts the aesthetic act in photography beyond the reach of conscious deliberation. "Don't think," he once advised.[48] According to his argument, conscious mental processes cannot keep abreast of modern action, which must be captured in "a creative fraction of a second."[49] Like many other practitioners, Cartier-Bresson turned to the primitive and the futuristic to accommodate the demands of modernity. He describes his early photography in this way:

> I had had blackwater fever in Africa, and was now obliged to convalesce. I went to Marseille. A small allowance enabled me to get along, and I worked with enjoyment. I had just discovered the Leica. It became the extension of my eye, and I have never been separated from it since I found it. I prowled the streets all day, feeling very strung-up and ready to pounce, determined to "trap" life—to preserve life in the act of living. Above all, I craved to seize, in the confines of one single photograph, the whole essence of some situation that was in the process of unrolling itself before my eyes.[50]

His description construes the camera as an extension of the eye. Its sight belongs to a prowling, pouncing subject that seems more cat than human. The animal instincts of the photographer accelerate the aesthetic faculty to the speed of a reflex.[51] "In photography, you've got to be quick, quick, quick," Cartier-Bresson says, "like an animal and a prey."[52] Bypassing the plodding deliberations of the mind, the photographer records a "decision made by the eye."[53] This consolidation of bodily instinct and aesthetic judgment liberates the photographer to work "in unison with movement."[54]

Cartier-Bresson's theory legitimates the pictorial significance of the photograph on both sides of the camera. Behind the camera, the photographer instinctually senses when the decisive moment has arrived, even if unconscious of the configuration of forms that his or her improvisation has recorded. In front of the camera, the decisive moment is not an arbitrary designation after the fact, but rather an opening to possibility that occurs in the course of events. Cartier-Bresson derives the term *decisive moment*

from a passage written by seventeenth-century clergyman Cardinal de Retz, who believed that such moments were actual fulcrums upon which history turns.[55] Every activity, according to Cartier-Bresson, has its decisive moment. Thus, the composition of the action photograph is not arbitrary but rather "must have its own inevitability about it."[56]

Cartier-Bresson's theory piggybacked on several contemporaneous strands of popular thought. Carl Jung had popularized the notion of synchronicity, according to which ostensibly random events could momentarily reveal the profound embedding of the individual psyche in the world. In 1952, the same year that Cartier-Bresson's *The Decisive Moment* appeared, Jung's essay "Synchronicity: An Acausal Connecting Principle" was published.[57] In it, he argues that a spontaneous density of meaningful connections distinguishes the archetypal pattern from the meaningless product of chance: "The problem of synchronicity has puzzled me for a long time, ever since the middle twenties, when I was investigating the phenomena of the collective unconscious and kept on coming across connections which I simply could not explain as chance groupings or 'runs.' What I found were 'coincidences' which were connected so meaningfully that their 'chance' concurrence would be incredible."[58] Jung's account of synchronicity was a boon to photographers, for it underwrote the possibility of a collectively significant yet instantaneous correspondence between individual and world.

Another important cultural correlate was the enthusiastic reception of Eugen Herrigel's *Zen in the Art of Archery,* first published in German in 1948, and translated into English in 1953. Herrigel's slim volume followed in the wake of D. T. Suzuki's influential writings introducing Zen Buddhism to an anglophone audience before the war. In his book, Herrigel recounts his struggle to understand his lessons in archery from a Japanese master who advises his student to let go of himself so that nothing is left but a "purposeless tension."[59] At one point, the master offers the confused Herrigel an entomological analogy:

Do not forget that even in Nature there are correspondences which cannot be understood, and yet are so real that we have grown accustomed to them, just as if they could not be any different. I will give you an example which I have often puzzled over. The spider dances her web without knowing that there are flies who will get caught in it. The fly, dancing nonchalantly on a sunbeam, gets caught in the net without knowing what lies in store. But through both of them

"It" dances, and inside and outside are united in this dance. So, too, the archer hits the target without having aimed—more I cannot say.

Cartier-Bresson took up Herrigel's notion of entering the flow of time. He advocated "forgetting yourself" to find the moment when "bow, arrow, goal and ego melt into one another."[60]

Working in concert with such strands of popular thought, Cartier-Bresson in *The Decisive Moment* crafts a theory mystifying the photographic act. The photographer and the world, like a spider and a fly, join unconsciously in a universal dance. Or, to use the examples of predator and prey suggested by Cartier-Bresson's language, one might say that the photographer traps the elusive significance of life as a cat traps a mouse. Either simile allows us to bridge the dark moat around the photograph, the disagreeable arbitrariness of chance.

In describing the photographer as a hunter, Cartier-Bresson was careful to sidestep concerns about predation. Although most of his photographs feature human subjects, his hunting metaphor characterizes the prey he "craved to seize" not as one or more fellow human beings but rather as "the whole essence of some situation." The ethical concerns that the asymmetrical relationship between the photographer and the photographed had raised with the emergence of the handheld camera slip to the margin in this formulation. The photographer was a tracker of condensed meaning and underlying significance, a hunter not of people but of dreams.

Over time, Cartier-Bresson's account of the decisive moment became a powerful alibi, and the photography market clung to it like a drug. If the photograph was an interface between the photographer's uncanny aesthetic intuition and the world's momentary revelation, it could claim both inspired authorship and documentary power. Buyers and sellers of photography could enjoy the perfect marriage of aesthetic sensibility and worldly relevance. The paradigm of the decisive moment underwrote Cartier-Bresson's practice at large, suppressing acknowledgment of directorial intervention or editorial contrivance. His dazzling production of captivating photographs seemed to confirm that all he said about his capacities was true. Beyond that, the paradigm legitimated the significance of a broad swath of photography in society at large, from news reportage to art school assignments. By exalting the modern photographer as a master of chance, it muffled the maddening strangeness of a society relying extensively on accident for the production of its most vital images.

In truth, Cartier-Bresson's famous theory saddles users of photography with two disabling forms of cognitive circularity. First, his theory would have us judge a photograph by its success in capturing the essence of its subject, but we often know the subject proper only through the photograph. The second form of cognitive circularity surfaces in Jung's theory of synchronicity. According to Jung, if an event very much seems significant, then it cannot be the product of chance, and if it is not the product of chance, then it can be significant. The problem with this circular logic is that chance inevitably produces coincidences that very much seem significant, and so the fact of seeming significant is a poor guide to what has—or has not—been caused by chance. Indeed, only a few years after Cartier-Bresson's *The Decisive Moment* appeared, a cognitive psychologist coined the term *apophenia* to refer to the strong propensity of human subjects to find meaningful order in random data.[61]

Even if we accept the possibility of a photographer embodying Cartier-Bresson's ideal of feline reflexes and Zen-like immersion in time's flow, we will still lack criteria for distinguishing photographs produced by an enlightened union with the moment from those produced by dumb luck. Although Cartier-Bresson argues that the sufficiently alert and sensitive photographer can seize the decisive moment of an event, his theory does not rule out the possibility that photographers can also capture such a moment by chance. The problem is latent in curator Peter Galassi's jocular remark that "other photographers have a sober respect for [Cartier-Bresson's] luck."[62]

To understand the limits of the decisive moment paradigm, it would be helpful to have a counterexample, a photograph that boasts the pictorial evocations of a decisive moment but is unmoored by any claims by its maker to have instinctively mastered the visual field. Fortunately, we have such a case: Joe Rosenthal's 1945 photograph of the flag raising on Iwo Jima (Figure 6.6).

Rosenthal's famous picture is exquisite in its particulars. The diagonal of the pole dynamically bisects the scene and culminates in the energetically flapping flag. The action, composed forcefully as a wedge, takes place on a ground of blasted debris, giving the elevation of the flag the feel of a resurrection in the realm of the dead. The midday light heightens the figures' sculptural qualities. The positions of the men progress rhythmically from left to right, forming a tightly knit group suggesting solidarity in the service of America. The obscurity of the faces, the repetition of bodily forms,

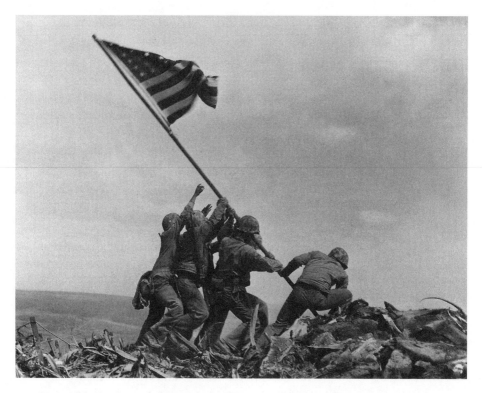

Figure 6.6 Joe Rosenthal, *Raising the Flag on Iwo Jima,* 1945. © Joe Rosenthal; AP/ Corbis

and the overlapping of one marine's hand by another all speak to the subsuming of individual identity into this act of teamwork and the national struggle of which it is a part.

The figure group is not entirely homogenous. It subtly negotiates the tension between collective effort and individuality so crucial to the American military ethos. The figure at far right is configured differently and connected to the other figures only along two seams. He stands apart at the head of the line, determining the precise place the flag will be planted. His muscular exertion, as suggested by the creases in his trousers and jacket, exceeds that of his fellow servicemen. Within the anonymity of teamwork there still is room for leadership, and this figure has moved away from the group to direct its collective effort. This decisiveness and the figure's strong left leg have pushed him across the bisecting line of the flagpole, further distinguishing him from the other figures and establishing a dialogue between his form at the base of the pole and that of the flapping flag at the

top. Indeed, this figure, in form and size, approximates the flag, making him a kind of mirror counterpart to Old Glory. The group is bracketed by this figure at far right and the one with outstretched hands at far left. The figure at the rear has presumably just let go of the flagpole, but his gesture nonetheless reads as one of reaching. Thus the figure group is framed between an aspiring reach for the heavenward flag and a determination to anchor the triumph of teamwork in the broken earth.

Rosenthal's photograph deftly weaves together multiple forms and tropes from the Western tradition of art. The triangular configuration of the muscular servicemen likens them to relief sculptures of a pediment, an architectural element associated with mythic narrative. The overlapping bodies recall the bonded brothers in Jacques-Louis David's neoclassical painting *Oath of the Horatii* of 1784, reaffirming the impression that the men raising the flag are fused by loyalty to state or cause. By hoisting a flag, these men recall the many representations of flag raising that circulated during the revolutionary moments of the nineteenth century and thus take on the connotations of democratic commitment and fervor that such representations bore. Finally, the rendering of this motif in Rosenthal's photograph is particularly redolent of sacrifice and resurrection because of its resemblance to scenes of Christ's martyrdom, particularly the bearing or erecting of the cross. Rosenthal's photograph thus expertly synthesizes several prominent strands of form and meaning in the Western tradition. By virtue of this synthesis, it conveys heroism, mythic import, loyalty, solidarity, patriotic fervor, and sacrifice.

Although this pictorial richness suggests an utter mastery of the visual field from which the image was drawn, the account Rosenthal gave of his photograph suggests otherwise. He was on assignment for the Associated Press when he climbed to the summit of Mt. Suribachi to record the replacement of a small flag with a larger one. After piling rocks and a sandbag to improve his vantage, he conversed with a film cameraman maneuvering around him and momentarily lost track of the action. Realizing suddenly that the flag was going up, he wheeled around and clicked the shutter. Afterward, he took a picture of the servicemen posed with arms raised in celebration. When he returned to the shore, he put his film bearing eighteen exposures from the day in a pouch taken by mail plane to Guam. While Rosenthal was still on Iwo Jima, the film was developed, and an editor wired a cropped version of the flag-raising photograph to the States, where millions of Americans saw it in their morning newspapers. When Rosenthal

finally got to Guam, a correspondent congratulated him on his success and asked if his great picture was posed. Rosenthal, thinking that the correspondent must be talking about the picture he orchestrated of the celebration, said yes.[63]

In other words, one day Rosenthal took eighteen exposures, one of which would become the most famous and reproduced photograph from the war, and he had no idea which one it was. He assumed that the best picture of his day was the one he had arranged by requesting a celebratory pose, when in fact it was his hurried shot of the flag going up. His click of the shutter had unconsciously caught a classic composition lasting only a tiny fraction of a second. In later years, he always acknowledged the blind luck involved in its making. "When you take a picture like that," he said, "you don't come away saying you got a great shot. You don't know."[64]

Rosenthal's account decidedly contradicts the claims to mastery over chance that abound in the literature on photography. Although the photograph perfectly renders its subject down to the last detail and captured for millions the essence of the battle for Iwo Jima, its maker claimed no special instincts or accelerated capacities. On the contrary, he confessed that its making was "largely accidental."[65] His account abjured any mythical bond between photographer and world that promised to saturate the image with authoritative meaning. "I have thought often," he said a decade after making his famous photograph, "of the things that happened quite accidentally to give that picture its qualities."[66]

Myths falter when they enter the wrong cultural setting. Rosenthal made his famous photograph far from the prattle of the art gallery or the puffery of the glossy magazine. He had spent months within a military culture in which any claims to having mastered chance would have seemed immature, foolish, and insulting to the wounded and the dead. The survivors of slaughter were usually quick to credit luck. To claim a mastery over chance would have been to suggest that fellow servicemen struck by bullets or shrapnel had failed to—in Cartier-Bresson's words from after the war—"work in unison with movement." To be sure, the culture of the American military during World War II had its own popular myths, but a mastery over the contingencies of the instant was not among them.

There is a photograph from after the war of Rosenthal sitting at a desk covered with copies of his famous picture, pen in hand to inscribe them with his autograph. Although he grins broadly, there is something unsettling about this depiction of a seasoned practitioner so wholly identified

with a single unpremeditated image. As the autograph session would suggest, the media refused to honor the claims that Rosenthal made on behalf of chance. This "largely accidental" picture won him a Pulitzer Prize and lasting fame. Even today, popular books on photography routinely treat the image of the flag raising in the same way that they treat painstakingly deliberate pictures. This resolute tendency of authorities to impute a mastery over chance to protect against any incursions on authorship and meaning can be maddening even to photographers. The photojournalist Eddie Adams, until he died, was frustrated that he won a Pulitzer for his famous "reflex" (his word) picture of Brig. Gen. Nguyen Ngoc Loan executing a Vietcong prisoner on the streets of Saigon rather than his carefully anticipated and engineered photographs of John F. Kennedy's funeral.[67] The belief that photographs capture decisive moments can also burden those depicted. The psychological stress that appearing in Rosenthal's famous picture exacted on the flag raisers has been well documented. Clint Eastwood's film *Flags of Our Fathers* explores the perniciousness of demanding that those who appear in a venerated photograph live up to its heroic rhetoric, no matter how random that rhetoric—and their association with it—might be. Finally, the event itself can fail to support the belief in photographic revelation. The fact that the flag raising Rosenthal recorded was the second on Suribachi has been taken as a sign of bad faith. It has suggested that the image might be a product of directorial staging rather than spontaneous insight. Myth demanded that the high rhetoric of Rosenthal's picture correspond to a glorious truth. How dare the world dream otherwise?

Rosenthal abjured the myth of revelation and instead affirmed the roles of chance and editorial discretion. Whereas Talbot had allegedly failed to note until afterward the clock face in the background of his photograph of Queen's College, Rosenthal confessed that he did not anticipate the picture that his famous photograph of the flag raising would turn out to be. Contra myth, the camera operated in fractions of seconds not registered by the continuous impressions of human perception. The photograph of the flag raising was arguably produced as much by the Associated Press editor who selected and cropped it for distribution as it was by Rosenthal.

The issue, it should be stressed, does not turn on a distinction between those subject to chance and those who have mastered it—that is, between a dedicated and competent one-hit wonder (Rosenthal) and a freakishly talented and prolific artist (Cartier-Bresson). Any such division would be

Figure 6.7 Jacques Henri Lartigue, *Automobile Delage, Grand Prix de l'ACF, juin 1912,* 1912, gelatin silver print, printed later. Photograph by Jacques Henri Lartigue © Ministère de la Culture—France; AAJHL

predicated on a firm bond between person and photograph that chance will not allow. The impossibility of such a categorical distinction is evident in a third and triangulating case: Jacques Henri Lartigue's celebrated picture of an automobile race in 1913 (Figure 6.7).[68] Lartigue, like Cartier-Bresson, was a French photographer made famous in America after the war by the Museum of Modern Art. He is now renowned for his prodigious aesthetic achievements as a teenager, and rooms can be filled with his superb photographs of modern dynamism. Yet he found one of the high points of his modernist production by looking backward at his work rather than mystically uniting with the flow of life.

The photograph in question depicts a Grand Prix race car in motion. Lartigue made it with a distinctive apparatus. His camera was fitted with a focal plane shutter that slid one metal curtain away to expose the film and then a second to block the light again. With short exposures, the second curtain followed quickly upon the first, forming a slit that moved across the aperture ("slit-scan" photography is another term for this mechanism). While most such shutters in use today move left to right, Lartigue's moved up from the bottom. Thus the film was exposed progressively from bottom to top.

In making his photograph of the race car, Lartigue also panned his camera from left to right in an effort to keep it aligned with the moving car. This is

why the figures look as if they were leaning to the left. The reason the race car is squished to the right is that Lartigue was panning his camera more slowly than the car was moving. In other words, three speeds determined the look of the picture: the speed of the bystanders, the speed of the camera, and the speed of the car. Relative to the speed of the camera, the bystanders were "moving" to the left, whereas the car was moving to the right. Hence the divergence between bystanders and car as the slit slid from bottom to top. By representing the dynamic intersection of relative speeds, the photograph delivers the thrilling and disorienting accelerations of a new century.

But relative speeds also governed the photograph's history. For Lartigue at least, the photograph was ahead of its time. He considered the picture a problem when he first developed the negative and made notes to that effect. He kept it, as he did all of his negatives, because he thought of his photographs as experiments from which he could continue to learn. Nearly forty years after he made the picture, and long after the blurs and distortions of speed had acquired a modern cachet, Lartigue rescued the picture from oblivion, circulating prints from his stored negative, and making new art from an old accident.[69] As this example demonstrates, editorial retrospection has served photographers of all stripes, including those celebrated as seers by the art establishment. Although great photographers may not need much chance, that doesn't mean they don't get lucky.

The dark side of vesting the bulk of visual culture in a chancy technology has rarely been acknowledged. Interestingly enough, the most telling acknowledgment between the world wars may have come in a short story not ostensibly about photography at all. In 1940, the *New Yorker* published a fictional piece by Russell Maloney entitled "Inflexible Logic."[70] The story describes the effort of a conservative Connecticut investor to test the hypothesis that chimpanzees sitting at typewriters would eventually tap out all the literature collected in what is now the British Library. To the investor's surprise, the chimpanzees begin to do just that, book by book, with nary a typographical error. The extraordinary improbability of their success causes a mathematician friend of the protagonist to go mad, and in the end, the investor, the mathematician, and all the chimps die in a blaze of gunfire.

Maloney's story weaves together many strands of the history this chapter has related. Although the story features typewriters rather than cameras, it addresses anxieties stirred by surrendering culture to mechanical processes prone to chance. Published five months after Great Britain and France

declared war on Germany in response to its invasion of Poland, Maloney's essay speaks to a crisis of confidence in Western culture. Germany, the country that had produced Bach and Beethoven, Goethe and Kant, Holbein and Dürer, had unleashed a mechanized barbarism in the guise of cultural ascension. The bewildering disconnection in Maloney's story between the seemingly random mechanical pounding of the chimpanzees and the canonical works it produces meditates trenchantly on this crisis. According to the story, the mechanization of the typewriter had opened a gap between intention and production that randomness had filled. In the typed pages the chimpanzees generate, what seems like a great achievement of Western culture is only an empty replica, a false double backed by sheer improbability. This cultural emptying incites madness that ends in violence, as the humanity of the characters surrenders to animal impulses and mechanical indifference.

Although chimpanzees banging away at typewriters are a far cry from skilled photographers on assignment, there is a parallel between the process Maloney's story describes and that which produced Rosenthal's iconic photograph. In the story, the chimps are figures for what remains of human agency when mechanical reproduction has removed the specific intentionality and deliberate design that art traditionally required. As one critic wrote in 1889, echoing many others before and since, to render sentiment via photography "is analogous to the turning out of poetry by machine."[71] For both chimps and photojournalists, a mechanical exploitation of chance yields work that improbably echoes exemplary traditional forms. The derangement occasioned in Maloney's story by the absence of the innumerable pages of gibberish that one would expect the chimps to churn out for every successful sentence—much less for each completed book—parallels a madness that threatens to erupt when the innumerable bland, disjointed, or objectionable photographs of the war in the Pacific are discarded and attention lavished instead on statistical outliers such as Rosenthal's iconic image. In the aggregate, the stochastic process of cultural production under the mechanized conditions of modernity produces dead certainties. Hire enough photographers to take enough photographs of armed conflict and you will get the one-in-a-million shot that echoes the erection of the cross (Rosenthal's flag raising), or the pietà (Sam Nzima, *Soweto Uprising*), or the crucifixion (Robert Capa's *The Falling Soldier,* Nick Ut's *Vietnam Napalm*). Any indications of a corrupt bond between the high rhetoric of these stunning pictures and the reality to which it is attached (for

example, claims that Capa staged his photograph, or the crucial cropping of the Ut image) attracts keen attention. The obsessive concern of the public for evidence of staging or manipulation is symptomatic of a belief that absent any such tampering the rhetoric of the photograph would attach securely to the event or history represented. If the process has been honest, the mythic logic runs, the photograph will be true. But the crucial issue is not staging or cropping; it is chance. The lie of the photograph has nothing to do with honesty. It resides in a belief that the world reveals itself to the camera that is wielded by the seer. It resides in a belief that pictorial rhetoric stems from and reveals an underlying reality that surfaces momentarily when the shutter clicks. It resides in a faith that the world dreams itself into the photograph, overcoming the play of chance.

In fundamental ways, the Maloney story, written at the outset of the Second World War, is an inversion of the Dimock account, written at the outset of the First. Whereas the real-life investor Dimock celebrates the primitivism of chance encounters while charting the progress from shooting with guns to shooting with cameras, the fictional investor in "Inflexible Logic" witnesses an evolutionary regression whereby the chaotic tapping of keys by chimps acting as men leads to the compulsive pulling of triggers by men acting as brutes. The hope that mechanical forms of culture could help foster a moral advance has given way in the Maloney story to a deep skepticism about mixing Darwinian drives and reproductive machines. Dimock's mechanical approach to the market, whereby he sought to withhold his humanity to harness the law of averages in the aggregate, becomes in Maloney's story a mechanical approach to culture, in which a violation of the law of averages leads to the unleashing of animal aggression.

When Maloney wrote his story, there was one photographer working in America who had an equally incisive understanding of the cultural interplay of animals, chance, violence, and mechanical reproduction. His name was Frederick Sommer, and the next chapter is about his work.

7

Frederick Sommer
Decomposes Our Nature

Rivalry has fostered artistic innovation for centuries. Ancient Greek dramatists competed for festival prizes, and the leading artists of the Italian Renaissance vied with one another for patronage and preeminence. In the early twentieth century, the rivalry between Matisse and Picasso drove modernism to splendid achievement. Such artistic contests have opposed not merely egos but also ways of understanding the changing demands on art. They have pitted one account of the present against another to stimulate insight and sharpen aesthetic positions.

A rivalry that took place in America during the years leading up to and including the Second World War opened a rift within the myth of the photographer as a hunter of dreams. Frederick Sommer initiated the struggle by drawing upon but also pushing against the precedent set by his friend the photographer Edward Weston. At stake was the meaning of photographic indifference and the question of how chance encounters could best be made into art. The antagonism led Sommer into one of the finest stretches of photographic production that any artist has ever had.

As a photographer, Sommer was a scavenger, not a predator. Between 1938 and 1945, his production centered on a modest number of photographs of three kinds: decaying animals on the desert floor (Plate 6), discarded parts of chickens on white surfaces (Figures 7.5–7.7), and horizonless desert landscapes (Figure 7.9). These photographs, in a weird and ruthless way, undermined wartime ideology and the complicit brand of modernism that Weston practiced.

Biography is important to the case. Sommer was born in 1905 in Italy to a Swiss mother and a German father.[1] When he was a child, his family moved to Brazil, eventually settling in Rio de Janeiro, where his father worked as a landscape planner. In 1925, Sommer went to the United States to study landscape architecture at Cornell, where he met Frances Watson, whom he wed two years later. After graduating in 1927, he returned to Rio and worked with his father for three years as a landscape architect. Then, in 1930, he was diagnosed with tuberculosis. He went to Switzerland with Frances to convalesce at Arosa, where he read widely and took up photography.

In 1931, Sommer returned to the United States by way of a short stay in Paris. Seeking a dry climate to preserve his health, he and Frances set out for California, but on the way they became entranced with the desert landscapes of the Southwest. They ended up settling in the small town of Prescott, Arizona, where Sommer became a professional artist and instructor.

Two meetings had a profound impact on Sommer's commitment to photography as art.[2] In November 1935, he hitchhiked from Prescott to New York City to meet Stieglitz and show him some drawings. The two men hit it off, and Sommer visited Stieglitz's gallery repeatedly during his week or so in the city. Stieglitz was in his last year of making *Equivalents* and doubtless showed some to Sommer. On his return to Prescott, Sommer used the small camera and 21 mm lens he had purchased in Arosa to make tiny and exquisite photographs. Each print, approximately 4 by 5 cm, seems a fragment of a secret world. Whereas Stieglitz had mostly been cutting out pieces of the sky, Sommer aimed his camera down, flattening botanical detritus into curious arrangements of form and texture. One photograph depicts pinecones, fir branches, and plant stems; another, dead leaves and twigs; a third, a stump. Whereas Stieglitz made the *Equivalents* by turning his lens on distant and unmanageable forms, Sommer embraced an intimate principle of touch and recombination, using biomorphic fragments as his working materials and the desert as his ground. His time in Paris and a familiarity with collage and other techniques associated with Surrealism and Dada doubtless informed his approach.

The second meeting took place in 1936, when a mutual acquaintance introduced Sommer and Frances to Weston and his partner Charis Wilson.[3] After seeing the little photographs that Sommer had been making, Weston suggested that he obtain an 8-by-10-inch view camera, which he

did in December 1937. When Weston and Wilson visited the Sommers in Prescott a month later, the two men spent several days making photographs in the vicinity. Exploring alongside each other, they made pictures of natural subjects they stumbled upon, each man abiding by his own aesthetic concerns.

In the preceding years, Weston, who was almost two decades older than Sommer, had established himself as an important modernist photographer. He cast himself as a free spirit, shedding Victorian assumptions about propriety and inhibitions about sensuality to discover transformative modern pleasures. Having become acquainted with leading practitioners such as Imogen Cunningham and Stieglitz, he shunned pictorialism in favor of making spare photographs depicting human bodies or other everyday things as if they were elegant sculpture. Like many of his peers, he came to disparage pictorialist soft focus as a way "to cloud and befog the real issue" rather than tell the truth about the world.[4] His photography celebrated the delivery of exquisite form to the sensitive eye in the course of everyday experience. In a daybook entry from 1930, he offers this account of his process:

> I start with no preconceived idea——
>> discovery excites me to focus——
>> then rediscovery through the lens——
>> final form of presentation seen on ground glass, the finished print previsioned complete in every detail of texture, movement, proportion, before exposure——
>> the shutter's release automatically and finally fixes my conception, allowing no after manipulation——
>> the ultimate end, the print, is but a duplication of all that I saw and felt through my camera.[5]

According to this account, Weston limits chance to his initial encounter with the object or scene. Before then, there is no preconceived idea, but by the time the shutter is clicked, previsioning has become absolute. The photograph is a reproduction of a mental image or aesthetic impression, of all Weston "saw and felt" through the camera in the course of his encounter. His extraordinary control over photographic variables enables him to bring an "artistic vision" into material form. Against those who doubt photography as art, Weston asserts that "art is a way of seeing, not a matter of

technique."[6] He carries on Talbot's project of shifting the locus of creativity to the eye, but with a new emphasis on the capacity of that eye to anticipate what the photographic apparatus will record. Affirming the revelatory powers of that apparatus, Weston asks in his daybooks: "Why limit yourself to what your eyes see when you have such an opportunity to extend your vision?"[7]

Weston insisted that the receptivity and judgment necessary to take advantage of chance were more important than chance itself. Following Stieglitz, he argued that preparation, diligence, and experience could yield a special sensitivity to accidental beauty, resulting in an improbably high rate of success in producing compelling photographs. His work, he said, amounted to "disproving chance." Or rather, chance in photography was like chance in the other arts, an occasion to find inspiration in an unexpected source that would mean nothing to a less perceptive mind.

Weston claimed to find a humble pleasure in accepting nature's proffer rather than inventing his own forms. "I get greater joy," he writes, "from finding things in Nature, already composed, than I do from my finest personal arrangements."[8] Most painters, he asserts, fail to approach nature "in a spirit of inquiry," going instead "with arrogance, to tell her how she ought to look, to be."[9] Echoing terms set a century before by Constable, Weston exalted the commonplace and nature's capacity to produce aesthetic configurations of its own.

Weston found particular beauty in subjects of two types: nudes and small organic objects, such as shells, vegetables, trees, rocks, or kelp (Figure 7.1). A central problem for him concerned how to give the featured object a background that would bring out the formal qualities he prized. In an essay, he describes the process of making his most famous photograph, a picture of a pepper from 1930 (Figure 7.2), in this way: "This particular pepper occupied me for several days. It seemed almost impossible to get all of its subtle contours outlined at once—I put it against every conceivable kind of background. . . . Then in a try-everything-once spirit I put it in a tin funnel and the moment I saw it there I knew my troubles were over."[10] Although Weston wished to unify his pictures in a modern photographic aesthetic, he treated his subjects, however mundane and inanimate, as discrete sculptural figures whose contours needed to be outlined—foregrounded—by what was behind them. Sometimes the setting in which he found objects sufficed, such as the wet sand that set off his kelp, but on other occasions locating the object aptly required ingenuity. The funnel was a way of giving

Figure 7.1 Edward Weston, *Nude,* 1936, gelatin silver print.
© 1981 Center for Creative Photography, Arizona Board of
Regents

his pepper a proper setting, one that would gather light and shadow to min-
imize distraction and distill the vegetable's voluptuous curves.

As a photographer, Weston liked nature best when it turned in on itself.
During the decisive years of his practice in the late 1920s and early 1930s,
spiral shells, collapsing peppers, twisted kelp or trunks, curled female
bodies, and other involute subjects became his stock in trade (Figure 7.3).
In this preference, Weston remained a Romantic, for Goethe had claimed
that the spiral manifested a fundamental principle of natural morphology.[11]
Weston even adhered to this principle in his infamous 1925 series of pho-
tographs of a toilet, the ceramic shape of which is inseparable from the
spiral motion of the waters it contains. Inward turning forms, materials,
and spaces appealed to Weston as a way to bring the world to wholeness

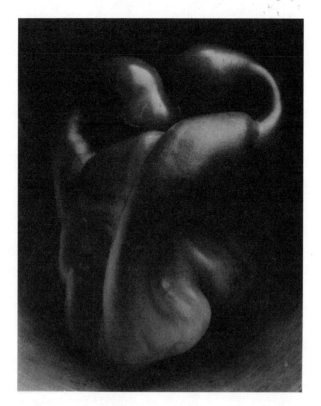

Figure 7.2 Edward Weston, *Pepper No. 30,* 1930, gelatin
silver print. © 1981 Center for Creative Photography,
Arizona Board of Regents

and concentrate attention on photographic form. By putting a curled pepper
into a funnel, he brought this principle to his background as well as to his
foreground. As the spiraling Guggenheim museum designed by Frank
Lloyd Wright would do decades later, Weston's funnel served as an abstract
and involute space conducive to the contemplation of an object within it
as a work of modern art.

In their many manifestations, involute forms enabled Weston to counter
photographic indifference. Photography was prone to pictorial surplus, in-
consequential details, and distracting accidents. By failing to discriminate,
it risked dissipating attention. The spiral was a means of distilling contour
and distinguishing a beautiful and unified object from the visual noise
around it. The object turning inward claimed its own space and secured for
itself a sculptural integrity.

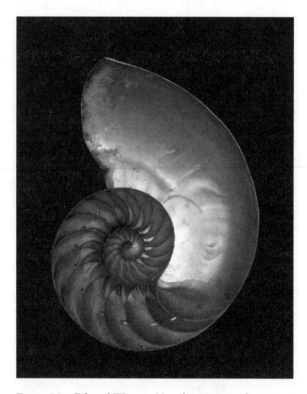

Figure 7.3 Edward Weston, *Nautilus,* 1927, posthumous digital reproduction from original negative. Edward Weston Archive, Center for Creative Photography © 1981 Arizona Board of Regents

Sommer learned a lot from Weston. He used similar words to stress the attunement that a photographer needs to make art from chance. In a seminar in 1979, he said: "Things have a way of finding their own order. There is no technical premeditation. It's just lucky that these things come together." But encounters with these lucky arrangements, he added, "are not chance occurrences. They will only occur if you have done your homework."[12] As did Weston, Sommer argued that only the prepared photographer would see the possible photograph in a felicitous moment.

But Sommer learned from Weston selectively. He desired other visual experiences from chance. In particular, he rejected Weston's tendency to use contour as a stable boundary between object and background. Long after the war, he noted that the subjects of Weston's photographs were

"beautifully placed" but "still somewhat parked there." "When [Weston] was doing a pelican," he added, "that pelican didn't belong in there just the way it could have."[13] According to Sommer, this lack of belonging was a function of photographically according the subject a privileged condition. In a talk he gave at Princeton, he described this condition and its shortcomings:

> Suppose you were going out with your camera and somebody asks you what you are going to photograph. There's a pretty fair chance that you have something on your mind, and you'll name something. But the more you can name it, the more you're going to face the great enemy, and that is the privileged condition. The privileged condition is a beautiful woman. The beautiful woman sits in the middle of a space and none of these shades that are so beguiling seem to go anywhere, it's just parked in the middle. . . .
>
> So the teacher has to show the student the danger of concentrating one's interest on one cluster of things, things that we can name too easily, like a flower, a beautiful portrait. And the reason is that they are islands. No matter what you do with them—you can push them this way a little bit, you can push them that way—they are islands, and they will never get to the rest of the sea. And the sea will never wash their shores.
>
> So what is really needed is to teach the student that art is ultimately not interested in privileged conditions, but is a distributive concern where all things share. And the more things can share in an enterprise, the more the thing is infected with all sorts of possibilities.
>
> It is the internal logic, the logic of the field of action. It is interesting that one can learn a lot about these field relationships of a large painting by reading modern physics. . . . I've been reading various books on physics for many years and I understand very little. But it's amazing how fruitful it is for me.[14]

In distinguishing his work from Weston's, Sommer sets the parked or privileged subject, which is readily named and, like an island untouched by the sea, has too little exchange with what surrounds it, against the distributive concern, a spatial configuration that draws together many relationships, allows fields to interact, and muddles the naming of things. He associates the privileged condition with the female nude, and the distributive

concern with shoreline erosion and modern physics. He suggests that his work departs from Weston's by more successfully breaking down the boundaries of the privileged condition (the "great enemy") and thus more successfully representing the ordinarily invisible particulate processes that permeate all matter.

The paradigmatic Weston subject may have been the nude, but for Sommer the use of the funnel made *Pepper No. 30* the definitive Weston photograph. In 1979, Sommer explained how the funnel betrayed the shortcomings of Weston's practice:

> You see finally it's a question of getting away with it. And . . . [Weston has that same problem with a lot of those vegetables, beautiful handsome vegetables. But the thing that should be somewhere connected with Edward Weston's representation of a lot of things and should be part of his monument someplace is a funnel. If it hadn't been for that funnel Edward Weston wouldn't be exactly Edward Weston. So the funnel permitted him not only to hold the vegetable at a certain position to keep it from rocking, but it simply—it gave it a setting, and . . . this setting permitted shadings and shadow pockets to arise and degrees of that depending on how the light was striking.[15]

Although Weston did not make a habit of using a funnel to display his subjects, the discovery of its usefulness held a dispositive place in his writings. Sommer likewise regarded the funnel as merely concretizing a structural principle that Weston regularly employed. In arguing that Weston was "getting away with it," Sommer was not criticizing him for violating a code of so-called straight practice; rather, he was noting that the pictorial fantasy of the privileged condition requires suppressing the exchanges between a subject and its surroundings.[16] To represent the privileged subject in isolation, as Weston did, was a ruse because it fostered misunderstanding. Sommer opened a seminar with this announcement: "The greatest trick in the world would be to show that things are disconnected."[17]

When it came to making photographs, this disagreement had real consequences. A comparison between Weston's *Dead Rabbit, Arizona* of 1938 and Sommer's *Jack Rabbit* of 1939 makes this clear (Plate 6, Figure 7.4). The basic move of the two photographers was the same. Each put in the middle of a photograph a dead rabbit, a subject suggesting the contingen-

Figure 7.4 Edward Weston, *Dead Rabbit, Arizona,* 1938, posthumous digital reproduction from original negative. Edward Weston Archive, Center for Creative Photography © 1981 Arizona Board of Regents

cies of travel over roads or across the desert, and the capacity of the photographer of special insight to discern beauty in unlikely places.[18]

In the two photographs, however, this similarity accommodates profound differences. The limbs of Weston's rabbit are splayed in elegant violence against the pebble-strewn dirt. The contrast between the gaping wound and the furry right ear renders death at its freshest and most poignant, when the beauty of life still lingers. The deep shadows on the ground and the human comportment of the camera (we feel ourselves crouching above the dead animal) evoke a familiar pathos.

Sommer's rabbit has passed into a different state. Its disintegration breaks down the contours separating animal and desert, figure and ground. The granular exchange between carcass and soil disintegrates the subject at its edges and calls into question when a rabbit is no longer a rabbit and where this particular rabbit begins and ends. Instead of recalling the instant of

death, Sommer's photograph addresses the subsequent gradualism of material decay. This decay undoes the privileged condition that his centrally placed rabbit might otherwise suggest. As the rabbit decomposes, it loses its formal integrity and distinctness. Instead of folding inward, it disintegrates outward, revealing its belonging to the earth.

For Sommer, formal disintegration rather than involution was the natural principle worthy of aesthetic pursuit. In an interview decades later, Sommer and James McQuaid had this exchange:

JM: Then, of course, there's this next one . . . which quite literally the coyote is beginning . . .

FS: There's a break-up.

JM: To go into the background.

FS: And I think it's much more to the point to say that is not a privileged condition because that thing belongs to that whole area. So, in a sense, the formal design problems parallel surprisingly the biological necessities of this. I mean, this is the outcome of that in a way.

JM: Yes.

FS: It belongs to it, all the time. It's a privileged condition for a few years while this animal is whole and runs around. To that moment it's still a pepper in transit to the landscape. No home, you know? Really, essentially, no home. Trying to feed itself and what is nourishment: an occasional momentary undertaking during the day to establish bonds between what we are and where we came from.

JM: You know, I'm hearing you using again and again expressions about "what a thing is" and "where it's located." I'm thinking really of . . . quantum mechanics, where you can specify what it is or where it is, but it's difficult to specify both at the same time.

FS: That is very, very important. And this is exactly what goes on in design. Art has always preceded science. It's unbelievable how important this is.[19]

In this conversation, Sommer asserts an alignment between "formal design problems" and "biological necessities." The decomposition of the rabbit satisfies his pictorial demand to undo the privileged condition of the subject. The privileged condition is the illusion of the whole entity; it is a kind of homelessness ("No home, you know?"), where the bonds between subject and world are concealed. The disintegration of the body allows for a

more thorough and open exchange between subject and world. Sommer once remarked: "Climatic conditions in the West give things time to decay and come apart slowly. They beautifully exchange characteristics from one to the other."[20] If the rabbit as a carcass is an island, the desert eats away at its shores.

When McQuaid refers obliquely to Werner Heisenberg's uncertainty principle to suggest a link between Sommer's approach and the baffling quantum behavior of subatomic particles, the photographer concurs vigorously. Heisenberg's principle holds that the more accurate our measurement of a particle's position is, the less accurate our measurement of its momentum will be, and vice versa. Whereas scientists had long assumed that accurate measurement of one natural phenomenon in no way interfered with accurate measurement of another, Heisenberg cogently argued that this assumption did not always hold, that acts of measurement could be incompatible. After its initial appearance in 1927, the uncertainty principle quickly captured the popular imagination. When Sommer listed for publication thirty-five recommended books "in and around the structure of art," three were by Heisenberg, including *Philosophical Problems of Quantum Mechanics*.[21] McQuaid was clearly asking Sommer to expound on a pet theme.

"This is exactly what goes on in design," Sommer says. But what for him is the uncertainty principle of design? According to his practice, it is the incompatibility of depicting something as a subject and depicting it as a node of distributive exchange. That is to say, the incompatibility of naming something and understanding its interdependence with the rest of the world.[22] By suggesting that an animal while alive exists in a privileged condition (a "pepper in transit"), Sommer emphasizes the illusory autonomy that we habitually bestow on the living organism. Apprehended as a subject, the living organism never puts its true ecological interdependence on display. For a rabbit to get beyond the status of a Westonian pepper, of an island unwashed by the waves, it must begin to disintegrate. Sommer sought out a liminal state of decay to negate the privileged condition.

To accentuate the disintegrating rabbit's lack of privilege, Sommer used framing and light. Whereas Weston buffers his rabbit with space, keeping three edges of the image equidistant from its furry extremities and leaving more room at the bottom for visual support, Sommer clips his rabbit by the ear and renders the margins less even. Space does not frame and isolate his rabbit to the same extent. In addition, Sommer has chosen an even

lighting that suppresses any play of shadow that would help distinguish the rabbit from the ground. Whereas each pebble in the Weston photograph functions as a kind of little rabbit or pepper parked in momentarily exquisite light, each tiny bit of desert surface in the Sommer picture is equal to every other bit. The indifferent lighting refuses to privilege.

In Sommer's photograph, the rabbit appears as flat as the ambient light. The soil has seemingly drawn the rabbit into it, and Sommer has used camera placement and technique to flatten the animal further. The camera points straight down, resulting in a disembodied vantage associated with the aerial photograph or architectural plan. This vertical address, combined with the even focus and flat light, presses the carcass into the ground plane. Sommer's lens helped him achieve this effect. Although the rabbit's remaining fur actually pushed its rotting skin off the ground (close inspection of the photograph reveals this), Sommer used his Tessar lens to suppress the elevation: "[It] does something that not all lenses do so well, which is a necessary thing to deal with. If you have depth-of-focus problems and you really need depth of field, a lot of lenses, if you could stop them down, would mush up. But this particular Tessar does a magnificent job stopped down. That rabbit was photographed at f/90. Otherwise I could not have possibly photographed it because it is lying on its fur and it's a good distance off the ground. It's piled up so neat that you don't see it."[23] Sommer conceals the elevation of the rabbit to bring out the interplay of decomposing body and granular soil. For him, this was not, as was Weston's funnel, trickery in the service of a false impression; rather, it was artfulness in the service of aesthetics.

In making *Jack Rabbit*, Sommer mixed photographic and biological processes to fashion a distinctive modernism. He enlisted biological decomposition to invert norms of artistic composition, delivering an elemental planarity that organically engaged the modernist concern for reflexivity and flatness. His picture consists of one weathered surface (a photograph) representing another (a carcass). Both film and rabbit have been exposed to the elements for just long enough to produce a surface bearing an image. By chance, Sommer had encountered not only a subject *for* a photograph but also a subject *as* a photograph.

In its double flatness, *Jack Rabbit* addresses the role of sublimation in the making of art. Seen from above, its oddly intact profile produces an oscillation between horizontal remnant and vertical display, calling at-

tention to the axial shift from desert floor to gallery wall. The corpse in the desert is a matter of unpleasantness, while the silver print on the wall is a vision of delight. Before Jackson Pollock hung the traces of his scatological drips and pours to make a field of modernist painting, Sommer had elevated a decaying corpse into an integrated image. Rosalind Krauss writes in an important essay on Pollock and sublimation: "To stand upright is to attain to a peculiar form of vision: the optical; and to gain this vision is to sublimate, to raise up, to purify."[24] If the Pollock system exalted and sublimated the effects of gravity, the Sommer system exalted and sublimated the effects of decomposition. In *Jack Rabbit,* the gradual material exchanges of desert ecology become stilled as a pictorial field; photographic comportment transmutes base materiality into modernist optical pleasure.

In his wartime modernism, Sommer pursued an overlap between the demands of art and the necessities of nature. Whereas Weston found contours and shadows to exalt in all manner of things, Sommer kept to a small set of subjects that exhibited (or could be made to exhibit) the common ground he sought. Subject matter still mattered to him, because he was bent on signifying principles of material exchange in the print as an image, as well as in the image as a print. In *Jack Rabbit,* for example, content disintegrates into the particularity of both sandy soil (print as image) and photographic silver (image as print). Decomposition in the photograph functions simultaneously as an organic process and as an avant-garde imperative. As Sommer observed, the "formal design problems" parallel the "biological necessities."[25]

Sommer's wartime pictures took time. In making them, he eschewed the acceleration and transient geometry of the decisive moment in favor of gradual processes of decomposition and desiccation. This slowing of time spread to the viewing of his pictures. Appreciation of their unscripted particularity and subtle exchanges required a lengthening of attention. Anecdotes suggest that when Sommer had visitors, he would put a single photograph out in front of them for an uncomfortably long time. At last he would take it down and put up another. "The trouble that is being stirred [by my photographs]," he once said, "is that you lengthen the moment of attention for someone. And when you lengthen the moment of attention of a person— this is a very impolite thing to do."[26] Spurning the speed of the urban street, Sommer set a contemplative tempo for his desert scavenging. By slowing

attention down, his carcass photographs foster a recognition of nature's metabolic refusal of eternal form. In our contemplation of them, the decaying body becomes an ethical matter.

The details of *Jack Rabbit* contain yet another subtle negation. A casual look at the photograph may suggest that the little sprigs around the corpse are strewn at random, but scrutiny indicates otherwise. All of them look fresh, and all of the larger ones, save for a sprig clipped at the left margin, radiate outward from the rabbit like prickly emanations. One sprig extends from its nose, another from its abdomen, and a third from its rear. One small sprig lies just beneath the tiny claws of the extended forefoot. Several pebbles lie atop or tightly around the sprig by the nose. These signs of handiwork put the rabbit in a hybrid state between chance encounter and assemblage.

When Sommer took the picture, the American photographic establishment generally disapproved of rearranging things before the lens. A journalistic ethos had emerged that deemed the photographer an honest witness, whose testimony could be tainted by staging or handling.[27] At the very least, the photographer was supposed to make any manipulations clear to avoid breaching trust. "This was done of course with no manual arrangement," assures Weston in one of his daybooks.[28] Sommer rejected this ethos outright. For him, the distinction between witnessing and manipulating was irrelevant: "Some people are very uncomfortable when they can't tell whether I put something together or found it that way. But why should they be against putting things together? This is like people who don't want to be cured by anything other than a natural medicine. They can't accept the synthetic compound that might cure them even better. They would rather drown in natural things."[29] Sommer's rejection of witnessing as an ideal for photography was essential to his modernism. Witnessing presupposes a rift between photographer and world that his practice contradicted at every turn. According to that practice, material processes of exchange pervade both photographic subjects and photographic craft, both the sand-particulate desert and the silver-particulate print. These exchanges, always composing and decomposing, forever entangle photographer and subject. From this perspective of entanglement, the pristine nature exalted by Ansel Adams and his followers falsely cordoned off humanity from an encompassing ecology. "Some speak of a return to nature," Sommer wrote. "I wonder where they could have been."[30]

So carefully arranged, the sprigs in *Jack Rabbit* clearly matter. They belong to a plant that the locals call puncture vine, because its spiny nuts, which do not appear in the photograph, have been known to puncture tires. The sprigs thus play on the rabbit's deflated state. Wandering in the desert, the photographer has encountered a flat.[31] Gastronomic humor seems present as well. At a glance, the sprigs recall rosemary and other herbs used to season cooked rabbit. Instead of a juicy hare, we have a dried carcass; instead of rosemary sprigs, we have clippings of a noxious weed. Sommer, who was fond of digestive metaphors for aesthetic processes, slows our metabolism of photography and raises questions about what exactly sustains and consumes us.[32]

Sommer pressed this inquiry further in his photographs of chicken parts. In this series, disgusting fragments of animal matter, rather than decaying corpses, stage the encounter with chance. *Chicken Parts* of 1939 is one of the best. It depicts the head, esophagus, and guts of a chicken, wrapped in a membrane that covers most of the head like a hood (Figure 7.5). The anatomy glistens in the overhead light, every detail recorded with precision and minimal shadow. The saggy scrap of flesh lies on a smooth white surface, marbled with stains, and bearing a fresh pool of exuded liquid. The picture recalls the imagery of meat processing, medical dissection, and ancient divination, the reading of entrails to recuperate meaning from chance.

In a series of interviews in 1991, Sommer described the origins of his pictures of chicken parts:

The first two or three years of my photographic work were very intense in terms of chicken anatomy. I had a darkroom in Prescott and often, shortly after five o'clock, when Frances got through with work, we'd meet and go to the grocery store just off the town square. In those days when you bought a chicken they didn't have it all prepared waiting for you, they had the whole chicken and the only thing that had been done was it had been plucked. We'd pick out a chicken and the butcher would put it on the block and cut off the head and legs and gut it and throw these parts into a large carton.

This went on for months, maybe a year and a half, when one time we went in and every one of those chicken heads just started to look different. Believe it or not, every chicken head had unbelievable personality and emotion.[33]

Figure 7.5 Frederick Sommer, *Chicken Parts,* 1939, gelatin silver print. ©
Frederick & Frances Sommer Foundation

By mentioning that the chicken heads in the butcher's carton at the local
Piggly Wiggly had "unbelievable personality and emotion," Sommer ties the
chicken part pictures to the uncanny.[34] According to that notion, when
the inanimate takes on personality, it unsettles the elemental division of
the world between the living and the nonliving.[35] Whereas Cameron had
approached the uncanny through an enlivening of her portraiture, Sommer
approached it through an animation of his dead chicken parts.

Chicken fragments are unquestionably uncanny material. Freud remarked that "dismembered limbs, a severed head, a hand cut off at the wrist . . . feet which dance by themselves . . . all these have something peculiarly uncanny about them, especially when . . . they prove capable of independent activity."[36] The headless chicken that continues to run and flap its wings is a staple of rural lore. By offering us dismembered chicken parts, including many heads, Sommer's photographs invoke the possibility of incomplete birds having independent life both inside and outside the frame.

The chicken part photographs are still lifes insufficiently stilled. Sommer drew his uncanny fragments from the supermarket, but they haunt the domesticity it was meant to serve. The job of the butcher was to prevent them from joining the spaces of everyday things or *rhopos* that still lifes have historically depicted.[37] These wet and rubbery remains have fallen into view like a bad dream, unwelcome visitors from the realm of the unclean or untouchable. They recall the ancient Greek term *miasma,* which referred to various forms of pollution, including prohibited forms of contact with the dead.[38] In wartime America, miasma was less a matter of religious prohibition than of modern squeamishness and sanitation. Commercial changes in the preparation of poultry were shifting the line separating the miasmic from the merely discarded. Spurred by the needs of the military for uniform, convenient, and well-preserved food, the sale of processed and packaged parts of chickens was supplanting the practice of selling them whole. A gulf opened between the purchased meat and its animal source, and scraps that never entered the home gradually became abhorrent.[39] Piggly Wiggly, the grocery store chain that supplied Sommer with his chicken parts, was at the forefront of this modern processing. According to the company, it was the first to offer self-service grocery shopping, checkout stands, refrigerated cases, and "employees in uniform for cleaner, more sanitary food handling."[40]

The sterile background that Sommer used for his chicken fragments amplifies their loathsomeness. As he liked to tell viewers, underneath the fragments was an oilcloth-like material for lining cribs and babies' beds. His chosen mode of display, however, is unsettling even absent this distasteful information. By showing the chicken parts against a blank plane, the photographs expose the waste of food production to the visual syntax of the dissecting table. What the modern food industry has cast from sight has become an object of clinical scrutiny. In the institutionally hybrid spaces

of these photographs, each chicken bit oscillates between discarded scrap and curious specimen.

Sommer negates the privileged condition in these photographs by reserving it for things not meant to be seen. By offering waste up to scrutiny, his photographs reinforce the notion of the uncanny as a return of the repressed. As Schelling famously put it, the uncanny is everything "that ought to have remained secret and hidden but has come to light."[41] Although Sommer's photography of chicken parts largely maintains the figure/ground separation that his carcass pictures subvert, the always leaky or otherwise indeterminate scraps of chicken flesh, adorned with stains and bits of debris, cannot sustain the privilege of their position.

The chicken-part photographs invert the sexiness of Weston's delectable subjects (Figures 7.1, 7.2). In the privileged position of the beautiful woman or her edible substitute, Sommer places repellant matter bearing signs of castration. The pictures display male chicken parts meant to be kept hidden, including sheathed peckers, flaccid lopped-off organs, and always too many or too few eyes (Figures 7.5, 7.6). In front of these photographs, vision is both empowering and disabling, mastery and scandal, clinical insight and sexual threat. The limp scraps cannot be reconciled with or distanced from the body. "The more creative and enterprising a person is, the more he is in a condition of shock," Sommer once said.[42] In his photographs of chicken parts, the shock stems from a grotesque dispossession, a male dismemberment that spoofs the sensual caress and voluptuous elegance that Weston provided. Instead of showing us a body curled into a mastered unity, Sommer gives us a fragment blown apart.

Sommer's undoing of Weston is a matter of treatment as well as subject. In making his pepper into a modern icon, Weston kept it free of all signs of handling. Abiding by the institutional terms of the grocer's market, he took the pepper as the invisible hand delivered it to him. Pristine and whole, the pepper maintains its perfect independence in the funnel. By keeping his own hands invisible, Weston thus produced an elegant image of an ordinary commodity for the consumer of art. Sommer did the reverse. He refused the terms of the grocer's market by bringing home waste and putting it to scrutiny. Fragmentary and disgusting, his chicken parts show obvious signs of having been handled. Membranes have been knotted, and eyes and other organs have been moved about. The unpleasant secrets of production are on display, defiling the invisible hand.[43]

Figure 7.6 Frederick Sommer, *Anatomy of a Chicken,* 1939, gelatin silver print.
© Frederick & Frances Sommer Foundation

Sommer used his rivalry with Weston to critique the commodity form and any modernism that exploited its precepts. In his public talks, he asserted that the self-contained perfection favored by Weston, which was modeled on the magical allure of the commodity, degraded the human condition. Sommer once said: "The more you conceive of something as wholesome, perfect, rounded, comprehensive, in its presence you are a loser."[44] According to this trenchant logic, Weston's pepper is humiliating.

Its illusory self-completion represses the material exchanges that sustain, integrate, and decompose us. The chicken-part photographs reverse the equation and the complicity subtending it. Whereas the capitalist market hides production to make the commodity a deathly wholesome form of life, these photographs bring industrial waste to visibility as a lively partial form of death.

Sommer's invocation of the uncanny is subtle and shifts from one picture to the next. In *Chicken Parts*, the handling of the decapitated head adds unsettling signs of life to the lifeless. From the back of the head, a pool of sanguine liquid fans out in the shape of a rooster's comb, rendering the profile a ghostly echo of its living counterpart. The membrane pulled over the head resembles a hood, which registers anthropomorphically as a sign of shame, secrecy, or malevolence. More disconcerting still are the distressing signs of vision or its lack. The membrane pulled over the eye leaves the fragment doubly blind. Stretched across the head, the membrane glistens in the overhead light, making conspicuous the eye socket's depression, where a shadow interrupts the sheen. The glint of the eye, ordinarily the only organ that exposes its wetness to the world, has thus been displaced, and lies scattered about the blind hollow. In its homelessness, the glint has migrated and multiplied, bringing a play of light to the newly exposed wet innards.

This displacement of the eyeball's glint recalls Jacques Lacan's notion of the gaze. In the published notes from his famous seminars on psychoanalysis, Lacan distinguishes the gaze from vision. He explains that whereas vision has been understood geometrically as a cone emanating from the subject's point of view, the gaze catches the subject from an external point. Whereas the traditional notion of vision centers and empowers the subject, the effect of the gaze is to expose and disable it. Lacan illustrates his understanding of the gaze through a story of being at sea with some fishermen. When they are about to pull in the nets, someone called Petit-Jean points out a glinting sardine can floating on the sunlit waves. His joke to Lacan—"You see that can? Do you see it? Well, it doesn't see you!"—provokes discomfort.[45] Lacan later reflects that if the sardine can did not see him, it was nevertheless looking at him. In this way, he distinguishes the gaze—"that which is light looks at me"—from vision and its subject-centered diagrams. Like Sommer, Lacan was interested in undoing the privileged position of the subject. According to him, philosophers, by positing "the absolute overview of the subject" to account for visual perception, had

"missed the point." In other words, they had missed the gaze, the point of light that catches the eye, reverses the cone of vision, and blindly puts the subject in a picture.[46] They had failed to register those moments of visibility when an accident of light disrupts our fantasy of symbolic command. In *Chicken Parts,* the discarded remnant of the food industry through which the gaze works is an unsightly poultry scrap instead of an old sardine can. The glints around the eye and on the esophagus captivate us, while the membrane over the head pointedly estranges this uncanny address from vision and recalls Lacan's remark about the gaze "that reduces me to shame."[47] While the example of a sardine tin looking at someone links the gaze to the uncanny, *Chicken Parts* amplifies the bond. The gleaming flesh in the picture proffers the gaze as a net-like dispersal of light, a random scattering of points that look at us but cannot see. These points signify what Lacan terms the "pulsatile, dazzling, and spread out function" of the gaze.[48]

The glints in *Chicken Parts,* of course, are only reproductions. Through photography, each reflection before the lens presumably left on Sommer's photographic negative a counterpart patch of darkness that yielded a patch of white on each of his prints. Looking at these white patches is not the same as being caught by the glint of a sunlit can floating on the sea. Whereas the glint of the can comes out of nowhere, the white patches have been made for our look. If *Chicken Parts* captivates us anyway, the cause may be our readiness to surrender. Having recounted his fishing anecdote, Lacan discusses the relationship between the gaze and the picture (for which he takes the painting as a paradigm): "The painter gives something to the person who must stand in front of the painting which . . . might be summed up thus—*You want to see? Well take a look at this!* He gives something for the eye to feed on, but he invites the person to whom this picture is presented to lay down his gaze there as one lays down one's weapons. This is the pacifying, Apollonian effect of painting."[49] According to Lacan, the painter solicits the viewer's attention, ostensibly offering a refuge from the violence of the gaze. As an established social form, art comes with the assurance that everything has been subsumed within the symbolic order for our pleasure, and that no stray point will deliver a disabling burst of light ("no flashes in the gallery, please").

But not all pictures are so Apollonian, and raw chicken scraps make a strange feast for the eye. Lacan anticipates such exceptions to his formula. "Expressionist painting," he writes, counters the Apollonian rule by providing "something by way of a certain satisfaction—in the sense in which

Freud uses the term in relation to the drive—of a certain satisfaction of what is demanded by the gaze."[50] With this clarification, Lacan puts the gaze and the eye at odds; for the eye to eat, the gaze must be surrendered. To satisfy the gaze, the Apollonian effect of painting must be renounced. But what is the "certain satisfaction" that the gaze demands? Lacan is understandably vague on this point. Because he has defined the gaze as that which thwarts *our* demands and reduces us to shame, the satisfaction in question is clearly not our own. This makes the gaze a kind of death drive, a compulsion to encounter our undoing. Drawing on the parable of the sardine can, we might say that the gaze insists on catching the subject where it does not belong, decentering and displacing it, breaking it into the viewer and the viewed. Elsewhere, Lacan uses the example of Hans Holbein the Younger's *Ambassadors* to exemplify these effects. The anamorphic skull Holbein curiously inserts beneath the figures in his painting appears correctly rendered only from a radically oblique angle. It thus splits pictorial space into two incompatible schemes, organized around two points the viewer cannot simultaneously occupy, one offering a pleasurable view of signs of life, the other requiring an uncomfortable vantage on an emblem of death.[51]

Chicken Parts splits the viewer differently. Rather than incorporating two perspectives, it laminates a surface promising pleasure to several sure to cause distress. Reproduced in exquisite silver gelatin prints, the photograph bears every mark of technical mastery, inviting the eye to contemplate its immaculately prepared surface. The impossibility of accepting this invitation without also taking in the repellant surfaces of the glistening organs voids the Apollonian promise. This lamination trapped many of the most prominent American authorities on photography in Sommer's day. Unable to deny his command of the medium, they could not surmount their violent distaste for his material.

Whereas Lacan couched his account of the gaze as a critique of the philosophy of vision and the centered subject it presupposes, the target of Sommer's uncanny pictures was an excessively wholesome photographic modernism. Adams and Weston predicated their practices on a highly agreeable lamination, one binding photographic virtuosity to imagined earthly pleasure. As the eye caressed the graceful arc of Half Dome or the hip of a female nude, a gratifying attention to photographic surface and form mingled with imagined pleasures of being in the presence or place of the represented. Time and again, this mingling granted both an experiential solitude in the gallery and an imagined solitude in the West. In both, the

gaze and its discomforts could subside, and the subject could spiral inward, as through a funnel, to find itself recentered in the world. This withdrawal into a double contemplation of gallery picture and Edenic plenitude combined a spiral inward with an escape outward. It promised a chance to "get away from it all" and become renewed through a return to a hallowed silence or uncorrupted freshness, such as Lacan sought in Brittany before the gaze caught up with him. By perfecting this promise, Adams became as important to the Sierra Club as he was to the Museum of Modern Art.

In the chicken-part pictures, Sommer strips photographic virtuosity from transportive pleasures and relaminates it to the odiousness of anatomical waste. The substitution is particularly shocking in *Chicken Parts*. In light of its uncanny contents, the picture's composure and precision, its fineness as a photograph, its comportment as a delectable offering to our sight, become a kind of taunt. The longer we look, the more ways the image finds to look back. For example, near the center of the picture, an oval of white opens in the crescent of flesh. This opaque ocular form, which echoes the shape and orientation of the shadowed eye socket, operates as a blind spot. The blindness is our own, for the white spot refuses to be tamed by our look. It seems to both belong and yet not belong to the surface beneath the scrap. As an interruption in the glistening flesh, it is the counterpart of the beak emerging from the hood. The sharp beak and the torn hole are bound by their causal proximity, as if the fragmentary bird has wounded itself and hides in shame. Inverting the spiraling wholeness mastered by Weston, Sommer suggests a violence curving inward, a death drive by which naked matter attacks itself. If we accept this picture's invitation to look, the impossibility of fixing the source of our disturbance, to feel at ease in our location, to escape the cavity at the center of the subject, elicits the gaze.

The operation of the gaze in Lacan's story of the sardine can has a social dimension particularly relevant to Sommer. Lacan writes in a coda to the story:

The point of this little story, as it had occurred to my partner, the fact that he found it so funny and I less so, derives from the fact that, if I am told a story like that one, it is because I, at that moment—as I appeared to those fellows who were earning their livings with great difficulty, in the struggle with what for them was a pitiless nature— looked like nothing on earth. In short, I was rather out of place in

the picture. And it was because I felt this that I was not terribly amused at hearing myself addressed in this humorous, ironical way.[52]

As Lacan suggests, jokes organize social relations. Some people are in on a joke, some are not, and some are the butt of jokes. Lacan associates this social ordering with the gaze. Both the glint of the sardine can and the joke of Petit-Jean single Lacan out as something opaque, such as a stain or spot, that does not belong in the picture. Struck painfully by the sharpness of both glint and joke, he realizes that the social life of these fishermen is a picture in which he has no place.

The gaze catches Lacan in a moment of class alienation. The fishermen are wet and salty workers embedded in a family enterprise, struggling for subsistence. Lacan is a dry intellectual, who has set off on his own to acquire experience. He moves with the present, whereas they remain tied to the past ("Brittany was not industrialized as it is now," he recalls).[53] He lives a different kind of life, and will die a different kind of death. In his introduction of Petit-Jean, Lacan says, "Like all his family, he died very young, from tuberculosis, which at that time was a constant threat to the whole of that social class."[54]

Although there is nothing overtly autobiographical about Sommer's wartime photography, its traffic in the gaze reminds us of the power of contingency to paint us into pictures with indifference to our designs. In particular, both in the story that Lacan tells of his life and in the biography that Sommer left others to tell, tuberculosis operates as a key component of a social picture in which some are painted in and some are painted out. Whereas in Lacan's story tuberculosis serves as a sign of the class otherness that results in his alienation as the target of a joke, in Sommer's biography it derails his life and leads to a wholly unexpected future. The disease first bears the young landscape architect to Arosa for treatment, where he takes up photography, and then to Arizona, in hopes of preventing a relapse. The passage from biography to art is so complex, and has so often been oversimplified, that many of our best art historians habitually avoid it. But there is no gainsaying the resonance in this case. Sommer made his photographs of carcasses being consumed by the desert in the aftermath of his experience with "consumption." He made his photographs of chicken parts after his own body had been subjected to clinical scrutiny, painful probing, and invasive handling. In Arosa, clinicians had collapsed the diseased portions of his lungs, one side at a time. For the sufferer of tubercu-

losis, what was inside came out; blood was spit up and sometimes withdrawn. Convalescence entailed a slowing of time and a lengthening of attention.[55] In these many ways, Sommer's wartime photographs have tuberculosis written all over them.

Sommer's diseased and dis-easing pictures repelled some purveyors of a more wholesome modernism, including Ansel Adams. His violent reaction to them surfaces in a document apparently bearing notes from a meeting of the board of *Aperture* in 1962. In the document, "AA" presumably refers to Ansel Adams, and "MW" to Minor White.

MW is asking AA about Fred Sommer making a Polaroid ad for a forthcoming issue of Aperture dedicated to FS.

AA accepts the use of the image of Max Ernst but not one of "dismemberment." AA is willing to make "editorial concessions" but not compromises. An ad would be acceptable so long as it does not convey the "sick, sick, SICK, SICK spirit of his work." AA is not sure that they would get a good Polaroid Land print out of him.

MW says to send FS the film and "ask him to function as an artist."

AA says the work of FS is sick, sour, decadent, and obscure. He fears FS as there are "some disturbing elements." FS is difficult and decadent and has created some horrors.

AA is pleased and says he would be embarrassed if FS did not do the ad right. AA says that decadent stuff smells bad—like a tired fart, and that it looks bad like a piece of mouldy bacon. AA says that FS reveals himself.

MW says that FS makes us face up to the reality of death and that there is little in his work that is of life. MW says that neither AA whose concerns are with life nor FS whose concerns are with death talk of the totality of endlessness.[56]

These off-color minutes betray the subversive force of Sommer's lamination of prodigious technique to abject subject matter. While Adams was known to express admiration for Sommer's photographic expertise, at this *Aperture* meeting he evidently made no effort to disguise his vehement dislike of his difficult imagery.

Sommer was equally critical (and insightful) about Adams's work. He once said, "[Adams] elects to ennoble this thing. And so this thing gets stuck with this ennoblement, no? And this ennoblement will be forever and

ever a stiffness and bareness because finally it's only hygiene."[57] Sommer suggests that Adams, by clearing away decay and death to exalt the eternal beauty of nature, was expelling the very metabolism and exchange responsible for its forms. Although Weston was not as hygienic a practitioner as Adams, his work shared the same side of the rift that Sommer had opened. As an exemplar of ecological process, "mouldy bacon" beats a pepper in a funnel hands down. The American photography establishment more or less accommodated Sommer, but he remained its bad boy. When the issue of *Aperture* featuring his work appeared, the photograph promoting Polaroid film was by Adams.

The ferocity of Adams's attack betrays a recognition that Sommer's wartime work, beyond being sick, was a sick joke at Adams's expense. The chicken parts and carcasses dissect or deflate with dark humor the erotic or wholesome elegance of much American photographic modernism. To his credit, Weston appreciated the jab far more than Adams did. He admired and promoted Sommer's "gorgeous [chicken] guts," and even made fun of his own tamer ways.[58] Having received a shipment from Sommer of chicken-part photographs in 1939, Weston answered by reporting on his own fowl work. "So as not to copy you," he writes, "I've used a duck (no guts) with guts from Grand Rapids Furniture Co. furniture and a Lily."[59] In the punning parenthetical aside of his return volley—"no guts"—Weston self-deprecatingly acknowledges that he had no nerve for real chicken entrails and had photographed only the crumbling remains of a decorative bird. Although Weston photographed dead rabbits and pelicans, and even a human corpse, he never inquired into matter and form with the fearlessness of Sommer.

Sommer's sardonic puncturing of the heroic search for natural beauty in the American West is by no means inconsistent with his rigorous investigation of the gaze. Lacan himself approaches the gaze through humor in his fishing story. The joke of Petit-Jean is the fulcrum of the tale, while the encounter with the sardine can spoofs a familiar narrative of cultivated risk. As exemplified by Ernest Hemingway, the male intellectual who tests himself at sea was a modern trope. Lacan claims that as "a young intellectual" he "wanted desperately to get away" and that the "risk" and "danger" of the fishermen were what he "loved to share." This prelude forecasts a heroic struggle with the elements in pursuit of a catch. But Lacan proceeds to describe instead a "fine" day, during which, "while waiting for the moment to pull in the nets," a sardine can catches his eye.[60] Having sought to

court danger with rustic survivors of a bygone age, an idle Lacan gets snared by the look of an empty industrial remnant. The anticlimactic sardine can captures him because both belong to the urban society of supermarkets and cash registers and mar the romantic picture in which they float. The sardine can is both an inversion of majestic wildness and a cliché of stifling modernity. When Hemingway came north to New York City from Florida to finish his manuscript of *For Whom the Bell Tolls,* he described feeling, as he climbed the steps of Penn Station, like "a blind sardine in a processing factory."[61] In his discussion of Petit-Jean's joke, Lacan makes clear that his anticlimax is a demystification of the redemptive return to nature, a recognition that he was barred by class difference from meaningfully experiencing the dangers of the sea.[62] In his chicken-part photographs, Sommer likewise concludes the heroic hunt with the gleam of discarded remnants. They confront us with the terror of belonging to the world they picture and not to the elegant eternities of Adams and Weston.

In Sommer's critique of mastery, *Eight Young Roosters* of 1938 looms large (Figure 7.7). In the photograph, blobs of cryptic flesh occupy rectangles laid out in a grid. Most of the fragments contain an ocular cavity or seam, but whether all of these puckered forms are eyes remains unclear. Although the fragments do not leak or decay, their multiplicity and illegibility undermines the privileged condition. Moreover, the discrepancy between the "eight" young roosters and the ten rectangles thwarts our effort to make sense of the grid. There are eight blobs of flesh, but two in the grid's upper row trail a long extrusion into the lower. A small piece of flesh abuts the end of one extrusion, confusing the relationship of rectangles and specimens. Although at first glance the grid seems independent from the fragments, in these ways a provocative exchange takes place between them. However we conceive of this grid—as pictorial matrix, say, or as laboratory template—it cannot control the crude matter within it. This failure calls into question the basic differential operations by which matter is separated, identified, and sorted. Sommer associates the privileged condition with that which can be readily named, and here we have a visual field more or less without nouns. Matter has lost the formal differences that names require and enforce.[63]

With these difficult-to-identify pieces of flesh, Sommer estranges nature from classification. The titular reference to "eight young roosters" cannot anchor an ambiguous number of scraps of such obscure anatomical origin. The chicken-part pictures all recall the oracular reading of animal entrails,

Figure 7.7 Frederick Sommer, *Eight Young Roosters,* 1938, gelatin silver print. ©
Frederick & Frances Sommer Foundation

but the fragments of *Eight Young Roosters* seem inscrutable enough to
push materiality beyond the bounds even of such intuitive cognition. Un-
like the decapitated heads and floating eyes of Sommer's other chickens,
these fleshy lumps offer only an unspeakable array of difference. Signifiers
sheared from any signified, they seem dredged from a primordial semiotic
abyss. Bodily matter is untamed in them. The repressed secret they return
is the uncomfortable fact that matter does not intrinsically possess the
structure of language. We see only a material basis—a baseness—for a
naming that must forever be deferred. "Linguistic logic could only have
arisen in the presence of pictorial logic," Sommer once said.[64] But in *Eight
Young Roosters,* linguistic logic disintegrates into the sheer arbitrariness
of its origins. The social and natural dimensions of the sign are disabled
together.

242

Bonnet, French Foreign Minister, says to the French cockerel:
"*Don't be afraid, Hitler is a vegetarian.*"
A political photo-montage from this month's LILLIPUT, "the pocket magazine."

Figure 7.8 John Heartfield, "Don't Be Afraid, Hitler Is a Vegetarian,"
from *Picture Post* 3, no. 3 (April 22, 1939), 69; inventory number: KS-JH
292. Photo: Akademie der Künste, Berlin, © Artists Rights Society
(ARS), New York / VG Bild-Kunst, Bonn

During the war, this play between base materiality and senselessness,
sight and dismemberment, bore especially barbed meanings. In *Don't Be
Afraid—Hitler Is a Vegetarian,* a photomontage published in 1939 in the
British illustrated magazine *Picture Post,* the German artist John Heart-
field satirically used a rooster to represent an impending victim of fascist
aggression (Figure 7.8). Although Sommer was averse to allegory, he ac-
knowledged the link between wartime ideology and his chicken-part

pictures. On their hostile reception, he once remarked: "So why should everybody at that point have been so squawking and squeaking about my doing all these things while they were—with great glee—sending their children to battle." Sommer's verbs—*squawking* and *squeaking*—portray the squeamish response of viewers as a kind of chickenness, a craven disregard of the unhomeliness of the homeland. While propagandistic logic was papering over the slaughter of nameless masses, Sommer was undoing that logic by displaying nameless masses on paper. As if to clinch the wartime significance of his anatomical studies, in 1939 he made a photograph of an amputated human foot.

In his wartime landscapes, Sommer undermines the privileged condition by eradicating the cues and structure that organize the genre. *Arizona Landscape* of 1943 is the limit case (Figure 7.9). It presents a swath of ground with no notable qualities or elements. The depicted terrain does not guide the eye or offer it a place to rest; tiny differentiations of gray, a shattering of subtle values, stretch from edge to edge. Here and there we can pick out pale tufts of scrub, variously shaped rocks, or the vertical forms of cacti. But making these distinctions is often tricky and always pointless. The picture disintegrates the landscape as a hierarchical or narrative scheme. Foreground and background collapse into a scattering of vaguely equidistant modulations, leaving us in limbo. Either something is missing or we are missing something. According to Sommer, contemporaries looking at his landscapes searched in vain for a subject worthy of their attention. "There is nothing to see, nothing featured; what's the matter with you?" is how he characterized their response to these pictures.[65] For them, *Arizona Landscape* was no landscape at all.

Sommer recasts the notion of photographic equivalence in his landscapes. In 1935, the year he visited Stieglitz, the aging artist made the last of his cloud pictures, or *Equivalents*.[66] In what would become an important formula for other practitioners, Stieglitz said he gave the pictures that title because they were equivalents of his "most profound life experience."[67] *Arizona Landscape* equalizes differently. In it, pictorial difference shrinks and multiplies, yielding a dynamic but egalitarian field of gray bits. As Sommer said, "The vegetation and the rocks have a way of playing and exchange. . . . It's surprising how the clusters of the rocks are somewhat equivalent to some of these clusters of green."[68] These words recall the way the mingling of dark and light patches in the *Equivalents* confuse cloud and empty sky. But in *Arizona Landscape* no glowing orb or operatic play of

Figure 7.9 Frederick Sommer, *Arizona Landscape,* 1943, gelatin silver print. ©
Frederick & Frances Sommer Foundation

light organizes our visual experience. Equivalence for Sommer is not a
correspondence between subjective experience and objective work (Stieg-
litz), or a vital rhythm common to all things (Weston), but rather an equi-
table accommodation of a visual field, a pictorial recognition that disinte-
gration or entropy is a process shared by matter in all its forms.[69]

The decomposition of Sommer's landscapes is tightly bound. In *Arizona
Landscape,* the balanced distribution of photographic fragments holds the
picture taut, and the upright cacti keep us axially oriented without a ho-
rizon. Unlike Stieglitz's *Equivalents,* which can be turned this way and that,
the landscapes retain their rectitude. In them, as in his other wartime se-
ries, Sommer hews to architectural habit and orthogonal stability, even as
he evacuates the privileged condition. He accommodates chance but also
structures that accommodation. By collapsing foreground and background

and equalizing tension and interest throughout the picture, Sommer's land-scapes dispel the distinction between conventional message and accidental inclusion, the *studium* and the *punctum,* to use Barthes's terms.[70] Sommer was explicit about the rarity of this integration: "The attitude of the average photographer is, there are all of these damned things in the background, what are we going to do with them? So you see in many exhibitions pic-tures that are inhabited by things which are not really welcome. They don't hang together; they don't have any coherence."[71] Sommer embraced the indifference of chance. He flattened space and splintered the pictorial field to depict a coherent web of unscripted relations.

Made during the last years of the war, Sommer's landscapes unmistak-ably engage practices of military photography. In their detached comport-ment and fine resolution, his landscapes remind us of aerial photographs and other images made for purposes of targeting or surveillance. In other respects, however they undermine the precepts and aims of such imagery. The even light chosen by Sommer obscures rather than highlights relations of depth, and the narrow tonal range often makes it difficult to determine whether a particular patch of the image represents plant or mineral matter. As dense fields of minute differentiation, the landscapes captivate the eye but ultimately yield only the dross of reconnaissance, the finely discrimi-nated irrelevance of empty terrain. In *Arizona Landscape,* there are no op-tical targets, no signs of human or animal life, no subjects of relative im-portance. The landscapes call upon habits formed and honed in a military culture of optical discernment only to frustrate them.

Sommer's subversion of military photography works in concert with his grappling with the gaze. The chicken part pictures, with or without eyes, seem to look at the viewer through their fleshy glints, which catch us in a state of dislocation, split between our perceptions and our preconceptions. In making his landscapes, Sommer caught the viewer differently. It is not the picture that seems to look at us. Rather, because the picture seems to contain nothing worth looking at, it elicits something like the gaze. As the viewer stands before a visual field empty of interest but saturated with signs of optical attention, she or he becomes, by default, the element that stands out. The pictorial experience is structured around the seeing and the seen, and as Sommer noted, viewers said that "there was nothing to see" in his landscapes. The pictures fail to perform their half of the formula, to be something to see. Through this failure the viewer loses command of the visual field and is drawn willy-nilly into the picture. Because the picture

Figure 7.10 Frederick Sommer, *Glass,* 1943, gelatin silver print. © Frederick & Frances Sommer Foundation

otherwise registers as an instance of surveillance, this inclusion bears with it an acute vulnerability.

If we needed any clearer sign from Sommer of the threat of violence in his desert, we get it in *Glass,* a photographic field of discarded and mostly smashed window glass, bottles, and jars, that Sommer made in 1943, a year largely devoted to making the best of his landscapes (Figure 7.10). The picture sits amid the landscapes like a parenthetical clarification, an assurance that pictorial shattering and material shattering, distributive visual field and demolition, are in dialogue. By discontinuing the production of his landscapes in 1945, Sommer left in coincidence the end of his photographic splintering of the Southwest and the first atomic bomb test, which flattened a swath of desert in Alamogordo, New Mexico, on July 16 of that year. At that point, the chancy world of subatomic particles that fascinated Sommer had been unleashed in the desert, and his practice turned away.

During the war, Sommer hunted for dreams in obscure pockets of the American West, including the butcher's slop bucket at the Piggly Wiggly. He found his modernism in what modernity wanted to ignore or forget. His photographs of carcasses, chicken parts, and desert landscapes refused or inverted the aesthetic program of the most celebrated American photography of his time. They negated the privileged conditions of completeness, purity, independence, singularity, timelessness, and exaltation that practitioners such as Ansel Adams and Edward Weston pursued. Although Sommer was keenly interested in chance and material flux, his photography also refused an older generation's adherence to vapor. Forced from moist climates by his tuberculosis, Sommer avoided sky and atmosphere in favor of the slow dry exchanges of the desert. Wetness clung to the dismembered organs of his photographs like an uneasy dream. These negations enabled Sommer to question deeper social structures pertaining to the commodity, the landscape, visual mastery, and the war. Overwritten with tuberculosis, his photographs put various forms of societal disease on display.

This systematic negation of the privileged position and its mystifications, however, contained affirmations dialectically within it. Of *Eight Young Roosters,* Sommer once said: "There's never been that much basic creative passion in an image made by an American as there is in that."[72] Even in his most critical and transgressive moments, he found workable material in what chance offered him and affirmed aesthetic improvisation as a social good.

8

Pressing Photography into a
Modernist Mold, c. 1970

Between the 1930s and the 1970s, the American art museum began to as-
similate photography. The Museum of Modern Art (MoMA) led the way
by gamely touting photography's modernist credentials despite doubts still
attending its popular forms and mechanical ways. Modernism required each
art medium to distill and question its basic structure, but photography's
broad functions as a means of communication and commemoration made
this a challenge. To what extent should photography in the museum be
required to abide by the expectations for other pictorial arts, such as painting?
To what extent should it encompass the forms it took elsewhere, such as in
magazines or family albums? In what modes of presentation did the art of
photography reside? A series of curators at MoMA, including Beaumont
Newhall, Edward Steichen, and John Szarkowski, wrestled with such ques-
tions as they strove to establish photography as a modern art. The eminent
critic Clement Greenberg assessed their progress, while also doing much
to define the modernism with which they had to contend. Over time, the
effort to grant photography the autonomy of a modernist art led curators
and galleries to ignore or dismiss the circumstances of photographic pro-
duction, as if photographs could operate aesthetically without regard to their
past. Like the valuable commodity it was fast becoming, the photograph
in the museum was purported to possess a self-sufficiency that made its
history merely a vague source of wonder. Meanwhile, a new generation
of intellectuals, mostly outside the museum world, had begun to subject
the structure and social operation of photographic meaning to unprece-
dented analytic rigor. A gap thus opened between the aesthetic isolation

of photography in the museum and the emergence of new systemic under-standings of photography as a semiotic and social form. This gap pre-sented an opportunity for artists to rescue photography from its own cus-todians and to renew a flagging commitment to understanding photography's aesthetics in light of its troublesome relationship to chance.

While Frederick Sommer was undoing the privileged condition of pho-tographic subjects in Prescott, photography was slowly gaining institutional privileges in New York. In the late 1930s and early 1940s, Alfred H. Barr Jr., the first director of MoMA, included photography in the new muse-um's mission. Educated at Princeton and Harvard, Barr had conducted re-search for his proposed PhD thesis, "The Machine in Modern Art," by traveling through northern Europe and Russia and immersing himself in the art of the Bauhaus and Constructivism.[1] The Constructivist enthusiasm for film, photography, and montage impressed him deeply.[2] When he be-came director of MoMA in 1929, he initiated a curatorial program that exceeded the traditional boundaries of art. He went so far as to enlist ar-chitect and curator Philip Johnson to organize a *Machine Art* exhibition featuring industrial objects ranging from boat propellers to mixing bowls.[3] In a foreword to the catalogue, Barr acknowledged that the beauty of many of the finest objects in the exhibition "is entirely unintentional," a by-product of functionality and efficient design. In 1932, a mural exhibition at MoMA organized by Lincoln Kirstein included eight photo murals, and four years later Barr invited the museum's librarian, Beaumont Newhall, to orga-nize an exhibition of photography. The resulting show, installed in the spring of 1937 and filling four floors, offered a broad survey of photography's history as a technology, with examples of astronomical photography, X-ray imaging, press photography, and other uses on display.[4] One section of the show was devoted to contemporary "creative photography" (Newhall's term) and featured work by, among others, Ansel Adams, Margaret Bourke-White, Brassaï, Cartier-Bresson, Walker Evans, Kertész, László Moholy-Nagy, Man Ray, Paul Strand, and Edward Weston.[5]

Newhall soon narrowed his interests to concentrate on creative photog-raphy. In 1940, he traveled to California, where on a trip to Yosemite he and Adams dreamed up a new photography department for MoMA. Adams immediately got on the phone and garnered support from collector and patron David McAlpin, who subsequently agreed to serve as chairman of the museum's Photography Committee on the condition that Adams serve as vice chairman.[6] While Newhall was still in California, Adams intro-

duced him to Weston, and the two men hit it off immediately. Canceling travel plans, Newhall spent two weeks with Weston, who took him into the field and into the darkroom to teach him photographic techniques.[7] Adams and Weston were eager to see their brand of masterly and elegant photography distinguished as art, and Newhall came around quickly. During the war years, he wrote letters from Europe to his wife, the writer and curator Nancy Newhall, in which he distinguished "painting-photographs" from ordinary "illustration photographs," and criticized his early curatorship as "being too 'broad-minded.' "[8] In one letter, he declared: "My interest is turning more and more to that particular use of photography which may be called artistic. . . . The so-called esthetic of accident is to me less moving than the successful solution of the self-imposed problem of creating a picture which will move others. It is peculiar to photography that, by the extreme ease of its production, many accidentally interesting photos are produced. But a Stieglitz, a Weston, a Strand are deliberate, and show a mastery over the medium that is most impressive."[9] The earnestness of Newhall's letter is palpable, but his language betrays the difficulty of insulating photographic art from the accidental beauty to which the medium was prone. When Newhall writes "a Stieglitz, a Weston, a Strand are deliberate, and show a mastery over the medium," is he talking about photographers or photographs? The ambiguity is crucial. Museums have tended to conflate artist and work to make the personal expressiveness of the work a presumption of gallery parlance.[10] To refer to a painting by Picasso as "a Picasso" is to posit an umbilical cord between the work and the man, lending his oeuvre a sense of organic unity and biographical development. Such a presumption is especially troubling in photography because of the often radically uncertain relationship between producer and product. A photographer can be deliberate and show mastery—indeed, Newhall had observed Weston's deliberateness and mastery up close in California—but a photograph is a different matter. Rosenthal's photograph of the flag raising looked so deliberate and masterly that many accused him of staging it, but the signs of deliberateness and mastery came about by accident. Newhall wants to insulate "a Stieglitz" from an "accidentally interesting" photograph, but wasn't even Stieglitz able to get lucky?

Peter Henry Emerson thought so. In 1924, Emerson asked Stieglitz for examples of his work so that Emerson could evaluate his worthiness for a medal he sponsored. Emerson explained the need for multiple examples by noting the inescapable role of luck: "A single work of art stands or falls

upon its own intrinsic merit. A photograph proves whether the producer 'has art' or whether he has not. That is why I wanted to see 12 prints. Photographers here and there have 'fluked' a single 'masterpiece.' That is the curse of photography. No one could do that in any of the graphic arts—he must be a master craftsman to produce a masterpiece."[11] This passage contains an odd waffling concerning the proof of artistic merit that a single photograph can bear, as if Emerson struggles to accept the implications of chance for photography. The latter sentences, however, clearly acknowledge the possibility of a lucky shot and the resulting need to measure artistic merit in the aggregate. Years later, Newhall conflates the photographer and the photograph in his letter to finesse the problem of chance.

To be sure, showing mastery in a single print was something that the leading California modernists sought to do. Adams especially produced prints in which light, tone, and value were conspicuously orchestrated. He could control the variables of the printing process in a way few other practitioners could. As academic painters had done in the late nineteenth century, Adams used a meticulousness of effect to signify masterful competence. Every print was meant to stand, like a painting, on its own. But for some critics, this fussiness became the point of his photography. To them, he sacrificed aesthetic verve and receptivity for a demonstration of skill, draining the life out of his pictures, much as many salon painters had done. When Sommer, who was an exceptional printer himself, suggested that the "stiffness and bareness" in Adams's photography amounted to "hygiene," he was underscoring the emptiness of sheer masterful order.

Soon after his trip to California, Newhall began heading MoMA's new department of photography. At the time, most museums did little if any collecting of photographs as works of art, and the market for fine art photographs was negligible.[12] Understanding the difficulty he faced, Newhall set forth the mission of his new department in the following terms:

Photography, entering upon its second century, faces a cross roads. Remarkable technical advances have enormously increased its scope. Never before has it been possible to make pictures so easily, so readily and so quickly. Thousands of photographs are published every day in newspapers, in magazines and in books; hundreds of thousands more never appear in reproduction. The manufacture of cameras and photographic materials has grown to be one of the country's greatest industries. The taking of pictures is a universal hobby: some eight thou-

sand camera clubs in the United States alone have been formed by enthusiastic amateurs. With almost everybody using a camera, photography has become truly an art of the people, practiced by millions.

Yet there is a danger in this amazing growth. Through the very facility of the medium its quality may become submerged. From the prodigious output of the last hundred years relatively few great pictures have survived—pictures which are a personal expression of their makers' emotions, pictures which have made use of the inherent characteristics of the medium of photography. These living photographs are, in the fullest meaning of the term, works of art. They give us a new vision of the world, they interpret reality, they help us to evaluate the past and the present.[13]

In this passage, Newhall argues that despite the profuseness of photography, the photograph of aesthetic worth remains rare. He thus builds the case that photography is suited to the connoisseurship and collection practices associated with the art museum. Photographic works of art have distinguished themselves, he suggests, in two respects. They have constituted "a personal expression" of emotion, and they have "made use of the inherent characteristics" of the medium.

Newhall's criteria for works of photographic art are hard to reconcile. The first criterion insists that practitioners counter the impersonal or mechanical qualities of photography to make the photograph a personal expression. The second criterion, however, requires photographic works of art to abide by the inherent qualities of the medium, which presumably have a mechanical character. In making these contradictory demands, Newhall renews the call for photography as art to overcome the gap between modern culture and industrial society, between man and machine. As Barr had put it in his foreword to *Machine Art*, "Not only must we bind Frankenstein—but we must make him beautiful."[14]

Newhall's criteria were also troublesome individually. The requirement that a photograph be a personal expression of the maker's emotion rephrases the old nineteenth-century dictum about art as the expression of an intention—a dictum invented to forestall the threat of mechanical reproduction to art. In itself, this requirement is trivial. Personal expressions of emotion are as cheap and ubiquitous as dreams. Why would a personal emotion, brought into form, be worthy of public attention or care? As the Whistler trial had demonstrated decades before, industrial society and its

repudiation of traditional beliefs put tremendous pressure on the redemptive powers of artistic selfhood. Artists were asked to compensate for the vacuity of mass commerce by means of subjective profundity. Under that pressure, creative expression always threatened to devolve into affectation or empty display, into "flinging a pot of paint in the public's face." Although freedoms in the private sphere might compensate for the discarded certainties of religion, what personal sentiment in the public sphere could possibly make up for a loss of tradition?

In setting forth his first criterion, Newhall was requiring photography to chase its own tail once again. He was demanding that it overcome its mechanical nature in the name of expression, while leading practitioners, curators, and critics across the fine arts were jettisoning expression to bring aesthetics up to date with photography. Between the wars, the artist Marcel Duchamp had declared the bankruptcy of subjective expression with his infamous urinal and other ready-mades, and Barr had more or less followed suit with Johnson's exhibition of industrial products. Related efforts arose in literature. In 1946, "The Intentional Fallacy," a landmark essay on literary criticism by W. K. Wimsatt and Monroe Beardsley, appeared.[15] In it, the authors argue that intention does not govern meaning, that judging a poem "is like judging a pudding or a machine. One demands that it work."[16] Whereas Duchamp had stripped the machined commodity of its function to pressure the institutional regulation of aesthetic value, Wimsatt and Beardsley had made functionality an aesthetic. In both cases, however, a modernist rebellion against Victorian sentiment had made the machine a measure of art.

A precept of much machine-age aesthetics was that beauty is best as a by-product of function. For faithless moderns, intention had been emptied of its magic. Darwin had cogently shown that beauty in nature was actually not a matter of design but rather an accidental consequence of an unintended functionality. In this respect, the machine-age aesthetic was a post-Darwinist naturalism, an exaltation of beauty both accidental and concomitant to function. Trying to make something beautiful risked pretention or quaintness. Many twentieth-century writers on photography observed with curiosity that early photographs made ostensibly without aesthetic intent were more aesthetically satisfying than the painstaking efforts at making art that photographers later pursued. This preference for unintended beauty was consistent with post-Darwinist naturalism and the

machine aesthetic. Newhall, in exalting photographs as personal expressions, was bucking a trend.

Newhall, however, was not simply being obtuse. Although the demotion of personal expression in the arts doubtless helped elevate photography in the long run, in the short run the medium was curiously ill-suited to become a machine-age art. In crucial respects, photography seemed neither like an art nor like a machine. Its flaw as an art was what we might term its intention deficit disorder. Wimsatt and Beardsley could judge poems like machines because the intentionality backing a poem and its structure could be assumed. The very first premise of "The Intentional Fallacy" reads: "A poem does not come into existence by accident. The words of a poem . . . come out of a head, not out of a hat."[17] No such proposition applied to photographs, which more or less came out of a box. Whereas complex structure in a poem was a reliable sign of deliberate intelligence, the same in a photograph was not. This is why Maloney's lucky chimps were such an apt model for the madness of the medium, and why the author function posited in Newhall's ambiguous term "a Stieglitz" was inherently unstable. A seemingly expressive photograph might represent the emotions of its maker, but it might stem largely from chance.

The machine side of the equation was equally troublesome. Like a machine, photography was efficient and reproductive, but unlike a machine, it yielded products that were arbitrary and unpredictably varied. As Barr noted, the beauty of a boat propeller was mostly a by-product of its design to efficiently propel a boat. Photography had no such clean relationship between form and function. Its functions were fluid and ambiguous, and form did not follow them in stable or obvious ways. Whereas every propeller came from the factory the same, photographs were particular. Whereas every propeller was sleek and minimal, the photograph was often a jumble of profuse and accidentally included detail. As a machine, photography was distinctively prone to chance.

Despite its mechanical character, photography could also seem too subjective to be a machine-age art. Its reproductions seemed to record a subject position or point of view. In this respect, it is revealing that Duchamp's fellow Dadaist, Man Ray, turned to cameraless photography to make his Rayographs, images of cryptic objectivity redolent of machine-age uncertainties. It is also revealing that although Johnson included in his 1934 *Machine Art* show a vast array of industrial products, including pistons,

headlamps, a gasoline pump, a fan, a dishwasher, various lamps, clocks, mirrors, and microscopes, he included no camera.[18] In other words, his "machine art" show excluded the machine most likely to make art.

Newhall's second requirement for photographic art—that it make use of the "inherent characteristics of the medium of photography"—served to ensure that photography would enter the museum as a *modernist* medium. In his essay for the 1937 exhibition catalogue, Newhall argues that photography "was definitely created to compete with manual ways of making pictures," and he structures this competition around each medium's specific demands.[19] "The desire to make pictures" is inherent in both the photographer and the painter, he writes: "The instinctive knowledge of how to make pictures must be acquired by both. Both must know the basic laws of composition, of chiaroscuro and color value. There photographer and painter separate: each must apply the basic laws in terms of the possibilities and limitations of his medium." A fine modernist credo, but easier said than done. What were the definitive features of photography? For Weston and Adams, the medium qua medium accommodated some techniques (for example, the darkroom techniques of dodging and burning to suppress or emphasize certain parts or qualities of the image) but not others (for example, soft focus or overt working of the surface, such as the makers of gum prints had practiced). The limits of the properly photographic were arbitrary and open to debate; indeed, Newhall later recalled that during his California trip he had been surprised by the liberties that Weston was taking in the darkroom given his ostensible adherence to "straight" photography. But however defined at its margins, modernist photography for Newhall, Adams, and Weston marked a rejection of pictorialism and an embrace of the notion that the time had come for photography to shed its imitation of other media and stand on its own aesthetic merits.

While Newhall was coming to terms with photography as art, the critic Clement Greenberg was in the midst of reconceiving modernism in influential terms. His famous essay "Towards a Newer Laocoön" was published in 1940, the same year that Newhall articulated the mission of his new department.[20] In the essay, Greenberg argues for a modernism based on painting remaining true to its medium. He claims that painting had become subservient to literature in the seventeenth and eighteenth centuries and needed restoration by the avant-garde. According to him, this subservience was paradoxically enabled by the extraordinary technical facility of the baroque masters, who were so adept at painting that they could

"pretend to conceal their mediums" in pursuit of illusion.[21] Greenberg's phraseology—"pretend to conceal"—captures perfectly the effect of the *fini*, which required the painter to demonstrate expert handling through an erasure of any signs of handling. In rebellion against this subservience, avant-garde painters, Greenberg claims, rather than offering an illusion by way of transparency, a fictional world through a frame, progressively insisted on painting's irreducible elements, on making work that affected the viewer physically instead of fictionally. Thus Greenberg articulated his general rule: "To restore the identity of an art the opacity of its medium must be emphasized."[22] For the medium of painting, artists such as Constable and Turner, whose conspicuous marks never allowed illusion to suppress the material fact of paint as paint, had led the way.

Greenberg's historical account is rich in moral connotation. Against subservience, facility, and illusion, he advocates on behalf of directness, self-reliance, and physicality. This moral hierarchy appealed to an American audience that understood the terms he exalted as descriptive of the national character. It suggested that modernism, although rooted in the achievements of a European avant-garde, was destined to find its highest expression in America.

Historians have neglected the curious role of photography within this scheme. Greenberg begins to take photography seriously only after the war, when he writes a series of reviews of photography exhibitions at MoMA, including a show of work by Weston (1946) and a show of work by Cartier-Bresson (1947). In these two reviews, and in other essays from around the same time, he sets photography against painting. He writes of Cartier-Bresson:

Unlike Edward Weston and the later Stieglitz, he has not forgotten that photography's great asset is its capacity to represent depth and volume, and that this capacity's primary function is to describe, convey, and make vivid the emotional 'use-value' of beings and objects. It is to anecdotal content that Cartier-Bresson, rightly, subordinates design and technical finish. I am told that he does not trim his prints, and it is obvious that he takes his shots under circumstances that make it difficult to calculate focus and exposure with any great exactness. This procedure testifies, even if the results did not, to his overriding concern with subject matter rather than with the medium—which comes into its own only in so far as it becomes transparent.[23]

The last sentence is striking: the medium of photography, according to Greenberg, comes into its own only insofar as it becomes transparent. It is properly about anecdotal content and the representation of depth and volume, not about its own physical or technical properties. In a review from a few months earlier of a show of paintings by Edward Hopper, Greenberg writes: "Hopper's painting is essentially photography, and it is literary in the way that the best photography is."[24] Transparency, he argues, brings photography into its own by enabling it to become like literature.

For Greenberg, photography is thus the inverse of painting. It must be transparent so that it can be anecdotal and literary, whereas painting must be opaque to resist the literary and restore itself. Indeed, according to these passages, photography is not only the inverse of painting, it is the inverse of a modernist medium. It comes into its own only when it is like literature. It is most true to itself when it is like something else. As a medium, photography runs counter to the entire scheme that Greenberg established for modernism.

Greenberg wavers on how to account for photography's paradoxical place within his aesthetic paradigm. In his review of the Weston show, he elaborates on the difference between photography and painting:

> Photography . . . has at this moment an advantage over almost all the other arts of which it generally still fails to avail itself in the right way. Because of its superior transparency and its youth, it has, to start with, a detached approach that in the other modern arts must be struggled for with great effort and under the compulsion to exclude irrelevant reminiscences of their pasts. Photography is the only art that can still afford to be naturalistic and that, in fact, achieves its maximum effect through naturalism. Unlike painting and poetry, it can put all emphasis on an explicit subject, anecdote, or message; the artist is permitted, in what is still so relatively mechanical and neutral a medium, to identify the "human interest" of his subject as he cannot in any of the other arts without falling into banality.
>
> Therefore it would seem that photography today could take over the field that used to belong to genre and historical painting, and that it does not have to follow painting into the areas into which the latter has been driven by the force of historical development. That is, photography can, while indulging itself in full frankness of emotion, still produce art from the anecdote.[25]

The crucial hinge in this remarkable passage is the inverted clause about photography that reads: "Because of its superior transparency and its youth." The *and* in this phrase allows Greenberg to remain fundamentally indecisive about photography. Is photography's superior transparency an inherent property or merely a function of its youth? Will photography always be best when it is literary and anecdotal, or will photographers one day need to reject literature and affirm the opacity of their photographs to restore photography as a medium? Greenberg does not address these questions explicitly.

Greenberg was reluctant to acknowledge the importance of photography for his modernist scheme.[26] In his early essays, he suppresses the ample evidence that photography's transparency was driving painting's need for opacity. Transparency and anecdote did not belong intrinsically to painting in significant part because they seemed to belong intrinsically to photography. Photography's youth, in other words, was producing painting's age and need for renewal. Or, to put it most radically, the very notion of a modernist medium had to be defined against photography, to be construed as its inverse, in order to counter the overwhelming historical momentum of photography as a perceptual, cognitive, and social form.

In Greenberg's scheme, literature, as the dominant medium chasing painting into opacity, conceals photography. If photography is most itself when it is like literature, this may be because literature, as a dominant medium during the Second World War and the decades that followed, increasingly took the form of photography. The journalism of image, layout, and caption was an ascendant form of visual culture, and painting had to find a way to resist it.

Greenberg's elision of photography is conspicuous not only in "Towards a Newer Laocoön" but also in his other influential early essay, "Avant-Garde and Kitsch" (1939).[27] Whereas in "Towards a Newer Laocoön" Greenberg argues that painting must overcome its subservience to a dominant medium (literature), in "Avant-Garde and Kitsch" he asserts that it must outflank or forestall a dominant culture (kitsch). In the latter essay, Greenberg offers various examples of kitsch, including Tin Pan Alley music, the poetry of Eddie Guest, pulp fiction, illustrations, rotogravure sections, ads, magazine covers, Hollywood movies, comics, tap dancing, the paintings of Russian artist Ilya Repin, the pictures of Maxfield Parrish, and the Indian Love Lyric. Near the end of the essay, he opines that Repin "would not stand a chance next to a *Saturday Evening Post* cover by Norman Rockwell."[28]

The absence of any specific mention of photography is glaring, especially since the essay explicitly associates kitsch with the mechanical, the accessible, the mass-produced, and the industrial. One could, of course, imagine photography lying hidden in the vague references to magazine covers or ads. Yet this indirectness is precisely the point: although Hollywood cinema is mentioned, the photograph as such stays out of view. Every particular example of kitsch deflects attention from it.

Indeed, in both "Towards a Newer Laocoön" and "Avant-Garde and Kitsch," essays that—as T. J. Clark has put it—"stake out the ground for Greenberg's later practice as a critic and set down the main lines of a theory and history of culture since 1850," still photography is never addressed as such.[29] Although great critics before Greenberg, including Charles Baudelaire and Walter Benjamin, understood the plight of painting to be intimately related to the emergence of photography, Greenberg finds painting's troubling rivals in literature, cinema, popular music, and illustration. The possibility that photography may be a key node in his scheme, a point where literature and kitsch routinely come together in a transparency requiring painting's opacity, is never acknowledged.

Greenberg's fixation on sentimental *Saturday Evening Post* covers illustrated by Norman Rockwell is symptomatic of this avoidance. When Greenberg wrote, Rockwell and the *Post* were popular but old hat. Rockwell's first cover for the *Post* appeared in 1916, and by the late 1930s magazine illustration had shifted decisively away from hand-drawn illustrations and toward photography. To use a Rockwell cover as an example of kitsch in 1939 was a bit like using a fax machine to exemplify office technology in 2009.[30] Greenberg's neglect of photography as art in the early essays is equally conspicuous. The activity at MoMA was making it clear that photography was on the threshold of the art museum. Newhall's 1937 show had received extensive press coverage, and the *New York Times*'s preview included reproductions of several of the exhibited photographs, including works by Stieglitz and Man Ray.

Greenberg's suppression of photography in his formative early essays and his insistence on defining the modernist medium as its inverse had several effects. To begin with, it masked the basic conservatism of his project. Disillusioned with Stalinism and its misuse of science, industry, and intellect, but still keenly sensitive to the ethical and aesthetic failures of capitalism in the Depression era, Greenberg sought a protected realm for culture, an avant-garde that could keep art alive through autonomous critique. "Today

we look to socialism simply for the preservation of whatever living culture we have right now," he said to close "Avant-Garde and Kitsch."[31] There was no way to fit photography comfortably into this romantic scheme. Photography was associated with commercial fluff, but it was also associated with revolution, social communication, demystification, and the redistribution of power. It was uncontrollable for Greenberg precisely because it confused the distinctions between avant-garde and kitsch, art and industry, one medium and another. The fact that photography had infiltrated the art museum as well as the magazine stand, the fashionable gallery as well as the supermarket, gave it a mobility that posed trouble for Greenberg. The saccharine Rockwell cover was an easier target.

Greenberg's suppression of photography also muffled the question of whether American modernism was coming too late. Greenberg promoted and welcomed the historical shift of high culture's dynamic center from Paris to New York.[32] Preservation of avant-garde painting was necessary to keep the American inheritance intact. Greenberg's decision to revive Gotthold Ephraim Lessing's aesthetic scheme based on medium was itself an assertion of historical continuity and the ongoing viability of painting. Greenberg, one could argue, was haunted by the possibility that America's ascent was belated, and the most potent sign of that belatedness was photography. By locating the threat to painting in the antiquated site of "literature," Greenberg imagined that American avant-garde painting could remain autonomous and responsive to history. By 1939, if there was one reason that painting would never be able to insulate itself adequately from the banal madness of commerce, it was photography.

After the war, the complex relationship of photography to American modernism marked the career of a painter that Greenberg championed, Jackson Pollock. Unlike Greenberg, Pollock was not coy about the role that photography played in driving painting to abstraction. "The modern artist is living in a mechanical age," he remarked in an interview, "and we have a mechanical means of representing objects in nature such as the camera and photograph. The modern artist, it seems to me, is working and expressing an inner world—in other words—expressing the energy, the motion, and other inner forces."[33] But Pollock would find that protecting painting and its "inner world" from photography was not easy. Photographers such as Martha Holmes made Pollock and his intense grappling with hidden forces into a press icon of modernism. In her most widely circulated depiction of the artist, he crouches over a canvas, paint dribbling from his brush,

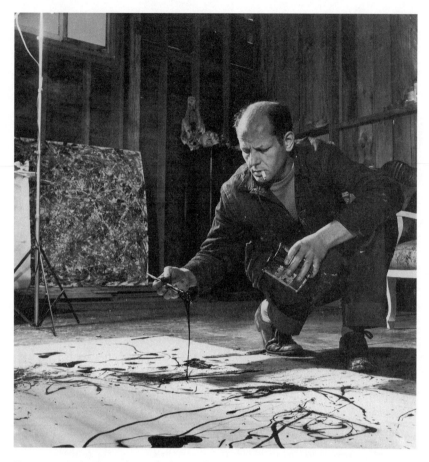

Figure 8.1 Martha Holmes, *Jackson Pollock*, 1949, gelatin silver print. The LIFE Picture Collection / Getty Images

a pair of skulls on a table behind him hovering like a puff of smoke from his cigarette (Figure 8.1).[34] Even as such representations mythologized the lonely torment of the modern painter, they violated its terms. When photographer Hans Namuth visited Pollock in the fall of 1950 to photograph and film him in the act of painting, the experience of performing in front of the camera evidently so unsettled the artist that he relapsed into drinking and engaged Namath in a hostile shouting match. Soon afterward, the commercial photographer Cecil Beaton used paintings by Pollock as backdrops to make fashion photographs at a gallery exhibiting the painter's work. Historians have linked Namuth's work in Pollock's studio both to

Pollock's personal undoing and to the turn of the American avant-garde toward performance art.[35] Meanwhile, the Beaton photographs have become emblematic of modernism's inevitable conscription by mainstream commerce. These episodes suggest that Greenberg had good reason to avoid the subject of photography in his formative essays. For painting, the camera spelled autonomy's doom.

The case of Pollock is particularly interesting because his method of painting, like photography, enlisted chance. Pollock's drip technique had extended the loose handling of earlier modernists to open a gap between brush (or stick or trowel) and canvas, pushing modern painting yet closer to the story of Protogenes throwing his sponge. Pollock dripped or poured skeins of paint, working the limit where mastery and control yield to chance. The otherwise unrepresentable content demanding this radical technique was not foam or vapor but an inner response to a technologically driven age. "It seems to me," Pollock said in an interview, "that the modern painter cannot express this age, the airplane, the atom bomb, the radio, in the old forms of the Renaissance or any other past culture."[36] Addressing a world in which matter, space, and time had lost their old structure, his technique freed contour from representational function, venturing into abstraction to fashion works redolent of anguish, madness, and indeterminacy.

Pollock's emphasis on movement and spontaneity in his working methods structurally aligned his practice with much modern photography. Like Cartier-Bresson, Pollock described his working process as an immersion in the flow of experience that released him from self-consciousness and put him in contact with the visual field before him. "When I am in my painting," he said, "I'm not aware of what I'm doing."[37] Like Cartier-Bresson, Pollock used a notion of unconscious attunement to argue that what seemed like accident was not. In his narration of the film made from Namuth's footage, he says: "When I am painting I have a general notion as to what I am about. I can control the flow of the paint; there is no accident, just as there is no beginning and no end."[38] Elsewhere his words were more forceful: "I deny the accident."[39]

In following Greenberg in pursuit of a painterly antithesis to literature and kitsch, Pollock inadvertently brought his medium alongside the repressed threat of photography. He withdrew the hand from marking and produced work that seemed unconscious, mechanical, and unthinking. His pictures appeared expressive but courted suspicion of being merely

accidental. The notion that a child or chimpanzee could do as much applied to both a Pollock painting and a photograph. In 1957, the poet Randall Jarrell cheekily observed in an essay on abstract expressionism that phrases often used to describe it, including "maximizing randomness," "spontaneous," and "exploiting chance or unintended effects," applied as well to a chimpanzee painting in the Baltimore zoo.[40] When, in the course of the infamous dinner on the night that Pollock returned to drinking, he and Namuth accused each other of being a phony, the symmetry spoke to the doubts attending the authorial status of both the drip technique and the photographic process.[41] Despite Greenberg's best efforts, American modernism could not escape photography or its problem of chance. In part for this reason, photography gradually made inroads on the art world.

All this is not to say that the bond Greenberg posits in his reviews between photography and literature had nothing to it. Indeed, it was a concise way for him to intervene in a struggle over the proper modernist approach to photography. If Weston and Adams were exemplary for Greenberg of the wrong path, Walker Evans was exemplary of the right one.

In 1938, while MoMA was using temporary exhibition spaces during construction of a new building, executive director Thomas Mabry and Kirstein worked with Evans to put up a show of his photographs of hardscrabble America.[42] By devoting a show to a single practitioner, the museum proposed that photography could convey a distinctive individual vision or style. In preparing the show, Evans and his fellow organizers selected, cropped, and arranged his photographs with great care. They refused frames, opting instead to glue his prints directly on the gallery wall.[43] They also produced an innovative catalogue for the show. Divided into two sections, the catalogue features one photograph per page, with a blank page opposite each, every spread free of captions, which appear compactly at the end of each section. The catalogue concludes with a short essay by Kirstein. Fluidity marked the project: the selection of photographs in the show differed from that in the catalogue, some photographs included in both were cropped differently, and the selection changed when the show traveled to other institutions. The organizers' process emphasized what we might call—following Hollywood—the postproduction of photography: the assembling, sizing, ordering, and combining of images. In preparing *American Photographs,* Evans and the museum treated photography as a new social form and not just a mechanical means of replacing painting. These efforts allowed Evans, following the lead of the European avant-garde, to open up an interstitial zone for his medium,

Figure 8.2 Walker Evans, *Houses and Billboard in Atlanta*, 1936, gelatin silver print.
© Walker Evans Archive, The Metropolitan Museum of Art, Digital Image © The
Museum of Modern Art / Licensed by SCALA / Art Resource, NY

locating it between text and picture, social record and artistic statement, raw
material and finished product (Figure 8.2).

Not everyone was pleased. Evidently repelled by the gritty subject matter
and ambiguous import of the presentation, Adams privately said that the
book *American Photographs* was "atrocious" and gave him "a hernia." The
museum's decision to publish it, he wrote in a letter, "is a mystery to me."[44]
For Adams, the emphasis on sequence was particularly unsettling. In a letter
to McAlpin, he wrote: "A picture stands by itself, but can fall when standing
against another, and bring the other down with it."[45] He found the am-
biguous social criticism of the catalogue distressing and resorted to anti-
quated anti-pictorialist imagery to make his point: "The 'esthetes' who are
mostly pink because they lack the guts to be red, build up a good bit of
smoke about a rather damp fire. Afraid of honest sunlight, they stay in dusky
alleys of thought."[46] He pressed Newhall to take the museum's photography
program in a contrary direction. Weston, who had more appreciation for

junked cars and broken windows as photographic subjects, was more sympathetic to Evans.[47] But the rift was clear, and the reservations were mutual. In anticipation of the catalogue essay, Mabry drew his own line between Evans and Weston in a letter to Kirstein:

> You know much more about Walker's work than I do. However I should think that you might want to define as simply and clearly as possible the difference between Walker's work and the majority of photographers both "documentary" and "lyric." Also I think that the article should not have an *in memoriam* flavor. The canonization of the commonplace that documentary photography has turned into (Margaret Bourke-White, "Life" photographers, and much of the Federal Art Project photography) is just as bad to me as any kind of Herald Tribune beautiful baby contest photography. Also, turning the commonplace into something precious, exquisite, etched and fabulous (Weston and Strand, to a degree) is equally bad. Incidentally, I think that some of Stieglitz's early work is very good.[48]

Mabry sets Evans against the "precious, exquisite, etched and fabulous" exaltation of the commonplace that he believed Weston to pursue. In his reviews, Greenberg would do much the same, disparaging photography such as Adams and Weston practiced for its "artiness" and pretense. Although Newhall included photographs by Evans in his exhibitions, his dichotomous elevation of "painting-photographs" over "illustration photographs" put him more in the Adams and Weston camp. Evans responded by keeping his distance from the curator, evidently doubtful about his aesthetic discernment.[49]

In his criticism, Greenberg repeatedly used Evans as a yardstick, and when arguing that photography was best when it was literary, he had Evans in mind.[50] The notion that Evans was a literary photographer was hardly Greenberg's invention; Evans presented himself as such, and so did Kirstein, who in his catalogue essay associated Evans with a host of famous writers, from Hart Crane to T. S. Eliot. Kirstein's assertion that Evans had offered in *American Photographs* "a collection of statements" rather than "isolated pictures" was an acknowledgment that the literary quality of Evans's work was a matter not merely of subject and anecdote but also of visual syntax.[51] For the organizers of *American Photographs,* the photograph was a unit that took fuller meaning from its placement within a sequence or array. Although

Greenberg lauded Evans, it was not entirely clear that he understood the importance of this syntactical dimension of his work.

The literary approach adopted by Evans and Kirstein addressed photography's problem of chance. Although anyone could "fluke" a compelling photograph, an arrangement of carefully selected, sized, cropped, and sequenced images submitted photography to an unmistakable and distinctive logic. No one could make *American Photographs* by accident. What Evans made explicit was implicit in much of the best work in photography that had preceded his. From Talbot's *The Pencil of Nature* to Cameron's albums, to Emerson's books, to Stieglitz's carefully fashioned series, the most canny practitioners had always understood, however implicitly, that photography had to earn its meaning in the aggregate, and that the traditional aesthetic processes of selection, rejection, and recombination could take a modern form after photographs were made. The play of chance might undermine the import of an individual image, but photographs embedded in a syntactical system accrued semantic weight. The deliberate hand, the traditional agent for producing aesthetic value, may have been withdrawn in the making of a photograph, but it returned with scissors to cut down negatives or prints, with other prints to make a sequence, and with adhesive to form an arrangement in an album or on a wall. To be sure, this hand could be directed by another, which is why the art of photography never left industry far behind. But postproduction efforts, however divided in their labor, could communicate a guiding intelligence. Many practitioners coming after Evans, including Robert Frank, would exploit this capacity.

During the middle decades of the twentieth century, the magazine business remained a vital crucible and foil for practitioners exploring the syntactical possibilities of photography. In foregrounding and shaping his editorial efforts, Evans drew upon the practices of this business, which also sponsored some of his best work.[52] As Evans borrowed, however, he also swerved. He, Mabry, and Kirstein had ambitions that the mass media refused to accommodate. By suppressing text, *American Photographs* preserved pictorial ambiguity at the expense of the clear and simple messaging that journalism prized. The catalogue delivered something closer to the cinematic montage of Sergei Eisenstein, a concatenation of images that would jostle and clash their way to a multitude of meanings, while keeping enough cohesion to constitute a moral point of view.[53]

After the war, the roles of photography in mass communication continued to inform the art world's assimilation of the medium. Any museum

interested in bringing photography into its collections or programs faced the question of whether to treat it like a traditional pictorial art or instead to accommodate some measure of its journalistic modes and quickening powers of persuasion. Newhall had tried the first tack but failed to generate much of a popular following for his programs. In 1945, MoMA tried the second by shunting Newhall aside and turning its photography department over to Edward Steichen. An accomplished practitioner, Steichen had been a leader of pictorialism before rejecting the movement as elitist and instead embracing the magazine business. Between the wars, he photographed for Condé Nast, publisher of *Vogue* and *Vanity Fair,* and for the J. Walter Thompson advertising agency. During World War II, he supervised combat photography for the U.S. Navy, while also curating two patriotic shows for MoMA, *Road to Victory* and *Power in the Pacific.* Steichen was far less discriminating than Evans in his enthusiasm for what journalism could offer photography as a modern art. Evans had borrowed from journalism its emphasis on image combination, sequence, and syntactical fluidity, but rejected its hierarchical division of labor and penchant for simple messaging and sentimental appeal. Steichen incorporated all of these elements of journalistic practice.

In hiring Steichen, the museum knew precisely what it was getting. Nelson Rockefeller, then president of the museum's board, openly stated that Steichen's charge was to bring the best of photography "to as wide an audience as possible" through "exhibitions where photography is not the theme but the medium through which great achievements and great moments are graphically represented."[54] Here was the transparency Greenberg prized, photography as history painting, but in simple terms that would ensure a mass appeal.

Steichen modeled his landmark 1955 show, *The Family of Man,* on the photographically illustrated magazine (Figure 8.3). He subjected photographers whose work he included to unilateral decisions about cropping and captioning, and in the gallery he interspersed variously sized images with blocks of large text. The exhibition resembled a giant three-dimensional photo essay through which visitors could wander. Steichen's curatorial methods suggested that photography in the art museum should feature not the aesthetically refined and personally expressive individual print but rather a selection of images that could impart a clear message to a broad and often impatient public.[55]

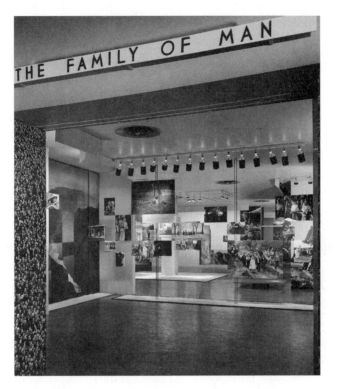

Figure 8.3 *The Family of Man,* 1955. © Ezra Stoller / Esto

The basic structure of Steichen's approach posed a challenge to what Evans and *American Photographs* had accomplished. Evans and his collaborators had arranged multiple photographs to generate a subtle yet coherent vision that could be attributed to the single practitioner who made them. As the title of the original exhibition had it, this was *Walker Evans: American Photographs.* Steichen pulled the postproduction side of photography away from the taking of photographs to claim a curatorial mode of authorship. His logic was understandable. If the activities of selection, sizing, cropping, and arrangement or layout were so vital to the exercise of aesthetic judgment in photography, then why couldn't they constitute a practice in their own right? Why couldn't a curator start with an array of "statements" produced by a legion of practitioners and combine them—and perhaps text—to deliver a compelling aesthetic experience? Steichen treated photography as an editorial medium and thus deemed himself the principal maker of

photographic meaning. "The greatest photographic exhibition of all time—503 pictures from 68 countries—created by Edward Steichen for the Museum of Modern Art," the cover of the catalogue for *The Family of Man* declares.

This strategy was more novel in the museum than in the publishing industry, where the weak bond between camera operator and photograph had long invited claims to editorial authorship. *Gardner's Photographic Sketchbook of the War* is the title of a famous album that Alexander Gardner assembled in the late 1860s from Civil War photographs mainly taken by or with other photographers. By bringing this logic of the publishing industry into the art museum, Steichen called into question the traditional model of authorship in the fine arts.

Steichen thought it necessary to enlist the full communicative capacity of photography to address Cold War dangers and anxieties. His curatorial practice celebrated photography as a universal language, a codeless Esperanto, capable of knitting together a world on the brink of blowing apart.[56] Photography, he asserted, "communicates equally to everybody throughout the world . . . requiring no translation."[57] His landmark exhibition treated the accidental aspects of photography as so many facets of a universal human condition, conveyed through the transparency of the lens. Refusing old distinctions between high and low, Steichen brought the premises of mass culture into the art museum to cast modernism as a new aesthetic means of communicating to a global community. In his celebration of photography as revelatory of humanity's shared nature and common fate, he drew stray photographs into the fold, wrapping their rhetoric—however accidental—into his overarching themes.

While Steichen prepared *The Family of Man,* another New York curator was thinking about the implications of the quasi-linguistic character of photography for the new global order. In his remarkable 1953 book, *Prints and Visual Communication,* William Ivins, the first curator of prints at the Metropolitan Museum of Art and a friend of Stieglitz's, offers a history of prints as a system of visual communication, with extensive discussion of photography and halftone reproduction. He pursues the notion of traditional prints as having their own language, referring to them as visual statements with a "linear syntax."[58] In the sixth chapter, entitled "Pictorial Statement without Syntax: The Nineteenth Century," he argues that, unlike a traditional print, the photographic image communicates without a syntax. The lines and dots of the halftone, he writes, "had been provided

by the thing seen and were not those of any syntactical analysis."[59] This way of distinguishing photographic representations proved to be helpful historically. Whereas Evans and others had emphasized the syntactical ways in which photographs could be combined with framing elements, text, or other photographs to overcome the radical uncertainty attending each individual image, Ivins clarified that this uncertainty stemmed from a lack of syntax within the photograph itself. The relationship between the uncodedness of the photograph, on the one hand, and the syntactical possibilities of photography in its postproduction mode, on the other, remained a crucial issue through the 1970s.

In his essay, Ivins goes so far as to credit photography with bringing to consciousness the syntax and thus cultural boundedness of manual picture making. It took the emergence of an uncoded image, he suggests, to call attention to the codes by which traditional images were made and interpreted. According to him, the photographic representation "made the European world see that 'beauty,' as it had known it, so far from being something universal and eternal was only an accidental and transient phase of the art of a limited Mediterranean area."[60] Whereas Eastlake and countless other nineteenth-century critics refused photography the status of art on the grounds of its reliance on the accidental and the transient, Ivins turns this old argument on its head to assert that photography revealed the accidental and transient character of traditional aesthetics. He suggests that the universality of photography heralded by Steichen and the magazine culture he embraced had revealed the provinciality of European art.

As the examples of Steichen and Ivins would suggest, photography's place in the art museum in the 1950s was bound tightly to its capacities and limits as a means of communication. At the time, communication had become an area of intensive theoretical investigation. The Second World War had spurred research in fields related to information transmission, such as cryptography, and once again leading scientists were moving forward by contending with chance. In a landmark 1948 article, the American mathematical engineer Claude E. Shannon, who had worked on cryptography during the war under a government contract, proposed that probability governed the transmission of messages, putting chance squarely at the heart of communication systems.[61] Shannon observed that transmitted information is always prone to loss and disorder (entropy), and that this process can be quantified through a probabilistic calculus. What Boltzmann had noted about gas particles, according to Shannon, was true for bits of

information as well. In the 1950s, various thinkers pursued the implications of Shannon's insight, deepening the connections between information and probability theory.[62]

In developing his scheme, Shannon focused on information delivered in binary electrical signals, which enabled him to build upon the theoretical investigations of the nineteenth-century English mathematician and logician George Boole. Boole had used a binary system of truth value (a statement is either true or false) to establish an algebraic logic that could mathematically represent human reasoning. For Boole, a principal advantage of this algebraic logic was its capacity to quantify degrees of certainty in probabilistic terms. As he put it at the outset of one of his most important works:

> The design of the following treatise is to investigate the fundamental laws of those operations of the mind by which reasoning is performed; to give expression to them in the symbolical language of a Calculus, and upon this foundation to establish the science of Logic and construct its method; to make that method itself the basis of a general method for the application of the mathematical doctrine of Probabilities; and, finally, to collect from the various elements of truth brought to view in the course of these inquiries some probable intimations concerning the nature and constitution of the human mind.[63]

Shannon, who became familiar with symbolic logic in an undergraduate course on philosophy, realized that the Boolean binary system could be mapped onto the relays and switches of electrical circuits. As a graduate student, he noted that the calculus for representing the operations of an electrical circuit were "exactly analogous to the Calculus of Propositions used in the symbolic study of logic."[64] The linkage Shannon fashioned between electrical circuits and information became foundational for the emergence of modern computers and computational systems.

As the groundwork was being laid for the information age, photography occupied a curious place. It was unmistakably central to mass communication, but it remained an analog medium, whose images—as Ivins had noted—were not coded in the manner of electrical signals. Electrical transmission by news agencies converted photographs into data, but this conversion merely mechanically reproduced and degraded the uncoded original (unlike a telegraphic transmission of an already linguistically coded message). Moreover, the quantification of information posed a more gen-

eral quandary for those interested in forms of meaning that were difficult to quantify. Boole had established his binary scheme by focusing on propositions and dividing them into the true and the false, but those interested in broad fields of human meaning and cultural production were interested in nuance and connotation that resisted such spare categorical schemes. How was a more rigorous and nuanced understanding of photography as a communication system to be obtained?

During the 1960s, the most ambitious efforts in this regard came from France, particularly in the essays of Roland Barthes, and in the sociological investigations led by Pierre Bourdieu. When *The Family of Man* appeared, Barthes gave it a scathing critique, accusing it of getting the premises of progressive humanism exactly backward. According to Barthes, rather than establishing human nature as a historical construct, Steichen had found "Nature at the Bottom of History."[65] In other words, he had used the transparency of photography to render history and many of its brutal inequities invisible, celebrating a mythical unity (the "Grand Canyon of humanity," in the nationalist words of the catalogue) that characterized social relations as a product of nature. Scholars have debated the merits of this critique in the decades since, but Barthes unquestionably deserves credit for recognizing that photographic communication was far more complicated and treacherous than many writers, curators, and photographers had understood.

In the early 1960s, Barthes pursued the matter further. In "The Photographic Message," an essay published in French in 1961 and in English translation in 1977, he mixes information theory and structuralism to contend with the semiotics of the press or advertising photograph.[66] He states at the outset that "the press photograph is a message," signaling that he will diverge from the many aesthetically framed discussions of photography and follow Ivins to address the photograph as part of a broader system of communication.[67] He proceeds to discuss the press photograph through a triad of analytic terms: "source of emission," "channel of transmission," and "point of reception." Written at a time when *The Family of Man* and Cartier-Bresson's theory of the decisive moment were touchstones of popular belief in the press photograph as a kind of visionary disclosure, Barthes's opening moves, couched in the language of information theory, clearly conveyed his plan to demystify photographic communication. Barthes contends that whereas emission and reception are proper subjects for sociological treatment (a challenge that his colleague Bourdieu would

tackle), the message itself has a structural autonomy that lends it to a prior and immanent analysis.[68] From there, he makes a claim, analogous to that made by Ivins, that the photograph is *a message without a code.*[69] This removes the photograph from the standard ambit of information theory and gives it a proper domain of its own.

A message without a code: the language provocatively articulates the strange distinction of photography. In his essay, Barthes uses terms from the study of language, especially the dichotomy of denotation and connotation, to grapple with the peculiar structure of photographic communication. Breaking out the connotative dimensions of photography enables Barthes to talk about "reading" the photograph and to underscore the historical contingencies and institutional determinants that such reading entails.[70] By poaching terms from the study of language, Barthes raises the question of what differentiates an uncoded message from a coded one. For him, the mixture in photography of connotative legibility and uncoded denotation is crucial. It paradoxically "makes of an inert object a language" and transforms "the unculture of a 'mechanical' art into the most social of institutions."[71] Barthes suggests that developing a critical relation to the mass media regime of the postwar era requires analyzing this paradox. How does the natural image become a social message, and how do the uncoded messages of photography operate within a system of communication?

In a second essay, "Rhetoric of the Image," published in French in 1963, and likewise translated into English in 1977, Barthes extends his pursuit of these questions.[72] He analyzes an advertising photograph to demonstrate the ways in which a photograph's denotation "naturalizes" its connotative message.[73] In other words, the advertising photograph hides its persuasive rhetoric in an image that registers as an automatically formed and natural likeness of things as they are. From this he draws the broader conclusion that "the world of total meaning is torn internally (structurally) between the system as culture and the syntagm as nature."[74] For Barthes, photography was of particular importance because of its poorly understood status as an interface between coded semiotic systems and continuous visuality. The photograph, he says, "is not the last (improved) term of the great family of images; it corresponds to a decisive mutation of informational economies."[75] Barthes demystifies the informational economy of the advertising photograph by recognizing the ways in which it overlays social meaning on a naturally formed image.

In "Rhetoric of the Image," Barthes brilliantly handles an old complaint about photography, namely, that it is too indiscriminate in its reproduction. In photography, whatever random stuff is here or there before the lens will probably end up registering in the image. In his essay, Barthes acknowledges this surplus when he observes that "the connotators" do not fill up the entire photograph.[76] But whereas many critics had regarded photography's indifferent transmission of detail a liability, Barthes recognizes that this surplus is precisely what boosts the persuasiveness of the connotation beyond what other pictorial media can deliver. Without this excess of denotation, he emphasizes, the discourse of photography "would not be possible."[77] Rather than dissipating attention, the accidental details in a photograph allow its connotative message to masquerade as just what is.

Whereas Barthes undertook a rigorous analysis of the structure of the photographic message, Bourdieu led a collaborative sociological study of everyday practices of photography and the norms governing them. The results, which were published as a book in French in 1965 and in English translation in 1990, remain a great resource for those wishing to understand how analog photography functioned in the middle decades of the twentieth century. In the book, Bourdieu concludes that despite the "theoretically infinite number of photographs" that are technically possible, "there is nothing more regulated and conventional than photographic practice and amateur photographs."[78] He argues that most photography abides by norms of aesthetic judgment and behavior that support an ethos organized by social class.[79] The typical camera user, in other words, makes photographs of birthday parties, tourist sites, and school picnics, precisely because there is nothing daring or innovative about these subjects or the act of recording them. On the contrary, the sheer predictability of everyday photography is essential to its function as a means of social belonging and cohesion. Indeed, popular photography in the 1960s was precisely the inverse of the "snapshot aesthetic" that was emerging in the museum world at the same moment. As Bourdieu asserts: "In fact, far from seeing its specific vocation as the capturing of critical moments in which the reassuring world is knocked off balance, ordinary practice seems determined, contrary to all expectations, to strip photography of its power to disconcert; popular photography eliminates accident or any appearance that dissolves the real by temporalizing it."[80]

Like Barthes, Bourdieu was determined to demystify the realism of photography that most users took to be self-evident. In his landmark study, he argues that photography's reputation as a realistic and objective recording device is grounded not in any intrinsic agreement between its images and reality but rather in its systematic conformity to the reality-upholding social uses to which it has been assigned.[81] In other words, photographic assurances that person X visited the Eiffel Tower or was happy celebrating his fortieth birthday are deemed realistic because affirming the reality of what is depicted is their social function.

In the book, Bourdieu also reports that photography's troublesome merger of mechanical process and artful product, which had befuddled nineteenth-century aesthetes such as Eastlake, remained a problem. The photographic act, Bourdieu says, "in every way contradicts the popular representation of artistic creation as effort and toil."[82] Elsewhere he writes of the assumption that making art requires hard work:

> This gives rise to certain of the contradictions in the attitude towards mechanical reproduction, which, by abolishing effort, risks depriving the work of the value which one seeks to confer on it because it satisfies the criteria of the complete work of art. A contradiction that is all the more stark since the work of art, particularly when it is not consecrated, always provokes the fear of being duped; the soundest guarantee against this is the artist's sincerity, a sincerity which is measured according to its effort and the sacrifices it makes. The ambiguous situation of photography within the system of the fine arts could lead, among other things, to this contradiction between the value of the work, which realizes the aesthetic ideal that is still most widespread, and the value of the act that produces it."[83]

Bourdieu's sociological research suggested that doubts attending photography as art had remained remarkably stable over the course of a century. After all, sincerity measured in effort and sacrifice was essentially a formula for the meticulous finish that had served as a sign of probity and skill for nineteenth-century academic painters. The split in photography between product and process continued to haunt efforts to elevate the medium to the status of art.

In reporting results from the same study, Bourdieu's colleague Jean-Claude Chamboredon returns to the troublesome role of chance in photo-

graphic aesthetics. He notes that even Man Ray, so keenly associated with chance, had "privileged control and mastery." According to Chamboredon, although Man Ray discovered solarization by accident, it was only after he had experimented with it "a hundred times" and "controlled it absolutely" that he exhibited his works.[84] "Chance and *naïveté*," Chamboredon writes, "are not recognized as means of legitimate creation, because the apparatus interposes itself and constantly threatens to intercept the creative intention, and also because the work of art can be seen as a work of juxtaposition, the product of the interplay of the instrument and chance."[85] The problem of the lucky shot had not gone away. One survey respondent, Chamboredon recalls, spoke of "a photographer who makes a masterpiece without knowing it."[86] The aim of Chamboredon's contribution, like that of the study as a whole, is demystification. Against photographers and curators claiming a charmed or transmuted relationship between the apparatus and its operator (for example, Cartier-Bresson's notion of his camera as an "extension" of his eye), he writes: "Any attempts to institute a magical relationship between the photographer and the camera, and to use the irrational and incomprehensible elective affinity with the instrument to negate the constraint imposed by the process and the uniformity it brings about, can only ever be verbal assertions contradicted by the concrete conditions in which photographs are made."[87] Cartier-Bresson could pontificate all day about the decisive moment, but anyone who had accidentally produced an evocative snapshot knew that the "concrete conditions" of photography do not establish any reliable link between intention and product. According to Chamboredon, aesthetes using photography "must deny the authority of the process, without ever admitting or acknowledging the effectiveness of chance."[88]

These works on photography by Barthes and Bourdieu entered anglophone conversations only slowly and irregularly before English translations appeared. But throughout the 1960s American writing on the social operations and effects of photography articulated critical doubts of its own. The intransigent ambiguity of the frames of film that Abraham Zapruder took of the John F. Kennedy motorcade on the day of Kennedy's assassination did much to alert the public to the complexity of photographic representation. Subsequent concerns in 1960s America that advertising photographs contained subliminal messages or that the footage of the moon landing was faked were symptomatic of a growing suspicion not merely about abuses of power but also about the disconcerting ways that photographs could abet

them. Marshall McLuhan, Daniel Boorstin, and other popular writers of the 1960s critically addressed photography's social functions and subtle persuasiveness.[89]

Meanwhile, the American museum establishment was still striving to confirm the aesthetic value of photography once and for all. In 1962, John Szarkowski took over from Steichen as head of MoMA's photography department. Although at the time Szarkowski assured a colleague that "creative photography is not dependent upon museums' approval," he worked assiduously for many years to ensure that it was bestowed.[90] He championed the modernist notion of medium specificity and the aesthetic potential of the individual print. Flatly contradicting Greenberg, he dismissed the capacity of photography for storytelling.[91] He asserted that the photographic legacy of *Life* magazine and the heyday of photojournalism lay in "individually memorable pictures, not coherent narratives."[92] He favored photographs in a documentary style (to use a term Evans coined) that offered a distinctive angle on social experience and its material circumstances. His efforts were instrumental in establishing such photographers as Lee Friedlander, Diane Arbus, and Garry Winogrand as contemporary masters.[93]

Extolling individual pictures required Szarkowski to negotiate the problem of chance. Following Stieglitz, he characterized photographic excellence as a matter of probability, arguing that only dedicated and talented photographers could produce highly successful photographs with "fair consistency."[94] He compared the gap between the ordinary and the exceptional photographer to that between the ordinary hitter of baseballs and Ted Williams, a statistical analogy if there ever was one. But he also believed that members of the haphazard multitude occasionally made a hit, and his exhibitions and publications interspersed photographs by accomplished practitioners with anonymous images from historical societies and other unlikely sources of art. He defended this practice by imputing an intrinsic revelatory logic to the medium, open to the expert and neophyte alike. Echoing Beardsley and Wimsatt on the assessment of poetry, he argued that either a photograph worked or it didn't. In his influential 1966 book, *The Photographer's Eye,* Szarkowski noted that the photographs he included "have in fact little in common except their success, and a shared vocabulary: these pictures are unmistakably photographs. The vision they share belongs to no school or aesthetic theory, but to photography itself."[95]

For Szarkowski, who had humble midwestern origins, the autonomy of the medium was a way to avoid academic dogma and open photography to those lacking training or pedigree. He referred to a selection of amateur snapshots as "pure and unadulterated photographs" that sometimes "hinted at the existence of visual truths that had escaped all other systems of detection."[96] According to Szarkowski, the new ways of making pictorial meaning that photography demanded "might be found by men who could abandon their allegiance to traditional pictorial standards—or by the artistically ignorant, who had no old allegiances to break."[97] A century after Eastlake had recognized the burgeoning "republic" of practitioners drawn by the "gambler's excitement" of photography, Szarkowski sought ways to bring what she termed their "prizes" into the art museum.

Much like the subjects of many photographs by Weston, Szarkowski's arguments on behalf of photography have a way of turning in on themselves. When extolling the aesthetic value of photography he returns time and again to phrases such as "visual experience," "visual truth," and "visual ideas." The adjective *visual* in these phrases serves to cordon off a purported dimension of experience that photography is uniquely qualified to explore. But what is the visual in itself? When Szarkowski proudly remarks that photography "can identify, consider, and resolve a dozen, or a hundred, complex visual ideas in the time it took a Barbizon painter to produce one preliminary sketch," or when he compares the shift from brush to camera to that from abacus to computer, he dresses up Talbot's old notion of photography as a labor-saving device, but without addressing the underlying problem that this saving poses.[98] The Barbizon painter sketching in the forest of Fontainebleau was not simply thinking through a visual idea; he was contending with issues of tradition, modernization, social class, patronage, and even ecology.[99] As we have seen, photographers were capable of contending with an equally broad array of issues, but one could not read that into a single snapshot, no matter how finely framed. It could only be found in a practice bent on making itself intelligible.

Whereas Greenberg understood the self-criticality of modernist painting to be demanded by historical circumstance, Szarkowski saw the autonomy of photography as an organic condition. Writing of the profusion of photographs that emerged in the late nineteenth century, he says: "Most of this deluge of pictures seemed formless and accidental, but some achieved coherence, even in their strangeness. Some of the new images were memorable,

and seemed significant beyond their limited intention. These remembered pictures enlarged one's sense of possibilities as he looked again at the real world. While they were remembered they survived, like organisms, to reproduce and evolve."[100] Szarkowski's language is worth following in its twists and turns. Some pictures "achieved" coherence, he writes. The word is redolent of effort and dedication, terms that stand opposed to luck. In this phrasing, the photograph has taken on its own agency, supplying the virtues that the photographer who took it may have lacked. His suggestion that some of these early photographs "seemed significant beyond their limited intention" similarly seeks to legitimate the recovery of meaning from a medium prone to accident. He then asserts that when one returns to view the real world the photograph held in memory enlarges one's "sense of possibilities." But what possibilities is he talking about? He is evidently talking about possibilities for viewing the real world as a photograph. According to him, the function of photography is to reproduce itself, like an organism. That is its nature. He urges photography to spiral inward, turning against and shearing off its social history to isolate the visual as the medium might render it.

In promoting such an autonomy, Szarkowski was once again asking photography to chase an ideal that it had already rendered obsolete. While Szarkowski was carrying the standard for photography as a medium bearing its own internal meaning—a standard fashioned more or less in imitation of the autonomous painting that Greenberg and others had articulated—a young generation of artists was working from a new set of premises. One premise was the impossibility of isolating any medium from the mass media. As the experience of Pollock had demonstrated, the effort to keep painting free from photography and other forms of mechanical reproduction was a hopeless business. The rise of Pop art was built around this recognition. A concomitant premise was the absurdity of expecting a public display of subjective expression to adequately counter or compensate for the shortcomings of mass culture. By the time Cartier-Bresson devised his "decisive moment" scheme in the early 1950s, humanity was pinned between the retrospective horror of the Holocaust and the prospective horror of atomic Armageddon. This intense pressure led to desperately overblown claims on behalf of the creative self and its capacity to represent or redeem a world gone mad. Whether delivered in support of the anguished gestures of Pollock or the visionary clicks of Cartier-Bresson, these claims of (straight white male) mastery over contingency swelled with pretension. Every drip and

every click was allegedly saturated with existential signature. Against the ubiquitous banality of televisions and billboards, the lone artist seeking to dredge up or snare a vision that could rescue modernity from itself faced impossible odds, and the leaders of a young generation of artists knew it.

More thoroughly than any other artist, Andy Warhol exploited the power of these insights in the early 1960s. He took mechanical reproduction to be the basis of painting, and his silkscreens of photographic imagery turned abstract expressionism and its masculine angst on their heads (Figure 8.4). Rather than await the conscription of painting by commercial photography, he performed the operation himself. This enabled him to open a channel into the collective obsession, desire, and repulsion generated by mass culture.[101] Chance figured prominently in his approach. Like Shannon tracking the degeneration of information, Warhol explored the loss and distortion that occurs when images are mechanically reproduced. In many ways, Warhol was a Cameron for a new century. Like her, he worked from a social margin to create a space for the production of identity, celebrity, and pseudo-celebrity (his was called the Factory, hers was called Dimbola Lodge). Like her, he investigated the reliance of culture on reproduction, and like her, he walked a line between tragedy and farce to bring the ambivalence and shortcomings of a historical moment into representation. Glitches were vital to the work of both: the smears and leaks that appear in his silkscreened pictures, like the tears and streaks that appear in her photographs, arrive like eruptions of reality in the midst of a mechanical transmission.[102] But whereas Cameron meditated on the failed aspiration of a social elite, Warhol explored a broader forfeiture of subjectivity to commercial fascination.[103]

Warhol and other leading artists of his generation made it clear that photography would enter the art world from the painting camp as well as from the photography camp. As the preceding paragraphs would suggest, the medium was up for grabs. Curators of photography were largely hewing to a notion of medium specificity that cut photography off from the circumstances of its production. This enabled them to absorb into their collections and programs pictures not made with aesthetic intent, from military expedition photographs to backyard snapshots. It enabled them to resolve the old tension between mechanical process and pictorial product by presuming that the product could stand on its own, thus confining the significance of photography to the visual. But systemic investigations of photography outside the art museum demonstrated just how behind the

Figure 8.4 Andy Warhol, *Double Elvis,* 1963, silkscreen ink and silver paint on linen. Andy Warhol Foundation, Artists Rights Society, and Authentic Brands Group

curve this thinking was. The gap between museum practice and emerging understandings of photography's semiotic and sociological operations offered artists an opportunity to provoke the art world and change the course of American modernism. In the 1960s and early 1970s several Pop and Conceptual artists recognized that the autonomy of painting was a pipe dream and that any pictorial art worth its salt had to contend with the primary force that rendered it as such, namely, photography. The fact that the institutional defense of photography as art had become caught in an eddy of self-mystification opened photography to appropriation by artists of greater ambition. One such artist, who was particularly sensitive to the problem of chance in photography, was John Baldessari.

9

John Baldessari Plays the Fool

In 1973, John Baldessari produced a work entitled *Throwing Three Balls in the Air to Get a Straight Line (Best of Thirty-Six Attempts)*. The work consists of a portfolio of fourteen offset lithographs produced by Galleria Toselli in Milan, including a title plate, a colophon plate, and twelve plates featuring three orange balls against a blue sky (Plate 8, Figure 9.1). The twelve images, which evidently represent the best of thirty-six attempts to get a straight line, are not numbered, so there is no prescribed sequence. *Throwing Three Balls* is one of many related series by Baldessari from 1972–1973 that depict the results of throwing or striking balls or other objects with the aim of producing a geometric configuration of some kind.[1] With these series, Baldessari carried forward into another socially turbulent era a conversation stretching back to Talbot about how art might arise from photography and chance.

The Sixties, especially if one accepts the frequently proposed ending date of 1973, were a crucial time for photography as art.[2] The key players were artists contending with a depleted faith in medium autonomy and a recognition that the aesthetic possibilities of photography had been underserved by a dated and narrow paradigm within the art museum. Today categorized as Pop or Conceptual artists, these practitioners exploited the failure of abstract expressionism to recognize the implications of photography as a social form, and the failure of much modernist photography to recognize the new historical demands on art. By using multiplicity, graphic translation, and relations between image and text, these artists forged a new aesthetic out of banal material. Often working across media, they devised

Figure 9.1 *Throwing Three Balls in the Air to Get a Straight Line (Best of Thirty-Six Attempts),* 1973 Artist's Book 9 ¾ × 12 ⅞" (detail). Courtesy of John Baldessari

ways to address in a single work the limits both of photography and of the artistic tradition they inherited. Because these artists wanted to engage photography in its popular modes and break the medium out of its insular aesthetic niche, they did not identify themselves as photographers. The Conceptual artist Richard Long has said, "I am an artist who sometimes chooses to use photographs, although I am not a photographer," and fellow Conceptualist Ed Ruscha has declared, "I'm not a photographer at all."[3] For these artists, photography was a way to move art forward, not a fussy craft abiding by technical rules or intrinsic principles of form.

Like much of the best art produced by this generation, Baldessari's *Throwing Three Balls* embeds analytic complexity in a simple form. Seemingly a record of dopey child's play, the series trenchantly engages—in part by *being* a record of dopey child's play—both a vexatious historical situation for art production and a new instrumental significance for chance. Its ostensible spontaneity masks its vigorous engagement with artistic precedents and its careful entwinement of photography and art. Many years after producing *Throwing Three Balls,* Baldessari recalled that when he was in

high school he noticed that photography and art seemed to have "two different histories."[4] In *Throwing Three Balls,* he brings these two histories together to reconfigure them in subtle but brilliant ways.

A vital precedent for Baldessari was Marcel Duchamp's *Three Standard Stoppages* of 1913–1914. By the early 1960s, the mystification of subjectivity that surrounded Pollock and abstract expressionism—the heroic notion of a lone individual resisting the onslaught of commerce to plumb the depths of his (always "his") psyche—had become insupportable. Pollock had succumbed to commercial spectacle and the ubiquity of the camera, and Greenberg's autonomy for painting had begun to seem crimped and bootless. For a young generation of artists, Duchamp offered a way to contend with this disillusionment, and the revival of his work in publications and exhibitions around 1960 came at the perfect time.[5] His "fountain" or urinal, which had become lost but was historically remembered in a photograph Stieglitz took of it, became a touchstone of critical insight for its exposure of the determinative role of institutional framing in the production of art. But some of his other work was equally ingenious in its testing of artistic subjectivity, and his practice as a whole affected Baldessari immensely. In an interview conducted in 1973, the same year that *Throwing Three Balls* was made, Baldessari said that when he encountered a book about Duchamp's work and saw "all his things together," it was as if he "had been hit between the eyes, like I'd come across some long lost relative. All of a sudden I felt I had a home, that I wasn't so strange."[6] In 1963, Baldessari attended the Duchamp retrospective at the Pasadena Art Museum organized by Walter Hopps. The retrospective, which left Baldessari "very impressed" and increasingly looms as a vital moment for Conceptual art, included a replica of Duchamp's *Three Standard Stoppages.*[7]

As displayed in Pasadena, *Three Standard Stoppages* comprised two sets of objects (Figure 9.2). One set, displayed on a horizontal platform, consisted of three curvilinear threads approximately one meter in length, glued to narrow strips of canvas painted Prussian blue, which were affixed in turn to three glass panels. The other set, mounted on a tilted support atop the platform, consisted of three flat wooden strips, cut along one side to replicate the curves of the threads.[8] To make the work, Duchamp dropped meter-long threads from a height of one meter to enlist gravity and chance in deforming a straight line into a sinuous curve. He thus followed prescribed actions in three dimensions to make templates in two.[9] He was interested in how the meter (as a thread) "absorbs" the third dimension in its fall.[10]

Figure 9.2 Marcel Duchamp, *Three Standard Stoppages,* 1913–1914. Photograph by Frank J. Thomas, Courtesy of the Frank J. Thomas Archives, © Succession Marcel Duchamp / ADAGP, Paris / Artists Rights Society (ARS), New York

Although the titular assertion that the chosen stoppages are "standard" is facetious, all three, despite the dicey curves that formed as they dropped, are nearly equal in span.[11]

Duchamp thus refashioned the basic terms of painting. Painters, after all, perform in three dimensions to leave effects for display in two. In *Three Standard Stoppages,* Duchamp substituted a manufactured thread for the painter's line, and gravity for the handling of the brush. One might say that he took Cubism one step further by plucking out Picasso's guitar strings and releasing them as free-floating measures.[12] Like Protogenes with his sponge, Duchamp opened up a space for chance. He suggested through his work that a subjective handling of paint could no longer adequately contend with an industrial society enthralled with mechanization. But he also resisted the standardization that industry enforced. The irregular behavior of the threads when dropped opposed the neat abstraction of the meter. In

a distilled moment of naturalism, gravity was allowed to insert a degree of entropy into an ideal scheme. Duchamp's delivery of the meter thus prefigured Shannon's understanding of entropic noise in the transmission of information. By making wooden templates from the threads, Duchamp brought his momentary effects of chance into the material substrate of reproduction. Like a photograph, each thread was an accidental moment subject to endless replication.

While Duchamp was enjoying a resurgence of attention in the early 1960s, he singled out *Three Standard Stoppages* as his most important work because it contained "the mainspring" of his future.[13] It provided "the way to escape from those traditional methods of expression long associated with art" and thus to move on to the "fountain" and other ready-mades. Escaping traditional methods of expression had become necessary because the capacity of artistic subjectivity to sustain the social value of art had come into doubt. Beauty, which for Immanuel Kant had been the judgment that called the individual into society and enabled the public to constitute itself, had largely disappeared under the crass appeal of the commodity and the whispered pitch of the gallery. In a society given over to commerce, aesthetic taste was rapidly becoming privatized as a highbrow form of consumer preference. Unable to rely on a public, artists sought a critical and objective basis for their work. Duchamp did so by substituting chance and gravity for composition and taste. He jettisoned subjectivity and illusion in favor of objectivity and material fact.

But Duchamp knew that these substitutions were an endgame. He had diminished and isolated, but not eliminated, the role of taste. He admitted this in the early 1960s: "I consider taste—bad or good—the greatest enemy of art. In the case of the Ready-Mades, I tried to remain aloof from personal taste and to be fully conscious of the problem. . . . Of course all this scarcely sustains a transcendental discussion, because many people can prove I'm wrong by merely pointing out that I choose one object rather than another and thus impose something of my own personal taste."[14] Duchamp understood that taste in some degree would inhere to any recognizable form of art he might produce.[15] But he had taken his critique of taste beyond precedent. In 1963, the year of the Pasadena retrospective, and fifty years after Duchamp had produced his "mainspring" work, the artist still believed that *Three Standard Stoppages* outstripped the receptivity of the public: "I don't think the public is prepared to accept it . . . my canned chance. This depending on coincidence is too difficult for them."[16] At a time when

much of the public still understood Jackson Pollock to have revived and extended the powers of subjective expression through dropping "threads" of paint on canvases, as if even gravity had come under his unconscious control, Duchamp had cause to doubt the public's receptivity to his fallen meters.

In *Throwing Three Balls in the Air to Get a Straight Line (Best of Thirty-Six Attempts)*, Baldessari carried on where Duchamp had left off. Using three balls instead of three threads, he subjected his materials to an aerial experiment in chance geometry. Once again, a performance in three dimensions left effects for display in two. Whereas Duchamp put the threads against Prussian blue, Baldessari depicted his orange balls against a bright cerulean. But beneath these affinities lay a basic inversion: whereas Duchamp used chance to deform the meter and its straight geometry, Baldessari used it to form approximations of a geometric ideal. The difference is fundamental. In *Three Standard Stoppages,* the presumption of mathematical perfection is the foil for Duchamp's canny critique. In the struggle against authority, chance became his agent. "My canned chance," he would say, or "*my* chance."[17] His public display of skill at chess (he played against a naked Eve Babitz at the Pasadena retrospective) made his masterly gamesmanship clear. In *Throwing Three Balls,* however, Baldessari hopes to produce an ideal geometric form but inevitably fails. The twelve images in the series are, under the rules of his game, the best he could do. *Three Standard Stoppages* has a saucy assurance that *Throwing Three Balls* surrenders.

In another fundamental departure from Duchamp, Baldessari used photography instead of thread and canvas. Whereas *Three Standard Stoppages* incorporates the structure of photography (a chance moment made into a template for reproduction), *Throwing Three Balls* incorporates photography proper, acknowledging that the medium had become—in Baldessari's words—"the language of the realm."[18] This fuller incorporation draws photography more explicitly into the critique.

In *Throwing Three Balls,* Baldessari provides a schematic representation of photography as a social form. The titular phrase *Best of Thirty-Six Attempts* alludes to the thirty-six frames of a standard roll of film. Like other makers of snapshots, Baldessari had thirty-six opportunities to capture, from a rapidly changing visual field, configurations matching preset aesthetic criteria. In his schematic representation, those criteria have been boiled down to a simple geometric figure, a straight line. After executing the thirty-six attempts, Baldessari saved the best images and discarded the rest. Every

ordinary SLR user did the same. In his failures and successes, others could thus see their own. His chance was their chance.

Baldessari's schematic representation of photography as a social form is also an ingenious critique. It confronts us with the role of chance in photography that many authorities would prefer to suppress. It invites us to consider how much more meaningful than his simple "straight line" rule our aesthetic demands on everyday photographs really are. But his critique also operates on a subtler level. By bringing the structure of snapshot photography into a work of art, Baldessari offers us a chance to consider how that structure may have infiltrated our ways of looking. He sharpens the inquiry in *Throwing Three Balls* by eliminating a space or difference essential to the function of photography as reportage or evidence. For photography to serve such a function, the image must be distinct from the event it records. When we say that a photograph has "perfectly captured" or "misleadingly represented" an event, our assessment has meaning because of this distinctness, which can leave photograph and event aligned or misaligned. In *Throwing Three Balls*, this distinctness has vanished. What each image records is an effort "to get a straight line," but the measure of that straightness only exists in the image. The success or failure of each round of the game has no reality beyond the record of it. The image is not merely a document of the result of one round of the game, it *is* that result. By eliminating the space between photograph and event in *Throwing Three Balls*, Baldessari questions whether our internalization of photography as a social form has annulled it. In other words, he asks whether what we actually want from the reportorial photograph is less a record of an event outside photography than simply a pictorial order matching our preconceptions. If Joe Rosenthal gets every marine, limb, and crease in the ideal place (that is, every ball in a straight line), the question of whether the pictorial rhetoric actually matches a true instance of heroism becomes secondary at best. Chance has given the authorities the image that they (and we) desire. Photography as a self-contained system, Baldessari shows us, is a shallow game.

Throwing Three Balls encapsulates its critique in an appealing form. Baldessari's schematic model produces beauty from stock ingredients of California postcards—blue skies, greenery, and sun-kissed oranges (or their surrogates). The work is as much an elegant distillation of popular photography and its fantasies as a critique of them. It both satirizes and celebrates the cheap elevation of the medium. Unlike Duchamp's threads, Baldes-

sari's orange balls never have to come down. The popular side of *Throwing Three Balls* extends to the work's dissemination. The lithographs, printed in an edition of two thousand, were relatively cheap and have circulated well beyond the gallery.[19]

Photography gives *Throwing Three Balls* a social structure. Although Duchamp could drop and affix his threads on his own, Baldessari's game required two players, one to throw the balls and the other to wield the camera. The artist made the tosses, and Carol Wixom, his wife at the time, took the photographs of the balls in flight.[20] Baldessari has long made the vitality of human interaction central to his practice. In his work, the deskilling of art is an invitation to participate. Games for multiple players have allowed him to escape the stifling existentialism of the Pollock model of artist-as-visionary working in a private trance. In *Throwing Three Balls,* two players have collaboratively determined the positions of the balls in each print, and no amount of looking can distinguish their efforts.

The title of *Throwing Three Balls* makes explicit what was only implicit in *Three Standard Stoppages*—namely, the roles of selection in photography and in art. As John Szarkowski has observed, the advent of photography "provided a radically new picture-making process—a process based not on synthesis but on selection."[21] But what criteria of selection did Baldessari use? Despite his declaration that the balls were "thrown to get a straight line," his criteria for determining the "best" of the thirty-six attempts remains uncertain. Are the chosen twelve indeed those with the balls most closely aligned? Or did other criteria—such as pictorial quality or variation, for example—intervene? In the gap between compositional intention ("to get a straight line") and final selection ("best") the ineradicable role of taste crops up again.

In the early 1970s, Baldessari engaged Duchamp's hobgoblin of taste repeatedly. In photographic works such as *Choosing (A Game for Two Players): Green Beans* (1971), *Choosing (A Game for Two Players): Carrots* (1972) and *Choosing (A Game for Two Players): Rhubarb* (1972), Baldessari playfully distilled the role of choice in art production, which photography had brought to the fore (Figure 9.3). To make these works, he would ask a participant to select three individual vegetables from an array of a specified type (for example, green beans). He would then choose one of the three by pointing to it, and a photograph of this act was taken. Then the participants would discard the two unselected vegetables and replace them with two more from

Figure 9.3 John Baldessari, *Choosing (A Game for Two Players): Green Beans,* 1972 Color Photographs, text 9 photographs, 12×22" each (Detail). Courtesy of John Baldessari

the array, at which point the process would be repeated. The work was finished when the supply of vegetables was exhausted. Baldessari's decision to use three vegetables in each round, and his tendency to feature elongated vegetables laid flat against a plain background, alludes again to *Three Standard Stoppages*.

Like *Throwing Three Balls*, the *Choosing* games reconceive Duchamp's "mainspring" work to question the role of taste in new ways. By using vegetables, Baldessari humorously brought aesthetic preference down to the level of supermarket browsing. The academic requirement stressed by Reynolds in his *Discourses* that art entail selection and rejection from nature is reduced to the trivial question of which vegetable is picked. In addition, the finger pointing into each image bears a visual correspondence to the carrots, beans, or stalks of rhubarb (one skinny growth gesturing to another), inviting us to consider the role of narcissism in taste. Finally, as the viewer moves from one photograph to the next within a series, the logic (if any) behind the successive selections is elusive. Suspicion arises that time and repetition, giving rise to boredom, may have figured into the process, that particular vegetables lost their desirability simply because the artist grew tired of choosing them. In principle, the very "best" vegetable, however defined, could turn up in the first set of three and then win out over all competitors in successive rounds, but this never seems to happen. Boredom, in this and other work by the artist, is a vital engine and theme. Baldessari once remarked: "Everywhere I look, I am thinking about alternate ways of seeing what I'm looking at. And it's just to escape boredom."[22] In the *Choosing* series, Baldessari critically reframes the eradicable remnant of taste to associate the definitive aesthetic act of selection with banality, narcissism, caprice, and monotony.

Throwing Three Balls has an origin story that leads us to another key precedent. In 1971, Baldessari participated in *Pier 18*, a group show put on by the Museum of Modern Art in New York. Each artist in the show was asked to meet two photographers, Harry Shunk and Janos Kender, at an unused pier and offer them a project. Baldessari came up with several, including bouncing a rubber ball on the pier and asking the photographers to try to take photographs with the image of the airborne ball at the center (Figure 9.4). He later reflected, "I was well aware of their reputation, and my strategy was to prevent them from making beautiful photographs. . . . I figured they'd be so busy [trying to center the image of the ball] that they couldn't compose. I went on with that idea, using it as a device."[23] This

Figure 9.4 John Baldessari, Harry Shunk, and Janos Kender, *Pier 18: Centering Bouncing Ball (36 Exposures),* 1971 B&W photographs 7×10 ⅛". Photo: Shunk-Kender © J. Paul Getty Trust. The Getty Research Institute, Los Angeles. (2014.R.20) Gift of the Roy Lichtenstein Foundation in memory of Harry Shunk and Janos Kender

ingeniously absurd assignment, which mingled art with stupid instruction ("follow the bouncing ball"), became the germ for an obsessive series of projects, including *Throwing Three Balls,* that Baldessari would undertake over the next few years.[24]

In the *Pier 18* assignment, Baldessari reduced the problem of composition to a single rule: locate the ball in the center of the photograph. The position of everything else in the picture—the pier and the people on it, the buildings in the background, the Hudson River, and the sky—became an arbitrary by-product of compliance. The elementary geometry of rectangle and bouncing ball thus decomposed the rest of the image. To be sure, there were various moments at which the ball could be caught in the center, and in theory compositional criteria could be brought to bear on the timing of the shutter click. But a crucial effect of Baldessari's rule, and a stated aim of the artist in devising it, was to put composition at odds with perceptual attention. To take command of the position of the bouncing ball

was to lose command of the visual field. Baldessari thus challenged the heroic ideal (and ideological premise) of the photographer monitoring a complex and rapidly changing scene to seize the perfect instant and the perfect crop, an ideal that had underwritten photography of life on the fly from Stieglitz to Cartier-Bresson.

In Baldessari's assignment, the compositional motivation of the entire image was condensed into the ball, so that only its position counted. As discussed earlier, Barthes famously coined the term *punctum* to refer to the incidental detail that escapes the photographer's notice but nonetheless appears in the photograph, a tiny but nonetheless piercing trace of reality that the viewer discovers afterward.[25] In the *Pier 18* project, Baldessari reversed the equation. By concentrating the attention of the photographers on the position of the ball, the *punctum* exploded into the surrounding welter of incidental imagery. The very thing that seemed like a *punctum*, the arbitrarily included rubber ball, became the basis of the composition. Baldessari not only defeated the compositional habits of the photographers; he also produced an image that inverted the conventional structure of the photograph. The semiotic tussle described by Barthes, whereby the photographer composes an image to convey a message and the viewer discovers the blind spot, the incidental detail that unleashes the poignancy of time's passage, was undone. The image from the pier, given over to arbitrary rules and a wayward ball, is neither the photographer's nor ours.

Baldessari has said that he "was well aware" of Shunk and Kender's reputation. The two photographers were best known for their work with Yves Klein. In 1960, they had photographed Klein using female models smeared with blue paint to make body paintings at an evening gallery event, *Anthropometries of the Blue Period*, and in 1960 they had made widely circulated photographs of Klein leaping from a ledge. To make the photographs of the leap, Shunk and Kender had spliced an image of Klein in midair with one of the street below, to erase all signs of the colleagues holding a tarp to catch him. Klein reproduced one version under the headline "Un Homme dans l'Espace! Le peintre de l'espace se jette dans le vide" in the one-off newspaper he produced and distributed, *Dimanche 27 novembre 1960 (Le journal d'un seul jour)* (Figure 9.5). The extended caption exclaimed that "the Monochrome [a moniker for Klein] . . . regularly practices dynamic levitation!" Versions of the doctored image were also published in the catalogue of Klein's 1961 retrospective at Krefeld and later that year in the German modernist journal *Zero*.[26]

Figure 9.5 Yves Klein, *Leap into the Void,* (IMMA 21), 1960. Artistic action of Yves Klein © Yves Klein, Artists Rights Society (ARS), New York / ADAGP, Paris. Collaboration Harry Shunk and Janos Kender © J. Paul Getty Trust. The Getty Research Institute, Los Angeles. (2014.R.20) Gift of the Roy Lichtenstein Foundation in memory of Harry Shunk and Janos Kender

Klein's work was pivotal to Baldessari. In 1961, Baldessari attended an exhibition of Klein's monochromes at the Dwan Gallery in Los Angeles. Years later he recalled: "It just defied everything I knew about art. . . . Just monochrome blue paintings, all the same size. I said, 'This can't be art.' You know, but in the analysis . . . It snapped something there."[27]

The doctored images by Shunk and Kender of Klein's soaring body became a historical touchstone for the interplay of performance and photography. The leap was executed for the camera (performance becomes

photography), yet the use of the doctored photograph in the newspaper was itself crucially performative (photography becomes performance). Although Conceptual artists appreciated Klein's radicalism and verve, their deadpan humor debased his mystical gestures. Bruce Nauman's 1966 photographic work *Failure to Levitate in the Studio,* in which the artist depicts himself in a double exposure slumping to the ground between two chairs, offers the most direct rejoinder.[28] It transforms the ecstatic elevation of the artist into a moment of slapstick.

At Pier 18, Baldessari took Klein down a peg as well, insisting that the photographers whose challenge in 1960 was to capture the leaping "Monochrome" at his apex now had to fix a rubber ball in the center of the image. The great leap into the void had become a mere bounce, a ball taking flight from dumb elasticity rather than poetic aspiration. The background of the soaring subject had become, in its banality and arbitrariness, the very thing that interested Baldessari most.[29]

A year later, Baldessari, like Nauman, deflated Klein further by taking him on more literally. In *Floating Color* of 1972, Baldessari tossed monochrome pieces of paper from his window and had them photographed airborne (Plate 7). Here, the "monochrome" in flight is not an artist but a piece of paper. Like Klein, the pieces of paper are caught at an early moment in their trajectory, when they seem poised between ascent and descent, hovering in photographic suspension. The colored papers take us through a spectrum from red to yellow to green to purple to blue to gold, and in this way are reminiscent of the monochromes of Aleksandr Rodchenko (*Pure Red Colour, Pure Yellow Colour,* and *Pure Blue Colour,* 1921) and Ellsworth Kelly (*Blue, Green, Yellow, Orange, Red,* 1966), works that broke painting into its constituent parts. With respect to modern painting, the work is poised between rejection and revival. The monochrome is being thrown out of a window by the artist, but at the same time it is being offered up to the camera, which records the floating color as a ready-made version of the zero degree of modernist art. The work represents photography as that which both dispenses with modernist painting and ensures, through a record of performance, its permanent elevation. In this way, Baldessari ingeniously reproduces the very roles of photography in modernism that Namuth had established in his sessions with Pollock.

In interviews with Baldessari, the names Duchamp and Klein come up often. But *Throwing Three Balls* and its kindred series critically engaged the work of another artist whose name does not arise in the interviews:

Alfred Stieglitz. Understanding this relationship is crucial to appreciating how Baldessari intertwined the histories of photography and art.

Although Conceptual artists routinely downplayed their ties to art photography and its dated aesthetic aspirations, disavowal can be a deadpan form of engagement. The artist and writer Jeff Wall has argued that Conceptual artists played as amateurs in part to critique the often precious aestheticism of art photography. According to Wall, these artists, in a utopian spirit, turned to the snapshot to overcome the social exclusivity of art and break the opposition between avant-garde and kitsch. In so doing, they had to take down the incipient regime of practitioners such as Stieglitz, who had sought to reproduce the exclusivity of art within photography. In Wall's view, Conceptual artists sought to make a critical medium of photography by articulating and upending its aesthetic assumptions. Only through self-critique could photography participate fully in modernism. The argument has a disarming brilliance: according to Wall, dismantling the aesthetics of art photography was paradoxically a precondition to photography as modernist art.[30]

It was evidently in this spirit that Baldessari in *Throwing Three Balls* dismantled Stieglitz's *Equivalents*.[31] In the early 1970s, the *Equivalents* were widely known but had an ambiguous status. In some respects, they were in keeping with the emerging art of a new generation. They were more or less ready-made abstractions, delivered as small pictures on postcard stock; they teetered precariously between meaning and nonsense, artistry and fraudulence; they took the form of a potentially endless string of permutations generated by particular restraints of material, size, and subject; and they tended to have the same title, occasionally particularized by an obscure archival designation (for example, *Equivalent 27c*). These qualities abided by precepts of conceptual art. In other respects, however, the *Equivalents* were ripe for critique. By associating abstraction with a visionary subjectivity, they seemed allied with the overburdened work of Pollock and his ilk. In addition, they smacked of masculine sexual melancholy.[32] In the years leading up to the *Equivalents,* Stieglitz had made Georgia O'Keeffe's body—her torso, her head, her hands, her feet, her breasts, and so on—his principal subject. He made the link between the two series clear when he gave *Portrait of Georgia, No. 3* its title, and when he told Charlie Chaplin about his idea for a film in which images of clouds would alternate with anatomical images of a woman's body (Figure 6.2).[33] The *Equivalents* were

thus linked to an equation of women with nature that feminists in the early 1970s were taking apart.

In *Throwing Three Balls,* Baldessari cleverly reworked Stieglitz's skyward views of accidental configurations. Consider a comparison between *Equivalent* of 1930, which Newhall reproduced in his landmark history, and a plate from Baldessari's series (Plate 8, Figure 9.6). Both images show an expansive swath of sky into which the tops of trees intrude. The principal subject of both is a random composition of aerial elements, a sinuous cloud in the photograph by Stieglitz, and a crooked line of orange balls in the image by Baldessari. The affinity looks like parody. Baldessari has evidently sucked out all of the symbolist air and transcendental pretense from Stieglitz's summa project. A portentous opera of heavenly vapor has given way to a playful exercise in a juggler's loose geometry. The mystical glowing orbs in the *Equivalents* have become toy planets, glinting in the sun, while the fun palette of the tourist brochure has replaced Stieglitz's somber grays. Once one has contemplated the Baldessari portfolio in this light, the *Equivalents* never look quite the same.

Throwing Three Balls also lampoons the latent sexual content of the cloud pictures. If Stieglitz was willing to exhibit and exalt the private parts of O'Keeffe, then Baldessari was going to elevate his balls for public display.[34] Jasper Johns had used a similar gambit in his *Painting With Two Balls* of 1960 to critique the swagger of abstract expressionism. The sexual puns of *Throwing Three Balls* seem directed instead at the sexist games of Duchamp (playing chess with a naked woman), Klein (using the bodies of naked women as paint applicators), and Stieglitz (reveling in O'Keeffe's naked anatomy).[35] Baldessari's acknowledgment that his wife took the photographs for *Throwing Three Balls,* however, introduces its own problem of sexual politics. A game for two players has ended up as a work signed by the one with balls.

Baldessari's critical reworking of the *Equivalents* informs his *Choosing* series as well. Stieglitz in the *Equivalents* conspicuously reduces selection to a kind of pointing by directing his camera at one patch of cloudy sky and not another. In the *Choosing* series, Baldessari takes selection to a meta level by photographing the act of pointing, which selects a vegetable to be photographed again in other company. By representing this process, he puts the hidden structure of photography on display. The camera has historically been, as the scholar Walter Benn Michaels puts it, "a tool of choosing."[36]

Figure 9.6 Alfred Stieglitz, *Equivalent*, 1930, gelatin silver print. Courtesy of George Eastman House, International Museum of Photography and Film

Baldessari reduces this process of selection to a regressive game. The mutely pointing hand in each image brings out the inarticulate "that" of photography, reminding us that selection with the camera does not require language and can seem a rudimentary act.[37] The unconscious reflexes of the photographer, celebrated by much writing on modernist photography for

300

their transcendental import, become in the *Choosing* series mere whim. Baldessari's disclosure of photographic structure in the series extends to the process of selecting among photographs after they are taken. By following a sequence of instances in which the vegetables not chosen are replaced with others, the camera records a process of surprise and selection analogous to that which characterizes the sorting phase of snapshot photography.[38]

Baldessari in other work took up the *Equivalents* again with both admiration and satire. In three series from 1972–1973, he made photographs that combine cigar smoke and pictures of clouds (Figure 9.7).[39] By seeking to match a photograph of a cloud with a plume of cigar smoke, he approached the old problem that had occupied Stieglitz at the end of his career, namely, the equivalence of external and internal. In Baldessari's series, this mystical equation becomes nothing but a formal resemblance, the morphological similarity of one wispy vapor in a photograph to another.[40] Like the semiotician Ferdinand de Saussure, who in the early twentieth century shifted attention from the bond between signifier and signified to the differences among signifiers, Baldessari flattens equivalence into a register of photographic form. The externalization of the artist's interior proves to be only a smelly exhalation, drawn from a comic symbol of the artist's phallic power. The virtuosity of Stieglitz becomes the uncontrollable dispersion of a discharged gas. The suggestive equation of cigarette and creative anguish in Holmes's celebrated photograph of Pollock, that master of chance, is mercilessly lampooned. In Baldessari's critique, the Romantic gambit of seeking the ineffable in vapor, one might say, goes up in smoke.

But more than critique is at work in Baldessari's obsessive return to the play between vapors. Comical as this play is, the smoke signifies his internalization of the principle of chance that Stieglitz encountered in the sky. That which corresponds in Baldessari to the cloud is not a profound feeling but rather a restless mode of spontaneity, an ephemeral pleasure, which circulates or is absorbed. Given his interest in boredom, it is significant that he "expresses" this internal equivalence while sitting around smoking cigars. He has said: "I guess the boredom part of me is something genetic. It's like having a disease you have to contain all your life. You just have to get to your studio every day and do nothing but sweep up. And eventually you will get bored. And you will try not to get bored. And that's the beginning of creativity."[41] Smoking, long associated with both boredom and creativity, is here the source of equivalence between the restlessness of the sky

Figure 9.7 John Baldessari, *Cigar Smoke to Match Clouds That Are Different (by Memory—Front View),* 1972–1973. Color photographs, 3 photographs, 14×9 ¾" each (detail). Courtesy of John Baldessari

and the dumb need to make art.[42] Baldessari takes a wry view of the Romantic predilection for vapor, but he also plays along.

Stieglitz was not the only master of modern photography that Baldessari ribbed. Edward Weston was another. When Baldessari was making his photographs of rhubarb, carrots, onions, and green beans, he could hardly have been oblivious to what was then perhaps the most celebrated American modernist photograph, Weston's *Pepper No. 3*. In his daybooks, Weston wrote with more than a little anguish about his process of selection and the way others interpreted it. He reported in one entry:

> More echoes from my exhibit: objections because I had made peppers into something they were not,—whether in this case phallic symbols entered in I don't know, but I hope some new note was struck—one wearies—Because I chose unusually strong and beautiful peppers to photograph—and why not—because I see more than a housewife who picks commonplace peppers for stuffing,—so I have in some way violated these poor peppers!"[43]

In this passage, Weston struggles with several issues addressed in Baldessari's *Choosing* series, including the problem of selection in modernism, the phallic narcissism that it may entail, and the fear that aesthetic taste and consumer preference had become one. If *Throwing Three Balls* and the *Cigar Smoke to Match Clouds* series took the symbolist gas out of Stieglitz's skies, then the *Choosing* series took the mystical redemption of natural form out of Weston's peppers. Unlike the single pepper set off in the funnel and transformed into a symbol of organic unity, Baldessari's green beans and stalks of rhubarb remain ordinary vegetables plucked randomly from the stream of commerce.

Although *Throwing Three Balls* is ostensibly about elevation, it is riddled with signs of descent. Juggling has long been a metaphor for meretricious art that impresses only those lacking proper judgment. Reynolds assures us that the well-grounded painter "is free from the painful suspicions of a juggler, who lives in perpetual fear lest his trick should be discovered."[44] "We forget," warns Roger Fry in a similar vein, "that an attitude which is perfectly justified before a juggler or an acrobat is entirely irrelevant before an artist."[45] In *Throwing Three Balls,* even the lowbrow artistry of juggling has been deskilled, resulting in a haphazard toss. The images in the series thus mix delight with the undoing of arty magic. "After a while," Baldessari has said, "you learn all the tricks of how to make things beautiful and you get

really suspicious. You look at art like a professional gambler looks at a card game, for all the tricks."[46]

Although Baldessari's aerial play in *Throwing Three Balls* ostensibly liberates the artist from the burden of anguished solitude and the tricks of his trade, that liberation entails a surrender of authority.[47] Freedom, as a 1969 song had it, is just another word for nothing left to lose. Chance offers an opening from rule and routine but remains radically indifferent to anyone who enlists it. Duchamp confidently referred to "my chance," but that claim to possession was dubious. Chance offers a way out of confinement but also out of subjectivity altogether. Whereas Klein had offered his body to Shunk and Kender, Baldessari—punning on his name—gave them only a ball. By identifying with the objects of chance, Baldessari modeled a subjectivity unfettered but on the brink of erasure.

The regression of *Throwing Three Balls* has a historical resonance peculiar to the moment of its making. The substitution of thrown balls for a constellation of celestial orbs partakes of the playful leveling of Pop (as the lyric of a 1966 song had it, "the morning sun is shining like a red rubber ball"). At the height of the Apollo era, such a reduction of the celestial blazed a quick path to satire. The imagery of *Throwing Three Balls* recalls the "Dawn of Man" sequence in Stanley Kubrick's *2001: A Space Odyssey* (1968). In that sequence, the apes encounter a black rectangular cuboid jutting up from the earth and momentarily aligned with sun and moon (three objects making a straight line). The leader of the apes (Moonwatcher, in Arthur C. Clark's novel) then uses a bone as a tool, smashing the skeletal remains of an antelope, to the portentous brass and drums of Richard Strauss's *Also Sprach Zarathustra*. From a low angle, we see the ape in slow motion crush the skull repeatedly, the repetition a sign both of the ape's orgiastic pleasure and—because some of the repetitions are of the very same action—of the mechanical reproduction of film. The scene depicts an evolutionary leap, but it also functions as a spoof of uncomprehending hostility to modern art. The apes screech and paw at the minimalist black monolith, and afterward their leader engages in a fit of gratuitous violence. In the skeleton-smashing sequence, Kubrick intercuts a tapir falling to the ground, adumbrating the use of the tool as a weapon and indicating that the bone smashing is a kind of repetitive, preparatory play. After demolishing the skeleton, the ape tosses the bone/tool into the air, where it tumbles in slow motion against the sky, before being replaced in a match cut by a similarly shaped spacecraft floating in darkness.

In *Throwing Three Balls,* Baldessari brings regressive play and projectiles together in a related but distinct way. Evacuating Kubrick's grand metaphors and momentous score, he leaves play to stand on its own, preparatory of nothing, except—quite literally—the chancy and repetitive process of mechanical reproduction. Whereas for Kubrick the thrown bone finds its historical necessity in the satellite, for Baldessari the balls have only their accidental arrangements and gleaming rotundity to recommend them. They are as much atoms as planets, set adrift from particular reference, freed from the work of allegory. They have become a pointless trick. Mimicking the agency that the artist has lost or surrendered, they form a hanging sculpture, suspended by the momentary click of the shutter. The philosopher and naturalist Karl Groos notes in his discussion of play among primates: "The next step, and one which monkeys cannot attain, is the fashioning of the projectile into a work of art."[48] Through mechanical reproduction, which "apes" traditional skill, Baldessari and his balls succeed where the monkeys fail, even while giving the work of art the monkey business.[49]

Although Baldessari followed Duchamp in enlisting chance to escape the dead end of expressive taste, he was highly responsive in *Throwing Three Balls* to the ways in which the significance of chance had changed since the making of *Three Standard Stoppages.* The emergence of the military-industrial complex after the war had given randomness a new role as an input in modeling of various kinds. By using chance to simulate the social practice of everyday photography, Baldessari participated in a broad social turn of the Cold War era. Just as Talbot, Cameron, Stieglitz, and Sommer had done before him, Baldessari found aesthetic possibility in a new historical meaning of chance.

By the early 1970s, randomized simulation had become a vital instrument of research in numerous fields. To model complex systems and forecast their future development, experts devised games and simulations using chance to represent uncertainty. The initial motive was to prepare for war, from the global theater to the subatomic activity that provided its most lethal threat. Drawing upon innovations in computers, operations research, and game theory, Cold War experts grappled with how to configure, on a manageable scale, models of complex natural and social phenomena.[50] The paradigmatic publication emerging from this initiative was John von Neumann and Oskar Morgenstern's *Theory of Games and Economic Behavior* (1944). Immediately following the war, von Neumann, Enrico Fermi, and others, in the effort to design the hydrogen bomb, developed the Monte

Carlo method, which simulated stochastic processes too complex to calculate in their analytic entirety.[51] As Peter Galison has observed, "Physicists and engineers soon raised the Monte Carlo above the lowly status of a mere numerical calculation scheme; it came to constitute an alternate reality—in some cases a preferred one—in which 'experimentation' could be conducted."[52] Fueled by random numbers, Monte Carlo simulations became a central mode of inquiry within the military-industrial complex that emerged from the Second World War. To generate and meet demand for such simulations, the RAND Corporation in 1955 produced a book entitled *A Million Random Digits with 100,000 Normal Deviates*. This compact supply of random numbers served various Cold War purposes, from simulations of fission to opinion polling, state lotteries, and encryption. In these unprecedented ways, the military-industrial complex instrumentalized chance during the early years of the Cold War.

Advocates for simulation claimed that the complexity of modern systems put them beyond the ambit of direct experience, and that only models and scenarios could foster the necessary expertise. As Sharon Ghamari-Tabrizi has written, the "analysts at the RAND Corporation argued that working through the steps of a simulation was the only way to acquire insight and skill in operations pertaining to nuclear war."[53] The speed of technological and social change also drove the turn to simulation. Some experts claimed that the future was coming so fast that only with hypothetical experience could they keep pace. Simulation was also a way for specialists in military strategy without field experience to claim superior expertise. As Herman Kahn, the most famous (and infamous) of the RAND systems theorists, put it, "The kind of policy research we are concerned with . . . emphasizes attempts to derive substitutes for 'relevant knowledge, experience, judgment, perception, insight and intuition.' It tends to rely heavily on such things as empirical research and analysis, and simple theory; metaphors and historical analogues; analytic models . . . propaedeutic and heuristic methodologies and paradigms; scenarios, gaming, and other use of 'arbitrary' specifications and stimulation."[54] In some industries, the training of personnel to use certain technologies could be done more cheaply and safely using simulation (for example, flight simulators).

Hypothetical scenarios that provided "substitutes" for lived experience had to be unpredictable, making randomization requisite. Those who mastered Monte Carlo methods could boast an advanced and highly technical form of expertise. In the 1950s, as Ghamari-Tabrizi has observed, "the

avant-garde among the military and their consultants determinedly arrogated authority for strategic planning from the lived experience of senior officers to the civilian virtuosi of the techniques of Monte Carlo, systems analysis, operational war-gaming, man-machine studies, and other innovations in simulating combat operations."[55] Simulating modern warfare became a major enterprise at RAND, which conducted four intricate war games in 1955–1956, the last of which lasted four weeks and occupied twenty analysts.[56]

Although game theory did not always require chance (the famous "prisoner's dilemma" game scenario, for example, has none), the predispositions and challenges of the Cold War era ensured that it would be introduced. In a series of articles published in 1967–1968, John Harsanyi analyzed games in which players had incomplete information. These "Bayesian games" used chance to represent a quantified uncertainty (they were named after Thomas Bayes, who first put to formula how relevant information should make one change a probabilistic degree of belief). These games productively complicated models of economic behavior, which had routinely been premised on dubious assumptions of complete information.[57]

RAND and other defense contractors specializing in systems analysis soon realized the economic advantages of marketing their approaches beyond the military and began to place articles in professional journals of urban planning and public policy.[58] The use of games and simulations as research and heuristic devices eventually spread to the social sciences and education at all levels. In the 1960s and early 1970s, thousands of government officials, researchers, teachers, and students in America participated in elaborate games modeling social dynamics of various kinds, such as the future of cities, under an unpredictable array of scenarios. James Coleman, a sociologist at Johns Hopkins, produced a simulation game, *Ghetto*, which modeled inner city life.[59] As Jennifer Light has observed, such urban simulation games "exploded in popularity in the second half of the 1960s."[60] Proponents such as Coleman claimed that games were a new mode of knowledge production responsive to the greater speed and complexity of modern society.

The early 1970s were particularly dynamic years for gaming as a mode of practical inquiry. In 1970, Sage began publishing the journal *Simulation and Games*. In the same year, the International Simulation and Gaming Association was formed in Germany; in 1973 it first met jointly with its American counterpart, the National Gaming Council. In *Gaming: The*

Future's Language (1974), Richard Duke, then a professor at the University of Michigan, discussed the "explosive" recent growth rate in gaming and simulation in the social sciences.[61] For Duke, gaming was "the future's language," a new form of communication that allowed the citizen, the scholar, and the policy maker to formulate and test hypothetical scenarios. In his view, gaming provided a gestalt mode of communication that operated more efficiently than the linear chains of sounds or marks of ordinary language.

For Clark Abt, who worked in the late 1950s and early 1960s on computer simulations of missile defense systems, games offered a new and better social form. In *Serious Games* (1970), Abt advocated the use of games in the solving of social ills. According to him, games provided a means of overcoming the modern split between thought and action, and that between the public and the private. He wrote, "It seems to be merely a matter of time before the principles of serious gaming analyzed in this book and used for problem-solving on the largest scale coincide with the same interactive techniques already used on the much smaller scale of individual problem-solving and analysis. If this day arrives, we will be closer to the classical ideal of life—in which thought and action, individuation and participation, are combined in the same activities. Once again citizens will be able to participate in social decision-making."[62]

The utopianism that Duke and Abt associated with the use of games and simulations as methods of creating and applying human knowledge is a neglected dimension of the Sixties. Along with music festivals, paperback books, and protest marches, gaming was an integral part of the civic, intellectual, and social life surrounding American colleges and universities. Much of a generation of elementary, junior high, and high school students took part in gaming simulations to develop a better understanding of social problems and possible remedies. For its advocates, gaming could be a model, in the sense of a miniature representation or prototype, for social dynamics, but it could also be a model, in the sense of an ideal form, for sociality itself.

The example of Abt, who shifted the focus of his gaming acumen from missile defense systems to social problems, suggests how fluid and unstable the politics of gaming were. Ghamari-Tabrizi characterizes the RAND gamesters as "a sort of modernist *avant garde*," because their collective work "was self-consciously exploratory, inventive and opposed to the

tradition-bound habits of the veteran military corps."[63] The RAND analysts spurned tradition and emphasized spontaneity and makeshift resourcefulness (the first System Research Laboratory was in the back of the Santa Monica Billiard Room).[64] Like Steve Jobs donning gallery black, the RAND analysts used their California location as a way to mix organizational ambition with signs of hipness. Long-haired college professors and Cold Warriors both used games to model the behavior of complex systems.[65]

Southern California, where Baldessari lived and worked, was a center of the military-industrial complex committed to Monte Carlo simulation. San Diego County, where he grew up, contained military bases and much defense manufacturing, and RAND had its headquarters up the coast, in Santa Monica.[66] The economy in which Baldessari made his art was saturated with Cold War anxieties about keeping pace with accelerating rates of technological and social change. These anxieties pushed experience toward the hypothetical and the simulated, where uncertainty could be modeled by randomization. For the analysts at RAND, chance was not a matter of mystery, the unconscious, or spontaneity; it was an instrumentally harnessed uncertainty, a raw material of simulations, a key input to their analysis of complex systems.

Baldessari incisively reproduced this leading social logic of his day to move art and photography forward. At the time, the principal efforts of art museums to make photography into a modernist medium were defining its limits visually. Surprise juxtapositions, dynamic truncations, and stark social confrontations had been deemed to belong to photography by dint of its essential nature. Baldessari knew this to be hogwash. If photography had an internal logic, it was to be found in its structure as an everyday social practice. To bring that structure into representation, *Throwing Three Balls* offers a simulation: throw three balls in the air to get (a photograph of) a straight line, choosing the best of thirty-six attempts. This was the formula of snapshot photography stripped down. By representing photography in a way that structurally mimicked Cold War methods of modeling, Baldessari broadened the reach of his critique. This broadening enabled his satire to strike multiple targets: it lampoons photography and taste by distilling their rules and procedures to a dumb game, while making this distillation itself appear absurd. It oscillates between being an insightful model that holds photography and taste up to ridicule and an overly reductive one that calls the epistemological efficacy of simulation into question. The

space-age resonance of Baldessari's orbs in the sky clinches the Cold War implications of his critique. There is a madness to his method, and that madness belonged to the establishment against which his generation rebelled.

The brilliance of *Throwing Three Balls* lay in the correspondence between its use of randomized simulation as a mode of inquiry and the chancy practice of photography it modeled. In the nineteenth century, photography and statistical reasoning had emerged into a modern world newly receptive to the powers of chance, and by the 1970s chance had become a standard input into systems of cultural or knowledge production. Like Protogenes, Baldessari had found in chance a way to align method and subject, and thereby escape the restraints of inherited dogma. This correspondence enabled him to rebelliously spoof both a flourishing bureaucratic mode of inquiry and the medium that had overtaken painting.

Conclusion

Photography changed what pictures could be. Marking by hand, whether with brush, pencil, crayon, or burin, was a deliberate process that melded design and duration to build up an image. Whether a picture made by hand was innovative or conventional, it bore the measure of the artist making it, and located itself in relation to tradition. With photography, light could be invited into a dark box to make representations automatically. Although the optics of the camera were engineered to preserve academic conventions of framing and perspective, the process remained marvelous and strange. Accidental compositions were snatched at whim, a pail of slop received the same attention as a barrister, and every image was subject to light bouncing capriciously off a restless world. Artists and critics fretted about the implications for art of this new technology. Like many other modern contraptions, photography promised to save labor, but the labor it promised to save in the making of pictures had been exalted as a definitive human capacity, even a means of bridging heaven and earth. How could a mechanical process prone to accident serve in its stead?

In the nineteenth century, the trouble photography brought to art echoed that which modern science was bringing to traditional belief. In a world saturated with divine will such as earlier generations had contemplated, photographs might have seemed pointless in their mechanical indifference. But while William Henry Fox Talbot and Louis-Jacques-Mandé Daguerre experimented with photography, modern thinkers were doubting the role of God in the course of events and substituting a natural history every bit as uncaring and prone to accident as a photographic plate. The incremental

reaction of a silver emulsion to light, like the subtle processes of shoreline erosion or species mutation as imagined by modern science, happened automatically, subject to chance and heedless of human concern. Like those processes, photography could produce, with a bit of luck, the effect of design without actual intent. If Victorians thought that photographs were like the world, it was because they were making the world into something like photography.

The Victorian plunge into more or less orderly aggregates of atomized actions extended to the management of society at large. While hope was placed in an invisible hand that might advance human welfare on the whole, the modern market spawned a chaos of particulars. For the individual under capitalism, life was a gamble. One year after photography had arrived in the world, Alexis de Tocqueville wrote of America: "When everyone is constantly striving to change his position; when an immense field for competition is thrown open to all; when wealth is amassed or dissipated in the shortest possible space of time amidst the turmoil of democracy,—visions of sudden and easy fortunes, of great possessions easily won and lost, of chance under all its forms, haunt the mind."[1] Photography, a favorite tool of capitalism, found itself haunted by chance from the start. Employing its own invisible hand, it offered practitioners the stimulation of chance and the hope that over time they might obtain an acceptable measure of success. But for those wishing to turn photographs into compelling or difficult statements, chance threatened to divert the communicative channel or clog it with a welter of gibberish.

The stakes for photographic art were therefore high. Victorians found themselves split between aesthetic aspiration and mechanical process, human meaning and arbitrary fact, arduous virtue and easy money. The making of photography into art might help the culture cohere. The challenge, however, was considerable. The chancy nature of the medium gave it a modern feel but cast doubt on its aesthetic potential. The promise of good returns in the aggregate was a statistical value that did not migrate readily to non-quantitative pursuits. Meaning was not traditionally understood as the net sum of bad pictures and good. The challenge was finding a way for chance and indifference to work on behalf of art instead of against it. According to academic tradition, nature held matter in a fallen state, and the burden of the artist was to discern the ideals hidden within the happenstance of encountered forms. The most brilliant of Victorian photographers, including Talbot, Julia Margaret Cameron, and Alfred Stieglitz, found ways to counter

this doctrinal denigration of chance. By affirming the value of serendipity, human imperfection, and material spontaneity, they introduced modern forms of opportunism and enlivenment. By concentrating their efforts on the book, the album, or the series, they found a way to substitute selection and arrangement for simple accumulation. Carving out a cunning role for chance, they refashioned aesthetic principles for photography and suggested new avenues for art.

Talbot proposed that a combination of accident and aesthetic sensitivity might compensate for a loss of skilled labor. Harnessing a naturalism surging in the fine arts prior to photography's arrival, he imagined that his apparatus, if governed by an attuned eye, could take artful compositions directly from nature. His approach had a surprising parallel in the emergent field of modern statistics. Rather than working up from first principles and lawful causes, empirical thinkers of Talbot's generation had begun to look for regularity in the quantifiable aggregates offered by the world. While theologians worried about the comprehensiveness of God's designs, statisticians were sampling natural and social phenomena and finding unexpected order. The photographic camera was a kind of sampling mechanism for pictorial matter, and surprising bits of information, Talbot observed, cropped up in the results. Both before and after the photograph was taken, he argued, the eye could stumble upon unintended pockets of significant form.

By the 1860s, photography had become an industry, and industry had become a pervasive Victorian worry. Could human sensibility survive mechanization? Was virtue obsolete? While Victorians obsessed about gambling and the spread of its amoral principles into the economy at large, a financially troubled Cameron speculated in photography as art. She addressed anxieties about the mechanical turn of her era by affirming that photography could bear the impress of passion and fallibility. She welcomed accident into her practice to mix human verve and chemical agency, and to mark her pictures with signs of vigorous social exchange. From her colonial past, she was keenly aware that culture, like photography, was a mode of replication. This insight enabled her to plumb widespread worries that the Victorian culture being defended against mechanization was itself mechanical. The glitches she accommodated spoke to the inevitable shortfall when culture is performed in the image of a traditional ideal. "Nine English traditions out of ten," an elderly Oxford Don remarks in a 1951 novel by C. P. Snow, "date from the latter half of the nineteenth century."[2]

Cameron allowed the accidents of reproduction to put both that process of invention and its costs on display.

The pictorialist generation that followed vested hopes for making photographic art in misty rural imaginings. They asked vapor, which had long served as a limit on the controlling order of perspectival representation, to curb the mechanical severity of their apparatus. By establishing a correspondence between softening techniques and atmospheric moisture, they sought to transmute photography through a natural resonance. But the predictable sentimentality of the results often undermined the poetic mutability that the atmospheric effects were purported to secure. In search of a more modern form of pictorialism, Stieglitz took a handheld camera into the vaporous streets of New York. By producing lantern slides, he represented the city via the particulate beam of a projector as well as the atmospheric radiance of his images, taking his audience doubly through modernity's magical and unsettling dispersals. Emerging from this evanescence, the workers he photographed took on an everyday monumentality that revived Baudelaire's dream of making a modern art worthy of antiquity. The ephemeral vapors enfolding these workers spoke both to the fleeting quality of urban experience and to the precarious circumstances of their labor. By using these vapors to depict the material transformation of the city, Stieglitz brought his mobile practice into dialogue with the historical conditions of its emergence, achieving a critical reflexivity that would characterize the best modernist photography to follow.

Social and technological changes between the world wars accelerated the use of photography in journalism, which placed a premium on geographic venturing and eye-catching revelation. Informed by the advent of psychoanalysis and modernist primitivism, this journalistic mode fostered an understanding of photography as a way to snatch unconscious meaning from the varied flow of modern experience. Epiphany was ostensibly delivered in the unexpected elegance and evocative conjunctions of everyday forms. Over time, the notion of the photographer as a seer roaming the land to distill its contoured truths took hold in American photography. In his photographs of 1938–1945, Frederick Sommer used wartime pressures to analyze and contest this regime. By slowing down the metabolism of photography through decomposition, he made strangely beautiful pictures that refused the exaltation of purity and enclosure that rendered much modernist work complicit with the commerce it sought to transcend.

After the war, the art world, which had barely acknowledged photography, gradually embraced it as a medium. To contain and legitimate photography as an art form, institutional gatekeepers suppressed its traffic in chance and therefore also the very doubts that had driven some of the best practices of prior eras. Working ahead of the curve, John Baldessari recognized this suppression and playfully critiqued it. In work such as *Throwing Three Balls in the Air to Get a Straight Line (Best of Thirty-Six Attempts)*, he made photography isolate its structure as a social practice, putting on display its peculiar reliance on chance and selection. By fashioning his inquiry as a randomized simulation, he ingeniously explored the correspondence between photography and a leading research method of his day. He thus carried forward the challenge of making the unpredictability of photography address the evolving state of chance in society at large.

These practitioners all understood that the question of whether photography could be art was inseparable from the question of what art could be in an age of photography.[3] When Duchamp offered up a urinal as a work of art in 1917, he was harnessing the aesthetic logic of the camera. As Talbot had insisted, photography could seize art ready-made from the world, reproducing the chimney pot and the Apollo of Belvedere with equal ease and care. It was this very opportunism and impartiality that Duchamp exercised to scandalous effect. To offer the machined contours of a porcelain urinal as the sculpted curves of a fountain was to adopt photography's indifferent and serendipitous terms. The fact that Duchamp's "fountain" was lost and passed into history as Stieglitz's photograph of it gave the work a perfect legacy. The "fountain" was, in a sense, always a photograph.[4] This modernist episode was a threshold moment in a long and unsteady convergence between art and mechanical reproduction. Each of the five practitioners featured in this book gauged the closing gap and inventively located their work within it.

However hostile photography was to modernism, modernism proved to be a rousing culture for making photographic art. The featured practitioners made exceptional work by contending with the basic structure and limits of photography as a material and social practice. This critical engagement was never keener than in the early experiments of Talbot and the serial games of Baldessari. In Talbot's *The Open Door* and Baldessari's *Throwing Three Balls*, the fundamental substitution of automaticity for handiwork comes into view. Both the forsaken broom and the tossed balls speak to the withdrawal of manual labor and to the ambiguous implications

of its absence for human creativity. Talbot's open door invites us into a shadowy future where modern science will obviate the need for drudgery. His text implies that this future will reserve creativity for the eye and exploit the power of superior vision to direct the workings of an invisible hand. Chance in this new regime will be an engine of compositional possibility, and photographic art a matter of taste and decisiveness. Baldessari arrived at the other end of the analog era to find that Talbot's photographic serendipity had become the structuring principle of a broad and entrenched system of pictorial production. Thirty-six frames on a standard roll of film allowed the ordinary photographer to take his chances with the snapshot, hoping for moments when the configured forms aligned with conventional taste. This gamble was the work of leisure, an obligatory supplement to everyday labor. By bringing this play of chance to light, Baldessari elevated critique to a spare structural beauty.

In the more-than-a-century span between Talbot and Baldessari, a series of modernist practitioners made art from photography through an alchemy of dry optics and wet chemistry. From the drips and stains of Cameron's portraits and literary scenes to the asphalt vapors of Stieglitz's New York streets and the gleaming chicken innards that Sommer depicted, these artists found ways to sustain the liquid spontaneity of photographic process in the dry print of the photographic product. In their work, the singularity of chance erupts within an indifferent image to envelop us in a circuit of exchange, a moment of labor, or a restless gaze. Their photographs, however much they deliver traces of the dead or inanimate, uncannily assert their own fluid presence.

An important lesson to draw from this history is the often constrained significance of photographs unbound by editorial structure or persistent practice. Due to its openness to chance, photography has tended to rely heavily for its meaning on efforts to select, size, print, sequence, arrange, and contextualize pictures. More subtly, the work of a practitioner or collective can transmit an evolving intelligence over time to hone and reinforce the impressions that a single image might impart. If underwritten by editorial structure or the logic of such a practice, photographs can brim with meaning. Absent either of these, a photograph, no matter how evocative, remains a communication very much haunted by chance. Most photography curators and issuers of photographic publications have been loath to acknowledge this state of affairs. Exhibitions and books abound that carelessly mix images from utterly dissimilar practices or offer a jumble from a

single undisciplined one. One hopes that the future might bring more public attention to how photography as art really works.

So where is the historical conversation binding photography, chance, and art today? At first blush, the times seem grim for chance. Digital technologies offer endless new ways to master the photograph. Although the click of the digital camera may still sample the visual field in an unpredictable manner, elements can easily be added, subtracted, filtered, adjusted, or rearranged after the fact. The latest technologies extend sampling so far that even the focus of the image can be determined after the sensor has been exposed. Moreover, many practitioners are pursuing mastery over the image by other means. In the late 1970s—before digital processes were commercially introduced—leading photographic artists began to stage scenes before the camera.[5] Artists such as Cindy Sherman and Jeff Wall subjected the scenes they recorded to meticulous orchestration, alluding to the effect of chance only through a kind of quotation. The combination of staging and photographic manipulation now in vogue sets much ambitious photography directly against the paradigm of the hunter of dreams. In contemporary photographic art, determinism has returned.

Chance in many respects has lost its grip on everyday photography as well. The so-called selfie, with its staging and posing, is the antithesis of the candid snapshot. More fundamentally, the sheer profusion of photographic imagery threatens to render the hunt for epiphany moot. When all possibilities can occur, chance merges with necessity.[6] The stochastic machine of photography has grown so vast and efficient that every permutation can seem established in advance.

Given the long history of photography and chance working in concert with larger historical shifts, it should come as no surprise that determinism has recently made a resurgence across other domains as well. Using the unprecedented computational power of the digital age, researchers have discovered lawful behavior in much seemingly random phenomena. Fractal geometry has revealed that simple operations can produce an apparently random array of results depending upon the precise set of initial conditions. Popular science writers often cite the course of a billiard ball struck on a table bearing cylindrical obstructions. A slight change in the angle at which the ball is struck produces a radical difference in the ultimate path. Science, in other words, has conquered the fluke. This conquest has implications for many phenomena, such as turbulent flow in fluids and gases. Meteorologist Edward Lorenz, an early user of computers to model changes in weather, discovered

that minute rounding differences in his settings produced wildly varying outcomes in his simulations. This insight formed the basis of chaos theory, which posits that many seemingly random phenomena actually result from mechanistic behavior now subject to tracking with the aid of computers.

The long entwinement of photography, chance, and art may be coming to an end. Daguerre's and Talbot's technologies introduced possible new roles for chance in picture making that the ensuing social practices of photography embraced or shunned. For generations, leading practitioners understood that chance was a problem requiring serious engagement. But as Sherman, Wall, and their many followers have amply demonstrated, photography can be pursued without much chance in the picture. Other dimensions of the medium may press more insistently on artists from now on. If this comes to pass, the entwinement of photography, chance, and art will have shared, more or less, the historical span of modernism. Perhaps chance in photography has functioned as a means of gaining traction on modernity and its commerce, mechanization, and contingency in ways no longer viable or desired.

But we should not close the coffin on chance just yet. As leading artists of Baldessari's generation recognized, much of the mythology attending the magic of chance has been flimsy, built from suppression and inflated rhetoric. The real work of chance has always been harder to execute than most writers on photography have been willing to accept. Whether the recent turn toward pictorial orchestration in photography brings the canonical conversation about chance to a close, or whether chance will come back to contest that turn as a kind of stilted academicism (à la Rejlander), remains to be seen. Either way, emerging artists and curators might wish to account for the deep intelligence of the work described in this book and to consider the possibility that chance remains a critical locus for reflecting on the conditions of human meaning.

If artists revive the conversation about chance in photography, cross-cultural pollination will almost certainly play a role. The history this book recounts has a tight cultural scope, entailing a regrettable neglect of photography outside it that has addressed chance in compelling ways. Those wishing to enrich and diversify this history might begin by looking back to the 1960s and 1970s, when conceptual art became an international movement, and practitioners in various countries used photography to work through problems of chance. To take but one example, the stains and spills in photographs from the 1970s by the Japanese artist Kōji Enokura inci-

Figure C.1 Nicholas Hughes, Untitled #16 (2012), from the series *Aspects of Cosmological Indifference*, chromogenic print. Courtesy of the Nailya Alexander Gallery, New York, and the Photographers' Gallery, London

sively address both the postwar anxiety of Japan and the legacy of ink and other liquids in its traditional art. In their different ways, Enokura and Cameron explored what Wall has termed photography's "liquid intelligence."

Despite the deterministic turn of recent years, there are signs that the history recounted in this book remains vital to photographic art. Contemporary artists have taken up the subject of vapor, grappling anew with Romanticism's passion for its spontaneous agency and unpredictable forms. John Pfahl's photographs of smokestack emissions (his *Smoke* series) and Lisa Oppenheim's two-channel digital video animation of billowing plumes *(Smoke)* are prominent examples. Another is Nicholas Hughes's series of cloud photographs, entitled *Aspects of Cosmological Indifference* (Figure C.1). In a 2013 publication, Hughes reproduced this work with an essay

explaining his concern with atmosphere: "The visual reverie of dust particles rising through the projector beam of a darkened London theatre formed the genesis of this series, an observation of light and matter that offered a glimpse into the formation of the universe itself."[7] Hughes's reflections on dust and creation recall the philosophy of Lucretius, and—because of his particular mention of a projector beam in a darkened London interior—the work of Stieglitz. For it was in London in 1897 that Stieglitz showed his lantern slides of asphalt pavers and steaming horses, a meditation on vapor that would lead to his postcard prints of clouds. For Hughes to take up the cosmological symbolism of dust dancing randomly in a projector beam and link it specifically to cloud imagery is willy-nilly to insist that pictorialism and its symbolist turn in Stieglitz's work once again have something to say about our lived experience of history.

The return to vapor is responsive to two contemporary conditions. One is the enduring use of gas as a metaphor for the material flux of a world without design. Popular science writing on cosmology is a case in point. "Even the most perfect vacuum," the BBC recently reported, "is actually filled by a roiling cloud of particles and antiparticles," and space and time "are churning and frothing into a foam of space-time bubbles."[8] Such language fairly calls for a modern-day Protogenes to reach for his sponge. The second contemporary condition germane to vapor is the emergence of atmosphere as a predominant ecological concern. Ruskin was all too correct when he surmised that industrialization was altering the atmosphere. In the aggregate, the captivating dance of gas molecules is threatening to change our climate to a devastating degree. Vapor—that exemplar of freedom, spontaneity, and romantic mediation—turns out to be a vehicle for an ineluctable mechanical shift in atmospheric chemistry. In the social imagination, the maddening destruction of the atomic blast is losing ground to the maddening effects of CO_2 accretion. The decisive moment is giving way to the cumulative doom.

In his *Aspects of Cosmological Indifference*, Hughes finds in chance a troubling interface between human failing and cosmic disregard. "Whilst we continue to rapidly evolve our resource-dependent lifestyles," he writes, "the Cosmos may well shrug its shoulders—completely indifferent to the mesmerizing mess we make of this planet."[9] If determinism has returned, it has returned via the carelessness of meteorological fact, the simple ratcheting up of carbon in our air. This is material determinism without a deity; all the indifference of a world of chance, yet devoid of the spontaneity that chance once promised. Hughes wagers that photography remains

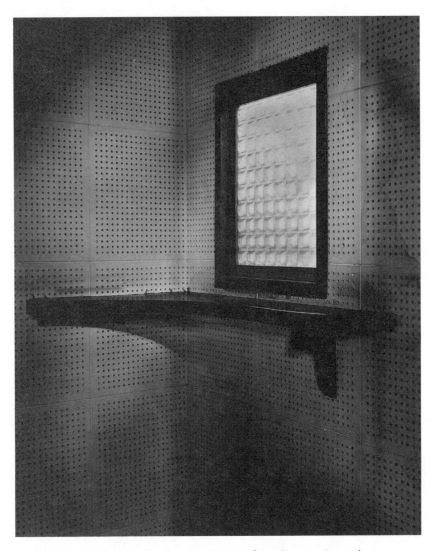

Figure C.2 S. Billie Mandle, *Saint Rocco* (2011), from the series *Reconciliation*, archival pigment print. Courtesy of the artist

a particularly appropriate means for representing this cosmic indifference and the atmospheric betrayals of modern life.

Chance also figures in contemporary practice in the form of accidental traces of our humanity. In a series of photographs of compartments for penitents in confessionals, the artist S. Billie Mandle has constructed a meditation on the human aspiration for forgiveness (Figure C.2). Because a

Figure C.3 Joseph J. Allen, *Wita Tanka* (Pike Island, MN), 2008, from *Dakota Sites Series*, c-print. Courtesy of the artist

photograph records a past moment of light, it has a special relationship to what remains. To make the photographs in her series, Mandle uses a long exposure, allowing light to accrue so that the dim spaces she depicts can register vividly on film. Her pictures bring out the accidental traces left by the penitents who came to shed their sins. Scuff marks, stains, and worn surfaces speak evocatively of the burdens they carried into these cramped compartments, and their wish to exchange contrition for absolution. By both offering a secular peek into the persistence of religious ritual and associating accidental traces with redemption, the series addresses problems of belief that photography as art has negotiated since Talbot.

Material accidents of photographic process such as Cameron once used to such rich and profound effect evidently also still bear some potential for meaning. An appreciation for such accidents—or at least the look of them—is by no means uncommon today. Indeed, the widespread taste for so-called lo-fi (low-fidelity) photography has become heavily commercialized in a manner that echoes the nostalgia industry of pictorialism in the 1880s and 1890s. Quite a number of practitioners have developed a fondness for unreliable processes or equipment, such as the medium-format Holga camera, a cheap plastic device known for its susceptibility to light leaks, blurs, and various forms of distortion. Whereas Cameron's embrace of ac-

cident was unruly and transgressive, the current cult value of accident has the structure of a fad.

But just as pictorialism had its redeeming moments in the right hands, some practitioners taking up the lo-fi aesthetic are producing serious art. For example, the Lakota/Ojibwe photographer Joseph J. Allen has used a Holga in making his series of photographs of places in Minnesota of special meaning to Allen and the Dakota people. One of the pictures in the series, *Wita Tanka,* depicts an island at the confluence of the Mississippi and Minnesota Rivers, a sacred origin site for the Dakota (Figure C.3). The picture is a double image that Allen made by advancing his film only partway before making a second exposure. Using a camera prone to accident, Allen thus invited both the look of accident and the play of chance into his production. The result is a picture that suggests a place that is not equivalent to its image, or perhaps a place forever divided between what it means and what it meant, or between what it means to some and what it means to others. The quirky unreality of the image signifies not merely a knowing nostalgic preference for the crude but also a recognition that material imperfection can register a memory of social violence, sacred immanence, and persistent loss. In such a picture, the art of chance continues to do real work.

How these and other instances of contemporary photography engaging chance will accrue or fail to accrue historical significance is a matter of speculation. What is certain is that the turn toward arbitrariness and indifference that accompanied and informed the emergence of photography in the Western pictorial tradition remains a central aspect of much-lived experience in the modern world. For that reason, the intersection of chance and photography may continue to yield art of consequence for years to come.

Notes

Introduction

1. The notion of works speaking for themselves is, among other things, an end run around authorial intention. On the troubles attending any such evasion in literary works, see Steven Knapp and Walter Benn Michaels, "Against Theory," *Critical Inquiry* 8, no. 4 (Summer 1982): 723–742. With respect to photography, the 1980s produced voluminous scholarship articulating the problems arising from interpreting photographs while ignoring the circumstances of their production. For an excellent sample, see Richard Bolton, ed., *The Contest of Meaning* (Cambridge, Mass.: MIT Press, 1989).

2. Marcel Natkin, *Photography and the Art of Seeing* (London: Fountain Press, 1935), 12.

3. Tod Papageorge, "What We Bought," *Yale University Art Gallery Bulletin*, 2001, 90. The book in question is Robert Adams, *What We Bought: The New World (Scenes from the Denver Metropolitan Area), 1970–74* (Hannover: Stiftung Niedersachsen, 1995).

4. Photographic reports must pass through the figuration associated with art to take on their full significance (otherwise their particulars cannot speak to a broader experience or condition), and works of photographic art would be impoverished without the expectation for disclosure associated with photographic reportage (which disposes us to consider how real their figurations may be). Steve Edwards has written of photography: "Proper [i.e., comparatively natural or realistic] images and figured forms require each other to establish their meanings. The proper can seem objective, or as a simple record of raw nature, because it is located at some distance from those forms that are understood to be figured. The figured appears as art, or as an ideal, because it can shine forth against a proper term." Steve Edwards, *The Making of English*

Photography: Allegories (University Park: Pennsylvania State University Press, 2006), 12. On the dichotomy of proper and the figured, see Richard Shiff, "Phototropism (Figuring the Proper)," *Studies in the History of Art* 20 (1989): 161–179.

5. Chance "constitutes a grey area that has evolved greatly over the last 150 years." Denis Lejeune, *The Radical Use of Chance in 20th Century Art* (Amsterdam: Rodopi, 2012), 12. Lejeune offers a smart and concise of history of chance in philosophical thought. Ibid., 27–45.

6. D. M. MacKay, "Contributions to Discussion on Definitions," in C. A. Muses, ed., *Aspects of the Theory of Artificial Intelligence: Proceedings of the International Symposium on Biosimulation* (New York: Plenum Press, 1962), 240.

7. As the philosopher Tim Maudlin has recently put it, a God along the lines described in the book of Genesis "would not create the huge [cosmic] structure that we see, most of it completely irrelevant for life on earth, with the earth in such a seemingly random location, and with humans appearing only after a long and rather random course of evolution." Tim Maudlin, quoted in Gary Gutting, "Modern Cosmology versus God's Creation," *The Stone* (blog), *New York Times,* June 15, 2014.

8. William Blackwood, "New Discovery—Engraving, and Burnet's Cartoons," *Edinburgh Magazine* 45, no. 281 (March 1839): 383.

9. See Peter Harrison, "Adam Smith and the History of the Invisible Hand," *Journal of the History of Ideas* 72, no. 1 (January 2011): 29–49.

10. Adam Smith, *An Inquiry into the Nature and Causes of the Wealth of Nations* (London: T. Nelson and Sons, 1884), 184.

11. On risk and collectivity, my thinking is indebted to Jason Puskar. See Jason Puskar, *Accident Society: Fiction, Collectivity, and the Production of Chance* (Stanford: Stanford University Press, 2012), 23–26. In his book, Puskar argues that American literature produced chance in the late nineteenth and early twentieth centuries. He writes: "The very category of the accident was made up and then used instrumentally and politically to characterize certain events as innocent of design." Ibid., 189. Because photography historically seems to have been produced *by* chance as much as the other way around, this book comes at chance from a different angle.

12. "The principles of justice are chosen behind a veil of ignorance. This ensures that no one is advantaged or disadvantaged in the choice of principles by the outcome of natural chance or the contingency of social circumstances." John Rawls, *A Theory of Justice* (Cambridge, Mass.: Harvard University Press, 1971), 12.

13. See Stephen J. Campbell, "*Fare una Cosa Morta Parer Viva*': Michelangelo, Rosso, and the (Un)Divinity of Art," *Art Bulletin* 84, no. 4 (December 2002): 596.

14. Terry Eagleton, *Culture and the Death of God* (New Haven, Conn.: Yale University Press, 2014), viii.

1. William Henry Fox Talbot and His Picture Machine

1. Pierre Laplace, *A Philosophical Essay on Probabilities,* trans. Frederick Wilson Truscott and Frederick Lincoln Emory (New York: Dover, 1951), 4.

2. Sir John Herschel wrote, citing Augustus De Morgan, "We speak of [chance] as opposed to human certainty, not as opposed to Providential design." Sir John F. W. Herschel, "Quetelet on Probabilities," in *Essays from the Edinburgh and Quarterly Reviews, with Addresses and Other Pieces* (London: Longman, Brown, Green, Longmans, & Roberts, 1857), 373.

3. Laplace, *A Philosophical Essay on Probabilities,* 6.

4. Ian Hacking, *The Taming of Chance* (Cambridge: Cambridge University Press, 1990), 1.

5. Charles Sanders Peirce, "The Doctrine of Necessity Examined," in *Chance, Love, and Logic: Philosophical Essays,* ed. Morris R. Cohen (Lincoln: University of Nebraska Press, 1998), 201.

6. Ibid., 200.

7. This transformation in the understanding of chance was broken and uneven. In the latter part of the nineteenth century and well into the twentieth, there remained many thinkers who continued to believe that, in the words of one, "chance . . . exists not in nature . . . it is merely an expression for our ignorance of the causes in action, and our consequent inability to predict the result, or to bring it about infallibly." W. Stanley Jevons, *The Principles of Science: A Treatise on Logic and Scientific Method* (London: Macmillan, 1874), 225. In 1931, well into the era of quantum mechanics, a patent specialist wrote, "From the strict scientific viewpoint there is no such thing as chance or accident. Every event in nature is strictly predetermined by the events which preceded it. From the viewpoint of a human being, however, with a limited knowledge of all preceding events and with a narrow horizon many things happen which he cannot predict beforehand." Joseph Rossman, *The Psychology of the Inventor: A Study of the Patentee,* rev. ed. (Washington, D.C.: Inventors Publishing, 1931), 117.

8. Thomas Rawson Birks, *Oration on the Analogy of Mathematical and Moral Certainty* (Cambridge: Cambridge University Press, 1834), 2.

9. A vital source of information on Talbot, Herschel, and the early years of English photography is Larry J. Schaaf, *Out of the Shadows: Herschel, Talbot, and the Invention of Photography* (New Haven, Conn.: Yale University Press, 1992).

10. Sir John Herschel first suggested the terms *positive* and *negative* for these different states of the photographic image. Sir John Herschel, "On the Chemical Action of the Rays of the Solar Spectrum on Preparations of Silver and Other Substances, Both Metallic and Non-Metallic; and On Some Photographic Processes," *Philosophical Transactions of the Royal Society of London* 130 (1840): 3.

11. See Schaaf, *Out of the Shadows,* 105. This accidental discovery is related in earlier texts. See, e.g., Rossman, *The Psychology of the Inventor,* 125.

12. Schaaf, *Out of the Shadows,* 62.

13. H. F. Talbot, "On the Nature of Light," *London and Edinburgh Philosophical Magazine and Journal of Science* 7, no. 37 (July–December 1835): 116.

14. Talbot, "Photogenic Drawing," letter to the editor, *Literary Gazette,* no. 1150 (February 2, 1839): 73.

15. On serendipity, see Robert K. Merton and Elinor Barber, *The Travels and Adventures of Serendipity* (Princeton, N.J.: Princeton University Press, 2004), 29. On Talbot and the idea of photography, see Schaaf, *Out of the Shadows,* 37.

16. Merton and Barber, *Serendipity,* 2.

17. These and other instances of accidental discovery are noted in ibid., 42. The history of concern about the role of accident in discovery predates the Victorian era by centuries. Of the telescope Descartes wrote, "To the shame of our sciences, this invention, so useful and so admirable, was found in the first place only through experiment and good fortune." René Descartes, "Optics," in *Discourse on Method, Optics, Geometry, and Meteorology,* trans. Paul J. Olscamp, rev. ed. (Indianapolis, Ind.: Hackett, 2001), 65.

18. Quoted in Merton and Barber, *Serendipity,* 43.

19. William Whewell, *The Philosophy of the Inductive Sciences,* Part 2 (London: J. W. Parker, 1840), 189.

20. Ibid.

21. Herschel to Talbot, April 22, 1839. Quoted in Schaaf, *Out of the Shadows,* 71.

22. H. F. Talbot, "Some Account of the Art of Photogenic Drawing," *London and Edinburgh Philosophical Magazine and Journal of Science* 14 (January–June 1839): 201.

23. On "engineering culture," see Jack Goldstone, "Efflorescence and Economic Growth in World History: Rethinking the 'Rise of the West' and the Industrial Revolution," *Journal of World History* 13, no. 2 (Fall 2002): 371.

24. William Henry Fox Talbot, *The Pencil of Nature* (London: Longman, Brown, Green, & Longmans, 1844–1846), n.p.

25. See Steve Edwards, "The Dialectics of Skill in Talbot's Dream World," *History of Photography* 26, no. 2 (Summer 2002): 113–118.

26. Talbot, "Some Account of the Art of Photogenic Drawing," 199.

27. Talbot was a poor draftsman and, according to his son, "disliked laborious application in beaten paths." Reminiscence by Charles Henry Talbot, November 13, 1879, quoted in Schaaf, *Out of the Shadows,* 11. On his poor draftsmanship, see Edwards, "The Dialectics of Skill," 114.

28. On this relationship, see Helmut Müller-Sievers, *The Cylinder: Kinematics of the Nineteenth Century* (Berkeley: University of California Press, 2012), 13.

29. A. D. Gridley, "Raphael Sanzio," *American Presbyterian Review* 4, n.s., no. 15 (July 1866): 422.

30. As Lorraine Daston and Peter Galison have noted of naturalist illustrations in the eighteenth and early nineteenth centuries: "The reasoned image was authored:

synthesized, typified, idealized by the intellect of the naturalist." Lorraine Daston and Peter Galison, *Objectivity* (New York: Zone Books, 2007), 95.

31. Talbot, *The Pencil of Nature,* text accompanying plate VI. The noun *aesthetic* (from German philosophy) entered general usage in England in the 1830s. See John Steegman, *Victorian Taste: A Study of the Arts and Architecture from 1830 to 1870* (London: Century Hutchinson, 1987; reprint of *Consort of Taste,* 1950), 17–18.

32. The relationship between the picturesque and the found object has drawn much intelligent writing of late. See W. J. T. Mitchell, *What Do Pictures Want? The Lives and Loves of Images* (Chicago: University of Chicago Press, 2005), 111–124. On photography and the picturesque, see James S. Ackerman, "The Photographic Picturesque," *Artibus et Historiae,* no. 48 (2003): 73–94.

33. For a brief and illustrated discussion of Talbot's various broom-in-doorway photographs, see Larry J. Schaaf, *The Photographic Art of William Henry Fox Talbot* (Princeton, N.J.: Princeton University Press, 2000), 30–31. For a discussion of the iconology of the broom in Dutch painting, see E. de Jongh, "The Broom as Signifier: An Iconological Hunch," in *Questions of Meaning: Theme and Motif in Dutch Seventeenth-Century Painting,* trans. and ed. Michael Hoyle (Leiden: Primavera Press, 2000). My thanks to Nanette Salomon for suggesting this source.

34. On this relation, see Edwards, "The Dialectics of Skill," 117.

35. John Moran, "The Relation of Photography to the Fine Arts," *The Philadelphia Photographer* 2, no. 15 (March 1865): 3.

36. I owe my awareness of this passage to Ann Bermingham's fine book on drawing in England. See Ann Bermingham, *Learning to Draw: Studies in the Cultural History of a Polite and Useful Art* (New Haven, Conn.: Yale University Press, 2000), ix.

37. Joshua Reynolds, Discourse XIII, in *Discourses on Art,* ed. Robert R. Wark (New Haven, Conn.: Yale University Press, 1997), 230.

38. Reynolds, Discourse III, in *Discourses on Art,* 52.

39. Ibid., 50.

40. Reynolds, Discourse XI, in *Discourses on Art,* 192.

41. Reynolds, Discourse XIII, in *Discourses on Art,* 237.

42. H. P. Robinson, *The Elements of a Pictorial Photograph* (Bradford: Percy Lund, 1896; reprint, New York: Arno Press, 1973), 33.

43. All quotations are from H. W. Janson, "The 'Image Made by Chance' in Renaissance Thought," *De Artibus Ouscula XL: Essays in Honor of Erwin Panofsky,* ed. Millard Meiss (New York: New York University Press, 1961), 260–261.

44. Joseph Addison, *The Spectator,* No. 414, June 25, 1712, in *The Works of Joseph Addison* (New York: Harper & Brothers, 1837), 2:142.

45. Ann Bermingham, *Landscape and Ideology: The English Rustic Tradition, 1740–1860* (Berkeley: University of California Press, 1986), 13–14.

46. Ibid., 14.

47. Joseph Addison, *The Spectator,* No. 583, August 20, 1714, in *The Works of Joseph Addison,* 2:373. On Addison and gardening, see Mavis Batey, "The Pleasures of the Imagination: Joseph Addison's Influence on Early Landscape Gardens," *Garden History* 33, no. 2 (Autumn 2005): 189–209.

48. Georges Potonniée remarked that Niépce always called his early photographs of outdoor scenes "points de vue." See Georges Potonniée, *The History of the Discovery of Photography* (New York: Tenant and Ward, 1936), 97. For a discussion of this terminology and its implications, see Geoffrey Batchen, *Burning with Desire: The Conception of Photography* (Cambridge, Mass.: MIT Press, 1997), 69–78.

49. John Constable, Lecture IV, "The Decline and Revival of Landscape" (1836), in *John Constable's Discourses,* comp. R. B. Beckett (Ipswich: Suffolk Records Society, 1970), 68.

50. John Constable, "Lecture II: The Establishment of Landscape" (1836), in *John Constable's Discourses,* 57. The two passages indicate the difficulty of Constable's negotiation of the competing values of nature and academic tradition. On this negotiation, see Bermingham, *Landscape and Ideology,* 87–155.

51. Reynolds, Discourse VII, in *Discourses on Art,* 117.

52. Patricia Mainardi has supplied a concise account of this history in France. See Mainardi, "Traditional Rivalries," in *Art and Politics of the Second Empire: The Universal Expositions of 1855 and 1867* (New Haven, Conn.: Yale University Press, 1987), 3–11.

53. On the distinction between liberal and mechanical drawing in the context of scientific illustration see Daston and Galison, *Objectivity,* 84–98.

54. Jevons, *The Principles of Science,* 224.

55. William James Stillman, "Photography as Art," *Photographic Times and American Photographer* (January 2, 1885): 1.

56. Roger Fry, "Mrs. Cameron's Photographs," in *Victorian Photographs of Famous Men and Fair Women by Julia Margaret Cameron,* with introductions by Virginia Woolf and Roger Fry (New York: Harcourt Brace, 1926), 12.

57. Robinson, *The Elements of a Pictorial Photograph,* 33.

58. Talbot, *The Pencil of Nature,* text accompanying plate XIII.

59. A. C. MacIntyre, *The Unconscious: A Conceptual Analysis* (London: Routledge & Kegan Paul, 1958), 41.

60. Ibid., 41.

61. As Daston and Galison have put it, "Scientists admonished *themselves* with the more attentive, more hard-working, more honest instrument." Daston and Galison, *Objectivity,* 139.

62. It was also possible for photographs to disclose details that surprised people familiar with the subject photographed. For example, the critic John Ruskin observes in a letter to his father that he had "found a lot of things in the Daguerreotype that I never had noticed in the place itself." *John Ruskin to Ruskin in Italy: Letters to His*

Parents, 1845, ed. Harold L. Shapiro (Oxford: Clarendon Press, 1972), 225. See also Ian Jeffrey, "Fatal Praise: John Ruskin and the Daguerreotype," in Christopher Newall, ed., *John Ruskin: Artist and Observer* (Ottawa: National Gallery of Canada, 2014), 64–75.

63. On this ambiguity, see Walter Benn Michaels, *The Gold Standard and the Logic of Naturalism: American Literature at the Turn of the Century* (Berkeley: University of California Press, 1988), 236.

64. As Siegfried Kracauer later put it, "from the perspective of memory, photography appears as a jumble that consists partly of garbage." Siegfried Kracauer, "Photography," in *The Mass Ornament,* trans. and ed. Thomas Y. Levin (Cambridge, Mass.: Harvard University Press, 1995), 51.

65. On the Talbot and the "magic" of photography, see Douglas R. Nickel, "Talbot's Natural Magic," *History of Photography* 26, no. 2 (Summer 2002): 132–140.

66. Carol Armstrong has discussed in passing the association in this passage between viewing and reading. See Carol Armstrong, *Scenes in a Library: Reading the Photograph in the Book, 1843–1875* (Cambridge, Mass.: MIT Press, 1998), 460 n. 19.

67. Although *crop* and *click* are very useful as general terms for the spatial and temporal selection that taking a photograph with a camera entails, the term *click* is admittedly anachronistic in the context of early photography employing no shutter mechanism.

68. See William Paley, *Natural Theology: or, Evidences of the Existence and Attributes of the Deity, Collected from the Appearances of Nature* (Philadelphia: John Morgan, 1802), 46.

69. Ibid. Paley frames the early chapters of his treatise by the examples of the watch and the eye. See ibid., 41 ("Every observation which was made, in our first chapter, concerning the watch, may be repeated with strict propriety concerning the eye").

70. The problem of the accidental detail also cropped up in mid-nineteenth-century writing on art. The painter George Watts wrote, "Deformities, pimples, warts, etc., are natural inasmuch as they are formed in existing circumstances as natural consequences of certain conditions; but they have nothing whatever to do with the primary, sublime principles of nature that are based upon perfection and beauty." *The Autobiography and Memoirs of Benjamin Robert Haydon* (1786–1846), ed. Tom Taylor, rev. ed. (London: Peter Davies, 1926), 2:833.

71. Talbot, *The Pencil of Nature.*

72. David Hume, *A Treatise on Human Nature and Dialogues Concerning Natural Religion,* ed. T. H. Green and T. H. Grose (London: Longmans Green, and Co., 1878), 1:424.

73. Ibid., 427.

74. Ibid.

75. Herschel to Gen'l Morrison, November 24, 1853, Royal Society, London.

76. Greenwich time became the standard time of England in 1837. On time and industrialization, see E. P. Thompson, "Time, Work-Discipline, and Industrial Capitalism," *Past and Present* 38 (December 1967): 56–97.

77. Talbot, *The Pencil of Nature.*

78. Herschel to Morrison, November 24, 1853.

79. Reynolds, *Discourses on Art*, xviii.

80. See Thomas L. Hankins, "A 'Large and Graceful Sinuosity': John Herschel's Graphical Method," *Isis* 97 (2006): 605–633.

81. See Gerd Gigerenzer et al., *Empire of Chance: How Probability Changed Science and Everyday Life* (Cambridge: Cambridge University Press, 1989), 1–36, esp. 12–13. See also Lorraine Daston, *Classical Probability in the Enlightenment* (Princeton, N.J.: Princeton University Press, 1988).

82. Hacking, *The Taming of Chance*, 2; Gigerenzer et al., *Empire of Chance*, 40.

83. Gigerenzer et al., *Empire of Chance*, 40–41.

84. Hacking, *Taming of Chance*, 75, translating from E. Lisle, *Du Suicide* (Paris: J. B. Ballière, 1856), 3.

85. Hacking, *Taming of Chance*, 107.

86. Siegfried Kracauer, *Theory of Film: The Redemption of Physical Reality* (New York: Oxford University Press, 1960), 5.

87. See Gigerenzer et al., *Empire of Chance*, 42, and Hacking, *Taming of Chance*, 143–145.

88. Hacking, *Taming of Chance*, 143, translating from Auguste Comte, *Système de politique positive* (Paris: L. Mathias, 1851–1854), 1:381.

89. Hacking, *Taming of Chance*, 144.

90. Hume, however, proposed that "every past experiment may be consider'd a kind of chance." Hume, *A Treatise on Human Nature*, ed. L. A. Selby-Bigge (Oxford: Oxford University Press, 1978), 135.

91. Herschel, "Quetelet on Probabilities," 417.

2. Defining Art against the Mechanical, c. 1860

1. In the early years of photography, the term *fine arts* was relatively new. In the eighteenth century, most writers used the term *polite arts*. See John Steegman, *Victorian Taste: A Study of the Arts and Architecture from 1830 to 1870* (Nelson, 1970), 18–19.

2. A Royal Academy exhibition was held concurrently, and plans were laid for an exhibition of French painting and sculpture near the Crystal Palace, but the government of the Second Republic refused to pay the shipping costs. See Patricia Mainardi, "The Unbuilt Picture Gallery at the 1851 Great Exhibition," *Journal of the Society of Architectural Historians* 45, no. 3 (September 1986): 294–299.

3. Tobin Andrews Sparling, *The Great Exhibition: A Question of Taste* (New Haven, Conn.: Yale Center for British Art, 1982), 40.

4. Elizabeth Gilmore Holt, ed., *The Expanding World of Art, 1874–1902* (New Haven: Yale University Press, 1988), 1:21.

5. In his remarkable book on early English photography, to which this chapter is deeply indebted, Steve Edwards warns against making too much of the use of the term *art* in discussions of photography. "We must understand," he writes, "that when the language of art was first used, it was not employed to claim that photographs were artworks, nor that photographers should be viewed as artists." Steve Edwards, *The Making of English Photography: Allegories* (University Park: Pennsylvania State University Press, 2006), 136. Although I agree that one must remain aware of the range of meanings of the term *art,* as well as the distinction between art and fine art, I am not convinced that the ceiling on the aspirations of early photographers was so low.

6. Quoted in Henri Zerner, "Gustave Le Gray, Heliographer-Artist," in Sylvia Aubenas et al., *Gustave Le Gray, 1820–1884,* ed. Gordon Baldwin (Los Angeles: J. Paul Getty Museum, 2002), 211.

7. Ibid.

8. William Hazlitt, "Fine Arts," in *Encyclopaedia Britannica,* 7th ed., 1838, quoted in "Art and Artists in England," *The Quarterly Review* 62 (June/October 1838): 150.

9. Ibid.

10. Aesthetes in the next generation picked up Hazlitt's line of thinking. Cameron's friend and contemporary George Frederick Watts opined that the paintings of the Old Masters "were in fact copies of reality." *The Autobiography and Memoirs of Benjamin Robert Haydon* (1786–1846), ed. Tom Taylor, rev. ed. (London: Peter Davies, 1926), 2:832–833.

11. "The British Institution, No. II," *The London Magazine,* September 1, 1825, 67.

12. The egalitarian strain of naturalism should not be too hastily linked to the picturesque. In his poem "On Landscape Painting," William Gilpin insists that the picturesque landscape should abide by a hierarchy of attention: "Chuse then some principle commanding theme, / Be it lake, valley, winding stream, cascade, / Castle, or sea-port, and on *that* exhaust / Thy pow'rs, and make to that all else conform." William Gilpin, "On Landscape Painting: A Poem," in *Three Essays: On Picturesque Beauty; on Picturesque Travel; and on Sketching Landscape: To Which Is Added a Poem, on Landscape Painting* (London: R. Blamire, 1792), 7. Constable pushed the envelope.

13. See Jens Jäger, "Discourses of Photography in Mid-Victorian Britain," *History of Photography* 19, no. 4 (Winter 1995): 316–321.

14. "Photography: Its History and Applications," *British Quarterly Review* 44 (July/October 1866), 374.

15. See Edwards, *The Making of English Photography,* 132–134; Joel Snyder, "Res Ipsa Loquitur," in *Things That Talk: Object Lessons from Art and Science,* ed. Lorraine Daston (New York: Zone Books, 2004), 197–204.

16. See Edwards, *The Making of English Photography,* 134.

17. John Lyly, "Sapho and Phao," in *The Complete Works of John Lyly,* ed. R. Warwick Bond (Oxford: Clarendon Press, 1902), 2:387.

18. Joshua Reynolds, Discourse I, in *Discourses on Art,* ed. Robert R. Wark (New Haven, Conn.: Yale University Press, 1997), 18.

19. John Ruskin, "Letter 79: Life Guards of New Life," July 1877, *Fors Clavigera,* vol. 3, in *The Works of John Ruskin,* ed. E. T. Cook and Alexander Wedderburn (London: George Allen, 1907), 29:160.

20. Linda Merrill, *A Pot of Paint: Aesthetics on Trial in Whistler v. Ruskin* (Washington, D.C.: Smithsonian Institution Press, 1993), 175.

21. Undated letter by Constable, quoted in *Neoclassicism and Romanticism 1750–1850: Sources and Documents,* ed. Lorenz Eitner (Englewood Cliffs, N.J.: Prentice-Hall, 1970), 2:65.

22. Lady Elizabeth Eastlake, "Photography," *Quarterly Review* 101 (January/April 1857): 453.

23. On the success of the English aristocracy in persuading the rising bourgeoisie to embrace gentlemanly values, see Martin J. Wiener, *English Culture and the Decline of the Industrial Spirit, 1850–1890,* 2nd ed. (Cambridge: Cambridge University Press, 2004), 11–24.

24. Quoted in Steegman, *Victorian Taste,* 21.

25. John Ruskin, "Letter 44: The Squirrel Cage: English Servitude," *Fors Clavigera* 4 (August 1874), in *The Complete Works of John Ruskin,* 28:135–136.

26. Elizabeth Gilmore Holt, ed., *The Art of All Nations 1850–1873: The Emerging Role of Exhibitions and Critics* (Garden City, N.Y.: Anchor Books, 1981), 50.

27. Eastlake, "Photography," 466.

28. My colleague Jennifer Roberts helped me get my head around this passage.

29. Gottfried Semper, "Science, Industry, and Art," trans. David Armbost and John Holt, in *The Art of All Nations 1850–1873,* 61–62.

30. Eastlake, "Photography," 466.

31. Ibid., 467.

32. Ibid., 453.

33. Ibid., 458.

34. Ibid., 460.

35. See Arnaud Maillet, *The Claude Glass* (Cambridge: Zone Books, 2009).

36. Eastlake, "Photography," 442.

37. Ibid., 443.

38. Ibid.

39. Ibid., 465.

40. Ibid., 443–444.

41. Roger Caillois, *Man, Play, and Games,* trans. Meyer Barash (New York: Free Press of Glencoe, 1961), 17.

42. Quoted in John Ashton, *The History of Gambling in England* (London: Duckworth, 1898), 135.

43. Just four years before Eastlake's essay appeared, the English Parliament passed an act suppressing betting shops and prohibiting the promotion of betting lists in pubs. See Peter Bailey, *Leisure and Class in Victorian England: Rational Recreation and the Contest for Control* (London: Routledge & Kegan Paul, 1978), 23–24. On gambling in Victorian England, see also J. Jeffrey Franklin, "The Victorian Discourse of Gambling: Speculations on Middlemarch and the Duke's Children, *ELH* 61, no. 4 (Winter 1994): 902–905.

44. Franklin, "The Victorian Discourse of Gambling," 904–905 ("by the mid nineteenth century the discourses of gambling and of finance capitalism had fully penetrated each other").

45. Reuven Brenner and Gabrielle A. Brenner, *Gambling and Speculation: A Theory, a History, and a Future of Some Human Decisions* (Cambridge: Cambridge University Press, 1990), 90. Many Victorians saw a morally troubling link between public risk and private gambling. See, e.g., Andrew Steinmetz, *The Gaming Table: Its Votaries and Victims, especially in England and in France* (London: Tinsley Brothers, 1870), 1:vii.

46. Ashton, *The History of Gambling in England*, 259.

47. Ibid. Ashton wrote, "As a place for gambling, the Stock Exchange is of far greater extent than the Turf," and the "time bargains and options without which the business of the Exchange would be very little, are gambling pure and simple." Ibid., 274. Wilfred Stone has argued that George Eliot in her last novel, *Daniel Deronda* (1876), confronted a "moral crisis" of her life and her age, and that " 'gambling' is a serviceable pole around which these crises cluster." Wilfred Stone, "The Play of Chance and Ego in *Daniel Deronda*," *Nineteenth-Century Literature* 53, no. 1 (June 1998): 27. According to Stone, Eliot saw "the democracy of the gaming room as a terrible leveling-down, the sign of a culture's decay." Ibid., 32.

48. Edwards, *The Making of English Photography*, 71.

49. Audrey Linkman, *The Victorians: Photographic Portraits* (London: Tauris Parke Books, 1993), 73.

50. William C. Darrah, *Cartes de Visite in Nineteenth Century Photography* (Gettysburg, Pa.: William C. Darrah, 1981), 4. For an array of estimates, see Edwards, *The Making of English Photography*, 71.

51. See Edwards, *The Making of English Photography*, 76–83.

52. Talbot, *The Pencil of Nature*.

53. "The Latest Novelties by Art-Critics on Photography," *Photographic News*, November 18, 1864, 558.

54. See especially Allan Sekula, "The Body and the Archive," *October* 39 (Winter 1986): 3–64.

55. "More Alleged Indecent Photographs," *Photographic News*, November 21, 1873, 556.

56. Stephen Thompson, "The Commercial Aspects of Photography," *British Journal of Photography*, November 1, 1862, 406–407.

57. Edwards, *The Making of English Photography*, 211.

58. On the shift in collecting, see John Steegman, "The 1850's: The New Connoisseurship," in *Victorian Taste*, 233–256. Steegman describes the shift from "the older generation who clung to Reynolds's *Discourses* as their guide" and collected Carracci, Guercino, and other Italian Baroque artists, to a generation more interested in fifteenth-century Italian and Flemish painters.

59. According to Roger Fry, Ingres told his pupils, " 'If you have a hundred pounds worth of skill it is always worth while to buy another halfpennyworth, but,' he added, 'you must never show it.' " Roger Fry, "Mrs. Cameron's Photographs," in *Victorian Photographs of Famous Men and Fair Women by Julia Margaret Cameron*, with introductions by Virginia Woolf and Roger Fry (New York: Harcourt Brace, 1926), 14.

60. Steegman, *Victorian Taste*, 44.

61. "Fine Arts," *The Examiner*, February 21, 1830, 117. As the decades passed and freer brushwork was increasingly accommodated by the art press, use of the term *slapdash* became more complex. In 1870, a critic distinguished between an approved "careful and calculated slapdash" and a disapproved "slapdash [left] to reign unchecked." "Pictures at the Royal Academy," *Pall Mall Gazette*, May 4, 1870, 6.

62. See Judy Crosby Ivy, *Constable and the Critics, 1802–1837* (Woodbridge, U.K.: Boydell Press, 1991), 36–49.

63. *The London Magazine*, April 1828, 27.

64. See Ivy, *Constable and the Critics*, 40–47; Rackstraw Downes, review of Graham Reynolds, *The Early Paintings and Drawings of John Constable;* and Peter Bishop, *An Archetypal Constable: National Identity and the Geography of Nostalgia*, in *Art Journal* 56, no. 4 (Winter 1997): 86.

65. "Exhibitions—The Royal Academy," *Blackwood's Edinburgh Magazine* 42 (1837): 335–336.

66. Charles Rosen and Henri Zerner, *Romanticism and Realism: The Mythology of Nineteenth-Century Art* (New York: Viking, 1984), 222.

67. Ibid., 221.

68. Ibid., 222. In recent years, Elizabeth Prettejohn and David Peters Corbett have argued that the licked surface in the work of Frederic Leighton took part in a welding of subject and painting to combine the imagined pleasures of touching the sensuous surfaces of both. See Elizabeth Prettejohn, "The Modernism of Frederic Leighton," in *English Art 1860–1914: Modern Artists and Identity*, ed. David Peters Corbett and Lara Perry (New Brunswick, N.J.: Rutgers University Press, 2001), 36; and David Peters Corbett, *The World in Paint: Modern Art and Visuality in England,*

1848–1914 (University Park: Pennsylvania State University Press, 2004), 97. Such a surface still served as a legible sign of skill and labor, which is one reason that Leighton rose to be president of the Royal Academy. As, Prettejohn notes, Leighton's paintings often reminded critics of work in other media, giving examples of comparisons to "a highly finished bas-relief" and "a Greek cameo." Through such secondary illusion, Leighton and many other *fini* painters conveyed skill and labor by making paint seem like something else. See Rosen and Zerner, *Romanticism and Realism,* 223.

69. Quoted in Rosen and Zerner, *Romanticism and Realism,* 223.

70. Merrill, *A Pot of Paint,* 220–221.

71. Alfred H. Wall, "On Focussing," *Photographic News* 14, no. 350 (January 18, 1867): 26.

72. H. P. Robinson, *The Elements of a Pictorial Photograph* (Bradford: Percy Lund, 1896; reprint, New York: Arno Press, 1973), 39.

73. Eastlake, "Photography," 464.

74. Oscar Gustave Rejlander, "On Photographic Composition; with a Description of 'Two Ways of Life,'" *Journal of the Photographic Society of London,* no. 65 (April 21, 1858): 191.

75. Ibid., 192.

76. Ibid., 192.

77. Ibid., 197.

78. "Impressions of the Photographic Exhibition," *The British Journal of Photography,* December 9, 1870.

79. By the 1880s, however, some critics were arguing that combination printing was unable to surmount the photographic reliance on happenstance. One writer said of combination prints, "But that these mosaics cannot be classed as art will appear from one consideration, viz.: that when they are completely successful they appear to be the result of nature's arrangement, but they never impress one as the work of the artist. Now nature occasionally produces, by accidents, arrangements of her material, so harmonious and happy that we consider them unusually fit subjects for the painter, but they can never be confounded with the work of an artist." "Photography as Art," *Photographic Times and American Photographer,* January 2, 1885, 1. In knotty prose and stumbling modernism, this critic jettisons the traditional aim of making art look natural and instead insists that a work of art declare itself as such.

80. On Queen Victoria and photography, see Anne M. Lyden, *A Royal Passion: Queen Victoria and Photography* (Los Angeles: J. Paul Getty Museum, 2014).

81. Tensions and contradictions beset Rejlander's project. As Malcolm Daniel has observed, the theatrical forms that the composite photography of Rejlander and Henry Peach Robinson most resembled were those of tableaux vivants (living pictures) and poses plastiques (living sculptures). In England of the 1850s, these forms of professional entertainment and drawing-room amusement were exceedingly popular and often deemed a bit vulgar. By including partially disrobed women and suggestions

of debauchery in his picture, Rejlander only amplified this negative association. His two strategies for overcoming the mechanical in photography, as Daniel points out, worked at cross-purposes. Rejlander had not photographed a tableau vivant in which people mingled in various states of undress, but the seamless finish of his picture made it seem as if he had. Through the artifice of combination printing, Rejlander had made artificial indecency. Malcolm R. Daniel, "Darkroom vs. Greenroom: Victorian Art Photography and Popular Theatrical Entertainment," *Image* 33, nos. 1–2 (Fall 1990): 13–20.

82. Rejlander, "On Photographic Composition," 192.

83. Painted scenes from Shakespeare were highly popular at the Royal Academy in Rejlander's day. Although writers on *Two Ways of Life* rightly cite Thomas Couture's *Romans of Decadence* and Raphael's *School of Athens* as sources for its composition, Daniel Maclise's *The Play Scene in Hamlet,* a large and extremely popular picture exhibited at the Royal Academy in 1842, is equally relevant. Both Maclise's picture and *Two Ways of Life* feature an arched, tripartite space and many signs of theatricality, including a curtain gathered above the scene. By following Maclise's work, Rejlander managed to invoke theater and the academy simultaneously.

84. William Lake Price, "On Composition and Chiaro-scuro," *Photographic News,* April 13, 1860, 386. Reports of artists preferring photographs with a less than precise finish go back to the very early years of photography. For example, in 1841, the inventor Charles Wheatstone wrote Talbot, "Your new photograph excited much interest at the Marquis' on Saturday. The artists generally greatly prefer[r]ed it to the more elaborately finished Daguer[r]otype portraits which were also exhibited there. One academician said it was equal in effect to any thing of Sir Joshua's." Wheatstone to Talbot, March 1, 1841. National Trust Collection, Fox Talbot Museum, Lacock.

85. Sir William J. Newton, "Upon Photography in an Artistic View, and Its Relation to the Arts," *Journal of the Photographic Society,* March 3, 1853, 6. Edwards, skeptical of claims that nineteenth-century writers truly contemplated the possibility of photography as art, notes that many writers discussed the potential of the photograph as an artistic study, not a finished work of art. In my view, he may somewhat overstate or simplify the import of this distinction. Romantic landscape painters of Constable's generation sought, albeit with inconsistent success, to "close the gap between outdoor sketch and finished picture," and at midcentury the preparatory sketches and artistic studies of the pre-Raphaelites were being exhibited and sold. John Gage, *A Decade of English Naturalism, 1810–1820* (s.n., 1969), 31; for the sale of Pre-Raphaelite sketches, see, e.g., Mary Bennett, "A Check List of Pre-Raphaelite Pictures Exhibited at Liverpool 1846–67, and Some of Their Northern Collectors," *Burlington Magazine* 105, no. 728 (November 1963): 477, 486, 493, 495.

86. Reynolds, Discourse IV, in *Discourses on Art,* 58.

87. Eastlake, "Photography," 460.

88. Ibid., 462.

89. The notion that photography's technical limitations could be used artfully would gain traction in the latter decades of the nineteenth century. In 1892, a prominent member of the Boston Camera Club would write that photography's "technical faults may be utilized for artistic rendering of truth with great delicacy." Benjamin Kimball, "The Boston Camera Club," *The New England Monthly* 8, no. 2 (April 1893), 205.

3. Julia Margaret Cameron Transfigures the Glitch

1. Cameron to Herschel, December 31, 1864, quoted in Colin Ford, *The Cameron Collection: An Album of Photographs by Julia Margaret Cameron Presented to Sir John Herschel* (Wokingham: Van Nostrand Reinhold for the National Portrait Gallery, 1975), 141. There is some question about the year in which Herschel first sent Cameron photographs. In a letter long afterward to Herschel, Cameron states that the year was 1839, but the earliest mention in the available correspondence dates to 1841. Cameron to Herschel, October 23, [1866], Herschel Correspondence, Royal Society, London.

2. "The Photographic Society's Exhibition," *British Journal of Photography*, May 19, 1865: 267.

3. See Julian Cox, "'To ... startle the eye with wonder & delight': The Photographs of Julia Margaret Cameron," in *Julia Margaret Cameron: The Complete Photographs*, ed. Julian Cox and Colin Ford (London: Thames and Hudson, 2003), 48–49.

4. For a critique of the shortcomings of many scholarly accounts of the issue of focus in Cameron's photography, see William Russell Young III, "The Soft-Focus Lens and Anglo-American Pictorialism," PhD diss., University of St. Andrews, 2008, 25–40. Although I ultimately disagree with Young's own account, which seems to me to grant too little significance to Cameron's accommodation of quirks, he exerts helpful pressure on Cameron scholarship.

5. Ibid., 33. Young has estimated the depth of field at 2¼ inches when Cameron was using her Jamin Petzval lens, which she was given in 1863, and 1¾ inches when she was using her Dallmeyer Rapid Rectilinear lens, which she acquired in 1866.

6. Cox, "'To ... startle the eye with wonder & delight,'" 48–50. Helmut Gernsheim claimed that her exposure times could stretch to several minutes. See Helmut Gernsheim, *Julia Margaret Cameron: Her Life and Photographic Work* (Millerton, N.Y.: Aperture, 1975), 71. Other estimates are lower. Peter Henry Emerson reported that her exposure times were one to five minutes, and Cox has suggested that the longest exposure times were perhaps more in the order of two to three minutes. Peter Henry Emerson, "Mrs. Julia Margaret Cameron," in W. Arthur Boord, ed., *Sun Artists*, no. 5 (October 1890), reprinted by New York: Arno Press, 1973, 37; Cox, "'To ... startle the eye with wonder & delight,'" 74 n. 38.

7. Young has raised the possibility that Cameron simply did not realize that the positive chromatic aberration of her lens meant that a subject appearing in sharp focus on the ground glass would not produce a sharply focused image on the plate. Young, "The Soft-Focus Lens," 31–38. But surely Cameron, who would have noticed this discrepancy at the very outset of her practice, could have consulted experts to overcome it (as Young notes, there was a standard remedy, whereby the focus was adjusted by a standard increment before exposing the plate). Although writers from Cameron's day to the present have posited technical ignorance as an explanation for her style, these appeals remain wholly unpersuasive due to the ease with which she could have availed herself of expertise, the many signs of her scientific curiosity, and her steadfast and vocal refusal through the years to abide by technical expectations and the aesthetic criteria based upon them.

8. In his 1975 monograph, Gernsheim writes, "Mrs. Cameron was so obsessed by the spiritual quality of her pictures that she paid too little attention to whether the image was sharp or not, whether the sitter had moved, or whether the plate was covered with blemishes. Even if she dropped and cracked the negative she would still make prints from it and boldly send them to exhibitions, when any other photographer would have discarded the picture. Lacking training, she had a complete disregard for technical perfection." Gernsheim, *Julia Margaret Cameron,* 70.

9. Cox, "To . . . startle the eye with wonder & delight," 54. Acknowledging Cameron's acceptance of accident, Mirjam Brusius has characterized her practice as "an autopoietic procedure that depends on chance, on the one hand, and is the product of artistic inspiration, on the other." Mirjam Brusius, "Impreciseness in Julia Margaret Cameron's Portrait Photographs," *History of Photography* 34, no. 4 (November 2010): 355. Even contemporaries critical of Cameron's work were sometimes astute enough to impute intent to its imperfections. For example, one critic wrote: "As one of the special charms of photography consists in the completeness, detail and finish, we can scarcely commend works in which the aim appears to have been to avoid these qualities." Quoted in Grace Seiberling, with Carlyn Bloore, *Amateurs, Photography, and the Mid-Victorian Imagination* (Chicago: University of Chicago Press, 1986), 110.

10. See Victoria Olsen, *From Life: Julia Margaret Cameron and Victorian Photography* (New York: Palgrave, 2003), 127.

11. Ibid., 225.

12. Mike Weaver, "A Divine Art of Photography," in J. Paul Getty Museum, *Whisper of the Muse: The Overstone Album and Other Photographs by Julia Margaret Cameron* (Malibu, Calif.: The J. Paul Getty Museum, 1986), 18–21 ("My father-in-law for the last two months has been utterly penniless, so that his debts are increased by butcher's Bills, etc.").

13. The myth of Cameron's disinterestedness began in her day. "It is probably not of the slightest consequence to her whether she gains or loses by photographic pursuits," wrote one contemporary. "Photography as a Fine Art," *The Intellectual*

Observer 10 (1867): 22. Mike Weaver has done more than any other to correct this myth. See Mike Weaver, "Julia Margaret Cameron: The Stamp of Divinity," in Mike Weaver, ed., *British Photography in the Nineteenth Century: The Fine Art Tradition* (Cambridge: Cambridge University Press, 1989), 151–161; and Weaver, "A Divine Art of Photography."

14. The story of the gift of the camera has undergone an interesting transposition over the years. In a letter to Herschel in February 1864, only weeks after the camera was presented, Cameron reports having received it from Norman. In "Annals," written in 1874, she recalls that the gift was from "her dear departed daughter and her husband," while contemporary writers often characterize the gift as one from daughter to mother, leaving Norman out of the equation altogether. The shift tends to move her photography from an economic context (a debtor and her creditors) to a matrilineal one (a mother and her daughter). Scholars have increasingly come to believe that Cameron experimented extensively with photography prior to receiving the camera. It is also notable that all of Cameron's basic photographic subjects—portraits, allegorical, literary, and religious subjects—appeared in her first month of photographic production. See Olsen, *From Life,* 149. These circumstances suggest that the gift of the camera responded to an already developed interest.

15. Cameron to Herschel, January 28, 1866, Herschel Correspondence, Royal Society, London. Hardinge Hay Cameron, Cameron's eldest son, was enrolled at the Charterhouse School. See Olsen, *From Life,* 145.

16. The phrase is from Cameron to Henry Cole, April 7, 1868, quoted in Olsen, *From Life,* 217.

17. Cameron to Henry Taylor, March 8, 1875, Bodleian Library, Oxford; Cameron to Herschel, January 28, 1866, Herschel Correspondence, Royal Society, London.

18. Cameron to Herschel, March 3, 1868, Herschel Correspondence, Royal Society, London.

19. Cameron to Sir Edward Ryan, November 29, 1875. Quoted in Joanne Lukitsh, *Cameron: Her Work and Career* (Rochester, N.Y.: International Museum of Photography at George Eastman House, 1986), 16.

20. See Joanne Lukitsh, "The Thackeray Album: Looking at Julia Margaret Cameron's Gift to Her Friend Annie Thackeray," *The Library Chronicle of the University of Texas at Austin* 26 (Summer 1996): 33–61. See also Olsen, *From Life,* 179. Even as she ventured into the photography market, Cameron relied heavily on the informal debt economy of gift exchange. On that economy, see C. A. Gregory, *Gifts and Commodities* (London: Academic Press, 1982).

21. Mike Weaver, "A Divine Art of Photography," 16. Overstone was not keen on Cameron's devotion to photography. See Olsen, *From Life,* 215.

22. Olsen, *From Life,* 81.

23. Mary Brotherton to Emily Tennyson, quoted in Olsen, *From Life,* 231.

24. Mary Poovey, *Unseen Developments: The Ideological Work of Gender in Mid-Victorian England* (Chicago: University of Chicago Press, 1988), 103. Citations omitted.

25. As Martin Wiener has noted more generally of Victorian England, "professional aloofness was of course partly a myth." Martin J. Wiener, *English Culture and the Decline of the Industrial Spirit, 1850–1890*, 2nd ed. (Cambridge: Cambridge University Press, 2004), 15.

26. "Art in Photography," *The Illustrated London News,* July 15, 1865, 50.

27. Julia Margaret Cameron, "Annals of My Glass House," reproduced in Violet Hamilton, *Annals of My Glass House: Photographs by Julia Margaret Cameron* (Claremont, Calif.: Ruth Chandler Williamson Gallery, Scripps College, 1996), 11–16.

28. Cameron, "Annals," 12.

29. Cameron to Herschel, undated, Herschel Correspondence, Royal Society, London. Other evidence casts doubt on this claim. See Cox, "'To . . . startle the eye with wonder & delight,'" 74 n. 37.

30. On Cameron's relationship to Rejlander, see Jordan Bear, "The Silent Partner: Agency and Absence in Julia Margaret Cameron's Collaborations," *Grey Room* 48 (July 2012): 79–98.

31. Cameron to Herschel, January 28, 1866, Herschel Correspondence, Royal Society, London.

32. Ford, *Cameron Collection,* 141.

33. Some writers at the time supported her audacious claims. One wrote, "Commencing the study of photography, as we are informed, only about eighteen months ago, in a retired part of the Isle of Wight; provided with a very ordinary apparatus; lacking many of the usual facilities; and, fortunately, as we are disposed to say, without any help or instruction whatever, this lady has succeeded in entirely opening a field for photography that had remained almost a terra incognita." "Art in Photography," *Illustrated London News,* July 15, 1865, 50.

34. [Coventry Patmore,] "Mrs. Cameron's Photographs," *MacMillan's Magazine* 13 (January 1866): 220.

35. Cameron, "Annals," 12.

36. Olsen, *From Life,* 225.

37. Cameron to Hardinge Hay Cameron, October 19, 1871, reproduced in J. Paul Getty Museum, *Whisper of the Muse,* 64–67.

38. Stories about serendipitous scientific or technical discovery remained popular in Cameron's day. See, for example, "Happy Accidents," *Chambers's Journal of Popular Literature, Science, and Art,* no. 648 (May 27, 1876). The author of "Happy Accidents" resolves the moral question of accidental discovery by asserting, "But the important point to notice is, that the value of the accident depends on the kind of man, or kind of mind, by whom or by which it is first observed. If the soil is not sufficiently prepared, the seed will not grow."

39. A. H. Wall, "Practical Art Hints," *British Journal of Photography*, November 3, 1865, 558.

40. Herschel to Cameron, February 5, 1866, Herschel Correspondence, Royal Society, London. A writer for the *British Journal of Photography* commented in 1866, "We were glad to observe, from an examination of the productions of Mrs. Cameron, that this lady seems to be acquiring facility in manipulation, her pictures being much more perfect in photographic technicalities than when we last had occasion to notice her works." "Soiree of the Photographic Society," *The British Journal of Photography*, June 15, 1866, 285.

41. Cox and Ford, eds., *The Complete Photographs*, 143.

42. Cameron, "Annals," 13.

43. Cameron's remarks cast in grave doubt efforts by her contemporaries and later historians to organize her aesthetic achievement along a path of technical improvement. It is worth noting in passing that Cameron's son Henry Hay Herschel Cameron, who carried on the photography business started by her mother, once stated, "Luck plays a great part even in the most careful work." Marie A. Belloc, "The Art of Photography: Interview with Mr. H. Hay Herschel Cameron," *The Woman at Home*, April 1897, 588.

44. See Whistler's remarks at the trial of Ruskin for libel in Linda Merrill, *A Pot of Paint: Aesthetics on Trial in Whistler v. Ruskin* (Washington, D.C.: Smithsonian Institution Press, 1993).

45. Cameron, "Annals," 15.

46. Lady Laura Troubridge, *Memories and Reflections* (London: Heinemann, 1925), 34.

47. Perspicacious reviewers understood this aesthetic move at the time. One wrote: "Instead of teaching her sitters to compose their faces, to button their garments tightly in at the waist, to smoothe out ribbons and roll up umbrellas preparatory to being photographed upon the plate, this lady seems to penetrate them with something of her own appreciation for the natural fitness of things and her own dislike to vulgar trivialities and commonplaces." "Mrs. Cameron's Photographs," *Pall Mall Gazette*, January 29, 1868, 10. It should be noted that although tousled hair had a particular significance in Cameron's day, her preference for it has roots in the picturesque. William Gilpin writes in 1792: "You sit for your picture. The master, at your desire, paints your head combed smooth, and powdered from the barber's hand. This may give it a more striking likeness, as it is more the resemblance of the real object. But is it therefore a more pleasing picture? I fear not. Leave Reynolds to himself, and he will make it picturesque: he will throw the hair dishevelled about your shoulders." William Gilpin, "On Picturesque Beauty," in *Three Essays: On Picturesque Beauty; on Picturesque Travel; and on Sketching Landscape: To Which Is Added a Poem, on Landscape Painting* (London: R. Blamire, 1792), 8.

48. Cameron to Sir Edward Ryan, December 6, 1874, quoted in Gernsheim, *Julia Margaret Cameron*, 47. Although Cameron drew on her friendship with Watts to bolster the legitimacy of her art, Watts hewed largely to a Reynoldsian view of art. "A portrait," he is quoted as saying, "should have in it something of the monumental; it is a summary of the life of a person, not the record of accidental position or arrangement of light and shadows." Jeremy Mass, *Victorian Painters* (New York: Abbeville Press, 1984), 219. Cameron evidently valued her glitches more than Watts did. The painter urged her to eliminate the careless defects, the "sort of imperfection [the public] can understand at a glance." Cox and Ford, eds., *The Complete Photographs*, 52.

49. Cameron to Herschel, September 11, 1867, Herschel Correspondence, Royal Society, London.

50. Mirjam Brusius perceptively associates Cameron's photography with the notion that "the idea would have exceeded the material." See Brusius, "Impreciseness," 345.

51. "Out of Focus," *British Journal of Photography* 11 (July 22, 1864): 261.

52. Emerson, "Mrs. Julia Margaret Cameron," 40.

53. Although the hurdy-gurdy became popular with the French aristocracy, in England it was generally played by poor itinerant immigrants and considered a tasteless nuisance by the upper classes. See John Picker, *Victorian Soundscapes* (Oxford: Oxford University Press, 2003), 45–52.

54. As Grace Seiberling has noted, the "acknowledgement of collodion as the standard" photographic process "implied an acceptance of clarity of detail as a fundamental feature of photography" and "marked the end of the dominance of amateurs who considered photography an experimental art-science." Seiberling, *Amateurs, Photography, and the Mid-Victorian Imagination*, 33.

55. Carol Armstrong, "Cupid's Pencil of Light: Julia Margaret Cameron and the Maternalization of Photography," *October* 76 (Spring 1996): 131.

56. In this context, Jennifer Roberts reminded me of this passage from *Alice in Wonderland*. As Fred Kaplan has argued, sentimentality has roots in the eighteenth-century moral philosophy of Adam Smith and David Hume, who proposed that an innate tendency to respond with moral feeling was crucial to good works and human happiness. See Fred Kaplan, *Sacred Tears: Sentimentality in Victorian Literature* (Princeton, N.J.: Princeton University Press, 1987).

57. Feminist theory of the 1970s offers insight into this bodily intervention. As Jeannene Przyblyski writes in a discussion of Cameron's photography: "[Julia] Kristeva's dual fascination with the maternal body and with the abject power of dirt (and the bodily fluids we tend to see as dirty) to trouble the disembodied fiction of the symbolic order have allowed us to see beauty where others might have seen an embarrassing externalization of the 'private' female body." Jeannene Przyblyski, "Julia Margaret Cameron's Women, Great Men and Others," *Afterimage* 27, no. 5 (March/April 2000): 8.

58. See Poovey, *Uneven Developments,* 114–115.

59. Ann Bermingham, *Learning to Draw: Studies in the Cultural History of a Polite and Useful Art* (New Haven, Conn.: Yale University Press, 2000), 180.

60. "The Exhibition Soiree of the Photographic Society," *Photographic News,* June 15, 1866, 279.

61. Ernest Chesneau, *The Education of the Artist,* trans. Clara Bell (London: Cassell, 1886), 257. The original version was published in France in 1880.

62. Cameron to W. M. Rossetti, January 23, 1866, Cameron Correspondence, Harry Ransom Center, Austin, Texas.

63. Oliver Wendell Holmes, "The Stereoscope and the Stereograph," *Atlantic Monthly* 3, no. 20 (June 1859): 745.

64. Walter Benjamin, "A Short History of Photography," in *Classic Essays on Photography,* ed. Alan Trachtenberg (New Haven, Conn.: Leete's Island Books, 1980), 202.

65. Roland Barthes, *Camera Lucida: Reflections on Photography,* trans. Richard Howard (New York: Hill and Wang, 1981), 40.

66. Cameron to Rossetti, January 23, 1866.

67. Thomas Carlyle, *Chartism,* 2nd ed. (London: James Fraser, 1840), 61.

68. Peggy Phelan, *Unmarked: The Politics of Performance* (London: Routledge, 1993), 35.

69. Paul Strand's blind woman may, of course, have been posing for the camera, but her blindness nonetheless operates as a sign that the usual performative mode of portrait sitters has been negated.

70. Steve Edwards, "The Machine's Dialogue," *Oxford Art Journal* 13, no. 1 (1990): 68.

71. Barthes, *Camera Lucida,* 31–32.

72. "Art in Photography," *Illustrated London News,* July 15, 1865, 50.

73. In Cameron's photography, as in a tableau vivant, the motion had to be subtle for the effect to work. When Cameron was staging photographs of Merlin and Vivien for her *Idylls of the King* series, her husband, who was posing as Merlin, evidently suffered from disruptive fits of laughter. The woman posing as Vivien reported, "With all the latitude Mrs. Cameron allowed herself in the way of 'out of focus' and 'sketchiness,' Merlin had moved far too much." "A Reminiscence of Mrs. Cameron by a Lady Amateur," *The Photographic News* 30 (January 1, 1886): 3.

74. Roger Fry, "Mrs. Cameron's Photographs," in *Victorian Photographs of Famous Men and Fair Women by Julia Margaret Cameron,* with introductions by Virginia Woolf and Roger Fry (New York: Harcourt Brace, 1926), 26. Cameron was not alone in using such means to convey the vitality of her subjects. Richard Shiff has noted that Gustave Le Gray used blur and grainy texture in his photographs of Fontainebleau Forest to represent its "continuous tremble or pulse." Richard Shiff, "Realism of Low Resolution: Digitisation and Modern Painting," *Impossible Presence:*

Surface and Screen in the Photogenic Era, ed. Terry Smith (Chicago: University of Chicago Press, 2001), 136.

75. Cameron, "Annals," 11.

76. See Gernsheim, *Julia Margaret Cameron,* 75.

77. Cameron to Herschel, February 18, 1866, Herschel Correspondence, Royal Society, London.

78. Herschel to Cameron, September 25, 1866, quoted in Cox and Ford, eds., *The Complete Photographs,* 64.

79. Gernsheim, *Julia Margaret Cameron,* 189.

80. This is one of several lines of inquiry that Helen Groth pursues in her book chapter "Cameron, Tennyson, and the Luxury of Reminiscing." See Helen Groth, *Victorian Photography and Literary Nostalgia* (Oxford: Oxford University Press, 2003), 148–184. The desire to produce the effect of liveliness in portraiture abounded in Cameron's day. Her friend the painter G. F. Watts wrote, "The mesmeric influence possessed by individuals must be possessed by artistic productions. Without this quality they will be cold, and not breathing, and will not live always." M. S. Watts, *George Frederick Watts* (London: Macmillan, 1912), 2.

81. Sigmund Freud, *The Uncanny,* trans. David McLintock (London: Penguin Books, 2003), 141. Carol Armstrong has suggested, "The maternal Real, the uncanny, the 'genetic trait,' the confrontation with the face, the poignant temporal paradox, the future-anterior 'that-has-been' of the photograph" are "features of photography . . . that are embraced and pronounced" in Cameron's work. Carol Armstrong, "From Clementina to Käsebier: The Photographic Attainment of the 'Lady Amateur,'" *October* 91 (Winter 2000): 107.

82. E. T. A. Hoffman, "The Sandman." I am using the translation that appears in Homi Bhabha, *The Location of Culture* (London: Routledge, 1994), 196. The aptness of the Hoffman text comes courtesy of Professor Bhabha.

83. "Mrs. Cameron's Photographs," *Pall Mall Gazette,* January 29, 1868, 10.

84. Edith Nicholl Ellison, *A Child's Recollections of Tennyson* (London: J. M. Dent, 1907), 76.

85. Belloc, "The Art of Photography," 582.

86. "A Reminiscence of Mrs. Cameron by a Lady Amateur," *The Photographic News* 30 (January 1, 1886): 3.

87. *William Allingham: A Diary,* ed. H. Allingham and D. Radford (London: Macmillan, 1907), 153.

88. Cameron to Sir Edward Ryan, November 29, 1874, quoted in Debra N. Mancoff, "Legend 'from Life': Cameron's Illustrations to Tennyson's 'Idylls of the King,'" in Sylvia Wolf, ed., *Julia Margaret Cameron's Women* (New Haven, Conn.: Yale University Press, 1998), 87.

89. Laura Troubridge, *Memories and Reflections* (London: William Heinemann, 1925), 33–34; Olsen, *From Life,* 170, 211. Olsen borrows the term "romantic authori-

tarian" from Phyllis Rose. See Phyllis Rose, *Parallel Lives: Five Victorian Marriages* (New York: Knopf, 1983), 264.

90. Ellison, *A Child's Recollection of Tennyson,* 72–74.

91. Przyblyski, "Julia Margaret Cameron's Women, Great Men and Others," 9.

92. Sarah Boxer, "Lifting the Veil from Beauties Cloaked in Tragic Disguise," *New York Times,* January 29, 1999. Boxer adds that "resistance is visible" in many portraits, and fellow critic Janet Malcolm concurs: "In many respects, Cameron's compositions have more connection to the family album pictures of recalcitrant relatives who have been herded together for the obligatory group picture than they do to the masterpieces of Western painting." Janet Malcolm, "The Genius of the Glass House," *New York Review of Books* 46, no. 2 (February 4, 1999): 13.

93. Robert Browning, "Porphyria's Lover," in *Robert Browning: The Major Works,* ed. Adam Roberts (Oxford: Oxford University Press, 2005), 122–124. All quotations from the poem are drawn from this source.

94. On the narcissistic imagination in "Porphyria's Lover," see Catherine Maxwell, "Browning's Pygmalion and the Revenge of Galatea," *ELH* 60, no. 4 (Winter 1993): 989–1013; Martin Bidney, "The Exploration of Keatsian Aesthetic Problems in Browning's 'Madhouse Cells,'" *Studies in English Literature, 1500–1900* 24, no. 4 (Autumn 1984): 671–681.

95. Dante Gabriel Rossetti, "Body's Beauty," in *Collected Works,* ed. W. M. Rossetti (London: Ellis and Elvey, 1887), 1:216. See also Virginia M. Allen, "'One Strangling Golden Hair': Dante Gabriel Rossetti's Lady Lilith," *Art Bulletin* 66, no. 2 (1984): 285–294. The extensive discussion of beards in Cameron's correspondence evinces that the play of desire in her photography was not limited to the tresses of her female sitters.

96. According to Emily Tennyson, the poet's wife, Cameron was "as severely exacting as a director as a photographer." Ann Thwaite, *Emily Tennyson: The Poet's Wife* (London: Faber and Faber, 1996), 486. For the sake of her art, strangers and children "were pressed into service." Belloc, "The Art of Photography," 584.

97. Troubridge, *Memories and Reflections,* 34.

98. Boxer, "Lifting the Veil."

99. Cameron to Herschel, January 28, 1866, Herschel Correspondence, Royal Society, London.

100. Herschel to Cameron, February 5, 1866, Herschel Correspondence, Royal Society, London.

101. Cameron to Herschel, February 18, 1866, Herschel Correspondence, Royal Society, London.

102. A year after the exchange with Herschel, Cameron did make a couple of photographs depicting sitters in white as if they were portions of the Elgin Marbles. The experiment seems to have been a dead end. Herschel, for his part, later praised the life-size heads, demonstrating that he did not hold Cameron's deflection of his advice against her.

103. On the extent of Cameron's oeuvre, see Cox and Ford, eds., *The Complete Photographs*. Gernsheim mentioned a view of a mountain waterfall in the Dimbula Valley, Ceylon—a picture that may or may not include figures—but I have yet to see it. Gernsheim, *Julia Margaret Cameron,* 60.

104. For a different interpretation of these photographs of Adeline Clogstoun, see Bear, "The Silent Partner," 93–98.

105. Malcolm Daniel has noted, for example, that Cameron "openly" acknowledged that "a picture showed not Merlin, but Mr. Cameron as Merlin." Malcolm R. Daniel, "Darkroom vs. Greenroom: Victorian Art Photography and Popular Theatrical Entertainment," *Image* 33, nos. 1–2 (Fall 1990): 18. Cameron's repeated use of particular models for her pictures contributed to the conspicuousness of the artifice. One reviewer wrote, "Mrs. Cameron is very felicitous in her choice of female models for her fancy subjects. However, one particular model—invaluable in many subjects, and especially where an expression is required of gentle pathos or piteousness—is reproduced so often as to greatly detract from the variety one expects in so large a collection." "Fine Arts," *The Illustrated London News,* November 18, 1865.

106. Malcolm, "The Genius of the Glass House," 13.

107. As Mike Weaver has put it, Cameron's "images find their meaning in the space between idealist fiction and realist fact." Mike Weaver, *Julia Margaret Cameron, 1815–1879* (London: Herbert, 1984), 26.

108. Gernsheim, *Julia Margaret Cameron,* 80. As recently as 1985, a writer has demeaned Cameron's Arthurian work as armored in "Victorian folly." Michael Bartram, *The Pre-Raphaelite Camera: Aspects of Victorian Photography* (London: Weidenfeld and Nicolson, 1985), 178. In my view, that armoring is what makes her work more profound than the less conflicted work of her peers.

109. John Henry Newman, *Lectures on Certain Difficulties Felt by Anglicans in Submitting to the Catholic Church,* 2nd ed. (London: Burns & Lambert, 1850), 237. Mike Weaver has cogently associated Cameron with the Tractarian movement. See Weaver, "A Divine Art of Photography," 23–58.

110. Charles Kingsley, *"What, Then, Does Dr. Newman Mean?" A Reply to a Pamphlet Lately Published by Dr. Newman,* 3rd ed. (London: Macmillan, 1864), 20.

111. Newman, *Lectures on Certain Difficulties,* 237–238.

112. As the curator Malcolm Daniel has argued, in Cameron's work "the charge of deception is precluded by plainly showing evidence of the theatrical process by which the images were achieved. Contemporary critics thought Cameron's narrative works more clumsy than immoral or deceptive." Daniel, "Darkroom vs. Greenroom," 18. A certain amount of ineptitude was helpful in distancing her work from the slick insincerity of the marketplace.

113. Bhabha, *The Location of Culture,* 51–52.

114. The demand to perform takes on an explicitly colonial cast in several portraits that Cameron made of British men in vaguely Middle Eastern garb. Jeff Rosen

has rightly drawn attention to these portraits and to the colonial imagery in Cameron's work generally. See Jeff Rosen, "Cameron's Photographic Double Takes," in *Orientalism Transposed: The Impact of the Colonies on British Culture,* ed. Julie F. Codell and Dianne Sachko Macleod (Aldershot: Ashgate, 1998), 158–186. Rosen also uses Bhabha's writings to understand the colonial dimensions of Cameron's practice, but in a way different from mine. In a portrait by Cameron, William Gifford Palgrave, who as a Jesuit missionary in the Middle East disguised himself as a Syrian doctor to gain access to forbidden places and who took an active role in helping to resolve the crisis leading to the Abyssinian War (1867–1868), appears wearing a turban. See Cox and Ford, eds., *The Complete Photographs,* 518. In another portrait, William Holman Hunt, who traveled to the Middle East to gather subjects for his paintings and credibility for his Orientalist practice, likewise appears in costume. On Hunt's Orientalism, see Albert Boime, "William Holman Hunt's The Scapegoat: Rite of Forgiveness / Transference of Blame," *Art Bulletin* 84 (March 2002): 94–114. These portraits more explicitly link Cameron's habit of playacting to her colonial past. Colonialism entails the performance of culture, posited either as a demonstration (we shall show the natives how to be English) or as an infiltration (we shall get to the heart of the exotic), but either way it inevitably refashions the culture of the colonist as itself theatrical. In Cameron's photography, accident is a way of keeping that theatricality in view.

115. On the circumstances of this photograph's production and their afterlife, see Rosen, "Cameron's Photographic Double Takes," and Panthea Reid, "Virginia Woolf, Leslie Stephen, Julia Margaret Cameron, and the Prince of Abyssinia: Inquiry into Certain Colonialist Representations," *Biography* 22 (Summer 1999): 323–355. Rosen and I part ways concerning the basic logic of her practice. In my view, she was never seeking to portray in a straightforward manner the "dramatic immediacy" or "prevailing stereotypes" he says she failed to achieve (175).

116. Cameron to Herschel, March 20, 1864. Herschel Correspondence, Royal Society, London.

117. Henry Taylor, *Autobiography of Henry Taylor* (New York: Harper & Brothers, 1885), 2:42.

118. Colin Ford, "Geniuses, Poets, and Painters: The World of Julia Margaret Cameron," in Cox and Ford, eds., *The Complete Photographs,* 12.

119. See Olsen, *From Life,* 14.

120. On Cameron, Eros, and photography, see Armstrong, "Cupid's Pencil of Light." Jeannene Przyblyski, with her usual acuity, has linked Cameron to Queen Victoria and criticized the scholarship on Cameron for its insensitivity to class issues. See Przyblyski, "Julia Margaret Cameron's Women, Great Men and Others."

4. The Fog of Beauty, c. 1890

1. Martin J. Wiener, *English Culture and the Decline of the Industrial Spirit, 1850–1890,* 2nd ed. (Cambridge: Cambridge University Press, 2004), 6.

2. *The Elder Pliny's Chapters on the History of Art,* trans. K. Jex-Blake (Chicago: Ares, 1976), 139.

3. My understanding of these matters is deeply indebted to Hubert Damisch's account of them. Hubert Damisch, *A Theory of /Cloud/: Toward a History of Painting,* trans. Janet Lloyd (Stanford, Calif.: Stanford University Press, 2002).

4. Giorgio Vasari, *Lives of the Most Eminent Painters, Sculptors and Architects,* trans. Gaston du C. de Vere (New York: AMS Press, 1976), 4:127.

5. Quoted in H. W. Janson, "The 'Image Made by Chance' in Renaissance Thought," *De Artibus Ouscula XL: Essays in Honor of Erwin Panofsky,* ed. Millard Meiss (New York: New York University Press, 1961), 260.

6. Richard Wollheim, *Painting as an Art* (Princeton, N.J.: Princeton University Press, 1987), 54–56.

7. Frank Fehrenbach, "Der oszillierende Blick: Sfumato und die Optik de Späten Leonardo," *Zeitschrift für Kunstgeschichte* 65 Bd., H. 4 (2002): 522–544.

8. Diogo Queiros-Conde, "The Turbulent Structure of *Sfumato* within *Mona Lisa,*" *Leonardo* 37, no. 3 (2004): 223–228.

9. Leonardo, *Treatise on Painting,* ed. and trans. A. McMahon (Princeton, N.J.: Princeton University Press, 1956), 1:270. Quoted in Alexander Nagel, "Leonardo and *Sfumato,*" *RES: Anthropology and Aesthetics* 24 (Autumn 1993): 9.

10. On David generally, see Ewa Lajer-Burcharth, *Necklines: The Art of Jacques-Louis David after the Terror* (New Haven, Yale, 1999).

11. On this rebellion, see, e.g., Joseph Leo Koerner, *Caspar David Friedrich and the Subject of Landscape,* rev. ed. (London: Reaktion Books, 2009), 67.

12. See ibid., 218.

13. Quoted in ibid., 67.

14. Quoted in ibid., 77.

15. See Ann Bermingham, *Landscape and Ideology: The English Rustic Tradition, 1740–1860* (Berkeley: University of California Press, 1986); and John Barrell, *The Dark Side of the Landscape: The Rural Poor in English Painting* (Cambridge: Cambridge University Press, 1980).

16. In his 1792 poem on the subject, Gilpin urges the painter to "mark each floating cloud; its form, / Its varied colour; and what mass of shade / It gives the scene below, pregnant with change / Perpetual." William Gilpin, "On Landscape Painting: A Poem" in *Three Essays: On Picturesque Beauty; on Picturesque Travel; and on Sketching Landscape: To Which Is Added a Poem, on Landscape Painting* (London: R. Blamire, 1792), 3.

17. Ibid., 15 (Gilpin writes: "Mark when in fleecy show'rs of snow, the clouds / Seem to descend, and whiten o'er the land, / What unsubstantial unity of tinge / involves each prospect: Vision is absorb'd; / Or, wand'ring thro' the void, finds not a point / To rest on: All is mockery to the eye").

18. Ibid., 13.

19. Hermann von Helmholtz, "The Recent Progress in the Theory of Vision," in *Science and Culture: Popular and Philosophical Essays,* ed. David Cahan (Chicago: University of Chicago Press, 1995), 181.

20. Ibid., 14.

21. The literature on Constable and clouds is vast. See especially Edward Morris, ed., *Constable's Clouds: Paintings and Cloud Studies by John Constable* (Edinburgh: National Gallery of Scotland, 2000); John E. Thornes, *John Constable's Skies* (Birmingham: University of Birmingham, 1999); and Gillen D'Arcy Wood, "Constable, Clouds, Climate Change," *Wordsworth Circle* 38 (2007).

22. Constable to Rev. John Fisher, October, 23, 1821. *John Constable's Correspondence,* ed. R. B. Beckett (Ipswich: Suffolk Records Society, 1970), 6:77. John Ruskin later followed suit, writing: "If a general and characteristic name were needed for modern landscape art, none better could be invented than 'the service of clouds.'" John Ruskin, *Modern Painters,* vol. 3, in *The Works of John Ruskin,* ed. E. T. Cook and Alexander Wedderburn, Library Edition (London: G. Allen, 1903–1912), 5:318.

23. "Royal Academy," *The Literary Gazette,* May 14, 1842, 331.

24. See Ian Carter, "Rain, Steam, and What?," *Oxford Art Journal* 20, no. 2 (1997): 3–12.

25. Thomas Carlyle, *Chartism,* 2nd ed. (London: James Fraser, 1840), 9.

26. John Ruskin, *Modern Painters,* vol. 1, in *The Works of John Ruskin,* 3:343.

27. Ibid., 3:344.

28. John Ruskin, "Lectures on Landscape," in *The Works of John Ruskin,* 22:15.

29. Ruskin, *Modern Painters,* vol. 1, in *The Works of John Ruskin,* 3:395–396.

30. Ruskin decries the dearth of evidence in the work of the Old Masters that "there were such things in the world as mists or vapours." Ibid., 3:397.

31. Ibid., 3:401.

32. Ruskin, "Lectures on Landscape," in *The Works of John Ruskin,* 22:17.

33. Ruskin writes: "Of course for persons who have never seen in their lives a cloud vanishing on a mountainside, and whose conceptions of mist or vapor are limited to ambiguous outlines of spectral hackney-coaches and bodiless lamp-posts, discerned through a brown combination of sulphur, soot, and gaslight, there is yet some hope; we cannot, indeed, tell them what the morning mist is like in mountain air, but far be it from us to tell them that they are incapable of feeling its beauty if they will seek it for themselves." Ruskin, *Modern Painters,* vol. 1, in *The Works of John Ruskin,* 3:411.

34. As years passed, Ruskin's vehement dislike of modern air only intensified. In what appears prescient in these days of global climate change, he asserted that industrialization was changing the sky and the weather in disturbing ways. See John Ruskin, "The Storm-Cloud of the Nineteenth Century," lecture 1, in *The Works of John Ruskin*, 34:9–41; and John Ruskin, "Letter 8: Not as the World Giveth," *Fors Clavigera*, vol. 1, in *The Works of John Ruskin*, 27:132–133.

35. T. J. Clark, "Modernism, Postmodernism, and Steam," *October* 100 (Spring 2002): 159.

36. John Ruskin, "Letter 79: Life Guards of New Life," *Fors Clavigera*, vol. 7, in *The Works of John Ruskin*, 29:160.

37. "Nocturnes, symphonies, arrangements, and harmonies in sundry pigments, add to their other offenses that of an exasperating nomenclature that does not belong to the realm of pictorial art, but that is an eccentricity of small moment compared to the vagueness, the void and formless chaos, which they leave for the creative power of the imagination to fill up. They belong to a domain of improvisation in colors which has been unfortunately extended in recent years, and that with too much encouragement even from Mr. Ruskin's able pen." "Flinging Paint in the Public's Face," *New York Times*, December 15, 1878, 6.

38. "Impressions of the Photographic Exhibition," *The British Journal of Photography*, December 9, 1870, 578.

39. "Flinging Paint in the Public's Face," *New York Times*, December 15, 1878, 6.

40. Ibid.

41. Linda Merrill, *A Pot of Paint: Aesthetics on Trial in Whistler v. Ruskin* (Washington, D.C.: Smithsonian Institution Press, 1993), 145.

42. Ibid., 158.

43. Ibid., 144.

44. "The Showman," *The Penny Illustrated Paper and Illustrated Times*, December 7, 1878, 365.

45. Merrill, *A Pot of Paint*, 152.

46. John Ruskin, *Seven Lamps of Architecture* (New York: John Wiley & Son, 1865), 182.

47. Ruskin, *Modern Painters*, vol. 1, in *The Works of John Ruskin*, 3:408.

48. The issue is important, because for Ruskin the effects of atmosphere—its light, its vapor, its precipitation and condensation—permeated the landscape. In a defense of the "loose and blotted handling" of some watercolors by the English landscapist David Cox, Ruskin writes: "There is no other means by which his object could be attained; the looseness, coolness, and moisture of his herbage, the rustling crumpled freshness of his broad-leaved weeds, the play of pleasant light across his deep heathered moor or plashing sand, the melting of fragments of white mist into the dropping blue above; all this has not been fully recorded except by him, and what there is of accidental in his mode of reaching it, answers gracefully to the accidental part of

nature herself." Ibid., 3:195. Ruskin thus follows Pliny in suggesting that the accidental in painting can be forgiven when the painter has cause to represent the accidental in nature.

49. "I have written fifty times, if once, that you can't have art where you have smoke; you may have it in hell, perhaps, for the Devil is too clever not to consume his own smoke, if he wants to. But you will never have it in Sheffield. You may learn something about nature, shriveled, and stones, and iron; and what little you can see of that sort, I'm going to try and show you. But pictures, never." Letter by John Ruskin, February 18, 1876, reproduced in "Arrows of the Chace," in *The Works of John Ruskin,* 34:521. Ruskin did indeed restate his belief in the necessity of clear air for art. See, e.g., Letter 9: "Honour to Whom Honour," *Fors Clavigera,* vol. 1, in *The Works of John Ruskin,* 27:159 (asserting that he "cannot too often or too firmly state" that "no great arts were practicable by any people, unless they were living contented lives, in pure air, out of the way of unsightly objects, and emancipated from unnecessary mechanical occupation").

50. John Ruskin, "Letter 8: Not as the World Giveth," *The Works of John Ruskin,* 27:136.

51. As Paul Sternberger has noted in the American context, "photographers rarely seemed to hesitate to look to authors who were openly antagonistic to photography." Paul Sternberger, *Between Amateur and Aesthete* (Albuquerque: University of New Mexico Press, 2001), 13.

52. J. A. M. Whistler, *"Ten o'Clock"* (Boston: Houghton Mifflin, 1896), 16.

53. Ibid.

54. Ibid.

55. Ibid., 14.

56. Ibid., 15.

57. Whistler's claim that in the misty evening nature "sings her exquisite song to the artist alone" aligned with Talbot's claim that the sensitive eye can stumble upon art in the world. There was, of course, more than a little English nationalism in the exaltation of the transmutative powers of mist in such an encounter.

58. Peter Henry Emerson, "Mrs. Julia Margaret Cameron," *Sun Artists* 5 (October 1890): 33.

59. Ibid., 34.

60. Ibid.

61. Ibid., 37.

62. For more on Emerson's biography, see Clive Wilkins-Jones, "One of the Hard Old Breed: A Life of Peter Henry Emerson," in *Life and Landscape: P. H. Emerson: Art and Photography in East Anglia, 1885–1900* (Norwich: Sainsbury Centre for Visual Arts, 1986), 2–6.

63. P. H. Emerson, *Naturalistic Photography for Students of the Art* (London: S. Low, Marston, Searle & Rivington, 1889), 167.

64. Ibid., 189. On Emerson's image manipulations, see John Taylor, *The Old Order and the New: P. H. Emerson and Photography, 1885–1895* (Munich: Prestel, 2006), 53–56. For an interpretation of this darkroom work, see Charles Palermo, "The World in the Ground Glass: Transformations in P. H. Emerson's Photography," *Art Bulletin* 89, no. 1 (March 2007): 131. Emerson acknowledged and defended the practice of printing in a sky from a separate negative. See Emerson, *Naturalistic Photography* (1889), 197: "Printing in clouds is admissible because, if well done, a truer impression of the scene is rendered." His other changes to negatives tended to be deletions. For example, he excised a treetop in the background of his photogravure of *A Still Pull* and removed the tail of a dog in his photogravure of *The Poacher—A Hare in View.*

65. Emerson, *Naturalistic Photography* (1889), 164–165.

66. Ibid., 286.

67. Joshua Reynolds, Discourse II, in *Discourses on Art,* ed. Robert R. Wark (New Haven, Conn.: Yale University Press, 1997), 26.

68. Reynolds, Discourse IV, in *Discourses on Art,* 64.

69. Merrill, *A Pot of Paint,* 157.

70. On the mystification of the artist in America as an individual par excellence, see Sarah Burns, *Inventing the Modern Artist: Art and Culture in Gilded Age America* (New Haven, Conn.: Yale University Press, 1996).

71. On Seurat, see Richard Shiff, "Realism of Low Resolution: Digitisation and Modern Painting," in *Impossible Presence: Surface and Screen in the Photogenic Era,* ed. Terry Smith (Chicago: University of Chicago Press, 2001), 138–142.

72. Emerson, *Naturalistic Photography* (1889), 286. At first blush, this extreme outward-directed naturalism is hard to square with Emerson's familiar dictum from elsewhere in *Naturalistic Photography* that "your photograph is as true an index of your mind, as if you had written out a confession of faith on paper." But by *index,* Emerson evidently means not a stamp of a mental image but rather a trace of an aesthetic faith or sensibility. Ibid., 247.

73. Ibid., 286.

74. Conrad Fiedler, *On Judging Works of Visual Art* (Berkeley: University of California Press, 1957), 48.

75. Emerson, *Naturalistic Photography* (1889), 287.

76. Emerson approvingly quotes his collaborator, T. F. Goodhall, expressing puzzlement that "a mere transcript of nature" was a phrase of reproach, when "we should believe it the highest praise that could be bestowed upon a picture." Ibid., 26.

77. Ibid., 23.

78. Ibid.

79. Ibid., 27.

80. Reynolds, Discourse IV, in *Discourses on Art,* 59.

81. William Henry Fox Talbot, *The Pencil of Nature* (London: Longman, Brown, Green, & Longmans, 1844–1846).

82. Emerson, *Naturalistic Photography* (1889), 151.

83. See, e.g., Max Born and Emil Wolf, *Principles of Optics* (Cambridge: Cambridge University Press, 1999), 262.

84. Emerson, *Naturalistic Photography* (1889), 97 ("Having thus demonstrated that the best artists have always tried to interpret nature, and express by their art an impression of nature as nearly as possible similar to that made on the retina of the human eye, it will be well to inquire on scientific grounds what the normal human eye really does see").

85. On Emerson and differential focus, see Douglas R. Nickel, "Peter Henry Emerson: The Mechanics of Seeing," in *The Meaning of Photography*, ed. Robin Kelsey and Blake Stimson (Williamstown, Mass.: Clark Art Institute, 2008). Nickel argues that the aim of Emerson's system of differential focus was not to replicate natural vision but rather "to force the camera to create pictures that function as signs for our cognitive experience of nature." Ibid., 69. In his view, this entails a shift from the photographer/subject relationship to the viewer/image relationship. Ibid. My quibble with this interpretation is that Emerson's use of the term *picture*, as exemplified by his discussion of the imaginary encounter with the girl on the dock, does not reliably signal a shift from the one relationship to the other. Whether Emerson argues in a circular fashion is another matter. Regardless, he believed that photography should not only signify our aesthetic experience of landscapes, it should reproduce some of its essential qualities, including those secured through differential focus.

86. For example, Reynolds advised, "To give a general air of grandeur at first view, all trifling or artful play of little lights, or an attention to a variety of tints is to be avoided." Reynolds, Discourse IV, *Discourses on Art,* 61.

87. Emerson, *Naturalistic Photography* (1889), 151.

88. Gilpin, "On Landscape Painting: A Poem," 15.

89. Emerson, *Naturalistic Photography* (1889), 150.

90. Ibid.

91. Ibid., 152.

92. For an example of this position, see J. W. Spurgeon, "The Artistic Aspect of Photography," *American Amateur Photographer* 6, no. 6 (June 1894): 281–283. Spurgeon makes another important defense of all-over crisp focus, namely that the same focus gradient that Emerson describes as structuring a view of an actual landscape will structure a photograph of it in the act of viewing. According to Spurgeon, crisp all-over focus allows the viewer to establish the pictorial hierarchy by focusing on whatever he or she chooses, whereas Emerson establishes the hierarchy in advance and doubles its focal effect by blurring what will be blurred anyway. Ibid., 282–283.

93. Emerson, *Naturalistic Photography* (1889), 120.

94. "Hewers of wood and drawers of water there must always be, but why dull, unloved and uncared for? Equality there can never be; the stern laws of heredity forbid that *in utero*. An anthropological aristocracy there must always be; the struggle for existence and survival of the fittest declares it." P. H. Emerson, *Pictures of East Anglian Life* (London: Sampson Low, Marston, Searle & Rivington, 1888), 135.

95. On Emerson and class, see John Taylor, "Aristocrats of Anthropology: A Study of P. H. Emerson and Other Tourists on the Norfolk Broads," *Image* 35, nos. 1–2 (Spring/Summer 1992): 3–23; and Sarah Knight, "Change and Decay: Emerson's Social Order," in Neil McWilliam and Veronica Sekules, eds., *Life and Landscape: P. H. Emerson: Art and Photography in East Anglia, 1885–1900* (Norwich: Sainsbury Centre for Visual Arts, 1986), 12–20.

96. In 1864, the Scottish lens maker J. Traill Taylor averred that he had developed a special landscape lens that "gives a picture *generally sharp* all over the plate, but particularly sharp nowhere. In short, it has no real focus at all." J. T. Taylor, "Popular Notes on Photographic Lenses, Part II—Landscape Lenses" *British Journal of Photography*, April 15, 1864, 135. For an account of discussions regarding moving the lens during exposure to achieve a soft focus, see William Russell Young III, "The Soft-Focus Lens and Anglo-American Pictorialism," PhD diss., University of St. Andrews, 2008, 17–23.

97. George Davison, "Pinhole Pictures," *Photography* 1 (April 4, 1889): 241.

98. David Stone, for one, has noted this problem. See his entry for Peter Henry Emerson in John Hannavy, ed., *Encyclopedia of Nineteenth Century Photography* (New York: Routledge, 2007), 1:484.

99. Emerson asserts that moisture in the air subtracts from "the sharpness of line and detail of the image, and the farther off the object is, the thicker being the intervening layer of atmosphere, the greater is the turbidity *cæteris paribus*, therefore from this fact alone objects in different planes are not and should not be represented equally sharp and well-defined." Emerson, *Naturalistic Photography* (1889), 118.

100. Ibid., 150.

101. Due to the virtues of atmospheric turbidity, writes Emerson, "the student must be very careful on bright days about his focusing, for on such days there is no mist to assist him, but still he must keep the *planes separate*, or he has no picture." Ibid.

102. This difference has been conspicuously neglected in scholarship on the history of photography. Early writers on photography, perceiving a strong correspondence between the photograph and the natural scene it recorded, readily likened photographic irresolution to the atmospheric effects of ordinary vision. "Compared to the masterful daguerreotype," Herschel said, "Talbot produces nothing but mistiness." Quoted in Beaumont Newhall, *The History of Photography from 1839 to the Present Day* (New York: Museum of Modern Art, 1964), 33. Herschel was referring not to focal blur but rather to the softening effects of the fibrous paper Talbot used for both negative

and positive. Subsequent technologies, based on collodion, albumen, or gelatin, provided smooth and detailed prints, but the complex relationship between image resolution and atmospheric vapor remained important.

103. "Books and Exchanges," *American Amateur Photographer* 2, no. 10 (October, 1890): 408–409. The journal mistakenly—but humorously—lists the work under review as *East Anglican Life* rather than its true title, *East Anglian Life*.

104. Emerson, *Naturalistic Photography* (1889), 24.

105. Howard Pyle, *The Story of King Arthur and His Knights* (New York: Charles Scribner's Sons, 1903), 216.

106. Philippa Wright, "Emerson and His Reputation: Moves and Strategies," in John Taylor, ed., *The Old Order and the New: P. H. Emerson and Photography, 1885–1895* (Munich: Prestel, 2006), 129.

107. See, for example, Taylor, *The Old Order and the New.*

108. Thorstein Veblen, *The Theory of Business Enterprise* (New York: C. Scribner's Sons, 1904), 178.

109. Wiener, *English Culture,* 81.

110. Emerson, *Pictures of East Anglian Life,* 81. For an account of Emerson's views of social change in East Anglia, see Knight, "Change and Decay: Emerson's Social Order," 12–20.

111. See Carter Moffat, *Dr. Carter Moffatt's Ammoniaphone* (London: Medical Battery Company, 1885).

112. For an example of this practice, see the text produced by the J. Paul Getty Museum for a touring exhibition on Emerson's photography entitled—what else?—*The Old Order and the New.* The text reads in part: "In the image . . . the old order, represented by the derelict windmill at far left, is replaced by the new, steam-driven wheels of the dredging mill." "The Old Order and the New: P. H. Emerson and Photography, 1885–1895," accessed November 17, 2014, http://www.getty.edu/art/exhibitions/em erson. The exhibition was organized by the National Museum of Photography, Film and Television, Bradford, England.

113. Karl Marx, *The Poverty of Philosophy* (Chicago: Charles H. Kerr, 1920), 119.

114. At least one source, the Getty, has finessed this problem by featuring a detail of the mills to illustrate a discussion of the title, but this gambit only underscores the problem. See "The Old Order and the New: P. H. Emerson and Photography, 1885–1895," accessed November 17, 2014.

115. Quoted in Henri Zerner, "Gustave Le Gray, Heliographer-Artist," in *Gustave Le Gray: 1820–1884* (Los Angeles: J. Paul Getty Museum, 2002), 212. For more such analogies, see Steve Edwards, *The Making of English Photography: Allegories* (University Park: Pennsylvania State University Press, 2006), 311 n. 138.

116. Peter Henry Emerson, *The Death of Naturalistic Photography* (1890), reproduced in Peter Henry Emerson, *Naturalistic Photography for Students of the Art and The Death of Naturalistic Photography* (New York: Arno Press, 1973), n.p.

117. Ibid.

118. Emerson elsewhere attributes his about-face to a meeting he had with "a great artist" in Paris. Emerson met Whistler in August 1890 after sending him a portfolio of photographs. See Ronald Anderson and Anne Koval, *James McNeill Whistler: Beyond the Myth* (London: John Murray, 1994), 430.

119. The abruptness with which Emerson adopted a philosophy that fundamentally contradicted his own has often been attributed to his unstable personality and to Hurter and Driffield's discovery that the ratio of tonal densities cannot be altered through development without dodging and burning. But unstable personalities are a dime a dozen, and although Hurter and Driffield's findings were discouraging, they do not adequately explain his about-face. Photography always mixed constraints with controllable variables, so why should one more constraint make all the difference?

120. Emerson, *Death of Naturalistic Photography*.

121. *Photographic Mosaics* 24 (1888): 15.

122. Edward L. Wilson, "The Progress of Photography during 1891," *Photographic Mosaics* 28 (1892): 10.

123. P. H. Emerson, *Marsh Leaves: With Sixteen Photo-Etchings from Plates Taken by the Author* (London: David Nutt, 1895), 30, 32, 65, 68, 76, 81, 82.

124. Ian Jeffrey, "Emerson Overturned: On English Lagoons and Marsh Leaves," in *British Photography in the Nineteenth Century: The Fine Art Tradition,* ed. Mike Weaver (Cambridge: Cambridge University Press, 1989), 214.

125. P. H. Emerson, *On English Lagoons: Being an Account of the Voyage of Two Amateur Wherrymen on the Norfolk and Suffolk Rivers and Broads* (London: David Nutt, 1893), 50.

126. Ibid., 5–6.

127. Emerson, *Marsh Leaves,* 40.

5. Alfred Stieglitz Moves with the City

1. André Gunthert, "Daguerre's Black Box," in *The Dawn of Photography: French Daguerreotypes, 1839–1855,* CD-ROM (New York: Metropolitan Museum of Art, 2003).

2. L. Daguerre, "Daguerréotype," prospectus, c. March, 1838, reprinted in F. Reynaud, ed., *Paris et le Daguerréotype* (Paris: Paris-Musées, 1989), 22 ("Chacun, à l'aide du DAGUERRÉOTYPE, fera la vue de son château ou de sa maison de campagne").

3. For a discussion of George Eastman's efforts to develop a new photographic system, see Reese V. Jenkins, "Technology and the Market: George Eastman and the Origins of Mass Amateur Photography," *Technology and Culture* 16, no. 1 (January 1975): 1–19.

4. On the history of the instantaneous photograph in France, see André Gunthert, "La Conquête de l'instantané: Archéologie de l'imaginaire photographique en France (1841–1895)," PhD diss., École des Hautes Études en Sciences Sociales, 1999.

5. Edward L. Wilson, "A Few Hints Backward," *Photographic Mosaics* 24 (1888): 9.

6. See Walter Benn Michaels, *The Gold Standard and the Logic of Naturalism* (Berkeley: University of California Press, 1987), 236–237.

7. *Photographic Mosaics* 24 (1888): 16.

8. For example, the introduction of dry plates, which were easier to use than wet collodion plates, gave rise to anxiety about the ease with which nonserious amateurs could take up photography. See Paul Sternberger, *Between Amateur and Aesthete* (Albuquerque: University of New Mexico Press, 2001), xvii.

9. Burrow-Giles Lithographic Co. v. Sarony, 111 U.S. 53 (1884).

10. Ibid., 60.

11. On Stieglitz's practice of drawing compositions from academic paintings, see Sarah Greenough, "The Key Set," in *Alfred Stieglitz: The Key Set* (Washington, D.C.: National Gallery of Art, 2002), 1:xi–lviii, especially xiv–xvi.

12. In 1893, Stieglitz reviewed an international photography exhibition in Philadelphia, which he claimed was "without doubt the finest exhibition of photographs ever held in the United States," and in which he had twenty-one of his own photographs on display. In his review, he credited Emerson with spurring photographers to produce works of artistic merit: "How many people realize the enormous benefit that P. H. Emerson has bestowed upon photographic art?" he asks rhetorically. "Call him by whatever name you may, criticize him from any point of view, and still the fact remains: his teachings formed the basis of what we saw in this exhibition." Alfred Stieglitz, "The Joint Exhibition at Philadelphia," *American Amateur Photographer* 5 (May 1893): 201; "The Sixth Joint Exhibition," *American Journal of Photography* 14 (May 1893): 215; "The Joint Exhibition at Philadelphia," 202. On platinum printing and atmosphere, see Alfred Stieglitz, "Platinum Printing," in *Picture Taking and Picture Making* (Rochester, N.Y.: Eastman Kodak, 1898), 67.

13. Alfred Stieglitz, "A Plea for Art Photography in America," *Photographic Mosaics* 28 (1892): 136–137.

14. See Rosina Herrera, "Alfred Stieglitz's Lantern Slides: History, Technique and Technical Analysis," Advanced Residency Program in Photographic Conservation report, George Eastman House, September 2007. For a more thorough discussion regarding Stieglitz's possible camera equipment during this key moment, see Jay Bochner, *An American Lens: Scenes from Alfred Stieglitz's New York Secession* (Cambridge: MIT Press, 2005), 321–322 n. 22.

15. On the material qualities and condition of Stieglitz's lantern slides from the 1890s, see Herrera, "Alfred Stieglitz's Lantern Slides."

16. From personal inspection. But see also Herrera, "Alfred Stieglitz's Lantern Slides," n.p.

17. Alfred Stieglitz, "Some Remarks on Lantern Slides," *The American Amateur Photographer* 9, no. 10 (October 1897): 447.

18. Few of Stieglitz's contemporaries were even tackling the modern figure in a fresh way. W. S. Briggs was an exception. See his *An Active Market,* in *New England Magazine* 8:2 (April 1893): 195.

19. Charlotte Adams, "An Answer to Mr. W. J. Stillman's Opinion of Photo. Art," *Philadelphia Photographer* (July 3, 1886): 386.

20. Sadakichi Hartman, "A Plea for Straight Photography," *The American Amateur Photographer* 15, no. 3 (March 1904): 102.

21. Ibid., 104.

22. Ibid.

23. On Galton and eugenics, see Daniel Kevles, "Francis Galton, Founder of the Faith," in *In the Name of Eugenics: Genetics and the Uses of Human Heredity* (Berkeley: University of California Press, 1985). On Galton and photography, see Allan Sekula, "The Body and the Archive," *October* 39 (Winter 1986): 3–64.

24. On the importance of historically embedding street photography in particular locations, see Katherine Bussard, *Unfamiliar Streets: The Photographs of Richard Avedon, Charles Moore, Martha Rosler, and Philip-Lorca diCorcia* (New Haven, Conn.: Yale University Press, 2014).

25. On the metaphoric reach of phase changes, see Henry Adams, "The Rule of Phase Applied to History" (1909), in *The Degradation of the Democratic Dogma* (New York: Macmillan, 1919).

26. Karl Marx and Friedrich Engels, *The Communist Manifesto: A Modern Edition* (London: Verso, 1998), 38.

27. James Clerk Maxwell to Lewis Campbell, July 1850, in *The Scientific Letters and Papers of James Clerk Maxwell,* ed. P. M. Harman (Cambridge: Cambridge University Press, 1990), 1:197. Harman has conjectured that Maxwell's remarks may have been stimulated by a reading of Herschel's review of Quetelet's book. P. M. Harmon, *The Natural Philosophy of James Clerk Maxwell* (Cambridge: Cambridge University Press, 2001), 125.

28. Karl August Krönig, "Grundzüge einer Theorie der Gase," *Annalen der Physik* 99 (1856): 316, quoted in English translation by Elizabeth Wolfe Garber, "Clausius and Maxwell's Kinetic Theory of Gases," *Historical Studies in the Physical Sciences* 2 (1970): 299–319.

29. James Clerk Maxwell to Sir George Gabriel Stokes, May 30, 1859, in *Scientific Letters and Papers of James Clerk Maxwell,* 1:610.

30. *The Scientific Papers of James Clerk Maxwell,* ed. W. D. Niven (Cambridge: Cambridge University Press, 1890), 2:253.

31. For more detail, see Stephen G. Brush, "Foundations of Statistical Mechanics, 1845–1915," *Archive for History of Exact Sciences* 4, no. 3 (1967): 145–183.

32. See James Clerk Maxwell, "On Governors," *Proceedings of the Royal Society* 16, no. 100 (1868): 1–12.

33. On Stieglitz's exposure to and understanding of modern scientific developments, see Geraldine Wojno Kiefer, "Alfred Stieglitz and Science, 1880–1910," PhD diss., Case Western Reserve University, 1990.

34. The lantern slide was not the only format that Stieglitz used for these pictures. In 1894, he exhibited at least one and probably two of them as carbon prints at the annual Royal Photographic Society exhibition in London. One carbon print was titled *The Terminus,* which is doubtless the picture now known as *The Terminal.* The other was titled *Winter,* and Sarah Greenough has speculated reasonably that it was probably the picture now known as *Winter, Fifth Avenue.* See "Catalogue: Thirty-Ninth Annual Exhibition, 1894," *The Journal and Transactions of the Royal Photographic Society* 19, no. 1 (September 1894): 4, 6, 12; and Greenough, *Alfred Stieglitz: The Key Set,* 1:49.

35. The showing was on September 27. *The Photographic Journal: Transactions of the Royal Photographic Society,* September 25, 1897, xxxii. Thus, by quick calculation, Stieglitz contributed more than one-quarter of the lantern slides in competition at the exhibition.

36. In 1861, Maxwell gave a demonstration at the Royal Institution in London of a color photography process he had devised. The process entailed using three magic lanterns to superimpose images of three black and white slides of the same subject (a tartan ribbon). The photographer and inventor Thomas Sutton had made the slides using three color filters, one red, one blue, and one green, and the slides were projected using filters of the corresponding color. The result was an image that more or less faithfully reproduced the colors of the original subject.

37. Because of the magnification of the projected image, the makers and users of lantern slides had to be exceedingly careful to keep them free of dust. In 1890, one writer warned his fellow photographers: "Specks and motes are ever present in the air, and either in the act [of making a negative] or in the drying will become affixed, and these, unseen in the ordinary print, are made visible in the lantern positive by its enormous amplification on the sheet." J. J. Higgins, "On Lantern Negatives," *Photographic Mosaics* 26 (1890): 58–59.

38. The social experience of projected images has been a central issue in discussions of cinema and its history. See Walter Benjamin, "The Work of Art in the Age of Its Technological Reproducibility: Second Version," in *The Work of Art in the Age of Its Technological Reproducibility,* ed. Michael W. Jennings, Brigid Doherty, and Thomas Y. Levin (Cambridge, Mass.: Harvard University Press, 2008), 19–55; see also Miriam Hansen, *Cinema and Experience: Siegfried Kracauer, Walter Benjamin, and Theodor W. Adorno* (Berkeley: University of California Press, 2012).

39. Percy Bysshe Shelley, "Lines," in *The Poetical Works of Percy Bysshe Shelley* (London: Ward, Lock, 1879), 532.

40. John Ruskin, *Modern Painters* (London: Smith, Elder, 1848), 1:208.

41. In the late nineteenth century, the behavior of particles suspended in a gas or liquid was playing a key role in debates about the possible atomic or molecular structure of matter, and in 1888, the French physicist Louis-Georges Gouy made new observations concerning Brownian motion that attracted great interest from the scientific community. L.-G. Gouy, "Note sur le movement brownien," *Journal de Physique, Théorique, et Appliqu*ée 7:1 (1888): 561–564. On the significance of Gouy's observations, see J. Perrin, "Mouvement brownien et réalité moléculaire," *Annales de Chimie et de Physique* 18 (1909): 1–114. For more on this history, see Bertrand Duplantier, "Brownian Motion, 'Diverse and Undulating,'" in T. Damour, O. Darrigol, B. Duplantier, and V. Rivasseau, eds., *Progress in Mathematical Physics* 47 (Basel: Birkhäuser Verlag, 2006): 201–293.

42. Alfred Stieglitz, "The Hand Camera—Its Present Importance," *American Annual of Photography and Photographic Times Almanac* (1897): 24–25.

43. Jean Porter Rudd, "My Wheel and I," *Outing Magazine* 26 (May 1895): 124.

44. Gary Allan Tobin, "The Bicycle Boom of the 1890's: The Development of Private Transportation and the Birth of the Modern Tourist," *Journal of Popular Culture* 7, no. 4 (Spring 1974): 838–849; Robert A. Smith, *A Social History of the Bicycle* (N.Y.: American Heritage Press, 1972).

45. "Champion of Her Sex: Miss Susan B. Anthony," *New York World,* February 2, 1896.

46. In the late 1880s, the London publisher Iliffe and Son produced a series of "Indispensable Technical Handbooks." In a preface to one, the editor and compiler write: "Treating on the subject of the construction, varieties and use of the Bicycle, the Tricycle, the Safety Bicycle, and Photographic Apparatus respectively, these Handbooks have proved wonderfully popular and have gone through several editions." Walter D. Welford and Henry Sturmey, eds., *The "Indispensable Handbook" to the Optical Lantern: A Complete Cyclopaedia on the Subject of Optical Lanterns, Slides, and Accessory Apparatus* (London: Iliffe and Son, 1888), 5.

47. Although many sources say that Stieglitz purchased a Folmer and Schwing 4-by-5 camera in 1892, the company evidently did not manufacture cameras until 1896 or so.

48. J. B. Jackson, "The Abstract World of the Hot Rodder," *Landscape Magazine* 7 (Winter 1957): 27. On the import of the near simultaneous emergence of the bicycle and the Kodak camera, see Kenneth Helphand, "The Bicycle Kodak," *Environmental Review* 4, no. 3 (1980): 26.

49. In 1893, while Stieglitz was roaming the streets of New York with his handheld camera, the United States government was establishing the Office of Road Inquiry within the Department of Agriculture to provide information to support and

guide road improvement efforts. Also in 1893, New York State passed a law allowing counties to raise funds to improve roads.

50. Stieglitz, "The Hand Camera," 19.

51. Helmut Müller-Sievers, *The Cylinder: Kinematics of the Nineteenth Century* (Berkeley: University of California Press, 2012).

52. The way these vapors obscure the receding lines of the elevated railway recalls this passage from Damisch:

> Perspective only needs to "know" things that it can reduce to its own order, things that occupy a place and the control of which can be defined by lines. But the sky does not occupy a place, and cannot be measured; and as for clouds, nor can their outlines be fixed or their shapes analyzed in terms of surfaces. A cloud belongs to the class of "bodies without surfaces," as Leonardo da Vinci was to put it, bodies that have no precise form or extremities and whose limits interpenetrate with those of other clouds.

Hubert Damisch, *A Theory of /Cloud/: Toward a History of Painting,* trans. Janet Lloyd (Stanford, Calif.: Stanford University Press, 2002). 124. For another analysis of smoke as a semiotic antithesis to the perspectival grid, see Michael Gaudio, "Making Sense of Smoke," in *Engraving the Savage: The New World and Techniques of Civilization* (Minneapolis: University of Minnesota Press, 2008), 45–86.

53. On the ethically complex relationship between photographic restraint and violation, see John Roberts, *Photography and Its Violations* (New York: Columbia University Press, 2014), esp. 1–5.

54. For a discussion of Stieglitz's 1893 photography and labor strikes, see Bochner, *An American Lens,* 1–22.

6. Stalking Chance and Making News, c. 1930

1. John Dewey, *The Later Works, 1925–1953,* ed. Jo Ann Boydston (Carbondale, Ill.: Southern Illinois University Press, 1981), 1:43. As Jason Puskar notes, for Dewey these historical conditions justified a welcome discharge of stagnant forms of metaphysics. See Jason Puskar, *Accident Society: Fiction, Collectivity, and the Production of Chance* (Stanford, Calif.: Stanford University Press, 2012), 20.

2. For a discussion of photography and the unseen, see Walter Benjamin, "Little History of Photography," in *The Work of Art in the Age of Its Technological Reproducibility,* ed. Michael W. Jennings, Brigid Doherty, and Thomas Y. Levin (Cambridge, Mass.: Harvard University Press, 2008), 276–279; and Shawn Michelle Smith, *At the Edge of Sight: Photography and the Unseen* (Durham, N.C.: Duke University Press, 2013).

3. Sir John Herschel, "Instantaneous Photography," *Photographic News* 4, no. 88 (May 11, 1960): 13. Jordan Bear has referred to Oscar Rejlander and Henry Peach

Robinson as "hunter-photographers" and discussed the discursive proximity of hunting and photography in the 1860s and after. See Jordan Bear, "Look Again: The Multiples of Photographic Discernment and Production," *Photography and Culture* 2, no. 1 (March 2009): 62, 58–65. In a less historically specific mode, Vilem Flusser has noted that the impression given by "a human being in possession of a camera (or a camera in possession of a human being)" is "of someone lying in wait. This is the ancient act of stalking which goes back to the Paleolithic hunter in the tundra." Vilem Flusser, *Towards a Philosophy of Photography*, trans. Anthony Mathews (London: Reaktion Books, 2000), 33.

4. On cameras, guns, and hunting, see Donna Haraway, *Primate Visions: Gender, Race, and Nature in the World of Modern Science* (New York: Routledge, 1989), 42–46.

5. See, e.g., Robert E. Mensel, "'Kodakers Lying in Wait': Amateur Photography and the Right of Privacy in New York, 1885–1915," *American Quarterly* 43, no. 1 (March 1991): 24–45; and Minna Irving, "The Camera Fiend," in Peter E. Palmquist, ed., *Camera Fiends and Kodak Girls II: 60 Selections by and about Women in Photography, 1855–1965* (New York: Midmarch Arts Press, 1995), 99.

6. See Walter Benn Michaels, *The Gold Standard and the Logic of Naturalism* (Berkeley: University of California Press, 1987), 225–234.

7. "A. W. Dimock Dead; Financier-Author," *New York Times,* September 13, 1918.

8. Anthony Weston Dimock, *Wall Street and the Wilds* (Deposit, N.Y.: Outing Publishing, 1915).

9. Ibid., 61.

10. Ibid., 68.

11. Ibid., 435–436.

12. A. W. Dimock, "Camera vs. Rifle," *Photographic Mosaics* 28 (1892): 78.

13. Dimock, *Wall Street and the Wilds,* 453–454.

14. Ibid., 72.

15. Dimock preferred the phrase "the gambler in stocks," because he regarded "speculator" as a "euphemism" that "deceives only the unintelligent." Ibid., 76.

16. Ibid.

17. Ibid., 81.

18. Ibid., 86.

19. L. P. Jacks, *The Revolt against Mechanism* (New York: Macmillan, 1934), 13.

20. Ibid., 32.

21. Dimock, *Wall Street and the Wilds,* 88.

22. Sigmund Freud, *Psychopathology of Everyday Life,* trans. A. A. Brill (London: T. Fisher Unwin, 1901).

23. Norbert Wiener, *The Human Use of Human Beings: Cybernetics and Society* (New York: Avon Books, 1967), 14. The first version of the book was published in 1948.

24. Ibid., 19.

25. Wiener, for example: "This recognition of an element of incomplete determinism, almost an irrationality in the world, is in a certain way parallel to Freud's admission of a deep irrational component in human conduct and thought." Ibid., 19.

26. On Freud and photography generally, see Mary Bergstein, *Mirrors of Memory: Freud, Photography, and the History of Art* (Ithaca, N.Y.: Cornell University Press, 2010).

27. Marshall McLuhan, *Understanding Media: The Extensions of Man* (Cambridge, Mass.: MIT Press, 1994), 197.

28. "Preface," in *Catalogue of Exhibits of the Fifth Annual Joint Exhibition of the Photographic Society of Philadelphia, The Society of Amateur Photographers of New York, and the Boston Camera Club* (Boston: Boston Camera Club, 1892), 5.

29. On the Rorschach test, see Peter Galison, "Image of Self," in Lorraine Daston, ed., *Things That Talk: Object Lessons from Art and Science* (New York: Zone Books, 2007), 257–296.

30. Rosalind Krauss, "Stieglitz/Equivalents," *October* 11 (Winter 1979): 129–140.

31. Weston Naef, ed., *Alfred Stieglitz: Photographs from the J. Paul Getty Museum* (Malibu: J. Paul Getty Museum, 1995), 132.

32. On the historical difficulty and implications of transporting pictures, see *Jennifer Roberts, Transporting Visions: The Movement of Images in Early America* (Berkeley: University of California Press, 2014).

33. When digital cameras arrived to great fanfare the 1980s, it was generally forgotten that wire services had been trafficking in digital images for several decades.

34. For a discussion of Futurism and motion photography, see Marta Braun, "Marey, Modern Art, and Modernism," in *Picturing Time: The Work of Étienne-Jules Marey (1830–1904)* (Chicago: University of Chicago Press, 1992), 264–319.

35. Anton Giulio Bragaglia, "Futurist Photodynamism" (1911), trans. and ed. Lawrence Rainey, *Modernism/Modernity* 15, no. 2 (2008): 366.

36. Ibid., 367.

37. On Kertész, see Sandra Phillips, "The Photographic Work of André Kertész in France, 1925–36," PhD diss., City University of New York, 1985.

38. On Cartier-Bresson and surrealism, see Ian Walker, *City Gorged with Dreams: Surrealism and Documentary Photography in Interwar Paris* (Manchester: Manchester University Press, 2002, 168–187. Breton's notion of objective chance changed over time. See Denis Lejeune, *The Radical Use of Chance in 20th Century Art* (Amsterdam: Rodopi, 2012), 85–128; and Margaret Cohen, *Profane Illumination: Walter Benjamin and the Paris of Surrealist Revolution* (Berkeley: University of California Press, 1993), 140–145.

39. Ian Walker has wisely observed that the ambiguous and unsettling quality of the picture renders the thrown ball a "red herring." Walker, *City Gorged with Dreams*, 176.

40. Clément Chéroux, *Henri Cartier-Bresson,* trans. David H. Wilson (London: Thames and Hudson, 2008), 38–39.

41. In the words of a prominent curator, Cartier-Bresson in the early 1930s sought to locate his figures in a "surrealist theater." Peter Galassi, *Henri Cartier-Bresson: The Early Work* (New York: Museum of Modern Art, 1987), 41.

42. Quoted in Peter Galassi, "And Everything in Between," in Philippe Arbaizar et al., *Henri Cartier-Bresson: The Man, the Image, and the World* (London: Thames and Hudson, 2003), 19.

43. See A. D. Coleman, "The Directorial Mode: Notes toward a Definition," *Artforum* 15, no. 1 (September 1976): 55–61.

44. Galassi, *Henri Cartier-Bresson: The Early Work,* 37.

45. Cartier-Bresson's photographic practice also shifted away from ambiguity and toward narrative disclosure. See Walker, *City Gorged with Dreams,* 176–179.

46. Henri Cartier-Bresson, *The Mind's Eye: Writing on Photography and Photographers* (New York: Aperture, 1999), 33.

47. Ibid., 16.

48. Henri Cartier-Bresson, in conversation with Charlie Rose, July 6, 2000, accessed September 10, 2008, http://www.charlierose.com/shows/2000/07/06/2/a-conversation-with-henri-cartier-bresson.

49. The words are Cartier-Bresson's. See Adam Bernstein, "The Acknowledged Master of the Moment," *Washington Post,* August 5, 2004.

50. Cartier-Bresson, *The Mind's Eye,* 22.

51. For a related theory of more recent vintage, see Malcolm Gladwell, *Blink: The Power of Thinking without Thinking* (New York: Little, Brown, 2005).

52. Bernstein, "The Acknowledged Master."

53. Cartier-Bresson, *The Mind's Eye,* 32.

54. Ibid.

55. Jean François Paul de Gondi, *Mémoires de Cardinal de Retz* (Paris: Belin-Leprieur, 1844), 2:86–96. De Retz was referring to decisive moments not in quickly unfolding action but in historical events.

56. Cartier-Bresson, *The Mind's Eye,* 32.

57. The essay appeared in Carl Jung, *Natuererklärung und Psyche* (Zurich: Rascher, 1952). An English translation of the volume appeared in 1955. Carl Jung, *The Interpretation of Nature and the Psyche,* trans. R. F. C. Hull (New York: Bollingen Foundation, 1955). All references are to this English version. In it, Jung argues that unique ephemeral events fall outside the purview of the experimental method and can reveal acausal connections between events. Carl Jung, "Synchronicity: An Acausal Connecting Principle," in Jung, *Interpretation of Nature,* 8.

58. Ibid., 30–31.

59. Eugen Herrigel, *Zen in the Art of Archery,* trans. R. F. C. Hull (London: Routledge & Kegan Paul, 1953), 47.

60. Bernstein, "The Acknowledged Master."

61. See Klaus Conrad, *Die beginnende Schizophrenie. Versuch einer Gestaltanalyse des Wahns* (Stuttgart: Thieme, 1958).

62. Galassi, *Henri Cartier-Bresson: The Early Work,* 29.

63. Joe Rosenthal with W. C. Heinz, "The Picture That Will Last Forever," *Collier's,* February 18, 1955, 62–67.

64. Ibid., 65.

65. Ibid., 64.

66. Ibid., 66.

67. See Donald R. Winslow, "The Pulitzer Eddie Adams Didn't Want," *Lens* (blog), *New York Times,* April 19, 2011.

68. In his excellent book on Lartigue, Kevin Moore has suggested, on the basis of a review of early twentieth-century advertisements and magazine illustrations, that Lartigue's photograph of the Grand Prix race car was "simply executing existing tropes, not inventing them." Kevin Moore, *Jacques Henri Lartigue: The Invention of an Artist* (Princeton, N.J.: Princeton University Press, 2004), 89. Although this admonition is a valuable corrective to exaggerated accounts, the precedents Moore assembles at best vaguely anticipate key visual qualities of Lartigue's photograph.

69. On the history of Lartigue's photograph, see Clément Chéroux, *Fautographie: Petite histoire de l'erreur photographique* (Crisnée: Yellow Now, 2003), 54–61.

70. Russell Maloney, "Inflexible Logic," *New Yorker,* Feb. 3, 1940, 19–22.

71. William James Stillman, "The Art Side of Photography," *Photographic Times and American Photographer* 19, no. 1 (May 3, 1889): 217.

7. Frederick Sommer Decomposes Our Nature

1. The biographical information in this and the following paragraphs derives from the chronology provided in Naomi Lyons and Jeremy Cox, eds., *The Art of Frederick Sommer: Photography, Drawing, Collage* (Prescott, Ariz.: Frederick and Frances Sommer Foundation, 2005) and a reading of many of the documents on which this chronology relies.

2. Prior to 1935, Sommer made photographs in Switzerland, some of which he put into an album now housed in the Frederick and Frances Sommer Foundation. These pictures are mainly rather conventional mountain landscapes or outdoor scenes.

3. Lyons and Cox, *The Art of Frederick Sommer,* 220.

4. Edward Weston, *The Daybooks of Edward Weston,* ed. Nancy Newhall (New York: Aperture, 1973), 1:9.

5. Weston, *Daybooks,* 2:154.

6. Ibid., 2:156.

7. Weston, *Daybooks,* 2:9.

8. Weston, *Daybooks,* 2:146.

9. Ibid., 228–229.

10. Edward Weston, "Light and Lighting," *Camera Craft* 46, no. 5 (May 1939): 197–205, reproduced in Peter C. Bunnell, ed., *Edward Weston on Photography* (Salt Lake City: P. Smith Books, 1983), 97–102, 101.

11. On Goethe and the spiral, see Jocelyn Holland, *German Romanticism and Science: The Procreative Poetics of Goethe, Novalis, and Ritter* (New York: Routledge, 2009), 50–52; see also Helmut Müller-Sievers, *The Cylinder: Kinematics of the Nineteenth Century* (Berkeley: University of California Press, 2012), 146–147.

12. Transcript of Seminar 7, November 14, 1979, Princeton, Box 17, Frederick Sommer Archives, Center for Creative Photography (henceforth FSA, CCP). Although this chapter makes extensive use of Sommer's interviews and writings, care must be taken to respect the gap between his wartime practice and these materials, which come almost entirely from long after the war. By then his practice had changed considerably, and doubtless his philosophical musings, too. The passages quoted in this chapter offer particular insight into his wartime work.

13. Transcript of interview at Visual Studies Workshop, 1973, FSA, CCP.

14. Transcript of public lecture at Princeton, October 22, 1979, FSA, CCP.

15. Transcript of Princeton seminar no. 1, September 19, 1979, FSA, CCP.

16. "Is it legitimate ever to arrange something?" Sommer once asked rhetorically. "Yes," he answered, "because the positions that would be the underpinning of your new state of affairs would be the ones you care to serve." Transcript of a talk given at the Art Institute of Chicago, 1970, revised 1983, reproduced in Frederick Sommer, *Sommer: Words* (Tucson, Ariz.: Center for Creative Photography, 1983), 40–49.

17. Transcript of Princeton seminar no. 2, September 26, 1979, FSA, CCP.

18. The two photographs are almost certainly historically connected. After taking his photographs of dead rabbits, Weston immediately wrote Sommer, with whom he had just been visiting. Postcard from Edward Weston to Frederick and Frances Sommer, postmarked January 11, 1938, FSA, CCP.

19. Transcript of interview with James McQuaid, International Museum of Photography/George Eastman House Oral History Project, Prescott, Ariz., December 2–6, 1976, Frederick and Frances Sommer Foundation (henceforth FFSF).

20. Sommer, *Sommer: Words,* 27.

21. The list is reproduced in ibid., 60–62.

22. In one of his aphoristic verses, Sommer writes: "Whatness is concerned with content. / In the solemnity of every hour life returns. / Whereness is concerned with linkages. / The legato of one squirrel holds a forest together." Sommer and Stephen Aldrich, "The Poetic Logic of Art and Aesthetics," reproduced in ibid., 36.

23. Transcript of Princeton seminar no. 10, December 5, 1979, FSA, CCP. Sommer attributed his purchase of the lens to a kind of beginner's luck: "By some chance, which turns out to be one of those good things that happens to an individual when he doesn't really know what he's doing, I bought a lens in Switzerland for 12

dollars. It was a 21 cm Zeiss Tessar f/4.5. Now, no intelligent person who knew a lot about photography would have bought an f/4.5 at that time. . . . But I didn't know anything about that." Transcript of Princeton seminar no. 10, December 5, 1979, FSA, CCP.

24. Rosalind Krauss, *The Optical Unconscious* (Cambridge, Mass.: MIT Press, 1993), 246.

25. Transcript of interview with James McQuaid, FFSF.

26. Transcript of interview at Visual Studies Workshop, 1973, FSA, CCP. Apart from this slow pace, Sommer may have learned his approach for showing photographs from Weston. See Beaumont Newhall, *Focus: Memoirs of a Life in Photography* (Boston: Bulfinch, 1993), 63.

27. The controversy attending Arthur Rothstein's moving of a steer skull in 1936 revealed the emergence of this ethos. See James Curtis, *Mind's Eye, Mind's Truth: FSA Photography Reconsidered* (Philadelphia: Temple University Press, 1989), 70–76.

28. Edward Weston, entry for March 8, 1930, in Weston, *Daybooks,* 2:146.

29. Transcript of Princeton seminar no. 13, January 8, 1980, FSA, CCP. The critics Roberta Hellman and Marvin Hoshino have put it this way: "Sommer . . . dismisses photography's sacred distinction between the found and the arranged by applying the Surrealist notion of 'chance' correctly: there is no difference between a subject the photographer finds 'intentionally' and one he creates by 'chance.'" Roberta Hellman and Marvin Hoshino, "Frederick Sommer," *Arts Magazine* 51, no. 10 (June 1977): 23.

30. "Frederick Sommer: 1939–1962 Photographs," *Aperture* 10, no. 4 (1962): 153.

31. In a delicious historical irony, puncture vine was rumored decades later to contain a testosterone booster that could assist body builders. Thus it deflated tires but was believed to pump people up.

32. Of Weston, Sommer once said: "He went out into nature and saw things under all sorts of conditions and he just let them be. He didn't conduct a critique of every morsel he was going to eat—that would give a guy indigestion." Transcript of interview at Visual Studies Workshop, 1973, FSA, CCP. Elsewhere, Sommer opined: "Aesthetics is the condition that wants to celebrate what our feelings are. And it starts with the taste buds. The taste buds are the most under-rated instruments that we have." Transcript of Princeton seminar no. 6, November 7, 1979, FSA, CCP.

33. From interviews conducted by Michael Torosian. See Lyons and Cox, *Art of Frederick Sommer,* 210.

34. The store is identified as the Piggly Wiggly in ibid., 222.

35. In his oft-cited essay of 1906, Ernst Jentsch defined the uncanny as "doubt as to whether an apparently living being is animate and, conversely, doubt as to whether a lifeless object may not in fact be animate." Ernst Jentsch, "On the Psychology of the Uncanny" (1906), trans. Roy Sellars, *Angelaki* 2, no. 1 (January 1997): 11.

36. Sigmund Freud, "The Uncanny," in *The Standard Edition of the Complete Psychological Works of Sigmund Freud,* ed. James Strachey (London: Hogarth Press, 1955), 17:244.

37. On *rhopos* and rhopography, see Norman Bryson, *Looking at the Overlooked: Essays on Still Life Painting* (Cambridge, Mass.: Harvard University Press, 1990).

38. See Robert Parker, *Miasma, Pollution and Purification in Early Greek Religion* (Oxford: Clarendon Press, 1983).

39. "World War II increased the military demand for poultry products. Military purchasers asked the USDA to supply the inspection and certification services necessary for processors to meet their specifications. As market preference shifted from live poultry to New York—dressed poultry and then to ready-to-cook (RTC) poultry, the USDA modified its inspection and certification program. . . . The wartime poultry needs of the military were met by plants surveyed and found to meet military sanitation requirements. Thereafter, the USDA required evisceration and canning plants to process New York–dressed poultry purchased only from plants that met USDA sanitation requirements." Sacit F. Bilgili, "Poultry Meat Inspection and Grading," in Casey M. Owens, Christine Alvarado, and Alan R. Sams, eds., *Poultry Meat Processing,* 2nd ed. (London: CRC Press, 2010), 49. For a broader discussion of these historical changes, see Roger Horowitz, *Putting Meat on the American Table* (Baltimore: Johns Hopkins University Press, 2006). Horowitz includes some interesting reproductions from promotional materials, including an advertisement for "Sanitary Poultry Eviscerating Equipment" from the 1940s and an advertisement for an automatic meat cutting machine that boasts "Meat Not Touched by Hand"; ibid., 92, 115. Historically, leaving the feet and head on the bird served the interests of consumers, who evaluated quality by looking for bright eyes, soft feet, and clear, yellowish skin; ibid., 108. Increasingly, the quality of the parts spoke for themselves through the cellophane-wrapped package; ibid., 137–141.

40. Piggly Wiggly website, accessed November 10, 2014, http://www.pig glywiggly.com/about-us.

41. Quoted in Freud, "The Uncanny," 225.

42. Interview with Studs Terkel, 1963. Transcript by author from tape in the collection of the FFSF.

43. As Hal Foster has noted, "refuse" is "not the other of the mechanical-commodified but its outcome." Hal Foster, *Compulsive Beauty* (Cambridge, Mass.: MIT Press, 1993), 144.

44. Transcript of Princeton seminar no. 4, October 10, 1979, FSA, CCP.

45. Jacques Lacan, *The Four Fundamental Concepts of Psycho-Analysis,* ed. Jacques-Alain Miller, trans. Alan Sheridan (New York: Norton, 1981), 95.

46. Ibid., 95–97. In the midst of Lacan's anamorphic discourse on the gaze, his famous diagram of intersecting triangles is a trap (as he says, "in this matter of the

visible, everything is a trap"). To the viewer it offers the gaze with the very geometric neatness that utterly contradicts its point, "which always participates in the ambiguity of the jewel." Ibid., 93, 96.

47. Ibid., 84.

48. Ibid., 89.

49. Ibid., 101.

50. Ibid.

51. For heuristic reasons, I am being reductive. The split between vision and gaze cannot be defined so neatly in the Holbein picture. On this point, see Slavoj Zizek, *Jacques Lacan: Critical Evaluations in Cultural Theory* (London: Taylor and Francis, 2003), 166.

52. Lacan, *The Four Fundamental Concepts of Psycho-Analysis*, 95–96.

53. Ibid., 95.

54. Ibid.

55. Stories abound concerning the introspection that tuberculosis has afforded by requiring a withdrawal from the world and a slowing of daily routine. Several years before Sommer arrived at Arosa for tuberculosis treatment, the physicist Erwin Schrödinger received treatment there for the same disease. Both during his initial treatment and during return visits to Arosa, Schrödinger developed some of his most profound insights into quantum mechanics. See Walter J. Moore, *Schrödinger: Life and Thought* (Cambridge: Cambridge University Press, 1992), 145–196.

56. Undated, unsigned typed memorandum, FSA, CCP.

57. Transcript of interview at Visual Studies Workshop, 1973, FSA, CCP.

58. Edward Weston to Frederick Sommer, December 6, 1939, FSA, CCP.

59. Ibid.

60. Lacan, *The Four Fundamental Concepts of Psycho-Analysis*, 95.

61. Kenneth Schuyler Lynn, *Hemingway* (Cambridge, Mass.: Harvard University Press, 1995), 483.

62. My interpretation of this passage as bathetic differs from, but is certainly indebted to, Joan Copjec, "The Orthopsychic Subject: Film Theory and the Reception of Lacan," *October* 49 (Summer 1989): 66.

63. On the importance of naming, see Saul Kripke, *Naming and Necessity* (Cambridge, Mass.: Harvard University Press, 1972).

64. Transcript of Princeton seminar no. 2, September 26, 1979, CCP.

65. In later years, Sommer was explicit about the importance of an inclusive composition: "What is at stake in all this is that the image must function from edge to edge." Transcript of Princeton seminar no. 8, November 11, 1979, CCP.

66. According to Sarah Greenough, Stieglitz made one cloud photograph, his last, in 1935. See Sarah Greenough, "Alfred Stieglitz's Photographs of Clouds," PhD diss., University of New Mexico, 1984, 175.

67. As quoted in Dorothy Norman, *Alfred Stieglitz: An American Seer* (New York: Random House, 1973), 144.

68. Transcript of interview with James McQuaid, FFSF.

69. An article on photographic equivalence in *Aperture* associates Sommer and his landscape work with the notion, but without acknowledging Sommer's radical reformulation of it. See "The Equivalent Tradition," *Aperture* 95 (Summer 1984): 6–25.

70. Barthes coins these terms in *Camera Lucida,* trans. Richard Howard (New York: Hill and Wang, 1981). For many purposes, the more general terms of *arrangement* and *interruptant* might be preferable. See Robin Kelsey, "Photography, Chance, and *The Pencil of Nature,*" in Robin Kelsey and Blake Stimson, eds., *The Meaning of Photography* (New Haven, Conn.: Yale University Press, 2008), 17.

71. Transcript of Princeton seminar no. 8, November 11, 1979, CCP.

72. Transcript of McQuaid interview, FFSF.

8. Pressing Photography into a Modernist Mold, c. 1970

1. See Sybil Gordon Kantor, *Alfred H. Barr, Jr., and the Intellectual Origins of the Museum of Modern Art* (Cambridge, Mass.: MIT Press, 2002).

2. Barr observed that cinema in Russia "is more artistically, as well as politically, important than the easel picture." Quoted in ibid., 172.

3. Philip Johnson, *Machine Art,* foreword by Alfred H. Barr Jr. (New York: Museum of Modern Art, 1934).

4. Beaumont Newhall, *Photography 1839–1937* (New York: Museum of Modern Art, 1937). See also Christopher Phillips, "The Judgment Seat of Photography," *October* 22 (Autumn 1982): 27–63; Douglas R. Nickel, "History of Photography: The State of Research," *Art Bulletin* 83, no. 3 (September 2001): 548–558; Beaumont Newhall, *Focus: Memoirs of a Life in Photography* (Boston: Bulfinch Press, 1993); Douglas Nickel and Sophie Hackett, "Beaumont Newhall and a Machine: Exhibiting Photography at the Museum of Modern Art in 1937," *Études Photographiques* 23 (May 2009): 177–191; Marta Braun, "Beaumont Newhall et l'historiographie de la photographie anglophone," *Études Photographiques* 16 (May 2005): 19–31; Christine Y. Hahn, "Exhibition as Archive: Beaumont Newhall, *Photography 1839–1937,* and the Museum of Modern Art," *Visual Resources* 18, no. 2 (2002): 145–152.

5. Newhall, *Photography 1839–1937,* 111–117.

6. Newhall, *Focus,* 59–64.

7. Weston, Newhall said, "taught me more than any other photographer I have known." Ibid., 63.

8. Letter from Beaumont Newhall to Nancy Newhall, December 25, 1944, quoted in ibid., 130; letter from Beaumont Newhall to Nancy Newhall, March 17, 1944, quoted in ibid., 119.

9. Letter from Beaumont Newhall to Nancy Newhall, November 26, 1944, quoted in ibid., 128.

10. See Rosalind Krauss, "In the Name of Picasso," *October* 16 (Spring 1981): 5–22.

11. Emerson to Stieglitz, June 6, 1924. Quoted in Nancy Newhall, *P. H. Emerson: The Fight for Photography as a Fine Art* (New York: Aperture, 1975), 128.

12. An early exception among museums was the Museum of Fine Arts, Boston, which began acquiring photographs by Stieglitz and others in the early 1920s at the prescient urging of curator Ananda Coomaraswamy. See Nachiket Chanchani, "The Camerawork of Ananda Kentish Coomaraswamy and Alfred Stieglitz," *History of Photography* 37, no. 2 (2013): 204–220. The Museum of Modern Art in New York did not acquire photographs until 1933. See "Photography Center, 9 W. 54 Street," *Bulletin of the Museum of Modern Art* 11, no. 2 (October–November 1943), 7. As for the negligible market, in the winter of 1941–1942, MoMA put on a show entitled "American Photographs at $10," with nine photographers participating: Ansel Adams, Berenice Abbott, Walker Evans, Helen Levitt, László Moholy-Nagy, Arnold Newman, Charles Sheeler, Brett Weston, and Edward Weston. "Photography Center, 9 W. 54 Street," *Bulletin of the Museum of Modern Art* 11, no. 2 (October–November 1943), 15. For more information, see Christopher Phillips, "The Judgment Seat of Photography," 48 n. 50.

13. Beaumont Newhall, "Program of the Department," *Bulletin of the Museum of Modern Art* 8, no. 2 (December 1940–January 1941), 4.

14. Alfred H. Barr Jr., "Foreword," in Johnson, *Machine Art,* n.p.

15. W. K. Wimsatt Jr. and M. C. Beardsley, "The Intentional Fallacy," *Sewanee Review* 54, no. 3 (July–September 1946): 468–488.

16. Ibid., 469.

17. Ibid.

18. The show did include an X-ray machine, which in a sense makes the absence of cameras all the more conspicuous.

19. Newhall, *Photography,* 14.

20. Clement Greenberg, "Towards a Newer Laocoön," *Partisan Review* 7 (July–August 1940), 296–310.

21. Clement Greenberg, "Towards a Newer Laocoön," in Clement Greenberg, *Clement Greenberg: The Collected Essays and Criticism,* ed. John O'Brian (Chicago: University of Chicago Press, 1988), 1:24.

22. Ibid., 1:32.

23. Clement Greenberg, "Review of the Whitney Annual and Exhibitions of Picasso and Henri Cartier-Bresson," in Greenberg, *The Collected Essays and Criticism,* 2:139.

24. Clement Greenberg, "Review of the Whitney Annual," in Greenberg, *The Collected Essays and Criticism,* 2:118.

25. Clement Greenberg, "The Camera's Glass Eye: Review of an Exhibition of Edward Weston," in Greenberg, *The Collected Essays and Criticism*, 2:61–62.

26. Greenberg continued to minimize the importance of photography to his modernism later in life. A debate with Thierry de Duve in 1987 contained the following exchange. De Duve: "Do you think the invention of photography has to do with the advent of modernist painting at all? As a threat, I mean." Greenberg: "That's exaggerated. Uh, uh. I disagree with you about that." Thierry de Duve, *Clement Greenberg: Between the Lines* (Chicago: University of Chicago Press, 2010), 153.

27. Clement Greenberg, "Avant-Garde and Kitsch," in Greenberg, *The Collected Essays and Criticism*, 1:5–22.

28. Ibid., 1:16.

29. T. J. Clark, "Clement Greenberg's Theory of Art," *Critical Inquiry* 9, no. 1 (September 1982): 139.

30. According to Patricia Johnston, in the early 1920s, fewer than 15 percent of illustrated advertisements in the United States employed photographs but by 1930 almost 80 percent did. Patricia Johnston, *Real Fantasies: Edward Steichen's Advertising Photography* (Berkeley: University of California Press, 1997), 1.

31. Clement Greenberg, "Avant-Garde and Kitsch," 1:22.

32. See Serge Guilbault, *How New York Stole the Idea of Modern Art: Abstract Expressionism, Freedom, and the Cold War,* trans. Arthur Goldhammer (Chicago: University of Chicago Press, 1983).

33. Quoted in Francis O'Connor and Eugene Thaw, eds., *Jackson Pollock: A Catalogue Raisonné of Paintings, Drawings, and Other Works* (New Haven, Conn.: Yale University Press, 1978), 4:250.

34. When the photograph was used as the basis for a postage stamp, the cigarette was excised.

35. For a concise summary of these interpretations, see Sarah Boxer, "Critic's Notebook: The Photos That Changed Pollock's Life," *New York Times*, December 15, 1998. For more information, see Kirk Varnedoe with Pepe Karmel, *Jackson Pollock* (New York: Museum of Modern Art, 1998); Jeffrey Potter, *To a Violent Grave: An Oral Biography of Jackson Pollock* (New York: G. P. Putnam and Sons, 1985).

36. Quoted in O'Connor and Thaw, eds., *Jackson Pollock*, 4:249.

37. Quoted in Varnedoe, *Jackson Pollock*, 48.

38. Quoted in O'Connor and Thaw, eds., *Jackson Pollock*, 4:262.

39. Quoted in Pepe Karmel, ed., *Jackson Pollock: Interviews, Articles, and Reviews* (New York: Museum of Modern Art, 1999), 22.

40. Randall Jarrell, "The Age of the Chimpanzee," *Art News* 56, no. 4 (Summer 1957): 35.

41. Peggy Phelan, "Shards of a History of Performance Art: Pollock and Namuth through a Glass Darkly," in James Phelan and Peter J. Rabinowitz, eds., *A Companion to Narrative Theory* (Malden, Mass.: Blackwell, 2008), 509.

42. There has been much scholarly discussion of the roles of Kirstein and Mabry in preparing the show and catalogue. For a concise summary, see Judith Keller, *Walker Evans: The Getty Museum Collection* (Los Angeles: Getty Publications, 1995), 136 n. 4. For a strong argument that Kirstein was vital to the construction of *American Photographs,* see Douglas R. Nickel, "*American Photographs* Revisited," *American Art* 6, no. 2 (Spring 1992): 78–97.

43. The use of frames and glass to display photographic prints did not gather momentum until the 1960s. MoMA curator John Szarkowski played a key role in establishing this practice.

44. These letters are quoted and discussed in many places. See, e.g., Nickel, "*American Photographs* Revisited," 86; Belinda Rathbone, *Walker Evans: A Biography* (Boston: Houghton Mifflin, 1995), 166.

45. Quoted in Nickel, "*American Photographs* Revisited," 86.

46. Quoted in ibid.

47. See Edward Weston, *Edward Weston* (New York: E. Weyhe, 1932). Weston's 1932 book of photographs has been taken as an important antecedent to *American Photographs.* See Anthony W. Lee, "American Histories of Photography," *American Art* 21, no. 3 (Fall 2007): 5.

48. Thomas Mabry to Lincoln Kirstein, April 29, 1938, quoted in Keller, *Walker Evans,* 129.

49. See Rathbone, *Walker Evans,* 157.

50. In 1946, Greenberg wrote: "If one wants to see modern art photography at its best let him look at the work of Walker Evans." Greenberg, "The Camera's Glass Eye," in *The Collected Essays and Criticism,* 2:63.

51. Lincoln Kirstein, "Photographs of America: Walker Evans," in *American Photographs* (New York: Museum of Modern Art, 1938), 192–193.

52. Most notably, *Fortune* magazine sponsored Evans's collaboration with James Agee that led to the publication of their book *Let Us Now Praise Famous Men.*

53. On these syntactical dimensions of *American Photographs,* see Alan Trachtenberg, "A Book Nearly Anonymous," in *Reading American Photographs: Images as History: Mathew Brady to Walker Evans* (New York: Macmillan, 1990), 231–284; see also Nickel, "*American Photographs* Revisited."

54. Quoted in Phillips, "The Judgment Seat of Photography," 45.

55. On these matters, see ibid., 27–63.

56. See Blake Stimson, *The Pivot of the World: Photography and Its Nation* (Cambridge, Mass.: MIT Press, 2006); and Fred Turner, "The Family of Man and the Politics of Attention in Cold War America," *Visual Culture* 24, no. 1 (2012): 55–84.

57. Edward Steichen, "Photography: Witness and Recorder of Humanity," *Wisconsin Magazine of History* 41, no. 3 (Spring 1958): 160.

58. William M. Ivins, *Prints and Visual Communication* (Cambridge, Mass.: MIT Press, 1969), 63–66.

59. Ibid., 128.

60. Ibid., 178.

61. C. E. Shannon, "A Mathematical Theory of Communication," *The Bell System Technical Journal* 27, no. 3 (July 1948): 379–423.

62. See H. H. Goldstine, "Information Theory," *Science* 133, no. 3462 (May 5, 1961): 1395–1399.

63. George Boole, *An Investigation of the Laws of Thought, on Which Are Founded the Mathematical Theories of Logic and Probabilities* (Walton and Maberly, 1854), 1.

64. C. E. Shannon, "A Symbolic Analysis of Relay and Switching Circuits," master's thesis, Massachusetts Institute of Technology, 1940, 2.

65. Roland Barthes, *Mythologies,* trans. Annette Lavers (New York: Hill and Wang, 1972), 101.

66. Roland Barthes, "The Photographic Message," in *Image-Music-Text,* trans. Stephen Heath (New York: Hill and Wang, 1977), 15–31.

67. Ibid., 15. To be sure, there was a precedent for writing about photography from a broadly social rather than aesthetic perspective. See, e.g., Robert Taft, *Photography and the American Scene, 1839–1889* (New York: Dover, 1938). On Taft and Newhall as offering divergent histories at around the same time, see François Brunet, "Robert Taft in Beaumont Newhall's Shadow: A Difficult Dialogue between Two American Histories of Photography," *Études Photographiques* 30 (2012): 6–69.

68. Barthes, "Photographic Message," 15–16.

69. Ibid., 17.

70. Ibid., 28, 31.

71. Ibid., 31.

72. Barthes, "Rhetoric of the Image," in *Image-Music-Text,* 32–51.

73. Ibid., 45.

74. Ibid., 51.

75. Ibid., 45.

76. Ibid., 50.

77. Ibid.

78. Pierre Bourdieu et al., *Photography: A Middle-brow Art,* trans. Shaun Whiteside (Stanford, Calif.: Stanford University Press, 1990), 6–7.

79. Ibid., 8.

80. Ibid., 76.

81. Ibid., 74–77.

82. Ibid., 77.

83. Ibid., 78.

84. Ibid., 138, quoting a conversation with Man Ray, *Jeune Photographie* 42 (October 1961).

85. Bourdieu et al., *Photography,* 138.

86. Ibid.

87. Ibid., 139.

88. Ibid., 140.

89. See, e.g., Daniel Boorstin, *The Image: A Guide to Pseudo-Events in America* (New York: Vintage Books, 1992), originally published under a different title in 1962; and Marshall McLuhan, *Understanding Media: The Extensions of Man* (Cambridge, Mass.: MIT Press, 1994), first published in 1964.

90. Quoted in Sandra Phillips, "Chronology," in *John Szarkowski: Photographs* (San Francisco: San Francisco Museum of Modern Art, 2005), 135.

91. "Photography has never been successful at narrative." John Szarkowski, *The Photographer's Eye* (New York: Museum of Modern Art, 1966), 9.

92. John Szarkowski, "Photography: A Different Kind of Art," *New York Times Magazine,* April 13, 1975.

93. Another key figure in the 1960s, Nathan Lyons, took a different route, emphasizing photographic sequence in a manner that ultimately derived from work such as *American Photographs.* Anne Wilkes Tucker, "Lyons, Szarkowski, and the Perception of Photography," *American Art* 21, no. 3 (2007): 25–29. It is worth noting that Szarkowki became more enamored of the individual print as his museum career progressed. Back in the 1950s, he wrote in an application for a Guggenheim that to represent a complex subject the photographer "must use the single picture as the writer uses the sentence, as the dependent part of a single, unitary statement. Communication is cumulative, and the individual picture is freed from the pretense of balanced finality." Quoted in Sandra S. Phillips, "Szarkowski the Photographer," in *John Szarkowski: Photographs* (New York: Bulfinch, 2005), 146.

94. Szarkowski, "Photography: A Different Kind of Art."

95. Szarkowski, *The Photographer's Eye,* 1966, 7.

96. John Szarkowski, *Looking at Photographs* (New York: Museum of Modern Art, 1973), 182.

97. Szarkowski, *The Photographer's Eye,* 6.

98. Szarkowski, "Photography: A Different Kind of Art."

99. See, for example, Steven Adams, *The Barbizon School and the Origins of Impressionism* (London: Phaidon, 1994); Greg Thomas, *Art and Ecology in Nineteenth-Century France* (Princeton, N.J.: Princeton University Press, 2000).

100. Szarkowski, *The Photographer's Eye,* 7.

101. See Thomas Crow, "Saturday Disasters: Trace and Reference in Early Warhol," in Annette Michelson, ed., *Andy Warhol* (Cambridge, Mass.: MIT Press, 2001).

102. See Hal Foster, "Death in America," in Michelson, ed., *Andy Warhol.*

103. See Blake Stimson, *Citizen Warhol* (London: Reaktion Books, 2014).

9. John Baldessari Plays the Fool

1. These other series include: *Aligning: Balls,* 1972, *Trying to Photograph a Ball so That It Is in the Center of the Picture,* 1972–1973; *The Artist Hitting Various Objects with a Golf Club so That They Are in the Center of the Photograph,* 1972–1973; *Throwing Four Balls in the Air to Get a Straight Line,* 1972–1973; *Throwing Three Balls in the Air to Get an Equilateral Triangle,* 1972–1973; and *Throwing Four Balls in the Air to Get a Square,* 1972–1973.

2. See, e.g., Andreas Killen, *1973 Nervous Breakdown: Watergate, Warhol, and the Birth of Post-Sixties America* (New York: Bloomsbury, 2006).

3. Ruscha quoted in A. D. Coleman, "I'm Not Really a Photographer," *New York Times,* September 10, 1972; Long quoted in *Richard Long: São Paulo Bienal 1994* (London: British Council, 1994), 7.

4. These quotations appear in a 2009 interview with Aaron Schuman in *Seesaw: An Online Photography Magazine: Observation Full and Felt* 12 (Autumn 2009).

5. Three crucial occasions for young artists to become familiar with Duchamp's work were Robert Lebel's book *Marcel Duchamp,* translated by George Heard Hamilton and published by Grove Press in 1959, *The Art of Assemblage,* a traveling exhibition organized by William Seitz for the Museum of Modern Art in 1961, and the Duchamp retrospective at the Pasadena Art Museum in 1963, organized by Walter Hopps.

6. Interview with John Baldessari by Moira Roth, *X-tra* 8, no. 2 (Winter 2005): 16.

7. For the Baldessari recollection, see the oral history interview with John Baldessari, April 4–5, 1992, Archives of American Art, Smithsonian Institution, accessed November 17, 2014, http://www.aaa.si.edu/collections/interviews/oral-history-inter view-john-baldessari-11806. On the replica of Three Standard Stoppages, see Arturo Schwarz, *The Complete Works of Marcel Duchamp,* 3rd ed. (New York: Delano Green-ridge Editions, 1997), 2:595.

8. The particulars of the display, which are important given the historical variety in installations of *Three Standard Stoppages,* are recorded in the installation photograph by Frank J. Thomas.

9. Richard Hamilton, *The Almost Complete Works of Marcel Duchamp,* exhibition catalogue (London: Arts Council of Great Britain, 1966), 48.

10. Quoted in Herbert Molderings, *Duchamp and the Aesthetics of Chance* (New York: Columbia University Press, 2010), 41.

11. Molderings has reported, "On a sketch of the *nine malic moulds* . . . Duchamp had referred to the network of the '9 stoppages semblables,' " the implication being that there were also stoppages that were not similar." Ibid., 72.

12. See Benjamin Buchloh, "Kelly's Matrix: Administering Abstraction, Industrializing Color," in *Ellsworth Kelly: Matrix* (New York: Mathew Marks Gallery, 2003), 29 n. 11.

13. Katherine Kuh, *The Artist's Voice: Talks with Seventeen Artists* (New York: Harper & Row, 1962), 81.

14. Ibid., 92.

15. According to the art historian Yve-Alain Bois, who has made the most rigorous study of efforts by modern artists to negate the role of their subjectivity in the production of art, Piet Mondrian and Duchamp were the only two artists in the twentieth century "who understood that it's impossible to abandon composition." Benjamin Buchloh et al., "Conceptual Art and the Reception of Duchamp," *October* 70 (Autumn 1994): 139.

16. Francis Roberts, "I Propose to Strain the Laws of Physics" (interview with Marcel Duchamp), *Art News,* December 1968, 63.

17. See ibid. and Molderings, *Duchamp and the Aesthetics of Chance,* 139.

18. "John Baldessari: Pure Beauty," Tate Channel video, accessed January 29, 2015, http://channel.tate.org.uk/media/45538302001.

19. Evidently, the lithographs were initially intended to be bound as a book. See *John Baldessari: A Print Retrospective from the Collections of Jordan D. Schnitzer and His Family Foundation* (Portland, Ore.: Jordan Schnitzer Family Foundation, 2009), 10.

20. Baldessari interview with Constance Lewallen, Legion of Honor, San Francisco, July 9, 2009, accessed January 29, 2015, http://fora.tv/2009/07/09/John_Baldessari_A _Print_Retrospective#fullprogram.

21. John Szarkowski, *The Photographer's Eye* (New York: Museum of Modern Art, 1966), 6.

22. "John Baldessari: Pure Beauty," Tate Channel video.

23. Sidra Stich, "Conceptual Alchemy: A Conversation with John Baldessari," *American Art* 19, no. 1 (2005): 81.

24. On this score and others, Baldessari's work in this moment sidles up to works by Andy Warhol, such as *Dance Diagrams* and his *Do It Yourself* series.

25. Roland Barthes, *Camera Lucida: Reflections on Photography,* trans. Richard Howard (New York: Hill and Wang, 1981), 40. Barthes's definition of the *punctum* morphs during the course of the book.

26. See Nan Rosenthal, "Assisted Levitation: The Art of Yves Klein," in *Yves Klein: 1928–1962, a Retrospective* (Houston: Institute for the Arts, Rice University, 1982), 127–128.

27. Oral history interview with John Baldessari, April 4–5, 1992, Archives of American Art, Smithsonian Institution, accessed January 29, 2015, http://www.aaa .si.edu/collections/interviews/oral-history-interview-john-baldessari-11806.

28. See Aaron Schuster, "The Cosmonaut of the Erotic Future," *Cabinet* 32 (Winter 2008–2009): 27. "From the triumphant leap of the artist-levitator, always suspected of charlatanry and cheap showmanship, we are presented [in *Failure to Levitate in the Studio*] with the fall of the clown."

29. Baldessari has said, "I'm more interested in things that have escaped attention." Quoted in Meg Cranston, "John Baldessari: Many Worthwhile Aspects," in *John Baldessari* (Milan: Skira, 2000), 36.

30. Jeff Wall, " 'Marks of Indifference': Aspects of Photography in, or as, Conceptual Art," in *Jeff Wall: Selected Essays and Interviews* (New York: Museum of Modern Art, 2007), 143–168.

31. Baldessari almost certainly was aware of Stieglitz and his *Equivalents*. Carl Andre, whose work was familiar to Baldessari and frequently exhibited in Southern California, is reputed to have entitled his 1966 serial installation *Equivalents I–VIII* after Stieglitz's famous photographs, which were circulating widely. James Meyer, *Minimalism: Art and Polemics in the Sixties* (New Haven, Conn.: Yale University Press, 2001), 189. Andre's *Cuts*, a field of concrete capstones containing voids mimicking the plan of *Equivalents I–VIII*, was exhibited at the Dwan Gallery in Los Angeles in 1967. See Pasadena Art Museum, *Recent Acquisitions 1969* (Pasadena: Pasadena Art Museum, 1969), 17; and Meyer, *Minimalism*, 196–197. Baldessari has recollected calling his CalArts class "post-studio," after coming across a use of the phrase by Andre in a magazine. Jori Finkel, "John Baldessari's 'Pure Beauty' at Los Angeles County Museum of Art," *Los Angeles Times*, June 20, 2010. In 1958, the National Gallery of Art had a Stieglitz exhibition that featured some *Equivalents*, and in 1968, the Philadelphia Museum of Art did as well. Welling, one of Baldessari's students when he was working on *Throwing Three Balls*, later remarked that Conceptual art was "trying to undo the work I gravitated toward—Strand, Stieglitz, and European modernism." "James Welling Talks to Jan Tumlir," *Artforum International* 41, no. 8 (April 2003): 216. In a 1973 interview, Baldessari recalled spending "a lot of time in library stacks . . . thumb[ing] through things," adding that "there probably wasn't a book on art printed that I did not know about." Interview with John Baldessari by Moira Roth, *X-tra* 8, no. 2 (winter 2005): 19. Reproductions of one or more *Equivalents* appeared in numerous publications, including the fourth edition of Beaumont Newhall's popular history of photography, *The History of Photography, from 1839 to the Present Day*, rev. ed. (New York: Museum of Modern Art, 1964). Anyone interested in the "two different histories" of art and photography could hardly have avoided Newhall. Moreover, Baldessari was well positioned to keep abreast of modern photography and its history. One of his haunts, the Pasadena Art Museum, was at the vanguard of photography collecting and exhibiting. The early collecting of photography at the museum is described in Gloria Williams Sander, ed., *The Collectible Moment: Catalogue of Photographs in the Norton Simon Museum* (New Haven, Conn.: Yale University Press, 2006). In 1970, an evidently *Equivalents*-inspired photograph of swirling clouds by Weston entered the collection. Sander, *Collectible Moment*, 277.

32. Early writers on the *Equivalents* interpreted them as conjoined to the pictures of O'Keeffe and in terms of the passion, expression, and experience of heterosexual love. See Lewis Mumford, "The Metropolitan Milieu," in Waldo Frank et al.,

eds., *America and Alfred Stieglitz: A Collective Portrait* (New York: Literary Guild, 1934), 57–58; Harold Clurman, "The Man and the Place," in *America and Alfred Stieglitz*, 271.

33. See Weston Naef et al., *Alfred Stieglitz, Photographs from the J. Paul Getty Museum* (Malibu, Calif.: Christopher Hudson, 1995), 84.

34. As a critic in the *Los Angeles Times* wrote in a review of a Baldessari retrospective: "With the feminist art revolution then in full swing, identifying 'balls' as traditional art's hidden organizing principle makes for a great, damning pun." Christopher Knight, "Art Review: 'John Baldessari: Pure Beauty' at LACMA," *Los Angeles Times,* June 27, 2010.

35. Another work to add to the mix: a poster that Duchamp and Claude Givaudan designed showing Duchamp's hand facing outward, with a cigar between his fingers, with smoke curling upward from it. Duchamp "mentioned that he was amused by this photo because of the formal analogy between the shape of the lower part of the smoke cloud and the female genitalia." Schwarz, *The Complete Works of Marcel Duchamp,* 2:869.

36. Walter Benn Michaels, *The Gold Standard and the Logic of Naturalism* (Berkeley: University of California Press, 1987), 238.

37. On photography as "sub- or pre-symbolic," see Rosalind Krauss, "Notes on the Index: Seventies Art in America," *October* 3 (Spring 1977): 75.

38. Michaels distinguishes the moment of selection with the camera from the moment of waiting to see what the camera has recorded. Michaels, *The Gold Standard,* 238–239. Baldessari critically addresses both moments in his work of 1972–1973.

39. The three series are: *Cigar Smoke to Match Clouds That Are Different (by Sight—Side View), Cigar Smoke to Match Clouds That Are Different (by Memory—Back View),* and *Cigar Smoke to Match Clouds That Are Different (by Memory—Front View).*

40. On the photograph, for Stieglitz, as an "equivalent" for inner vision, see Sarah Greenough, "Alfred Stieglitz's Photographs of Clouds," PhD diss., University of New Mexico, 1984, 133.

41. "John Baldessari: Pure Beauty," Tate Channel video.

42. "Dumb, for me, is a good word." Quoted in Cranston, "John Baldessari: Many Worthwhile Aspects," 37. Mark Twain once said, "I find cigar smoking to be the best of all inspirations for the pen." A. Arthur Reade, ed., *Study and Stimulants* (Philadelphia: Lippincott, 1883), 122.

43. Edward Weston, *The Daybooks of Edward Weston,* ed. Nancy Newhall (New York: Aperture, 1973), 2:231.

44. Sir Joshua Reynolds, *Discourses on Art,* ed. Robert R. Wark (New Haven: Yale University Press, 1997), 37.

45. Roger Fry, "Mrs. Cameron's Photographs," in *Victorian Photographs of Famous Men and Fair Women by Julia Margaret Cameron,* with introductions by

Virginia Woolf and Roger Fry, rev. ed., ed. Tristram Powell (Boston: David Godine, 1973), 27.

46. "What Is Erased," a conversation between John Baldessari and Christian Boltanski, *Blind Spot,* no. 3 (1994): 1–4. Szarkowski, however, associated the pointlessness of juggling with the purposelessness of art: "Some of the very best photography is useful only as juggling, theology, and pure mathematics is useful—that is to say, useless, except as nourishment for the human spirit." John Szarkowski, *Looking at Photographs* (New York: Museum of Modern Art, 1973), 204.

47. See Michaels, *The Gold Standard,* 232: "Insofar as accidents help to make actions free, however, they also threaten to make them random and thus (just as the discourse against accident feared) not really actions at all. To give us agency for freedom seems a paradoxically heavy price to pay; in what sense is an agent free if he isn't free to act?"

48. Karl Groos, *The Play of Man,* trans. Elizabeth Baldwin (New York: Appleton, 1901), 103.

49. During the pictorialist era, "artistic monkeying" with photographic plates was derided as a cheap way to produce aesthetic effect. See Annie W. Brigham, "Just a Word" (1908), in Peter E. Palmquist, ed., *Camera Fiends and Kodak Girls, II* (New York: Midmarch Arts, 1995), 101.

50. Richard Duke, *Gaming: The Future's Language* (Beverly Hills, Calif.: Sage, 1974), x–xi.

51. Peter Galison, *Image and Logic: A Material Culture of Microphysics* (Chicago: University of Chicago Press, 1997), 690–691.

52. Ibid., 691. Monte Carlo simulations run on random numbers. Because random numbers are difficult to obtain from seemingly random physical processes, such as radioactive decay, von Neumann and Stanislaw Ulam developed a means of generating pseudorandom numbers—that is, numbers that exhibit statistical randomness despite being generated deterministically. Ibid., 701.

53. Sharon Ghamari-Tabrizi, "Simulating the Unthinkable: Gaming Future War in the 1950s and 1960s," *Social Studies of Science* 30, no. 2 (April 2000): 165.

54. Herman Kahn, "A Methodological Framework: The Alternative World Futures Approach" (1966), in *The Essential Herman Kahn: In Defense of Thinking,* ed. Paul Dragos Aligica and Kenneth R. Weinstein (Lanham, Md.: Lexington Books, 2009), 185–186.

55. Ghamari-Tabrizi, "Simulating the Unthinkable," 164.

56. Ibid., 174.

57. See John C. Harsanyi, "Games with Incomplete Information Played by Bayesian Players," *Management Science* 14, no. 3 (1967): 159–183 (Part I), no. 5: 320–334 (Part II), and no. 7: 486–502 (Part III).

58. Jennifer Light, *From Warfare to Welfare: Defense Intellectuals and Urban Problems in Cold War America* (Baltimore: Johns Hopkins University Press, 2003), 46.

59. See Paul Starr, "Seductions of Sim: Policy as a Simulation Game," *American Prospect* 5, no. 17 (Spring 1994): 21.

60. Jennifer Light, "Taking Games Seriously," *Technology and Culture* 49, no. 2 (April 2008): 355.

61. Duke, *Gaming: The Future's Language,* x.

62. Clark C. Abt, *Serious Games* (New York: Viking, 1970), 131.

63. Ghamari-Tabrizi, "Simulating the Unthinkable," 170.

64. Ibid., 181.

65. In the early 1970s, during the boom in gaming as a new form of knowledge production, complex new tabletop games were becoming a popular pastime and a burgeoning industry. War games, not surprisingly, were at the forefront, with game publishers such as Avalon Hill, founded in 1954, and Simulations Publications, Inc., founded in 1969, leading the way. In 1974, the war game craze gave rise to *Dungeons and Dragons,* which merged martial tactics with role-playing fantasy. Although chess, the paradigmatic war game, involves no chance, nearly all of the war games produced by these publishers used dice or some other means of randomization. The push of gaming into fields of inquiry beyond warfare extended to tabletop games as well. In the early 1960s, Layman Allen of the Yale Law School developed *WFF n' Proof,* a dice game to train students in the rules of symbolic logic (WFF was an acronym for "well-formed formula"). The game was marketed nationally. Although propositional logic and chance are often opposed, *WFF n' Proof* combined them in a box. The game pedagogically rehearsed the pervasive challenge during the Cold War of making sense of a world thrown open to contingency.

66. See Roger W. Lotchin, *Fortress California: From Warfare to Welfare* (New York: Oxford University Press, 1992), 297–318.

Conclusion

1. Alexis de Tocqueville, *Democracy in America* (Cambridge, Mass.: Welch, Bigelow, 1862), 2:181. The second volume was originally published in French in 1840.

2. C. P. Snow, *The Masters* (New York: Scribner, 1951), 349.

3. On this issue, see Walter Benjamin, "The Work of Art in the Age of Its Technological Reproducibility," in *The Work of Art in the Age of Its Technological Reproducibility, and Other Writings on Media,* ed. Michael W. Jennings, Brigid Doherty, and Thomas Y. Levin (Cambridge, Mass.: Harvard University Press, 2008), 28.

4. On Duchamp's urinal and Stieglitz's photograph of it, see Thierry de Duve, *Kant after Duchamp* (Cambridge, Mass.: MIT Press, 1996), 115–123. De Duve's account of Duchamp in the book is characteristically brilliant, but the polarity he draws between a mastermind Duchamp and a witless and duped Stieglitz is unconvincing and poorly supported. There is every reason to think that Stieglitz's pictorialist treatment of the urinal was his own sort of joke, along the lines of his photograph from

1923 of a castrated horse entitled *Spiritual America*. Besides, how foolish would it have been for Stieglitz to believe that making a signed photograph of the urinal would advance his own historical relevance and standing? After all, it has. For a more persuasive account, see Marcia Brennan, *Painting Gender, Constructing Theory: The Alfred Stieglitz Circle and American Formalist Aesthetics* (Cambridge, Mass.: MIT Press, 2002), 58.

5. To describe these practices, the critic A. D. Coleman coined the term "directorial mode." See A. D. Coleman, "The Directorial Mode: Notes toward a Definition," *Artforum* 14, no. 1 (September 1976): 55–61.

6. Stéphane Mallarmé articulated this principle. See Denis Lejeune, *The Radical Use of Chance in 20th Century Art* (Amsterdam: Rodopi, 2012), 76 ("Mallarmé suggested that 'le hasard' could only be suppressed as such if all its possible combinations were made to occur, as a result of which absolute chance would shade into absolute necessity").

7. Nicholas Hughes, "Aspects of Cosmological Indifference," *Photographies* 6, no. 2 (September 2013): 273.

8. Robert Adler, "Why Is There Something Rather Than Nothing?," BBC Earth, accessed November 6, 2014, www.bbc.com/earth/story/20141106-why-does-anything-exist-at-all.

9. Hughes, "Aspects of Cosmological Indifference," 273.

Acknowledgments

The argument of this book began with a talk on Talbot's *The Pencil of Nature* that I delivered as a graduate student at the annual Frick/IFA symposium on the history of art in 2000. At the time, my adviser Henri Zerner and his colleagues were doing much to inspire my thinking, and the welcome effects of that inspiration continue to this day. Subsequent conversations with Peter Galison helped motivate and direct my historical inquiry into photography and chance. The students in two graduate seminars I taught on the subject generated hours of stimulating discussion, and an overlapping set of students provided superb research assistance. Maggie Cao, Jason LaFountain, Jennifer Quick, Nancy O'Connor, Connie Fu, Kevin Hong, Hye Won Yoon, Maggie Innes, and Sam Ewing all deserve mention in this latter regard. These students, some already leading scholars, have been extraordinary interlocutors as well as researchers, and Ms. Innes and Mr. Ewing lent invaluable aid with illustrations. Deanna Dalrymple facilitated all research efforts, including my own, with peerless efficiency and good humor. As the book came into shape, the editorial encouragement and acumen of Joyce Seltzer and the patient diligence of her assistant, Brian Distelberg, earned my lasting gratitude.

The study of the histories of photography and American art has immersed me in scholarly communities marked by intellectual liberality and lively sociability. Conversations with Jennifer Roberts, Eric Rosenberg, Blake Stimson, Yve-Alain Bois, Benjamin Buchloh, Doug Nickel, Sarah Greenough, François Brunet, Steve Edwards, Jennifer Tucker, Geoff Batchen,

Acknowledgments

Joshua Shannon, Anne McCauley, Jason Puskar, Jimena Canales, Joanne Lukitsh, Matt Witkovsky, Debi Kao, Larry Schaaf, Kelley Wilder, Lars Bertelsen, and John Tagg have affected the course of this book in particular. I also wish to thank two anonymous readers of the manuscript for their helpful suggestions.

Institutional backing has been essential as well. My employer, Harvard University, has been munificent at every turn, and the Clark Art Institute, Williams College, the Terra Foundation for American Art, and the École normale supérieure supported my scholarship at crucial moments. Welcome opportunities to present and refine my work came from the Max-Planck-Institut für Wissenschaftsgeschicte, the Center for Advanced Study in the Visual Arts, Wesleyan University, Stanford University, the University of Michigan, Boston University, the Universität Zürich, the Museum of Fine Arts, Boston, the Tate Modern, Paris Ouest Nanterre La Défense, the Institut national d'histoire de l'art (INHA), Université François-Rabelais, Tours, Universidade Nova de Lisboa, the University of Cambridge, the Massachusetts College of Art and Design, the Bowdoin College Museum of Art, the University of Montana, the English Institute, and the Potomac Center for the Study of Modernity. Among the many gracious representatives of these institutions, I especially want to thank Michael Ann Holly, Marc Gotlieb, Lorraine Daston, Jennifer Tucker, Bettina Gockel, Veerle Thielemans, Béatrice Joyeaux-Prunel, Margaret Iverson, Diarmuid Costello, and Margarida Medeiros. At Harvard, the History of Art and Architecture Department and the Mahindra Humanities Center have allowed me to share my scholarship with brilliant company.

The research for this book would not have been possible without the kindness and expertise of various librarians, archivists, curators, and other keepers of historical material. Staff members at the Royal Society, the Bodleian Library, the Harry Ransom Center, the George Eastman House, the J. Paul Getty Museum, and the Center for Creative Photography provided vital assistance. Special gratitude is due Naomi Lyons and Jeremy Cox of the Frederick and Frances Sommer Foundation for their unstinting help.

Earlier thoughts on issues addressed in this book have appeared in other publications. In this respect, I gratefully acknowledge the efforts and interest of the Clark Art Institute (Yale University Press), *History and Theory* (Wesleyan University/Wiley Blackwell), the University of Zurich (De

Gruyter), *Critical Inquiry* (the University of Chicago Press), and the Art Institute of Chicago.

In the preparation of this book, Sara, Addie, and Margot supplied generosity of a kind that requires love and has no rival. My thanks go daily and always to them.

Index

abstract expressionism, 264, 281, 284, 286, 299

abstraction, 123, 261, 263–264, 287; in aesthetic judgment, 23, 43; of modern experience, 35, 171; of vapor, 112, 192, 298; in photography, 192, 200, 219, 298

accident, 5, 9, 105, 146–147; in taking photographs generally, 2, 29–33, 38–39, 73–74, 153, 191, 204, 208–209, 211, 219, 245–246, 251, 255, 270, 277, 280; in literature, 2, 255; replacing providence, 6, 311; as universal, 8, 271; as sign of the human, 10, 77, 82, 87, 321–322; in invention or discovery, 15–17, 73, 127; in the picturesque, 19, 24–27, 146; the look of, 21, 36–37, 108, 251, 279, 322–323; as antithetical to art, 22–23, 28–29, 131, 263, 271, 277; aesthetic potential of, 23–24, 130, 143, 146, 168–169, 178, 181, 211, 217, 254, 299, 305, 313; as stimulating the imagination, 24, 107, 115; significance of, 32–33; neutralized by scientific judgment, 36; as suppressed in popular photography, 56, 72, 275; as sign of aspiration, 64–65, 69, 80, 96, 135; material, in photographic production, 66–68, 101, 127, 314, 322; the cultivation of, 74, 80, 119, 126, 287–289, 322–323; as glitch versus as stray detail, 81–82; as the price of belief, 96; in painting or drawing, 104–105, 123, 263–264; as statistical noise, 161; as muted by pictorialism, 162; and the unconscious, 187–188, 191–192; in Surrealism, 197, 200, 277; and the gaze, 235, 263; as addressed by the photographic book,

267; standards of beauty as, 271; and photographic realism, 275; in Dada, 288; in contemporary art, 321–323

Adams, Ansel, 236–237, 239, 248, 250; and nature as pristine, 228, 237, 239–241; and Beaumont Newhall, 250–252; and signs of mastery, 252; and "straight" photography, 256; and Greenberg, 264, 266; and Evans, 265

albumen, 44–45, 66, 77, 102

Allen, Joseph, 323

analog medium, photography as, 4, 82, 84, 272, 275, 316

animals, 104–106, 115, 177, 181, 184, 201; as random, 104–105, 211–213, 241–242; as models for the modern photographer, 202; and violence, 211–213, 243–244; and decomposition, 214, 222–229; and the uncanny, 229–244, 316; and abstract expressionism, 264; and modern art, 304–305

apophenia, 205

arbitrariness, 8, 32, 35–36, 188, 204, 242, 323

Armstrong, Carol, 77

Ashton, John, 54

asphalt, 149, 158, 163, 169–175, 316, 320

atmosphere, 108–110, 114–116, 163, 200, 248, 314; as locus of chance, 10, 35, 105, 146, 162; as archive of modernization, 10, 117, 140–141, 179, 320–321; as sign of modernity, 10, 118–119, 126, 149; as challenge to or limit of representation, 46, 108, 112–126, 148; as aesthetic

Index

atmosphere *(continued)*
 mediation, 102–104, 110–112, 126, 128, 138, 146–147, 155–159; and camera optics, 135–136; and lantern projection, 166–168, 314, 320
atomic bomb, 247, 263, 280, 305, 320
authorship, 29, 42, 69, 80–81, 84, 95, 154, 204, 209; editorial, in photography, 209, 268–270; and confusion of photographer and photograph, 251–252, 280; as compromised by chance, 264, 304

Baldessari, John, 3, 11, 283, 284–310, 315, 318; and photography as art, 284–286; and Duchamp, 286–289, 291–293; and the structure of photography as a social practice, 289–291, 309–310; and decomposition, 293–295; and Klein, 295–297; and Stieglitz, 297–303; and Weston, 303; and regression, 303–305; and randomized simulation, 305–310
Barbizon, school of, 58, 129, 279
Barr, Alfred H., 250, 253–255
Barthes, Roland, 81–82, 85–86, 92, 246, 273–277, 295
Baudelaire, Charles, 58, 59, 178, 260, 314
Bayes, Thomas, 14, 307
Beardsley, Monroe, 254–255, 278
Beaton, Cecil, 262–263
Benjamin, Walter, 81, 181, 197–198, 260
Bermingham, Ann, 25, 79
Bhabha, Homi, 96
bicycles, 152, 169–173, 176, 194
Blanquart-Evrard, Louis Désiré, 45
blur, 64, 100, 150; cultivation of, 68, 79, 86, 322; as sign of life, 87, 91; as aesthetic mediation, 102, 126, 138; and hierarchy of attention, 131, 135–136; as atmospheric effect, 135–138, 156–158; as sign of labor, 143; as statistical noise, 159–162, 165; as dynamism, 195–196, 200, 211
Boltzmann, Ludwig, 188, 271
books or catalogues, photographic, 2, 17, 71, 83–84, 126–127, 138, 146; suppression of chance in, 2, 209; and editorial discretion, 3, 76, 148, 264–267, 269–270, 289–291, 313
Boorstin, Daniel, 278
Bourdieu, Pierre, 273, 275–277
Boxer, Sarah, 89, 92
Bragaglia, Anton Giulio, 195–196
Breton, André, 200
Browning, Robert, 81–82, 90–91
Burne-Jones, Edward, 46, 59

Caillebotte, Gustave, 117–118, 158
Caillois, Roger, 53
calotype, 14–15, 19–20, 41, 44, 64
camera obscura, 14, 23
Cameron, Julia Margaret, 3, 65, 66–101, 102, 126–127, 132, 145, 150, 186, 305, 312–313; and haphazardness, 66–68; and speculation, 70–71, 182; and signs of labor, 69, 94–95, 267; and reinventing photography as art, 71–73; and serendipity, 73–74, 127; and the demotion of skill, 74–75, 153; and the glitch as a sign of aspiration, 75–77, 80–81, 93–96, 101, 135, 195–196; and finish, 77, 80, 119; and wet photographic processes, 77–79, 316; and patriarchy, 79–80; and the accidental detail, 81–82; and a photographic exchange of performances, 82–94; and the enlivening of portraiture, 85–93, 230; and colonialism, 96–101; and the replication of culture, 96, 100–101, 313–314; and Warhol, 281; and contemporary art, 322–323
canons, 3–4, 42, 212, 266, 318
capitalism, 7, 149, 260; vapor and the representation of, 114, 117, 119, 140–141, 149; uncertainty under, 114, 178, 312; as hunting, 182; and the uncanny, 234
carbon prints, 174, 176, 178
Carlyle, Thomas, 84, 87, 89, 114
carte de visite, 54–56
Cartier-Bresson, Henri, 200–205, 209–210, 250, 263, 277, 295; and the decisive moment, 201–205, 208, 273, 277, 280; and Greenberg, 257
Chamboredon, Claude, 276–277
Clark, T. J., 118–119, 260
class, social, 51, 75, 84, 110, 127, 134, 140, 178, 241, 275, 279; patrician, 47; managerial, 48; working, 49, 149, 177, 314; mixing of, in photography, 52–56, 71; alienation from, 238, 241
clouds, 141, 143, 146, 151, 157, 171, 200; and Romanticism, 10, 111–112, 167–168; randomness of, 24, 107–108, 121, 200; challenge of representing, 105–106, 175; and the Enlightenment, 108–110; and Ruskin, 115–116, 124; probabilistic science of, 165; as sign of modernity, 174, 179; photographed by Stieglitz, 192–193, 215, 244, 298–301; arbitrariness of, 299; and Baldessari's cigar smoke, 301–303
coincidence, 133, 247, 288; in history, 7; in photography, 141, 185, 196; as meaningful, 197–205

Cold War, the, 5, 270, 305–310

Coleman, A. D., 201

collodion wet-plate process, 44–45, 47, 49, 64, 66–68, 77–78, 100, 150

combination printing, 59–62, 77, 128

commodities, 41, 129, 254, 288; photographs as, 2, 20, 249; and uniformity, 10; critique of, 232–234, 248

communication, photography as, 249, 261, 267, 270–273, 312

composition, 32, 36, 128, 141–143, 155, 226; as found, 19, 24, 26–27, 43, 61, 145–146, 217, 311, 313, 316; requiring aesthetic judgment, 25, 29, 60, 125, 128, 131, 256; and the decisive moment, 203; as unseen by photographer, 208; encroachment of chance on, 288, 291, 294–295, 299

Conceptual art, 283–286, 297–298, 318

Constable, John, 46, 129; and the found composition, 26–27, 146, 217; and the hierarchy of attention, 43; and finish, 57–58, 62, 257; and clouds, 112

Constructivism, 250

copying, 15, 17, 45, 49, 73, 83–84, 240; as aesthetically limited when from nature, 27, 46, 50–51, 124–125; as aesthetically sufficient when from nature, 42–44; a right and wrong way of, 50–51, 88; and colonialism, 96–97, 100

copyright in photography, 138, 154

Cox, Julian, 68–69

Daguerre, L. J. M., 14–15, 41, 44, 49, 150, 311, 318

Daguerreotype, 14–15, 41, 44–45, 64, 150, 174

Damisch, Hubert, 175

Darwinism, 6, 181, 187; and accidental mutation, 5–6, 13, 163, 188; social, 133; and moral progress, 184; and violence, 213; and accidental beauty, 254

Daston, Lorraine, 186

David, Jacques-Louis, 108–110, 200, 207

Davison, George, 134, 146

death in photography, 223–224, 239–240; found in stray details, 81–82; as performed for the camera, 85–93, 97–101; and the uncanny, 87–88, 234–237; as stasis, 196

decomposition, 223–228, 245, 294, 314

Delaroche, Paul, 41, 44

democracy and photography, 51–52, 54, 207

determinism, 12–13, 33, 38–39, 105, 187–189, 317, 320

digital medium, photography as, 4, 11, 317

Dimock, Anthony Weston, 182–187, 190, 213

divination, 229, 241–242

divinity, 8, 10, 27, 76. 96. 106, 142; of laws, 6; of will or providence, 6, 14, 105, 311; of judgment, 8; as omniscience, 12; as intervention, 13; of design, 33, 35, 188

Duchamp, Marcel, 254; and the critique of subjectivity, 254, 288; and institutional framing, 286; and the structure of painting, 286–288; and entropy, 288–289; and the structure of photography, 288–289, 315; and Baldessari, 289–293, 293, 297, 299, 304–305

dust, 7, 68, 166–168, 320

Eagleton, Terry, 9

Eastlake, Lady Elizabeth, 71, 75, 271; and photography as mechanical, 45–49, 86, 276; and photographic mechanics as flawed, 49–50; and the lost aesthetic promise of photography, 49–51, 64–65, 71–72, 77; and photography as process or product, 50; and social class, 51; and the role of luck in photography, 52–54, 56, 70, 279; and photographic finish, 59

Eastman, George, 150, 152, 171

Edwards, Steve, 56, 84

egalitarianism, 8, 43, 244

Emerson, Peter Henry, 104, 150, 155, 267; and Cameron, 77, 126–128; on the making of photographic art, 126–130; and vapor as history, 126, 138–143; on the hierarchy of attention and differential focus, 130–138, 158; and atmospheric perspective, 135–138, 158; and his recantation regarding photography as art, 143–146; on vapor and accident, 146–148; on the role of chance in photography, 251–252

Enlightenment, the, 6, 10, 108–110

Enokura, Kōji, 318

entropy, 245, 271, 288

equivalence, 10, 34–36, 54, 244–245, 301

Evans, Walker, 84, 177, 250, 269, 278; and 1938 MoMA show and catalogue, 264–267; and Greenberg, 264, 266; and photographic syntax, 266–267, 271; and the magazine business, 268

expression, artistic, 129, 257; presumption of, 251, 255; as requirement of photographic art, 253–255; in abstract expressionism, 261–263; limits of, 268, 280, 288–289, 305

financial markets, 13, 185; as prone to chance, 14, 178; as gambling, 53–54, 183–184; as jungle, 182–183

finish, pictorial, 57–59, 119, 121–123, 276; and combination printing, 59, 61–62; in photography, 59, 64, 102, 153, 216, 252, 257; and Cameron, 77, 80, 119

fluke, 24, 29, 73, 168, 252, 267, 317

focus, camera, 72, 75, 144, 161–162, 226, 256–257, 317; softening, for aesthetic effect, 62–64, 146, 159, 162–163, 195, 216; Cameron's unusual use of, 68, 73, 76–77, 80–81, 127; differential, 131–138, 144; and Stieglitz's turn toward clarity, 158–159, 162–163

Freud, Sigmund, 30, 190–191; on the uncanny, 87, 231; and determinism, 187–188; on everyday errors, 187–188; on dreams, 189–190; on the unconscious, 190–191, 198; and the death drive, 236

Freudianism, 187–189

Friedrich, Caspar David, 110–112, 119, 177

Fry, Roger, 28–29, 86, 303

Futurism, 180, 195

Galassi, Peter, 205

Galileo, 6, 164

Galison, Peter, 186, 306

Galton, Francis and composite photography, 159–162, 165–166

gambling, 5, 8, 304; photography as akin to, 31, 36, 52, 54–56, 70, 74, 179, 279, 312, 316; as a modern economic form, 53–54, 183–186; Victorian anxiety about, 53–54, 313; modern life as a form of, 180, 312

games and gaming, 13, 53, 179, 185; Baldessari and, 289–293, 299–300, 304; as a Cold War social form, 305–308

gases, 114, 163, 179, 301–303, 317; mechanics of, 13, 163–168, 185, 188, 271, 320; as metaphors, 117, 126, 174, 320; and gasworks, 158; in the city, 166, 175–176; and surfaces, 174

Ghamari-Tabrizi, Sharon, 306–308

Gilpin, William, 110–112, 132–133

God, 13, 18, 39, 91, 95, 167, 188; as supplanted by chance and indifference, 6–10, 311; and the authority of art, 8, 39, 128; and small accidents, 33, 189, 313; and modern belief, 96

gravity, 227, 286–289

Greenberg, Clement, 268, 278; on modernism, 249, 256–257, 279–280, 286; struggles with photography, 257–263; and Walker Evans, 264, 266–267

Hacking, Ian, 13–14, 37–38

halftone process, 194, 270–271

hand, invisible, 7, 8, 31, 117, 129, 232, 312, 316

haphazardness, 7, 57, 111, 127, 147, 192, 303; of photography generally, 2, 168, 278; and Cameron, 66–68, 76, 81

Hazlitt, William, 42–43, 129

Heisenberg, Werner, 188–189, 225

Herschel, Sir John, 163, 181; and serendipity, 16; on chance in photography, 35–36; and Cameron, 66, 70–74, 76, 78, 87, 89, 92, 99

Holmes, Martha, 261–262

Holmes, Oliver Wendell, 81

Hughes, Nicholas, 319–321

hunter, photographer as, 180–185, 187, 196, 214, 317; and Cartier-Bresson, 201–204

ideology, 27, 48–49, 127, 182, 214, 295

impressionism, 119, 129, 158, 197

indifference, 6, 212; cosmic, 6, 8, 188, 320–321; photographic, 6–7, 9, 17, 33–35, 40, 56, 82, 219, 275, 311–312, 315–316; of modern world, 11, 35; Sommer's use of, 11, 214, 226, 238, 246; Talbot's negotiation of, 33, 54, 133; as bound to chance, 34, 52–53, 246, 304; in Hughes's work, 319–321

indiscriminateness, 8; of photography, 22–24, 31, 130–132, 190, 275; as traditionally contrary to art, 22–24

industrialization, 16, 41, 180, 187, 195; and photography, 3–4, 40, 44–49, 52, 54, 171, 253–256, 260–261; and God, 18; and time, 36; and dehumanization, 47; and humiliation, 48; and pictorial finish, 58–59; pictorialist distaste for, 102–104; and modern art, 114, 116–117, 124, 250, 253–255, 260, 267, 287; and atmosphere, 117, 140–141, 179, 320–321; and Emerson, 140–142; and Stieglitz, 149, 158, 163, 165, 167–168, 175; and alienation, 238, 241

industry, 1; insurance, 14; transcribing natural beauty as mere mechanical, 21; and the picturesque garden, 25; of mind versus that of hand, 27; and Cameron, 74, 77, 88; photography, 152, 194–195, 252, 313; journalism, 194–195, 198–199, 259–261, 267–268, 314; food, 231–232, 234–235;

publishing, 270; military, 305–306, 309; nostalgia, 322
information theory, 5, 271–274, 281, 288, 307
inkblots, 191–192
instinct, 79, 185–187; and the pleasure of chance, 52–54; the photographer and animal, 181, 184, 202, 205, 208, 256
intention, 6, 159; and the invisible hand, 7–8; cleaved from result by the intrusion of chance, 9, 30–31, 35, 74, 105, 190, 212, 277; mixing with chance in the picturesque, 25; photograph exceeding, 31, 75, 280; and the question of cosmic design, 33, 39; weakened in photography, 39, 59, 153, 255, 277; and composite printing, 60–61; and serendipity, 73; as incompatible with chance, 105, 108; as integral or not to art, 128–129, 201, 250, 253, 281, 311; and manual work, 154; and psychoanalysis, 190; false traces of, left by chance, 205–209, 312; demotion of, in the machine age, 254–255; and taste, 291
Ivins, William, 270–274

Johnson, Philip, 250, 254–255
judgment, aesthetic: as traditionally integral to pictorial value, 18–19, 29; as opportunistic in photography, 24–25; as difficult to differentiate from chance in photography, 29; as at odds with the indifference of the camera, 33; as akin to scientific judgment, 36; as revised by naturalism, 43; and industrialization, 46–48; and professional portrait photography, 56, 62; in pictorial finish, 59; in composite printing, 59–60, 62; in enlisting accident, 64–65, 127; as restricted in photography, 144–145; and copyright law, 154; as exercised retrospectively in photography, 191, 209–211, 267–269, 301, 313, 316; as reflex action, 202; as conventional and class-based in photography, 275; as enabling the public to constitute itself, 288; as mere choosing, 291–292, 299, 303
Jung, Carl, 190, 203, 205

Kender, Janos, 293–296, 304
Kertész, André, 196–197, 250
Kirstein, Lincoln, 250, 264, 266–267
Klein, Yves, 295–297, 299, 304
Kodak, 150–152, 154, 163, 171, 179, 181–182
Kracauer, Siegfried, 38, 198
Krauss, Rosalind, 192, 227

labor, 20, 47, 143, 174; photography substituting chance and automatic process for, 18–19, 142, 313; Talbot and drawing as, 21; photography as saving, 21–22, 29, 36, 50, 279, 311; art and, 27, 130, 153, 276; and time, 35–36; manual, as mechanical, 45; and industrialization, 48–49, 129, 149, 194; in photographic metaphor, 49; photographic, 52, 268; and managerial oversight, 53; versus gambling, 53; pictorial signs of, 57–59; photographic signs of, 69, 77, 80, 94–95; distanced from pictorial value, 75, 124; chance as supplement to, 105; and the picturesque, 111; pictorial, and vapor, 117–119, 123–124; and copyright, 154; as a pictorial subject, 173–178, 314–316; and the communication of intelligence, 267; and leisure, 316
Lacan, Jacques and the gaze, 234–238, 240–241, 246
landscape, 50, 85, 177, 248, 314; and the origins of photography, 18; and chance, 24–26, 106; and the leveling of pictorial attention, 43, 214, 244–246; and lack of finish, 58; and pictorialism in photography, 62–64, 102–103, 127, 132–134, 141–142, 145–146; and atmosphere in Romanticism, 110–112; and atmosphere for Ruskin, 115–117; and modern speed, 171; vapor separated from, 192; planning, 215; and pictorial integration, 245–246; and violence, 247
Laplace, Pierre-Simon, 12–13, 164
Lartigue, Jacques-Henri, 173, 210–211
Leonardo da Vinci, 24, 107–108, 132, 190
literature, 211; role of chance in, 2; and speculation, 70; and literary subjects in photography, 94, 155; and Freud, 187; role of intention in, 254–255; and modernism in the pictorial arts, 256–261, 263; and the syntax of photography, 264–267, 278
lithography, 41, 124, 154, 284, 291
London, 51, 57, 83, 87, 153, 158, 320; and Great Exhibition of 1851, 41; photographic firms within, 54; Royal Photographic Society exhibition in, 166–167, 176, 320
Lucretius, 7, 10, 320

Mabry, Thomas, 264, 266–267
machine, the, 1, 21, 152, 167, 173–175, 194; and uniformity, 10; and God, 18; and saving labor, 18, 22; and copying, 44; photography as or not as, 44–49, 69, 86; and finish, 58;

machine, the *(continued)*
 and dehumanization, 81, 88, 129, 186;
 and effluents, 114; as a blight, 140;
 speculator as a, 185–186; as model for
 human behavior, 186; as producer of
 culture, 212; and violence, 213; as measure
 of art, 254–255
madness, 114, 122–123, 263, 320; of
 photography, 52, 204, 255; of pareidolia,
 107–108, 121; of mechanical reproduction,
 211–212; of commerce, 261; Cold War, 280,
 310
Malcolm, Janet, 94
Maloney, Russell, 211–213, 255
Mandle, S. Billie, 321–322
Manet, Édouard, 117–119, 158, 175, 177
Marx, Karl, 141, 163
mass media, 180, 194, 267, 270–274, 280
Maxwell, James Clerk, 13, 162–168, 188
McLuhan, Marshall, 190, 278
Michaels, Walter Benn, 299
miracles, 13, 28, 61, 95–96, 104
modernism, 180, 284; and the early role of
 photography within it, 11, 62, 130, 195; in
 America, 11, 257, 261, 283; and facture,
 58–59; of Cameron, 74, 77, 94, 97; and
 vapor, 118–124; of Stieglitz, 159, 177–178,
 299–303, 314; and primitivism, 200; of
 Lartigue, 210; and rivalry, 214; of Weston,
 214, 216, 233, 236–237, 240, 303; of
 Sommer, 226–228, 233–240, 247–248,
 314; of Adams, 236–237, 239–240, 252;
 and photography at MoMA, 249, 256–264,
 270, 298, 300–301, 315, 318; of Greenberg,
 249, 256–264, 279; and medium self-
 criticality, 249, 256, 279, 314; and rebellion
 against sentiment, 254; of Pollock, 261–264;
 and conscription by commerce, 263, 280;
 of Steichen, 270; of Szarkowski, 278–280;
 of Klein, 295–297; and Baldessari,
 297–310
modernity, 11, 84; and its investment in
 photography, 4, 47; relationship of
 photography to, 46, 127; as pictorial
 subject, 59, 141; insecurity and flux of,
 71, 166, 179–180, 182; internal contradic-
 tions of, 103–104; and vapor, 117–119,
 123–126, 163, 174; and alienation, 134;
 and material transformation, 149, 163,
 174–175; and visual dynamism, 152, 194,
 197–198, 200, 210; and mobility, 171,
 202; and antiquity, 177–178, 314; and
 psychoanalysis, 187

modernization, 167–168, 175, 279; and
 atmosphere, 10, 117, 124, 140, 166, 179,
 320–321; and time, 35; and its complex
 relationship to modernism, 58; as pictorial
 subject, 142; and uniformity, 147; lost faith
 in, 188
Monet, Claude, 117–118, 158
montage, 243, 250, 267
Munkácsi, Martin, 198–200
Museum of Modern Art, 210, 257, 260; and
 Adams, 237, 250–252; and Newhall,
 249–256; and Evans, 264–267; and
 Steichen, 268–270; and Szarkowski,
 278–280
museums, 217; and the assimilation of
 photography, 1–2, 249–253, 260–261,
 267–268, 278, 281, 315; and the suppression
 of chance, 2–3, 315–316; and the suppres-
 sion of history or social structure, 11,
 249–250, 279–281, 284, 309; and Emerson,
 138–139; as framing devices, 219; and
 authorship, 251–252

Namuth, Hans, 262–264, 297
naturalism, 26, 42–44, 121–125; and
 photography, 50, 129–131, 134, 155–156,
 258, 313; and modernism, 57, 288; as
 hampered by skill, 104; and Romanticism,
 129; post-Darwinist, 254
nature, 13, 18, 84, 88, 112, 114, 121, 134; laws
 or order of, 6, 12, 17, 33, 38, 49, 128, 203;
 as author in photography, 7; at odds with
 modernization, 10; as abiding by chance or
 uncertainty, 13, 104–105, 189, 225, 254,
 311; small accidents in, 23, 25–26, 28–29,
 43, 64, 105; ideals of, 23, 64; aesthetic need
 to modify or improve on, 24, 27–29, 47–48,
 50–51, 59, 65, 124, 144–145, 191, 312; and
 the accidental composition, 24–29, 42–43,
 130, 145–146, 312; human, 30–31, 52, 88,
 186, 270, 273; and time, 35, 37; aesthetic
 adequacy of, 42–43, 125, 129–130, 145,
 159, 217, 313; and photography, generally,
 47, 49–50, 64, 144, 162, 261, 274, 280; and
 vapor as aestheticizing, 104, 114–116, 125,
 146, 156, 163, 314; and the Enlightenment,
 109; as not abiding by the same aesthetic
 principles as pictures, 110–111; study of,
 119, 121–123, 217, 313; as repository of
 forms, 122, 125, 216, 293; as abiding by
 the same aesthetic principles as pictures,
 131–133; aesthetic perception of, 131–133;
 and commercialization, 140; modern

experience of, 171; and abstraction, 192; and morphology, 218; processes of, 224, 227, 240; and inseparability from culture, 228; and class, 237, 241; and signification, 241–242; and ideology, 273–274; and sexism, 299; simulation of, 305

Newhall, Beaumont, 249, 268; and Weston, 250–251; and his curatorial program at MoMA, 250–256; and "painting-photographs," 251–252, 266; and Stieglitz, 299

Newton, Sir William J., 12–13, 54, 63–64, 165, 188

New York City, 158, 215, 241, 250, 270, 293; streets of, 10, 156–157, 163, 168–169, 176–178, 200, 314, 316; and pictorialism, 155; modernization of, 163, 166, 178; and asphalt paving, 169–172; and immigrant labor, 173–174; and gambling, 185; and modernism, 261

Niépce, Joseph-Nicéphore, 14, 49, 174

nostalgia, 77, 323; and pictorial finish, 58; and pictorialism, 103, 127, 154–155, 174, 322

Olsen. Victoria, 89

painting, 41–42, 195, 268; as opposed to photography, 2, 21, 29, 42, 80, 256, 258–260, 280; photography as a form of, 7; and vapor, 10, 104–126, 135, 158, 175, 177; as unsettled by photography, 17; labor required in, 18–19, 21, 27, 29, 45–46, 75, 117, 119–124, 153, 279; as requiring, like photography, aesthetic discernment, 19, 21, 130, 133, 180, 191, 256; ideals of, 23, 47–48, 54, 86–87, 217; and naturalism, 26–28, 42–44, 129; as a liberal art, 27, 45; unconscious dimensions of, 30–31; under modernity, 41, 47, 48, 178, 256–257, 261, 279; and finish, 57–59, 61, 276; and academicism, 62, 155; establishment, 80, 145; sharing with photography the status of picture, 103; chance in the execution of, 104–105, 263–264; and hierarchy of attention, 130–131, 134; invocation of, in photography, 142–143, 207; as an object of analysis, 189–190; and sublimation, 227; and the gaze, 235–236, 238; and the terms of photography's assimilation in the museum, 249, 251–252, 264, 280; integrates photography, 281–283, 286–305, 310

Paley, William, 33, 105

pareidolia, 24, 107–108, 115, 119, 121

Peirce, Charles Sanders, 13, 189

performance in photography, 84, 94–101, 313; as an exchange between sitter and photographer, 82–86, 88–89, 91–93, 96, 100; and Pollock, 262–263; and photography in performance, 296–297

perspective, 134, 236; linear, 105–106, 108, 114, 179, 311; atmospheric, 108, 135–138

photographic details, 9, 228–229; as no sign of labor or achievement, 18, 59; improbability of excluding unwanted, 28; as enhancing legibility, 30–33, 159, 208; as unconscious but intelligible inclusions, 30–33, 181; and time, 35; composite printing as a means to control, 61; as aesthetically troublesome, 62, 104, 132–134, 162, 219, 255, 275; versus details in painting, 80; versus photographic glitches, 81–82; and differential focus, 132–135; as an occasion for mastery, 216; and decomposition, 246, 295; as persuasive, 275

photogravure, 126, 137–138, 143, 146–148, 155

pictorialism, 102, 159, 268, 314; and its ostensible opposition to modernization, 102–104, 142; and the aesthetic effects of vapor, 104, 125–126, 146–147, 155; as monotonous, 145, 163; and its hostility to the snapshot, 151; and authorship, 154; and surface marking, 154–155; and America, for Stieglitz, 155–156, 158, 165–166, 173–174; and imitation, 155, 159; and soft focus, 162–163; and labor, 173–174; abandonment of, 180, 195, 216, 256; and blur, 195

picturesque, the, 32, 133, 155; and the accidental encounter, 19–27, 31, 40, 60, 131, 152; and time, 21; and intention, 29; and combination printing, 60–61; and atmosphere, 110–112; as a subject of pictorial reflection, 142; and its codification in pictorialism, 145–146; in the city, 158, 173

Piero di Cosimo, 24, 106–108, 115

platinum prints, 102–104, 126, 138–139, 155, 174

Pliny the Elder, 104–105

Pollock, Jackson, 280; and sublimation, 227; and photography, 261–264, 280, 286, 297; and subjective expression, 286, 289, 291, 298

Pop art, 280, 283–284, 304

portraiture, 42, 68, 70, 132; in carte-de-visite format, 54–56; and the conventions of the photography studio, 62, 68, 72, 75, 103; as renewed and enlivened by Cameron, 68–69, 73–76, 80, 85–92, 230, 316; and the inadvertent detail, 81; and reciprocity, 83–88, 91–93, 96, 100; and copyright, 154; composite, 161–162; and its undoing, 193; and the privileged condition, 221

primitivism, 10, 85, 180, 199, 202, 213, 314

probability, 37; science of, 13, 34, 37–38, 272; of accidentally encountering a worthy composition, 28, 61; of exposing the camera at the optimal moment, 35–36, 211–212; of photographic success generally, 74, 153, 169, 174, 278; as represented in photography, 162; and kinetic theory of gases, 163–165; and statistical mechanics, 188; and subatomic physics, 188; and madness, 211–212

Protogenes, story of, 104–105; and Renaissance painting, 105–108; and Romantic painting, 113–114; and Victorian painting, 122–123; and photography, 198; and abstract expressionism, 263; and Dada, 287; and conceptual art, 310; and cosmology, 320

psychoanalysis, 180, 187, 314; misinterpretation of, 189; and images, 189–190; and intention, 190; and latent significance, 190–191; and random forms, 192; and Benjamin, 197–198; and the gaze, 234–236

quantum mechanics, 188–189, 224–225

Quetelet, Adolphe, 38, 162–164

RAND Corporation, 306–309

Raphael, 18–19, 42–43, 74–75

Ray, Man, 192, 250, 255, 260, 277

Rejlander, Oscar G., 59–62; and Cameron, 72, 77; and pictorialism, 102; and Emerson, 130, 143; and Stieglitz, 169; and contemporary practice, 318

Rembrandt van Rijn, 51, 57, 124

Renaissance, Italian, 263; and chance resemblances, 24; and copying, 43; and vapor, 105–108, 119, 122, 175; and linearity, 114; and rivalry, 214

Reynolds, Sir Joshua, 65; and selection and synthesis, 22–23, 29, 42–43, 125, 145, 293; and extraneous detail, 22–24, 31; and industry of the mind, 27; and statistical thinking, 36; and mechanical handling, 46;

and Victorian photographic discourse, 56–57, 64; and intention, 128; and hierarchy of attention, 130–131; and trickery versus art, 303

risk, 219, 254, 276; as social bond, 8; management of, 10; and artistic innovation, 168; and modern life, 180; and speculation, 183; and class, 240

Robinson, Henry Peach, 24, 29, 59, 61

Romanticism, 129, 178; and vapor, 10, 110–122, 165, 301, 319; and accidental beauty, 27; and time, 36; and finish, 57–58; and dust motes, 167–168; and the spiral, 218

Rorschach, Herman, 191–192

Rosenthal, Joe, 205–209, 212, 251, 290

Rossetti, William Michael, 76, 81–83, 88, 128

Ruskin, John, 47; and trial against Whistler, 46, 59, 119–124, 128; and clouds, vapors, or atmosphere, 114–117, 126, 141, 167–168; and climate change, 320

scavenger, photographer as, 181, 196, 201, 214, 227

science, 123, 260, 316; and an indifferent or autonomous universe, 6–7, 311–312; and mechanical determinism, 12–13, 188, 317–318; and the emergence of chance, 14, 163–164, 271–272; and serendipity, 15–17; visualization in, 18–19, 23, 49, 62, 64, 320; and art, 27, 46, 64, 66, 80, 112, 135, 162, 224; and expert judgment, 36; and statistical methods, 36–38, 114; and deskilling, 48; and vapor or gas, 108–110, 164–168, 185; optical, 131; and objectivity, 186; and the unconscious, 188; and uncertainty, 225; and information, 271–272; and simulation, 307–309

serendipity, 15–17; in discerning photographic subjects, 19–20, 32, 40; and photography, generally, 39, 217, 313; and camera focus, 73–74, 127; and snapshot photography, 169; and the readymade, 315

Shannon, Claude E., 271–272, 281, 288

Sherman, Cindy, 317–318

Shunk, Harry, 293–296, 304

simulation, 5, 11, 305–310, 315, 318

skill, 41, 79, 212; mistaken for luck, 2; obviated by photography, 18, 21, 28–29, 43–44, 49, 150, 154, 181, 276; traditionally required of art, 18–19, 42, 276; nature's accidents as supplanting, 26–28, 313; in the liberal arts, 27, 41; and its repudiation in conceptual art, 28, 291, 303–305; in

copying, 43; modern meaning of, 48–49; demanded of fine photography, 56–57, 61–62, 152–153; and finish, 56–59, 276; as demoted by Cameron, 74–75, 96; as interfering with the representation of chance, 104–105, 108; rejection of signs of, in modernism, 124; photograph as proof of, 184, 252; and psychoanalysis, 190; and simulation, 306

slides, lantern, 149, 169, 174, 176, 178, 200; and toning, 157; visual qualities of, 166, 314; social experience of, 167–168, 314; and contemporary art, 320

snapshots, 150, 173; and chance, 1, 168–169, 198, 277; term for, from hunting, 151; modernity of, 152, 198; and modern mobility, 171; and retrospection, 191; deathly stasis of, 196; aesthetic taste for, 275, 281; as detecting new visual truths, 279; and conceptual art, 289–290, 298, 301, 309, 316; and the "selfie," 317

Sommer, Frederick, 3, 10–11, 213, 214–248, 305, 314, 316; and rivalry with Weston, 214–228, 232–234, 236–237, 240, 247; and the privileged condition, 220–226, 232–234, 241, 244–248, 250; and sublimation, 226–227; and the lengthening of attention, 227–228, 239; and witnessing, 228; and the pristine nature of Adams, 228, 239–240, 252; and metabolism, 229; and the uncanny, 230–237, 246; and the commodity form, 232–234, 248; and the gaze, 234–238, 240–241, 246; and disease, 238–240; and landscape, 244–248

speculation, financial, 211; and kinship with gambling, 53–54; and Cameron, 71, 84, 313; and hunting or photography, 181–187, 211, 313

statistics, science of, 6, 114, 310; and the mastery of chance, 10, 13–14; and moral anxiety, 13–14; and judgment, 36; and unexpected order, 37–39, 313; and Galton's composite photography, 161–162; and gas mechanics, 164–166, 188; and subatomic physics, 188

steam, 165; as modern subject for painting, 10, 112–119, 158, 196–197; versus smoke, 116–117; in pictorialism, 126, 138, 140–142, 146; age of, 142, 163; and Stieglitz, 149, 158, 165–166, 173–179, 192, 320

Steichen, Edward, 159, 249, 268, 278; and *Family of Man*, 268–271, 273

Stieglitz, Alfred, 3, 10, 84, 149–179, 200, 251, 267, 270, 305, 312, 314; and New York City, 10, 156, 158, 163, 314, 316; and steam, vapor, or atmosphere, 149, 155–169, 173–179, 196–197, 314, 316, 320; and turbulence of modernity, 149, 157, 163, 175–176, 178, 314; and asphalt paving, 149, 163, 169, 173–176, 316; and lantern slides, 149, 157, 166–168, 176, 178, 200, 314, 320; and urban labor, 149, 173–179, 314; and a new pictorialism, 155–166, 173, 314; and the hand camera, 168–169, 181, 184, 200–201, 217, 278, 295, 314; and cloud pictures, 192–193, 201, 215, 244, 298–301; and Sommer, 215, 244–245; and Weston, 216; and Newhall, 251, 255, 260; and Greenberg, 257; and Mabry, 266; and Duchamp, 286, 315; and Baldessari, 298–303

Strand, Paul, 84, 250–251, 266

subjectivity, 182; artistic, 129; as revealed by chance images, 191; and photographic equivalence, 192, 245; as antidote to mass commerce, 254, 280; of photography, 255; forfeiture of, 281; Duchamp's demystification of, 286–289; as critiqued by conceptual art, 298, 304

Surrealism, 180, 191–192, 197, 200–201, 215

syntax, 16; of photographs, 231, 266–267, 271, 274; of traditional pictures, 270–271; as lacking in photography, 270–271, 274, 300

Szarkowski, John, 249, 278–280, 291

Talbot, William Henry Fox, 3, 9, 12–39, 41, 44, 72, 77, 150, 267, 305, 322; invents a photographic process, 14–15, 150, 311, 318; and the role of serendipity in invention, 15–16, 19; enlists chance in place of labor, 17–20, 24, 31, 66, 279, 313, 315–316; hopes for a new art, 19, 40, 284, 313; vests creativity in the opportunistic eye, 21–28, 49, 53, 60, 127, 130–131, 133, 152, 154–155, 180, 191, 217, 313, 316; and proximity of chance and cheating, 21, 36–37; counters academic tradition, 22–24, 312–313; and the picturesque, 24–27, 42, 313; and the shortcomings of his scheme, 28–30, 152; and the accidental detail, 30–33, 81–82, 152, 181, 190, 209, 313; and the camera's indifference, 33–36, 54, 130, 133, 315; and photographic time, 35–36, 147; and the emergence of social statistics, 37–39, 313; and the distinction between photographic process and product, 50

taste, 51, 59, 79, 180, 316; the cultivation of, through drawing, 22; and the picturesque, 25–26. 29, 32; popular, in photography, 44, 72, 84, 163, 196; for the irregular, 64, 322; and the market, 71; and pictorialism, 102–103, 126, 155, 163; elevation of, 129; for visual dynamism, 152, 194; American, 159; versus analysis, 189; retrospective dimensions of, in photography, 191; and distaste, 236; as ineradicable in art, 288, 291; as critiqued by Baldessari, 293, 303, 305, 309, 316

Tennyson, Lord Alfred, 67, 70, 89, 97

theater, 85; as an alternative to chance, 29, 37, 209, 213, 228, 251; Rejlander's composite photography as, 61–62; Cameron and, 70, 79, 88, 92–93, 97; and pictorialism, 131–132; the city street as spontaneous, 168–169; of war, 305; contemporary photography staged in the manner of, 317

time, 263; geologic, 7; and the picturesque, 19, 22; as accidental, 28, 36, 61; photograph as record of, 29–30, 32; as uniform and divisible, 35–37, 88; as romantic, 36–37; exposure, 44, 68, 87, 161; painting outside, 47; photograph as poignant sign of, 81–82, 295; Emerson, and dream-like, 126, 147; and instinct, 182; photographer merging with, 204–205; Sommer and the slowing of, 225, 227–229, 239; and boredom, 293; and vapor, 320

tuberculosis, 215, 238–239, 248

Turner, J. M. W., 62, 257; and vapor or atmosphere, 10, 112–117, 123, 126; and rebellion against finish, 57–58, 119; and Stieglitz, 174–175

typewriters, 195, 211–212

uncanny, the, 87–88, 196, 201, 230–237, 246

vapor, 10, 263; as a test of determinism, 12; mercury, 15; and pictorialism, 104, 126, 314; in Renaissance painting, 106–108; in Romantic painting, 110–114; and Ruskin, 115–117; meanings of, at the Ruskin/Whistler trial, 119–124; and Emerson, 126, 128, 138, 140–143, 146–147; and Stieglitz, 149, 155–169, 173–179, 192–193, 299, 314, 316; and the language of photography,

157–158; modernist turn away from, 200, 216, 248; and Baldessari, 301–303; and contemporary art, 319–320

Victorians, 216, 254; and chance, 5, 10, 31, 153; and aggregations of particles, 7, 9, 312; and luck versus merit, 16, 20; and drawing, 22; and time, 35; and art, 39, 41, 47, 71, 198; and hopes for photography, 40, 47; and the shock of photography, 44, 54–56; and the mechanical, 45, 313; and aesthetic mediation, 50; and gambling, 53–54, 313; contradictions besetting, 66, 94–96, 103, 145, 312; and gender roles, 78–79; and vitality, 85–86, 91; and replication, 100; and atmosphere, 126; and physiognomy or phrenology, 160; and typological thinking, 162; and gases, 163; and objectivity, 186; and intention, 190

Wall, Jeff, 298, 317–318

war, 10; and colonialism, 97–100; and lost faith in modernization, 188; and photography and chance, 205–209; and mechanical madness, 211–213; and ideology, 214, 248; and base materiality, 243–244; and surveillance, 246; and information theory, 271; and simulation, 305–310

Warhol, Andy, 281–282

Weston, Edward, 214–219, 241; and rivalry with Sommer, 214–228, 232–234, 236–237, 240, 247; and his funnel, 217–219, 222, 226, 240; and his subjects and settings, 217–218, 227; and the spiral, 218–219, 237, 279; and the privileged condition, 220–226, 247; and witnessing, 228; and the commodity form, 232–234; and laminated pleasures, 236; and universal rhythms, 245; and Newhall, 250–251; and "straight" photography, 256; and Greenberg, 257–258, 264; in contrast to Evans, 265–266; and Baldessari, 303

Whistler, James McNeill, 119; and trial against Ruskin, 46, 59, 119, 122–124, 128, 253; and labor, 75, 123–124; and vapor, 121–125; and Emerson, 145

Wimsatt, W. K., 254–255, 278

Winogrand, Garry, 3, 278

Zen Buddhism, 203, 205

Zerner, Henri, 58